THE CULTURAL TUTOR

The Cultural Tutor

Forty-nine Lessons You Wish You'd Learned at School

SHEEHAN QUIRKE

PENGUIN
VIKING

VIKING

UK | USA | Canada | Ireland | Australia
India | New Zealand | South Africa

Viking is part of the Penguin Random House group of companies
whose addresses can be found at global.penguinrandomhouse.com

Penguin Random House UK,
One Embassy Gardens, 8 Viaduct Gardens, London SW11 7BW

penguin.co.uk

First published 2025

002

Copyright © Sheehan Quirke, 2025

The moral right of the author has been asserted

Penguin Random House values and supports copyright.
Copyright fuels creativity, encourages diverse voices, promotes freedom
of expression and supports a vibrant culture. Thank you for purchasing
an authorized edition of this book and for respecting intellectual property
laws by not reproducing, scanning or distributing any part of it by any
means without permission. You are supporting authors and enabling
Penguin Random House to continue to publish books for everyone.
No part of this book may be used or reproduced in any manner for the
purpose of training artificial intelligence technologies or systems. In accordance
with Article 4(3) of the DSM Directive 2019/790, Penguin Random House
expressly reserves this work from the text and data mining exception

Set in 12/16.32pt Garamond Premier Pro
Typeset by Six Red Marbles UK, Thetford, Norfolk
Printed and bound in Great Britain by Clays Ltd, Elcograf S.p.A.

The authorized representative in the EEA is Penguin Random House Ireland,
Morrison Chambers, 32 Nassau Street, Dublin D02 YH68

A CIP catalogue record for this book is available from the British Library

ISBN: 978–0–241–74285–3

Penguin Random House is committed to a sustainable future
for our business, our readers and our planet. This book is made from
Forest Stewardship Council® certified paper.

For all the people I never met

Contents

Prelude ... 1

I. How Did We Get Here?
 i. Skeuomorphs ... 11
 ii. Queries Regarding Postal Permits ... 16
 iii. The Sixth Age ... 27
 iv. 9192631770 ... 37
 v. 'Of arms and the man I sing . . .' ... 45
 vi. Lionel Messi and Giovanni Battista Tiepolo ... 54
 vii. What Shape is History? ... 60

II. Watching the Wheels
 i. Where Does Zeus Live? ... 71
 ii. *Barba non facit philosophum* ... 81
 iii. Snoozing on the Shoulders of Giants ... 89
 iv. Concerning Kakistocrats ... 96
 v. You, Me, and Signor Cremonini ... 105
 vi. Napoleon versus Refrigerators ... 113
 vii. Why is the World Going Grey? ... 119

III. The Language of the World

 i. Why Doesn't Ron Weasley Live in a Minimalist Mansion? 133
 ii. *Cor magis tibi sena pandit* 142
 iii. Order and Freedom 149
 iv. On the Origins of Barnacles 160
 v. *Je sais quoi* 170
 vi. Aircon Revolution 180
 vii. The Temple of the Golden Pavilion 187

IV. Apocalypse and Genesis

 i. Cavalry in the Refectory 197
 ii. Love! 206
 iii. An Oak Tree 216
 iv. Through Marble Darkly 224
 v. The Lesser Arts 237
 vi. Humpty Dumpty and Homer 244
 vii. Is *Hamlet* True? 253

V. Magic is Real

 i. On Calculating the Circumference of the Earth 263
 ii. A Mind of One's Own 269
 iii. The Grain Merchant of Rhodes 275
 iv. Stage and Salvation 281
 v. 'You talking to me . . . Cicero?!' 288
 vi. Objective Considerations of Contemporary Phenomena 298
 vii. Ough, Ough, Ough, Ough, Ough, Ough, Ough, Ough 307

VI. How to Live (and How to Die)
 i. The Trial of Socrates 319
 ii. When Xenophon Met Mulan 327
 iii. Revenge of the Stoics 335
 iv. The Art of Doing Nothing 343
 v. Ten Duovigintillion Years 351
 vi. Melencholia 359
 vii. Death, Thou Shalt Die 366

VII. The Way Things Are
 i. *'Ché de la reni tornato 'l volto . . .'* 377
 ii. Coals of Juniper 385
 iii. The Howling of Garmr 392
 iv. O Bezaleel, Where Hast Thou Gone? 400
 v. Peasant's Quantum 407
 vi. The Last Library on Earth 416
 vii. Postlude 423

Acknowledgements 429
Notes 431
List of Illustrations 455
Suggested Reading 467

Prelude

As I write these words I am looking at a mountain – a hill, really – and it is raining. The time is eleven thirty at night. And I ask myself, 'What is the right way to start a book?' You can tell that I'm struggling. Everyone knows the advice: say something to hook your reader. Well, I'm afraid I have no hook. But there *are* some things I want to tell you, and I think you will find them interesting.

This book is about art, architecture, history, literature, poetry, philosophy, war, technology, and love. That sounds like a lot, but they can all be summed up in a single word: culture. Yes, this book is about culture, the story of what we human beings have done. It started millennia ago and is still being told now, with every passing moment. You are part of this story – and this book is your introduction to it.

Culture is like a language. It can be learned, and anybody can learn it. And, just as learning a language opens up new possibilities, learning about culture changes how you see and interact with the world. There is wonder all around us, endless wonder and fathomless beauty, a hundred million fascinating stories behind every mundane detail of life. With this book I want to help you discover all of that, to help you see the world in a richer and more vivid way.

So this book isn't just about culture as a thing to be studied. The value of art isn't 'knowing about' art; the value of art is how it reveals to you parts of yourself you did not know were there. Literature will give you solace in your darkest moments; philosophy will help you make better decisions; and history will clarify the problems of the present day. This is the real purpose of education – not knowing for

the sake of knowing but knowing in order to live well and do right, to understand both yourself and the world better. Learning about architecture, for example, has turned every journey I take – be that visiting a new country or going to the dentist's – into an adventure. Each street – every corbel and cornice – tells myriad tales, and understanding architecture lets you read them. There is *more* around us, more than we ever quite realise, and culture is what gives us the eyes to see it.

Although these things have always interested me, just a few years ago I knew very little about them. I was curious about the buildings that surrounded me – why did they look like that? I kept hearing about ancient Greece and Rome in books or films but had no idea which came first. Art seemed intriguing, but I thought you needed expert knowledge to 'get' it.

Well, three years ago I started exploring culture more deeply and wrote about this journey online. I quit my job and created an X account called 'The Cultural Tutor'. Soon I had 1 million followers and it became clear that it wasn't just me who wanted to know more about culture. People really do want to learn about art, history, architecture, and all the rest of it – they just don't know where to begin. And the internet is, though a potentially fabulous place, too often a tornado of gruelling political arguments, depressing newsflashes, unceasing gibberish, and people trying to sell you stuff. Cultural enrichment is an alternative. It is a place of joy and intrigue, of that 'something more' we are always searching out. The popularity of my online writing is testament to the fact that people are, indeed, looking for something – and that in culture we can find it. *The Cultural Tutor* is the culmination of that work, and of all the things I have learned; it is my attempt to create an introduction to culture, not as a list of factoids or as a product, nor as an academic

PRELUDE

treatise or guide to impressing people, but as a way of seeing and understanding the world.

What I have written for you is the book I would like to have read before I began my journey, a book which introduces the different pillars of culture, explaining each in its own way and showing how they are connected. *The Cultural Tutor* will not tell you everything you need or want to know of course, because the things I'm writing about are illimitable in scope. It is a place of departure, not arrival. And we will travel far together, even through time. Gothic architecture, air conditioning, Lionel Messi, alarm clocks, Socrates, spelling, dying, Kinkaku-ji, and Ragnarök – these, and much else besides, we will glance at. So think of this book, above all, as a cultural primer. It is mainly, though far from exclusively, about what we usually call the West. And so I hope it will serve as a useful primer for anybody interested in Western culture, wherever you are from. But, more importantly than that, its themes and approaches – embracing culture as a way of life – are universal.

It's hard to know where to begin with subjects like art or philosophy, and even once you do begin there seem to be numberless books to read and multitudinous angles to be studied. This is intimidating and time-consuming. *The Cultural Tutor* is my attempt to do that work for you, to give you some foundational understanding and provide the knowledge you need to journey further. I have spent my time leafing through battered old books, investigating the shadowy corners of ruined buildings, and staring into the faded pigments of forgotten paintings – now I bring all that to you. Because you can teach yourself about these things, and in the internet age this is more readily possible than ever before. So you don't need to know anything about the *Annals* of Tacitus or the differences between Impressionism and Expressionism to read this book; it is your

starting point. Though, even if you do know a thing or two about these subjects, there is plenty in here that will surprise you.

My aim with this book is also to share cultural education more widely. Too often culture is either compressed into thirty-second soundbites, reduced to trivia, or described in a needlessly complicated way. *The Cultural Tutor* represents a different approach. Because culture is more than trivia and more than a field for experts – it is the water we are all swimming in, and it is something we should all know about. Art, for example, isn't just for people who have studied art, and it isn't just for the elite. Art is – always has been and always must be – for everybody. An individual painting or sculpture can seem incomprehensible or ridiculous, but that is usually because it has been presented in the wrong way. The purpose of this book is to sweep away the nonsense that sometimes surrounds culture and give you culture as it really exists, in all its glory and catastrophe, as it relates to you and shapes the world we are living in.

I also wanted to write about things that are not being given the attention they deserve, things that have been sidelined in our age of self-optimisation, be it the origins of how we measure time or the best ways to write love poetry. Because ours is a wide and fantastical world, an awful and miraculous place. More and more I believe a little wonder is what we are missing in our everyday lives. Not mere factoid-wonder but a deep and magical awe. Culture gives us that. And now, more than ever, we need it to remind us that human beings have imaginations and hearts, not just bank accounts and schedules. Remember: culture is the story of everything we have done, and you are part of this story. To help you feel this depth, to live with a sense of perspective, place, and profundity – that is the ambition of *The Cultural Tutor*.

PRELUDE

So here we are. You the reader. Me the writer. Our Earth is turning. Time rushes on. Are you standing in a bookshop? Reading an online preview? Who are you? What did you dream of last night? The only thing I can say for now is that, if you read this wad of paper printed with symbols called letters, glued and bound together, you may find it useful. And we will get to know each other somewhat, even have a laugh along the way!

The Cultural Tutor has been divided into seven pillars. I could have called them sections, I suppose, but that is a brutally boring word. And the metaphor is accurate: each of the pillars that support a building may be beautiful, but they only work through their unity.

The first pillar is about history; the second is about the forces that have shaped that history; the third is about the world we have built, our architecture; the fourth is about those things we inevitably make, our art; the fifth is about thinking, speaking, and writing; the sixth is about ways of living; and the seventh is about our present day.

Each of these pillars has been divided into seven short chapters, making forty-nine in total. You can read them in any order. Some are directly informative and others are more vagrant. There is overlap in places, but it could not be any other way – all these subjects are fundamentally inseparable. To give just one example, you can't talk about architecture without talking about history, and you can't understand history without understanding architecture. So certain ideas and themes reoccur, but every time in a different light.

Two more things I should mention.

First: there are lots of quotations in this book. Why? Far more useful to have these voices talking directly to you than me barging in with attempts at summarisation. And, more importantly, I want you to meet first-hand the cast of heroes and villains who have played their part in this great drama called humankind. These quotations also serve as recommendations along the way for further reading.

Second: the world is not limited to the places or people mentioned in these pages. Would I had written of more! But I trust you

to think for yourself. Whatever I have mentioned are examples, not ideals.

All things now said, all preliminary caveating done, any more chance of an introductory thought swift melting away... for good or bad, I give you *The Cultural Tutor.*

The First Pillar of
The Cultural Tutor

How Did We Get Here?

CHAPTER I

Skeuomorphs

†

For whatsoever from one place doth fall
Is with the tide unto another brought:
For there is nothing lost, that may be found if sought.
— Edmund Spenser, *The Faerie Queene*

In 1889 an archaeologist called Henry Colley March was studying ancient pottery. He came across some clay jars with decorations that looked like twisted ropes. Why did they look that way? People had used woven baskets before pottery. And when they started to make jars with clay, March realised, they imitated the appearance of those baskets. Weaving does make a pretty pattern, but with the baskets it had been necessary. With the clay jars, however, the pattern became purely decorative. March coined a new word to describe this phenomenon: 'skeuomorph'. *Skeuos* means 'tool' in ancient Greek and *morphe* means 'shape'; together they mean 'in the shape of a tool'. So a skeuomorph is any new invention designed to look like what it replaced, even though it doesn't need to. But skeuomorphs are not unique to ancient pottery – they are all around us.

If you use Microsoft Word I urge you to look in the upper-left corner, at the 'save' button. What is it? A floppy disk – even though they became obsolete twenty years ago. Digital phone cameras don't

have mechanical shutters, but they *do* make a clicking sound – like physical cameras. The Gmail logo imitates an envelope despite neither paper nor postage being involved. I could go on: the desktop recycle bin, the visual paper texture of eBooks, hubcaps that evoke spokes. What is the point of skeuomorphs? There's no intrinsic need for websites to have a 'shopping trolley' represented by a small image of a physical trolley, but when it looks that way we intuitively understand what it is. So skeuomorphs make new technology easier to understand. That being said, sometimes they are purely aesthetic. Cooling vents are only needed for cars with combustion engines, but because a car without a grille looks odd designers have retained them for electric cars.

Eventually we forget where our skeuomorphs came from and they simply become 'the way things are'. Look at the White House in Washington DC, for example. Look closer, at the columns on its north front. Notice that each of them has decorative swirls. These are called volutes.

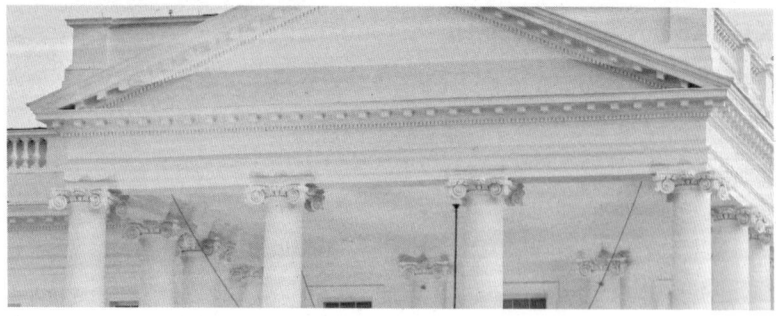

Why are they there? Thousands of years ago, Greek temples – which inspired the Neoclassical architecture of the White House – were made with wood, and their columns were timbers. These columns were sometimes decorated with the curved horns of male

sheep. When the Greeks started building with stone they carried across all the original features of the wooden temples – including the spiralling horns, which became volutes in marble. Several thousand years later these petrified horns adorn the house of the President of the United States of America. Curious!

I hope you can see why I have chosen skeuomorphs as our starting point – because they are a supreme reminder of how the past shapes the present, of *history*. As the poet-historian Thomas Carlyle wrote: 'The poorest Day that passes over us is the conflux of two Eternities; it is made up of currents that issue from the remotest Past, and flows onwards into the remotest Future.'[1]

We did not build the world we are living in. Everything we say, think, and do (plus everything we are able or unable to do) has been shaped by people who are no longer alive. Why are there 365 days in a year, 30 (or 31, or 29, or 28) days in a month, 7 days in a week, 24 hours in a day, and 60 seconds in a minute? That's quite a mess. We can thank Mesopotamians, Egyptians, Julius Caesar, Indian mathematicians, Hebrew scholars, Greek astronomers, and Pope Gregory XIII for it. We are steeped in inherited ideas and systems which we have accepted, unthinkingly, as we found them. Even these words you are reading were created by long-gone generations. And who built the roads you walk along, decided they should be in that particular place, go in that particular direction? More often than not we walk the same roads people walked centuries ago simply because a shepherd decided to build his cottage there or a caravan found it the easiest route to follow on its trade journey. Look at what things are called and you will learn a lot. July, named after Julius Caesar; Wednesday, a corruption of Odin's Day. The clues to the past are in the present; the past *is* the present.

Maybe you're sceptical about what I'm saying. 'The iPhone,' you

might ask, 'is that not entirely new?' But without transistors the iPhone would not work, and the transistor was invented in 1947. And the transistor could not have been invented without silicon, first isolated by Jöns Jacob Berzelius in 1824. Berzelius was only able to do that because of the chemical theories of the Frenchman Antoine Lavoisier, published four decades earlier. Still, Lavoisier would never have formulated them without the pioneering experiments of the Scottish chemist Joseph Black. And Black conducted his experiments with alchemical equipment made of, among other things, glass, invented 4,000 years ago in ancient Mesopotamia, possibly by accident. But glassmaking was made possible only because of the heat produced by metalworking, which was undertaken for the first time by humankind some 10,000 years ago or more. Metalworking itself would have been impossible without fire, mastered long ago in a way that will always remain a mystery. In short: the iPhone in your hand would not exist if our ancestors had not made all these innovations across these many millennia. And that's not to mention everything else that was needed for these discoveries to occur: law, maths, organised labour, paper, translation, international shipping, and so on. Steve Jobs said as much:

> I speak a language I did not invent or refine. I did not discover the mathematics I use . . . I am protected by freedoms and laws I did not conceive of or legislate, and do not enforce or adjudicate . . . I did not invent the transistor, the microprocessor, object-oriented programming, or most of the technology I work with.[2]

This baggage of history – the things we have inherited, from whole political systems to individual words, which necessarily restrict us – is precisely why some people have tried to start over again. During the French Revolution, for example, the old calendar was replaced

by one with ten-day weeks, plus new names for the months and days. This change didn't stick – but others, like the introduction of metres and grams, did. Such is the story of civilisation. We can never truly start again, but we *can* choose how we react to and deal with our past, slowly adding to or removing from what we have inherited.

So history matters because we have no choice in the matter; it is with us whether we like it or not. The past seeps interminably into the present. It is not only the story of things that have happened but the story of things that are happening. And so, even if we wish to disregard history, we should at least know what we are disregarding. To quote the Roman statesman Cicero, writing in the first century BCE: 'To be ignorant of what occurred before you were born is to remain always a child.'[3]

Let us see what history is about, then – let us hang like the Norse god Odin from the Cosmos-tree Yggdrasil, its roots stretching below the earth and its branches into the heavens, to see what we can perceive in the darkness of ages past. The lights go down, the curtains go up, and we begin our journey through time and space . . .

CHAPTER II

Queries Regarding Postal Permits

†

> Go thou to Rome,—at once the Paradise,
> The grave, the city, and the wilderness.
>
> – Percy Shelley, *Adonais*

We arrive in the fifth century BCE. Much is happening. The world is hot-blooded and young. A strange awakening is at work. Siddhartha Gautama is preaching in the hills of northern India; Confucius is teaching in the mountains of Shandong; Hindu poets are composing the *Upanishads* in the forests of the upper Ganges; Hebrew scribes are giving Genesis its final form; a man called Socrates is wandering Athens. Yes, strange as it sounds, all these things are happening at a similar time – an older age of humankind is drawing to a close, melting like wax before the blaze of something new. Foundations of a different age are being laid, foundations on which our modern world rests.

But where had civilisation come from in the first place? A solemn mystery! Suffice to say it was a long time coming. *Homo sapiens* had already been walking the Earth for 300,000 years before our ancestors in the Middle East stopped living purely by hunting and gathering and started farming. This was a process that had started, very roughly, in 10,000 BCE. But another 6,000 years passed before

full-blown civilisation burst into life. We settled. We built towns. With a town comes a population, law, craft, trade, and politics – civilisation was stirring in the hearts of humankind. The flame was first lit during the fourth millennium BCE in Mesopotamia, modern-day Iraq. That was when recorded history started – thanks to the invention of writing. Soon afterwards civilisations arose independently in Egypt, in the valley of the Indus River, in China, on the Gulf of Mexico, and on the coast of Peru.

So, before either Greek or Roman had so much as carved a volute, the Mesopotamians had invented writing and the wheel, the Egyptians had thrown up their Pyramids, and far off flourished the vigorous civilisations of India and China. Why, then, are we always thinking about Greece and Rome? Because history is (usually) written by the victors, and their culture – for good or bad – has been victorious: their ideas, laws, art, literature, and language. 'Democracy': the word and concept are Greek; 'Republic' is Latin – the language of the Romans – and the names of our planets also. Look any way you will, you cannot but find Greco-Roman fingerprints all over the twenty-first century. And so, perhaps *because* Greece and Rome permeate our culture – including popular culture: films like *Troy* or the two *Gladiator*s, plus countless novels, video games, and TV shows – there is an unspoken assumption that everybody knows the basic facts. But I don't think that's true. I, for example, once had no idea whether Greeks or Romans came first.

My purpose in this chapter is to give solid form to any vague illusions you may have regarding these two societies which we cannot stop talking about. It will, I hope, help you make sense of various things you perhaps already know or have heard about, and help you put some names to faces and dates to places.

We begin with a word: classical. 'Classical', 'the classics', or

'antiquity' refers to the period from about 500 BCE to 500 CE, a thousand-year stretch when Greco-Roman civilisation flourished. First came the Greeks. Their origins lay much further back in time, but by 500 BCE they had matured into the society we generally think of today when we talk about 'ancient Greece'. Crucially, this 'ancient Greece' was *not* a country. It was a collection of independent and often-warring cities around the Mediterranean, many along the coast of modern-day Turkey, others in Sicily, France, Egypt, and Lebanon, and around the Black Sea in Ukraine and Bulgaria. These cities were linked by heritage, language, religion, and (perhaps surprisingly) sport. Our modern Olympics were resurrected from the original Greek Olympics, which was the most important of the four Panhellenic Games, to which wrestlers, discus throwers, sprinters, and boxers journeyed from afar to win glory for their city, receive the ribbons of victory, and have their likeness carved in marble or cast in bronze. Greek scholars even dated their history by 'olympiads', four-year intervals measured from the first Olympics, instituted by mythical Herakles himself in 776 BCE.

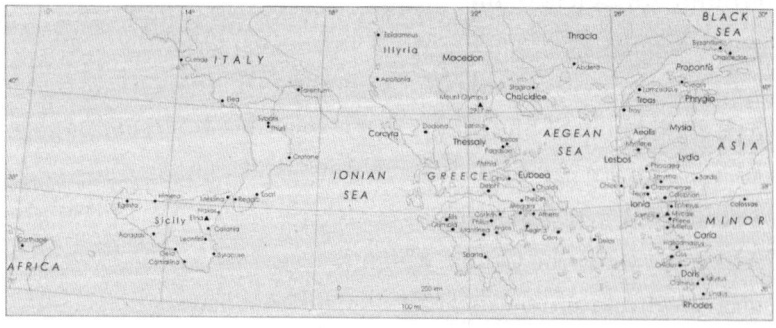

The city – the *polis* – was the basic unit of Greek society. These were distinct cities with their own political systems: some were ruled

by kings, others by aristocracies, and some by assemblies. In 490 BCE these cities united against the invading Persian (or Achaemenid) Empire. The Persians had built history's first *true* empire, a vast and sophisticated state that stretched from India to the Balkans – but even with all their wealth and power they could not overcome Greece. The Greeks united again in 480 BCE to fight off another Persian invasion, and after various legendary battles (including the Battle of Thermopylae, portrayed in the 2006 film *300*) were victorious. Athens became the most powerful of Greek cities and, with a statesman called Pericles steering its democracy, enjoyed a Golden Age of art, literature, and philosophy. This Athenian zenith is best symbolised by the Parthenon, completed in 432 BCE, that temple you have likely seen plastered all over tourist brochures advertising holidays in Greece.

But the Athenian Golden Age did not last. The intra-Greek Peloponnesian War concluded with Athenian democracy toppled and Sparta – Athens' great rival, a city with a famously militaristic culture – triumphant. Then another city, Thebes, rose to crush Sparta; Thebes crumbled in turn. The *polis*, even if fertile ground for science and philosophy, was incompatible with political unity.

Somebody else would have to do the unifying for them . . . and did: King Philip of Macedon, whose kingdom lay just to the north. By 337 BCE he had made himself ruler of Greece. But Philip was assassinated by a fame-seeking bodyguard, and so it was his son, Alexander (later the Great), who set out to realise both his father's ultimate dream and the dream of all Greeks. Within a decade he had smashed the Persian Empire and led his armies to the Hindu Kush. But in 323 BCE, after a hard night's boozing, Alexander the Great died. His empire then splintered into kingdoms ruled by his generals.

These conquests ushered in the 'Hellenistic Age'* – a period when Greek culture was dominant from Egypt to Afghanistan.

What about Rome? Legend says it was founded in 753 BCE by wolf-suckled Romulus, a descendant of Aeneas, the prince who fled Troy when it was besieged by the Greeks with their wooden horse.† Well, be that myth or truth, Rome's early days are explained succinctly enough by Tacitus, a Roman historian who lived in the first century CE. This is the first line of his *Annals*:

> Rome at the beginning was ruled by kings.[4]

Yes, there were seven kings of Rome! But in 509 BCE a man called Brutus led a revolt and established the Roman Republic. During the great Greco-Persian Wars it would have been laughable to suggest that this piddling Italian city would eclipse them both . . . but that is what happened. Rome conquered the Italian Peninsula and then went to war with the Carthaginians, an ancient kingdom centred on what is now Tunisia. It was in the second of these wars that Hannibal of Carthage travelled with his elephants through Spain, along the French coast, over the Alps, and into Italy, where he terrorised for a decade. In the end these invaders were pushed back to Carthage and defeated. That was in 202 BCE. Sixty years later the Romans had also conquered Greece and Macedonia. In short: this republic was no longer just a city.

So, perhaps inevitably, by the first century BCE Rome had grown too large for its republican constitution. Ceaseless strife ensued. Julius Caesar conquered Gaul, modern-day France, and a rival

* So called because the Greeks referred to their broader nation as 'Hellas' and to themselves as 'Hellenes'.

† This quasi-mythical Trojan War is purported to have taken place in about 1200 BCE, long before the rise of classical culture.

general called Pompey extended Roman territory into the Middle East. These men could not share the republic and so they fought for it. Caesar won and became 'dictator for life'. In 44 BCE the last dregs of republican spirit were channelled in a man called Brutus, descended from that very Brutus who first established the republic. He joined a group conspiring against the dictator – and Caesar was assassinated. Arise Octavian, Caesar's heir, who won his own civil wars and rebuilt the republic around himself. There was no king in the Roman constitution, but Octavian, in 27 BCE proclaimed Augustus by the Senate, had effectively become an emperor.

Then followed the Pax Romana, or 'Roman peace', when Rome was a single state stretching from Spain to Saudi Arabia, with its famous legions along the borders. Every province was connected by extensive and well-maintained roads. Bridges spanned once-impassable chasms, aqueducts brought fresh water into cities, and villas had underfloor heating. There were public baths, theatres, and stadiums in every town. New hairstyles became fashionable and bookshops were stocked with the latest poetry. There were fire brigades, a postal service, traffic regulations, building codes, annual budgets, tax incentives, and citizenship rights. Laws were consistent across thousands of miles and architecture was the same on three continents. There was even a welfare state, with thousands of citizens living on the 'grain dole'. That little city had come a long way.

But, if Rome ended up politically dominant, why do we say 'Greco-Roman'? Because the Greeks conquered their conquerors with culture. Every educated Roman spoke Greek and admired Hellenic art and literature. Just two examples of how extensively 'Greekness' permeated Rome are that the emperor Marcus Aurelius wrote his famous *Meditations* in Greek, not Latin, and that its very philosophy of Stoicism also originated in Greece. So the rustic

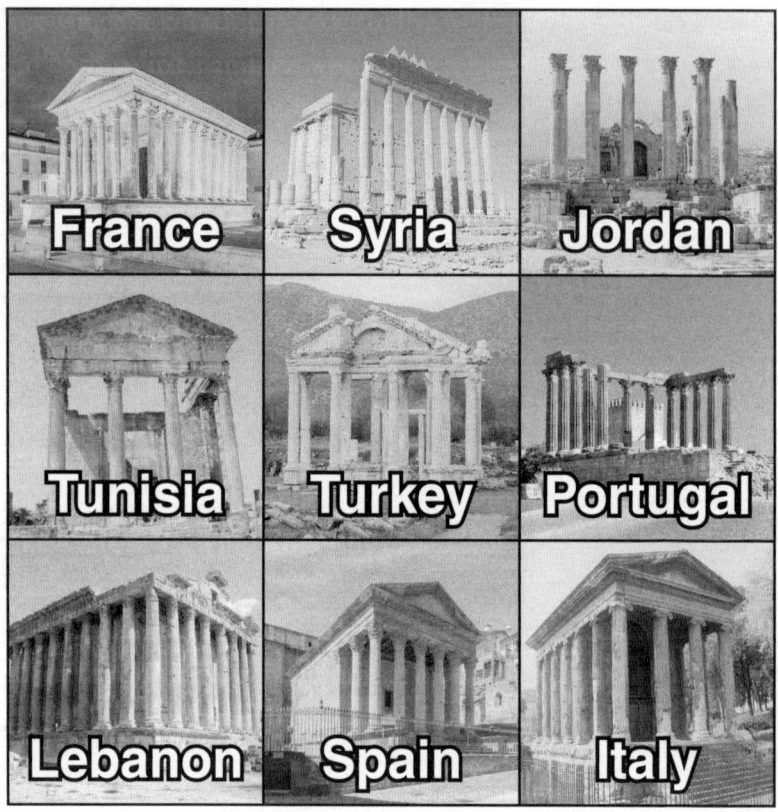

The same Roman architecture on three continents.

Romans had been Hellenised. And in the end they were Christianised too. Although the followers of a certain Galilean upstart called Jesus were at first persecuted by the Roman regime, the Christian faith eventually won the war of ideas. In 380 CE Christianity became the state religion of the empire and the temples of the pagan gods were closed down.

Enough! That was a lot of information – dates, names, and places – in quick succession. I have given you facts, but what of *feelings*? I think we should look at the story of a man born near Lake Como in 61 CE, raised by his mother and educated by his uncle. His

name was Pliny the Younger. In Rome he studied under the great rhetorician Quintilian and (after witnessing the eruption of Mount Vesuvius) embarked on a career in inheritance law, though he also prosecuted corrupt officials before the Roman courts. He also helped out at the treasury and even ended up as governor of a province called Bithynia, in the north of modern Turkey. But Pliny is not remarkable for his career. It is through his letters (published in his lifetime) that we remember him. Epic poetry, great deeds, and sombre statues can make the classics seem distant. But Rome comes to life with Pliny – because we see it through the eyes of somebody simply *living* there.[5]

Chiding a friend, Fabius Justus, for ghosting him:

> I have not heard from you for a long time, and you can't say you have nothing to write about because you can at least write that.

Complaining about sports fans to Calvisius Rufus:

> The Races were on, a type of spectacle which has never had the slightest attraction for me. I can find nothing new or different in them: once seen is enough, so it surprises me all the more that so many thousands of adult men should have such a childish passion for it.

Telling his wife, Calpurnia, he misses her:

> I, too, am always reading your letters, and returning to them again and again as if they were new to me – but this only fans the fire of my longing for you.

Or, to the emperor Trajan, trying to figure out the postal service:

> Are permits to use the Imperial Post valid after their date has expired, and, if so, for how long?

He was not one of the poets, philosophers, or warriors who dominate talk of Greece and Rome. Pliny was just a man – pragmatic, tender, and hopeful. As he wrote to Valerius Paulinus:

> So we must work at our profession and not make anyone else's idleness an excuse for our own. There is no lack of readers and listeners; it is for us to produce something worth being written and heard.

In some ways, then, cosmopolitan Rome is startlingly familiar to us. Another example is sport. Not long ago the French footballer Kylian Mbappé turned down a potential $1 billion deal that would have seen him play for the Saudi Arabian football team Al-Hilal – but this would *not* have made him the highest-paid athlete in history. That was Gaius Appuleius Diocles, a charioteer from the province of Lusitania, modern-day Portugal. There were four *factiones*, or teams, in Roman chariot-racing: Green, Red, White, and Blue. These were professional organisations with their own stables, managers, breeders, racers, and raucous fans. At the age of eighteen Gaius debuted with the Whites. Seven years and a pitiful spell with the Greens later, he joined the Reds. There he remained for fifteen years, winning over a thousand races and retiring at the age of forty-two. Where did Gaius race? At the Circus Maximus in Rome, now a ruin but once a stadium that held at least 150,000 spectators. Two monuments erected in his honour record the statistics of his career – 4,257 starts and 1,463 victories – and his total prize money: 35,863,120 *sesterces* (which one estimate puts at the equivalent of about $15 billion today). What does it say about Roman society that regular people had enough time, and that there was enough money in the system, to support such a huge sporting scene? The Colosseum held 80,000 spectators, which even by today's standards makes it a major venue, and it was just one of several

hundred Roman arenas all around Europe. This culture of mass entertainment is not so dissimilar from our own.

As for *what* they watched in these arenas... therein lies some difference: men and beasts fighting to the death. The Romans' fascination with oracles and augurs is also strange to us – priests studying the skies for instructions and examining sheep guts to make military decisions. And we cannot forget that slavery was ubiquitous in the Greco-Roman world,* along with legally permitted brutalities of the sort we would rather not imagine. Just take this little piece of Roman legislation, enshrined in the Laws of the Twelve Tables of 449 BCE: 'A notably deformed child shall be killed immediately.'[6]

What happened to the Roman Empire in the end? A Roman citizen in the time of Pax Romana would surely have presumed (as many of us tend to think about our own today) that their civilisation would last forever. But, through a mixture of decadence, political atrophy, mass migration, war, economic downturn, and the death throes of civil war, it started to go wrong. The civilisation of Rome did not 'fall' overnight – it bled to death as books ceased to be written, the Senate stopped meeting, chisels fell quiet, and outposts fell, all until the final Western Roman emperor, by fate-twist called Romulus, was deposed in 476 CE.† A thousand years of Greece and Rome had breathed their last... for a while.

Because nobody forgot Rome. After all, even today there is not

* Though, that being said, a Roman slave could change their legal status. Pallas, a 'freedman' (as former slaves were called), became one of the richest men in Rome under Emperor Claudius. Yes, there was even social mobility – several emperors were the sons of peasants!
† The empire had been split in two and its eastern half survived for another thousand years as the 'Byzantine Empire'. They did not call themselves the Byzantines, however. That name is an invention by later scholars. It came from the old name of their capital city, Constantinople, which had once been called Byzantium – and which now goes by a third name: Istanbul. The Byzantines, meanwhile, called themselves Romans.

a twenty-mile stretch in Europe without some Roman road, bridge, viaduct, sewer, or temple, and beneath the barley a broken marble torso, in the seaweed a fist of bronze. Rome lingered as a backdrop to the Middle Ages: its systems morphed into the Catholic Church, the Dark Age king Charlemagne declared himself 'Holy Roman Emperor', and ancient philosophy underpinned medieval scholarship. Eventually 'pure' Greco-Roman culture was consciously resurrected during the Renaissance, beginning in the fifteenth century. Then, in the centuries following, the foundations of our modern world – among them the Scientific Revolution, the Enlightenment, and the Industrial Revolution – were laid.

But who am I to talk? The garrulous Greeks and gossipy Romans will tell you about themselves: fragments of Sappho, odes of Pindar, epics of Homer and Virgil, mythologies of Ovid, letters of Seneca, geographies of Strabo, travelogues of Pausanias, philosophy-poetry of Lucretius, love-poetry of Catullus, speeches of Cicero, dialogues of Plato, histories of Herodotus and Thucydides, of Polybius and Livy, biographies of Plutarch and Suetonius, diaries of Caesar . . . it's all there, some glorious, some tedious, some too filthy to reprint. Want to know about the Greeks and Romans? Ask – and they will answer.

CHAPTER III

The Sixth Age

†

> Although we read that wine is never for monks, in our times it is impossible to persuade monks of this.
>
> – from the letters of Saint Benedict

Antiquity melts and another thousand-year epoch arises, vast in scope and half inscrutable: the Middle Ages. We still cannot make up our minds about them. Were they a grim and plague-ridden whirlpool of illiterate tyranny? Or were they a glittering age of knights, chivalry, and Robin Hoods? There was something of both in those long centuries. But understanding the Middle Ages – even surrounded as we are by their remnants, the cathedrals and castles and abbeys looming up from what seems like a lost civilisation – can be strange and difficult work.

First of all, I think there are some common myths about the Middle Ages that should be dispelled. Four, in particular. First: medievals did not think the world was flat. That is nineteenth-century American propaganda. Second: they were not the drab people depicted in films or on television. The Middle Ages were, as surviving clothes and art attest, a time perhaps more colourful than our own. Third: the frequent and crude definition of the Renaissance as a 'rediscovery' of classical civilisation is inaccurate. Medieval writers knew all about the classics; they just thought of

them differently. Fourth: although many a peasant never strayed beyond their parish borders, many a monk, mason, composer, and soldier *did*. One letter written by Abbot Cuthbert in northern England to the Archbishop of Mainz in Germany in 758 CE, in the darkest of those so-called 'Dark Ages', illustrates this:

> If there is any man in your diocese who knows how to make glass vessels well, when a suitable occasion presents itself, kindly send him to me . . . It would please me also to have a zither-player . . . for I have a zither and do not know how to play it.[*7]

Enough myth-busting. If we are to make up our minds about the Middle Ages we must figure out what they were. And the best way to do this is by trying to discern the medieval worldview. So here is our point of departure: a little gargoyle carved upon the walls of a church, a bawdy 'work of art' in a sacred place. It is confusing to us now that ribaldry and sanctity went so readily hand in hand. But by looking at this strange object we grasp just how much our ways of thinking have changed. Time to investigate.

We in the twenty-first century consider other people our equals, differentiated from us only by changeable things like the job they happen to do. There is nothing (according to the prevailing philosophy

* A diocese is the area over which a bishop has authority and a zither is a type of stringed instrument.

of our democratic-consumerist-capitalist system, at least) that you or I would be able to do that anybody else could not also do. We choose who rules us – we can even enter politics and be elected ourselves. To understand the Middle Ages you must forget all of this. In those days people were mostly part of a fixed, hierarchical order. A lord was your lord and that was that; no such thing as a vote. With some exceptions (and admittedly more than we might suspect) you were allotted your position in life at birth and got on with your designated duties. So, where we are bound to other people by general laws and by whatever contracts we have chosen to enter, the medievals were bound to other people by the mutual responsibilities and obligations of their status.

That may sound like tyranny or chaos to us, but a thirteenth-century encyclopaedia compiled by Bartholomew Anglicus, *The Properties of Things*, tells us how and why this system worked:

> A rightful lord, by way of rightful law, heareth and determineth causes, pleas, and strifes, that be between his subjects . . . putteth forth his shield of righteousness, to defend innocents against evil doers, and delivereth small children and such as be fatherless, and motherless, and widows, of them that overset them. And he pursueth robbers and rievers, thieves, and other evil doers.[8]

Medieval aristocracy was not like aristocracy as it still exists in parts of the world today, largely as a historical relic; Medieval lords were governors, soldiers, and judges on whom thousands relied for peace and their livelihood.

Intermingled with all this was the Church, headquartered in Rome. One way to think of it – and it's not wholly wrong – is like the European Union: a colossal organisation with officials and establishments in every corner of the continent, creating multinational regulations and constantly in tension with local governments. That

being said, we risk garbling the past by seeing it through the lens of the present. In our secular and rationalistic world, the Church – and all medieval religion – makes no sense. Just as you would not ask somebody, 'Do you breathe oxygen?', a person in the twelfth century would not have asked, 'Are you religious?' Christianity permeated everything. It was not part of culture; it *was* culture. And people took their religion very seriously. Consider what a knight called Sir Jean de Joinville wrote about the Fourth Crusade, which began in 1202:

> A little later the Pope sent one of his cardinals, Monsignore Pietro de Capua . . . to proclaim on his Holiness' behalf: All those who take the Cross and remain for one year in the service of God in the army shall obtain remission of any sins they have committed, provided they have confessed them. The hearts of the people were greatly moved by the generous terms of this indulgence, and many, on that account, were moved to take the cross.[9]

Would you crusade for the promise of the remission of your sins? No. But you might for money. What to us is financial gain was in medieval times salvation, and this is something we struggle to grasp. People were also motivated by money or power in those days, of course, and in their own writings they make it very clear how frequently. But trying to understand the workings of the Middle Ages through money or politics alone will leave us forever scratching our heads.

Then again, we will never grasp anything about the Middle Ages unless we first remember that medieval people did not think of themselves as living in the 'Middle Ages'. Those words were invented by Renaissance scholars who sought to bring back the culture of Greece and Rome. What to call those ten dingy centuries of ignorance *between* the creation and the revival of classical culture? The 'middle' ages, of course. Medieval people, meanwhile, thought they

were living in the Sixth and Final Age, one that had dawned with Christ and would conclude with Judgement Day.

Nor did they have any concept of 'progress' as we understand it; they did not share our general view of the human story as a steady and certain process of improvement. They did not worship humankind as we do now, as Greeks and Romans did. They were eagerly awaiting Doomsday, the end of the world. Material progress makes no sense when it is spiritual preparation for the Final Judgement that matters most. As Thomas à Kempis, a fifteenth-century priest, wrote in a wildly popular book called *The Imitation of Christ*:

> Keep thyself as a stranger and a pilgrim upon the earth, to whom the things of the world appertain not. Keep thine heart free, and lifted up towards God, for here have we no continuing city . . . If it is a fearful thing to die, it may be perchance a yet more fearful thing to live long.[10]

Classical statues of athletes tell us how highly the Greeks and Romans thought of humankind, how they revered our might and beauty; medieval art gives a somewhat different impression.

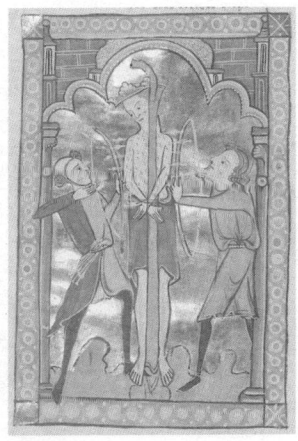

Medieval people did not think of the universe in the way we do: scientifically. A bird was not an evolved biological machine of respiratory and digestive systems – it was the freedom to which a human soul might aspire. When you see a flower, what do you *see*? Something to be purchased? A type of plant? Something pretty? This is what Beatrice saw in Dante's *Divine Comedy*, an epic fourteenth-century poem charting one man's journey through Hell, Purgatory, and Heaven:

> . . . here is the rose,
> Wherein the word divine was made incarnate;
> And here the lilies, by whose odour known
> The way of life was follow'd. [11]

Medieval people had a much more symbolical worldview than we do, and so they loved allegory – stories where every 'thing' was a symbol for some vice or virtue. Their stories often took place in dreams, as in the fourteenth-century poem *Piers Plowman*, whose protagonist repeatedly falls asleep and has visions of the end of the world. What is real and what is a symbol? All was intertwined. Consider this fifteenth-century Flemish tapestry: a fair lady between a unicorn and

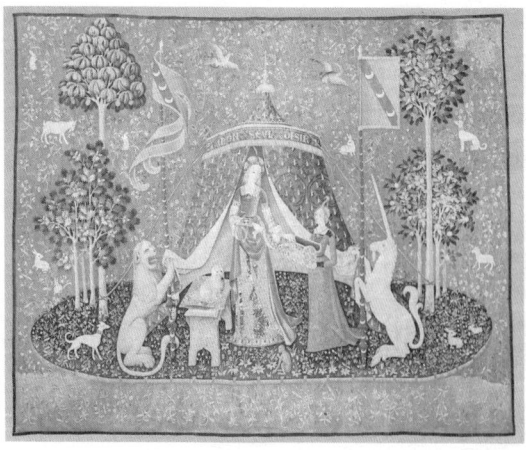

a lion, surrounded by fruits, flowers, trees, birds, goats, and rabbits. Is it supposed to be a real garden? I suspect we are already losing when we ask that question.

The people of the Middle Ages also had a peculiar sense of humour and readily mixed sacred with obscene, deathly with satirical, beauty with ugliness. We see this humour in the marginalia of manuscripts, created by monks, which so often featured strange drawings of (for example) horse-riding rabbits in armour shoving lances up priestly buttocks. Hard to say what was going on. But the key to the medieval worldview lies in their art, as does the worldview of any age. Look at the gargoyles on church towers, or the misericords (carved seats in choir-stalls), where we find angels and drunkards, prophets and monsters, crowded together. Here medieval aesthetics – whereby the scatological, fanciful, affectionate, and nightmarish were equally welcomed into sacred spaces – is revealed most clearly.

This explains why the medieval imagination feels fundamentally different to ours. Because, although they could be darkly

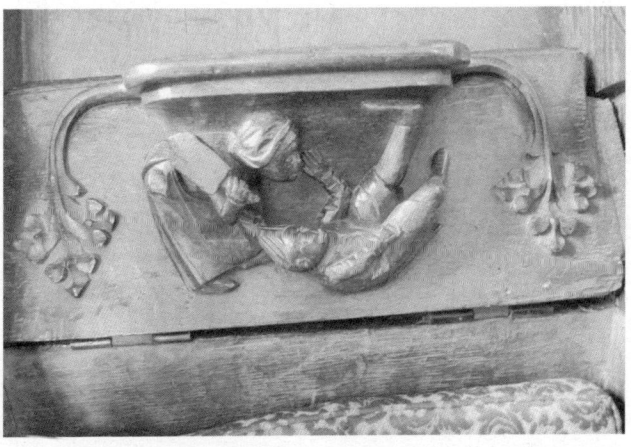

A fifteenth-century misericord, a type of folding church seat, decorated with a wife beating her husband.

comic and hair-raisingly ribald, in their stained-glass windows we also find an astonishing purity of spirit and depth of devotion. These windows were expensive, and workers' guilds would club together to pay for them. Would we club together to pay for such things? It seems the medievals neither took themselves too seriously nor looked on humankind with malice. They walked a 'via media', a middle way, encompassing all, at once pious and profane, ever revolving around the fulcrum of religion.

And yet, however hard we must work to recognise that the Middle Ages were incredibly different, we would be wrong to think its people were entirely unlike us. There are many voices I could call on, but nobody speaks to us with such timeless clarity as Héloïse d'Argenteuil. She was a brilliant woman, erudite and tender, involved in a love story for the ages, more bittersweet by far than any Romeo and Juliet. I cannot recount in full the tale of her tragic affair with Peter Abelard, the radical celebrity-philosopher of twelfth-century France. All I can do is implore you to read their letters and discover it yourself.

> The pleasures of lovers which we shared have been too sweet – they can never displease me, and can scarcely be banished from my thoughts . . . Even during the celebration of the Mass, when our prayers should be purer, lewd visions of those pleasures take such a hold upon my unhappy soul . . . Men call me chaste; they do not know the hypocrite I am.[12]

You see, then, that their times were different, but they were not. Is there anything incomprehensible in what Héloïse said? Let us not be afraid to look these medieval people in the eyes and ask, 'Who are you?' There is no shortage of chroniclers, bards, poets, scribblers,

painters, and historians who can speak to us directly, even in our digital age.*

Why did the Middle Ages end? The Renaissance. An intellectual fire was lit in the fifteenth century that burned up the medieval world, and within a century or two it was turned to ash: status, fealty, freemen, wandering masons, travelling troubadours, dream-allegories, gargoyles . . . their time in our world was done.

This chapter has painted a somewhat rosy picture. There was a lot of trouble, a lot of awfulness, in those times. Even medieval chroniclers themselves do not hesitate to describe the brutalities and darknesses they witnessed; the Fourth Crusade in which Sir Jean de Joinville took part, for example, culminated in a carnival of violence and desecration. I will say more about these miseries and hypocrisies later in this book. For now, at least, only remember that those thousands who were burned at the stake or slaughtered in sieges, that uncountable mass of forgotten and ordinary folk who were exploited and ground into dust, these and thousands more must stand between us and any medieval romanticising. My hope has simply been to shed a little light on the Middle Ages, to redeem from the total condemnation of barbarism an age that also had in it beauty, love, and joy.

And before we leave them another caveat should be addressed: referring to the 'Middle Ages' is a European way of organising history, and so it is ill-suited to classifying the past of other places.

* Some were garrulous and others were thriftier of word. In the *Anglo-Saxon Chronicle*, steadily maintained for six centuries, we find that all somebody thought worth mentioning of the entire year of 773 CE was this! 'In this year a red cross appeared in the sky after sunset. This same year the Mercians and the Kentishmen fought at Oxford, and strange adders were seen in Sussex.'

While things were going on in Europe – which has been the broad focus of this chapter – a lot was going on elsewhere. Tsar Simeon raised up the First Bulgarian Empire and nearby the Byzantines reigned in Constantinople. Far away, though linked by trade, Mansa Musa reigned in Mali; meanwhile, in Ethiopia, a king called Gebre Meskel was busy creating his own version of Jerusalem. For a time the Mongols ruled half the world, though they eventually splintered into dynasties like the Ilkhanates and Timurids in Central Asia, and the Yuan in China. Between all lay India, the eighth continent. From Arabia rose the Rashidun caliphate, followed by Umayyad, Abbasid, Mamluk, and a dozen more great Islamic societies stretching from Córdoba to Cairo. We could go on. My point is that there were also Ottomans, Georgians, Khmers, Kievan Rus', Maya, and a hundred more civilisations that thrived during what Western Europeans have called the Middle Ages.

CHAPTER IV

9192631770

†

Dreaming when Dawn's Left Hand was in the Sky
I heard a Voice within the Tavern cry,
'Awake, my Little ones, and fill the Cup
Before Life's Liquor in its Cup be dry.'

– Omar Khayyam, *The Rubaiyat*

How did people wake up before alarm clocks? How would *you* wake up tomorrow if you couldn't set an alarm on your phone? Solutions in the past weren't always elegant – in the nineteenth century there were 'knocker-uppers' paid to hit your window with a stick.

But the first question, of course, is how people kept track of time at all. For millennia it was through observation: the movement of the Sun by day and the Moon and stars by night. So it makes sense that the first devices for measuring time were sundials. After sundials came more complex inventions. In both Greece and China water clocks were used, which relied on the carefully calibrated flow of water from one vessel into another. Plato is said to have combined one with a water organ and created a rudimentary alarm clock.

Later, in the Middle Ages, came church bells and the *adhan*, the Islamic call to prayer. Both sounded at regular times throughout the day to mark hours of worship and gathering. So bells and muezzins

singing from minarets were one of the first forms of alarm clock – in each case communal and fundamentally religious. But we must not forget the most powerful and oft-used alarm of all: the Sun. Dawn also brings with it an abundance of other natural wake-up calls: birds singing, cows lowing, cockerels crowing.

In any case, the invention of mechanical clocks in the fourteenth century introduced a more precise method of timekeeping.* Over time they were scaled down and improved; domestic clocks, even watches, had been invented by the sixteenth century. Shortly afterwards came the second hand, and humanity's conquest of time was nearly complete. Mechanical alarm clocks were patented in the nineteenth century, followed in the twentieth by radio and then – bringing us to 2025 – digital.

But more important than how people woke up is why they needed to wake up at all. Look at this graph:

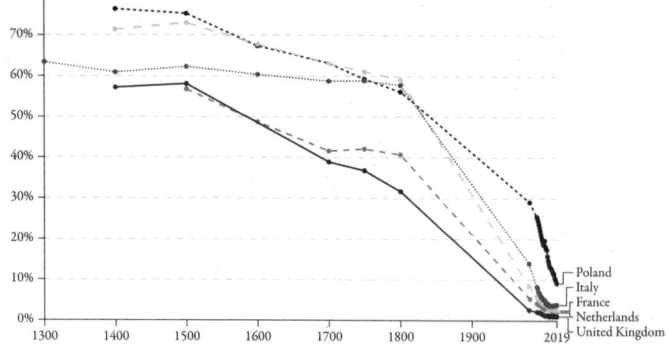

* With clocks came the notion of 'clockwise'. Now, mechanical timepieces were invented in the northern hemisphere and so their rotating hands imitated the rotation of a sundial's shadow. But in the southern hemisphere the shadow on a sundial rotates in the *opposite direction*. In another universe clocks were invented in the southern hemisphere; there 'clockwise' and 'anticlockwise' are reversed.

Merchants, scholars, princes, monks – they needed reliable timekeeping. But such people represented a very small percentage of the population. The overwhelming majority worked according to natural rather than manmade schedules: the behaviour of animals and the seasonal growth of crops and fruits. Peasants, labourers, and craftsmen couldn't afford watches or domestic clocks, but nor did they need to. Their 'job' wasn't about how many hours they had to work; it was about what tasks needed to be done in any given day, week, or season. This fifteenth-century illustrated book, made for a French duke, contains sumptuous insights into a world that seems to us thoroughly romantic but is a fair portrayal of life in the late Middle Ages.

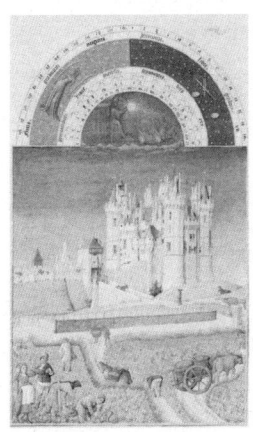 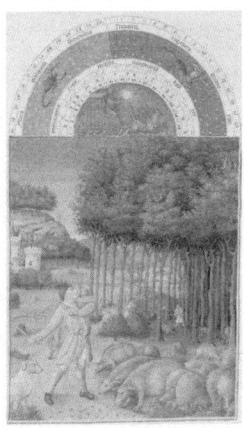 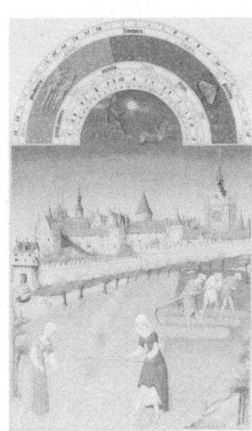

The situation was similar in Roman times. In Virgil's *Georgics*, published in 29 BCE, we find a mixture of political commentary, rural idealism, and a practical guide to agriculture:

> Then thou shalt suffer in alternate years
> The new-reaped fields to rest, and on the plain
> A crust of sloth to harden; or, when stars
> Are changed in heaven, there sow the golden grain

> Where erst, luxuriant with its quivering pod,
> Pulse, or the slender vetch-crop, thou hast cleared,
> And lupin sour, whose brittle stalks arise,
> A hurtling forest.[13]

Virgil sings also of beekeeping, botany, animal husbandry, and the management of olive groves. This all sounds gorgeously bucolic, but what he describes is now irrelevant to most of us – even when we understand his words, we can hardly imagine what they really mean. And that brings us back to the knocker-uppers. They were needed during the Industrial Revolution because people were working in factories rather than fields. Suddenly it was hours set by the manager, not by the Sun and seasons, that dictated when people worked; it was man who organised time, not nature. You can see how the precision afforded by seconds and minutes goes hand in hand with commerce. If you didn't have your watch or phone, how would you know when twenty minutes had passed, or whether your break had ended, or whether it was time for that meeting? Without clocks our modern economic system could not exist. The factory and office recognise neither summer nor winter: we work every day of the year identically – once unthinkable!

Over the past century time measurement has moved ever further from the world as we experience it, ever closer to things the ordinary person cannot comprehend without advanced scientific equipment. Whereas people once measured time based on estimations of how long it took to roast corn or say certain prayers, we now have the International System of Units, or SI for short. This is how we now define 'one second':

> The second is defined by taking the fixed numerical value of the caesium frequency, $\Delta\nu C_s$, the unperturbed ground-state hyperfine

transition frequency of the caesium 133 atom, to be 9192631770 when expressed in the unit Hz, which is equal to s−1.[14]

Measurements of length were once based on parts of the human body (feet) or common objects (barleycorns), and every country once had its own, slightly differing definition of an inch, an ancient measurement nominally based on the width of the thumb. But the old imperial system of inches and yards has been replaced by the metric system,* and so the basic unit of length is now a metre. Can you guess how we define a metre? It is done by

> taking the fixed numerical value of the speed of light in vacuum, c, to be 299 792 458 when expressed in the unit m s−1, where the second is defined in terms of the caesium frequency Δv.[15]

Obviously.

Such extreme standardisation – from locally estimated to internationally official – is necessary in a globalised and industrial world. Whereas every town once kept its own time, the rise of railways forced the introduction of time zones to prevent transport chaos. Now, when computers around the globe are running on shared systems, there is no room for error. By measuring things according to universal scientific standards we have precluded this possibility, even if humans are not biologically prepared for such a system. But that's the whole point: the precision of SI is not for us – it is for the machines and systems we use.

We still live in the world of the 'knocker-uppers', only now they have become phones rather than people. The ubiquity of alarms – without which life seems unimaginable – is emblematic

* With the exception of the USA, Liberia, Myanmar, and the United Kingdom (partly).

of the evolution to a consumerist, industrial world, of the difference between having to sow the seeds before sundown and having to attend a Zoom meeting at 4:15pm ET. The lives of our ancestors may have been miserable in many ways, but they made schedules by the Sun and stars and worked according to the seasons and animals, with days ordered by bells and songs and time measured by how long it took to cook an egg – a far cry from the bullet-pinging precision of phones. The question with which we started was: how did people wake up before alarm clocks? The more revealing question is its reverse, asked of us by our ancestors: why do you need an alarm clock to wake up?

So we unveil the real subject of this chapter: the modern world in which you and I live. In differences we see the nature of a thing most clearly; history lets us compare past with present to discern those differences and draw our conclusions. Our society has many peculiarities, but here we focus on one, introduced to us via the alarm clock: our ever-increasing reliance on technology.

Technologies either do for us what we had to do for ourselves (think of the incalculable hours saved by washing machines) or allow us to do something new (like flying). But the rabbit hole runs deeper. Technology doesn't only change what is possible, and doesn't just save time and effort: it fundamentally alters how we behave. To accept the advantage offered to us by a new invention there is something we must leave behind. For example: our ancestors had better memories than us. How do you think people remembered things before writing? A thing would be forgotten unless you remembered it; good memories were necessary. Hence Homer composed the *Iliad* and the *Odyssey*, together 300,000 words long, without ever writing anything down, and these poems survived by memory alone until they were committed to paper. Now machines do the remembering

for us. Why learn the facts of the Battle of Ain Jalut when you can pull them up on Google? Why learn a poem when you can read it? Whereas once we studied a beautiful building carefully, knowing we might never see it again, we now take photographs – we no longer *look* at the world. So modernisation has been partly defined by the delegation of human activities to machines, along with a decline in our ability to do those things.

And yet, it seems, we are increasingly occupied by doing for ourselves what machines have been doing for us, or at least counteracting the negative effects of this. When somebody uses a gym they are compensating for the fact that the modern world does not require us to use our bodies; a hunter-gatherer did not need a gym. The Norwegian footballer Erling Haaland wears glasses that block blue light from digital screens; the ancient Greek wrestler and six-time Olympic champion Milo of Croton had no need of such glasses. So this is another peculiar fact about modernity: we yearn for things our ancestors took for granted, rooting through the past to retrieve what we have traded for health, convenience, safety, and prosperity.

But once something becomes too distant we can no longer recall what we have forsaken. The potential problem with accepting the benefits of technology and giving up so much in return is that we may lose the eyes to see, the mind to notice, and the shoulders to bear. It does seem, sometimes, that we have handed over to machinery our most fundamental faculties, leaving us collectively masters of the world but, as individuals, little more than system operators, incomparably weaker than any of our ancestors and far less sensitive to ourselves or to nature. One wonders if, once we have created machines to do all the work for us and engineered AI-metaverses indistinguishable from real life, we will end up pretending to be farmers, emulating those real farmers of the *Georgics*, living simple

lives among fields and olive groves, or even simulating an Edenic bliss like that of our hunter-gatherer ancestors, such that thousands of years of progress will have taken us back to where we started.*

So I ask you what is stranger: to wake up by the crowing of the cockerel and gilded rays of the dawn, which vary from day to day and throughout the year, or to divide each day into 86,400 identical units defined by the unperturbed ground-state hyperfine transition frequency of the caesium 133 atom? In that question the nature of the modern world, with all its miracles and curses, is made plain. The poet John Donne sensed this four hundred years ago, as the first quakings of the Scientific Revolution were felt. Things were changing in a way they never had before, and we are still trying – consciously or otherwise – to deal with what has happened.

> And new philosophy calls all in doubt,
> The element of fire is quite put out,
> The sun is lost, and th'earth, and no man's wit
> Can well direct him where to look for it.[16]

* You might say: 'No! There will be no suffering or death in the simulation.' Perhaps, but without death things will quickly become boring and we will likely reinvent it.

CHAPTER V

'Of arms and the man I sing...'

†

I want a hero: an uncommon want,
When every year and month sends forth a new one,
Till, after cloying the gazettes with cant,
The age discovers he is not the true one.

– Lord Byron, *Don Juan*

History is yours. There are no unbreakable rules for how or what we should think about it, and don't let anybody tell you otherwise. Truth be told, there is more history in one rusty door handle than in all the history books ever written. Understanding is infinitely more valuable than knowledge, and you will gain a deeper understanding of history by contemplating the storied life of one door handle – or any mundane detail of this world – than dryasdust books (including the one in your hands!) about 'this' and 'that', however good they are.

Imagine the thousands of hands that have touched this slender strip of metal, hands which belonged to people like you and me with our mardy mornings and evenings of hopes and fears, all of them leading in their thousands to you, right now. The past begins and ends here, in this moment, and goes on beginning and ending continuously. And what is true of one door handle is true of the universe. So do not be afraid to use your imagination, as guided by

learning and reason – there is no more powerful way of understanding history.

And, of course, we needn't always think about history chronologically. We can also see it through the lens of a theme, like food or etymology, and follow its winding path through nations and eras. So let's think about history thematically, taking 'heroes' for our theme. Who are your heroes? Who do you admire and hope to emulate? Do your friends have similar heroes? This is not trivial, because our heroes simultaneously reveal how we see the world and the sorts of people we want to be.

The word 'hero' is from the Greek *hērōs*, once meaning 'protector'. These ancient Greek heroes, whose stories are told in the poetry of Homer, Hesiod, and Pindar, were warriors descended from gods. The likes of Achilles, Ajax, Odysseus, and Hector fought in the Trojan War, striving to perform valorous deeds and win the admiration of their countrymen. But unlike our modern superheroes they did not fight for the common good. As Hector says in the *Iliad*, Homer's epic retelling of the Trojan War: 'Let me not then die ingloriously and without a struggle, but let me first do some great thing that shall be told among men hereafter.'[17] Hector wants to do something that will win him personal acclaim; we do not find Spider-Man saying such things, and we probably wouldn't like him if he did.

After Achilles' death it is Ajax who brings his body to the Greek camp. There, the foremost warriors hold a competition to decide who should inherit his magical armour, forged by the divine blacksmith Hephaestus. Odysseus wins, and Ajax – ashamed his heroic deeds were unworthy – kills himself. Glory was where it began and ended. Still, the Greeks did not invent heroes. The oldest epic poem in the world, composed long before Homer sang a word of his *Iliad*,

THE FIRST PILLAR OF THE CULTURAL TUTOR

is about Gilgamesh. This story was inscribed in cuneiform (humanity's first writing system) on clay tablets over 4,000 years ago among the city states of Mesopotamia. Gilgamesh, like his Greco-Roman descendants, fought with or was favoured by gods or goddesses and went about questing perilously. Suffice to say that, like the Homeric heroes, Gilgamesh was, even if once a real man, recast in time as a warrior entangled in celestial affairs.*

But heroes are not only mythical, of course. The Romans – who also worshipped those legendary Greeks, calling Herakles Hercules – are a good place to start here. Take Lucius Quinctius Cincinnatus. He lived in the earliest years of the Republic, a Rome without philosophy or empire struggling among a sea of other Italian city-states. The noble-born Cincinnatus was a powerful politician, but when his son was embroiled in scandal the subsequent legal feud bankrupted Cincinnatus and he retired to his farm. Years later, during a war with the Aequi, the Roman army and its leaders fell into a trap and were surrounded by the enemy. Panic ensued in Rome and in desperation the Senate voted Cincinnatus dictator, a position appointed only in times of crisis and which granted its holder supreme power. Cincinnatus left his plough, took charge of the state, rescued the Roman army, defeated the Aequi, and – after just fifteen days – resigned his dictatorship and returned to his farm. He wielded the plough *and* the sword, lived modestly, and put his country above personal gain. To the intensely patriotic Romans, Cincinnatus was a model of civic virtue.

Things changed in the Middle Ages. Admittedly, the medievals wrote poetry about Arthur and his Round Table, and rulers like

* So much is true of all ancient heroes, Nordic or Maya or Korean, and our love for divine warrior-heroism, however obscure its origins in the jungle of prehistory, still burns brightly in our modern superheroes.

Barbarossa and Saladin were deemed great. But we are pursuing here the prime nature of heroism as conceived in the minds of the people. And, for the people of the Middle Ages, their heroes were saints, whose images in glass or gold, in clay or lapis lazuli, adorned every church wall and streetcorner. People were named after them, prayed to them, and celebrated their feast days. The stories of their lives, called hagiographies, were known to all.* There was Lucy, who removed her own eyes to discourage a suitor and was burned at the stake for refusing to renounce her faith – she became the patron saint of the blind and of people with eye diseases. There was also Bartholomew, an apostle of Jesus skinned alive while preaching in Armenia; in art he is inevitably portrayed holding up his own flayed skin. And there was Sebastian, a Roman knight who as punishment for converting to Christianity was tied to a tree and shot with arrows. This did not kill him, however, as you may surmise by his rather unimpressed expression.

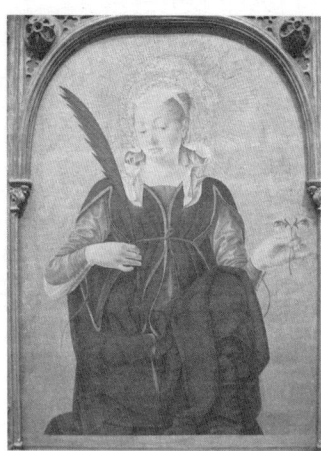 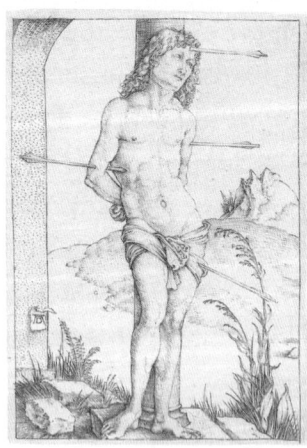

Saint Lucy by Francesco del Cossa (1472) and *Saint Sebastian* by Albrecht Dürer (1499).

* *The Golden Legend* by Jacobus de Voragine, a collection of hagiographies, was among the most popular books in the late Middle Ages.

THE FIRST PILLAR OF THE CULTURAL TUTOR

Unlike Achilles or Cincinnatus, these saints had neither power nor wealth and did not seek personal glory or political success. They were invariably people whose faith was stronger than their fear of death and who were persecuted for their beliefs. Some had been soldiers, but people admired them *because* they had laid down their arms. These saints were hero-worshipped for their non-violent resistance to authority, their care for the needy, and their disregard for earthly matters. More than dissimilar, they are almost the opposite of the warriors of Greece or the republicans of Rome. Neither Mesopotamian nor Greek nor Roman would ever have written, as John Milton did: 'They also serve who only stand and wait.'[18]

Change again – after the Middle Ages came the Renaissance. New heroes emerged, two above all: the scholar and the artist. There had been both in times past, of course, but none who achieved the same adulation in their own lifetimes as Erasmus or Leonardo da Vinci. Each was admired, above all, for his genius and his learning – fundamentally humane rather than military, political, or moral qualities. Erasmus can reasonably be described as the most admired man in sixteenth-century Europe. Popes, kings, bishops, emperors, painters, poets, revolutionaries . . . they all wrote to Erasmus, asking his advice and begging him to visit: King Henry VIII, Pope Leo X, Albrecht Dürer, and Martin Luther are but four examples. Everybody was reading his books: the Christian teachings of *Enchiridion*, the classical wisdom of *The Adagia*, or the satire of *On the Eating of Fish*. He was gentle, witty, erudite, and a beacon for education and peace. When Europe was riven by the Reformation, both sides called to Erasmus – he refused to join either: 'I am a lover of liberty. I will not and I cannot serve a party.'[19]

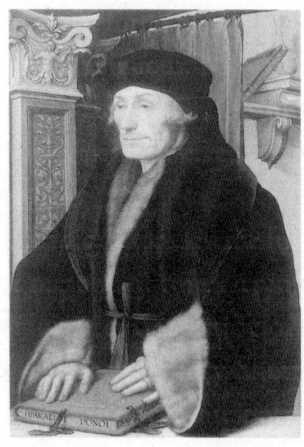

Portrait of Erasmus by Hans Holbein the Younger (1523).

As for Leonardo, suffice to say King Francis I of France held him in his arms as he was dying, and that just thirty years after his death the biographer Giorgio Vasari wrote of him:

> . . . occasionally, in a way that transcends nature, a single person is marvellously endowed by Heaven with beauty, grace and talent in such abundance that he leaves other men far behind, all his actions seem inspired and indeed everything he does clearly comes from God rather than human skill.[20]

What do you suppose it means that writers and painters were admired so greatly, so much more than ever before? It was a sign of the times, the sign of a new and more recognisably modern world emerging. But this social evolution was not yet complete – another sort of society was still to follow in the nineteenth century.

In 1843 Thomas Carlyle wrote that the national epic of the world was no longer 'Arms and the Man' but 'Tools and the Man'. This reworked the famous first words of Virgil's *Aeneid*, an epic poem written in the first century BCE. The words were *arma virumque*

cano in the original Latin, meaning 'I sing of arms [i.e. weapons] and the man.' Carlyle's point was that civilisation had become industrial rather than feudal and commercial rather than religious. Generals, saints, prophets, and warriors could no longer be heroes; businessmen and engineers had replaced them. Take the English engineer Isambard Kingdom Brunel. His first name means 'iron bright', and it was with iron that Brunel changed the world. All we need to explain this transformation – of society and its heroes – is a single photograph. Think of Ajax with sword and shield, Cincinnatus with plough and toga, Bartholomew holding his flayed skin, Erasmus his quill and Leonardo his brush, and now look upon Brunel with cigar and cyclopean chains:

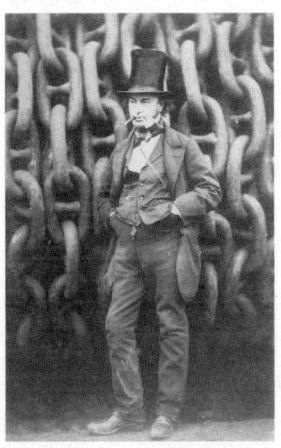

The hero of the nineteenth century was the engineer who raised up bridges and crystal palaces, laid railways and dug sewers, pumped rivers and bored mine-holes, and at the head of an army of labourers brought forth iron ships and steam trains. Brunel dragged civilisation forward not with swords, speeches, art, or books – but with girders, glass, and bulwarks. Not so long ago

every child wanted to be an astronaut; once upon a time it would have been an engineer.

Further metamorphosis. In 1999 *Time* published a list of the hundred most important people of the twentieth century. Who came out on top? Albert Einstein. So a new hero rises: the scientist. And another kind of hero also emerged in the twentieth century: the humanitarian. Think of Mahatma Gandhi, Martin Luther King Jr, and Nelson Mandela. These humanitarians are treated with the admiration that used to be reserved for saints, but the nature of this hero worship is tied in the minds of most people to political causes and general values rather than a specific creed; in what was the bloodiest century in our history they stood for peace, justice, and equality. There are still some politicians and leaders we treat as heroes – not least because war will always breed heroes. The First World War (for example) produced Thomas Edward Lawrence, better known as Lawrence of Arabia. But he was the last of a dying and now-dead type, an almost-mythic form of knight-wanderer-warrior.* To these heroes and many others, for now, we have said farewell.

There we rest. This selection is not exhaustive (need I even say so) and has focused exclusively on Western heroes. The broad categories, however, are essentially universal. My purpose has not been to scrupulously list all the different heroes or sorts of heroes around the world and across epochs. Instead, my intention has been to show that heroes can and do change, that the sort of person admired now was not always admired – and may not be admired in future. It is also another reason to study history: not merely to learn from the

* Perhaps the closest thing since was Che Guevara, an international rebel-icon. 'But wasn't he a murderer?' some may protest. We have always chosen to excuse the faults of our heroes. The very nature of heroism is that we choose to value one thing over another. Hence the saying that one man's terrorist is another man's freedom fighter.

mistakes of the past but to find examples of admirable people and deeds worthy of emulation.

As for the twenty-first century . . . I leave that to you. Who are our heroes? How do they compare with past heroes? And – most important – what does our admiration for them say about us? Gods, warriors, generals, orators, politicians, sages, saints, scholars, artists, engineers, scientists, humanitarians, entrepreneurs. They wheel together as constellations, some long dimmed by the condemnation of posterity – who now thinks of Brutus? – others forgotten entirely, others revived, or saved from villainy in their own times to be vaunted now. So many, too, whose apparent heroism is mere fame, a blind force that distracts us from the real work of choosing whom we claim our very best, and of whom we say to the next generation, 'Look, this is the sort of person you ought to be!'

CHAPTER VI

Lionel Messi and Giovanni Battista Tiepolo

†

And the Quangle Wangle said
To himself on the Crumpetty Tree,
'When all these creatures move
What a wonderful noise there'll be!'
– Edward Lear, *The Quangle Wangle's Hat*

Whoever talks with certainty about cycles of history, the procession of the ages, or the course of events, as if everything that has ever happened can be locked together like jigsaw pieces into a coherent and logical picture, spun into some playwright's tale of rational cause and effect, has evidently paid little attention to the past. Do I call history a sequence of coin tosses? Not necessarily. But it is vital that we understand how great a role coincidence has played in creating our world.

No doubt the 'butterfly effect' is fascinating, but I wonder why we do not consider the opposite more often: rather than small events cascading into major consequences, small events that lead to further small events, linking some unremarkable detail of the modern world to another unremarkable detail of the past by a

breadcrumb trail of unlikelihoods. This sort of history begins with asking: 'why?' Ask it more often, not of majesties and mysteries but of patent mundanities, and you will quickly see how often our world has been guided by chance rather than careful planning. No, history is not all doom and gloom, wars and heroes, civilisations rising and empires falling. Sometimes we humans are nothing but mice in a motherboard – and our nibbling of the cables has thrown up some delightful happenstances. After all the rather serious talk of recent chapters I think we should follow one of those breadcrumb trails.

In December of 2022 I was, like one and a half billion others, watching the World Cup Final. During the presentation ceremony I was struck by the blue-and-white stripes of the Argentinian kit. Here was Lionel Messi being *looked at* by over one billion people, in the process of creating an image that has already become iconic. He was wearing a blue-and-white shirt. Why? Because those kit colours are taken from the Argentinean flag, of course. But why is the flag those colours? Thus opens a wormhole that takes us back to the early years of the Byzantine Empire.

In the sixth century CE blue was the colour of the Byzantine imperial family. So when it came to creating church mosaics of Mary, Mother of Jesus and Queen of Heaven, what better way to signify reverence than to depict her in the colours of royalty? Portraying Mary in a deep and rich blue soon became standard in Christian art all over Europe. A thousand years later, during the Italian Renaissance, the most expensive and cherished of all blue pigments came from a mineral called lapis lazuli mined from the mountains of Afghanistan. The colour it produced was called ultramarine, or *ultramarinus* in Latin, meaning 'from over the sea'. This darkly vivid blue was inevitably reserved for Mary.

Virgin and Child, mosaic from the Hagia Sophia in Istanbul (12th century) and *Madonna of the Book* by Sandro Botticelli (1481).

We go now to the Spanish Empire of the eighteenth century which ruled swathes of North, Central, and South America – and its king, Charles III. His son and heir had been married but childless for five years, so Charles prayed to Mary that she would bring him a grandson. In 1771 a child was born and the king created a noble order in celebration. These orders, important in the Middle Ages, had by then become clubs for prominent citizens, with membership awarded as recognition for notable deeds of public good. This one was called the Order of Charles III. Of course, every order must have its colours. Because Charles had prayed to Mary for a grandson he chose blue – *her* colour – and white, typically associated with purity and faith.

Curious, however, is that Charles III chose a shade of blue significantly paler than that of the Byzantines or Renaissance. Why? On the next page is a painting of Mary by the Venetian artist Giovanni Battista Tiepolo. He was *the* painter of his age and the undisputed master of the theatrical phase of art known as rococo. It was painted in 1767 and, according to Tiepolo's tastes, depicted Mary with

 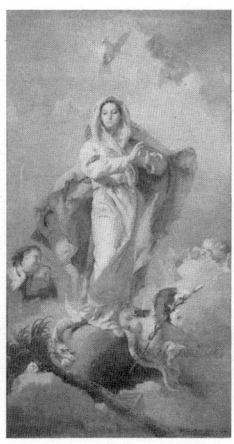

Charles IV by Carlos Espinosa Moya (1818) and *The Immaculate Conception* by Tiepolo (1767).

sky-blue robes. This is important to our story because the painting was commissioned by none other than King Charles III. In other words, and thanks to Tiepolo, the colour Charles associated with Mary and thus used for his order was not ultramarine but sky blue.

Thirty years later, Ferdinand VII, grandson of Charles III, was King of the Spanish Empire. But a certain Corsican called Napoleon invaded Spain, and in 1808 forced Ferdinand to abdicate. Joseph, Napoleon's brother, was crowned king in his place. The people were unimpressed. They revolted in Spain – and also in Argentina, where rebels wore the colours of the Order of Charles III in a show of loyalty to their true king.

Two years later a full-blown war of independence broke out. In 1812 the leader of this revolution, the great Manuel Belgrano, created the Cockade of Argentina, a knot of ribbons used to denote revolutionary forces. It was only natural that he chose colours previously associated with both revolt and Argentinian identity: the pale blue and white of the Order of Charles III. The revolutionary government

proclaimed the cockade a national symbol and, soon afterwards, Belgrano created a flag for Argentina with the same colours. In 1816 his design was officially adopted as the flag of independent Argentina; the sun was added later. When Belgrano first presented his design to the people he compared its colours to the sky and the clouds. This has been interpreted to mean they were his inspiration, but in truth they had come from the Order of Charles III.

Several decades later a new sport called football arrived in Argentina via British dock and railway workers. The locals rather liked this game. By 1891 they had a national league – the fifth oldest in the world – and in 1893 the Argentine Football Association was founded. The national team's first match was held in 1902, against Uruguay, and for it they wore an all-blue kit. Six years later they played an All Star team from the Brazilian League and, for the first time, wore a kit of white-and-sky-blue stripes. More than a century later this is the design they still wear – as worn by Diego Maradona in 1986 and by Lionel Messi in 2022 – adapted from the Argentinian flag, whose colours are the result of a centuries-long chain of political, religious, artistic, economic, and sporting unlikelihoods.

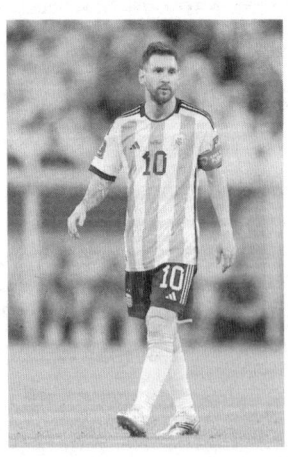

You can see why I urge against casting the past with too much certainty . . . or the future! Could those Byzantine artisans have known their mosaics of Mary would result in an Argentinian footballer called Lionel Messi wearing a blue-and-white shirt in view of one and a half billion people? We might ask the same of Tiepolo and his preference for sky blue over ultramarine, or of Charles III and his founding of a noble order in gratitude to Mary, or of Manuel Belgrano and his revolutionary symbols. As Hamlet says:

> Our wills and fates do so contrary run
> That our devices still are overthrown;
> Our thoughts are ours, their ends none of our own

And this is the story of the kit colours of just one football team. What about every other sports team, or every other flag, or every other *thing* in the world?! The story behind Lionel Messi's white-and-blue shirt is not unique. Each idea, word, and object has its own story to tell. There was no plan here, no master politician or great thinker at work, no grand narrative to be woven. There was only coincidence – delightful, unsecondguessable – at times called chance or randomness, and the cross-section of unlikely people, places, and times, of minuscule decisions made centuries ago that have shaped our world in minor but manifold ways.

CHAPTER VII

What Shape is History?

†

I tell you/someone will remember us/in the future
— from the *Fragments of Sappho*[21]

In the far future an alien scholar writes a book called *The History of Humankind*. It begins in 300,000 BCE, when *Homo sapiens* first emerged, and ends with the death of the last ever human. I ask: on which page would you find the year 2025? Are we in the middle or near the beginning? Maybe we are still on the first page, or even the first line. Perhaps the twenty-first century will be so distant to our descendants 10,000 years from now that the things we hold most important, which seem so permanent – our religions and sciences, Shakespeares and Napoleons – will be completely forgotten, no more relevant or comprehensible to those future humans who colonise the stars than the fireside chatter of our hunter-gatherer ancestors is to us. Or maybe we are in the last chapter . . . on the last page? Perhaps this is it, and everything that has happened thus far represents the total sum of what humanity will achieve, because tomorrow some catastrophe will precipitate our demise.

With this zoomed-out perspective in mind, I ask another question: if you were to draw a line charting the human story, what shape would it be? I offer six options. Decide which, if any, you

think is correct. As the American composer Leonard Bernstein once said, 'I reserve the right to be wrong!'

1. Progress

In material terms the human story has clearly been one of constant progress. By every metric there is simply more of everything – and more of good things. There are 8 billion people in the world; we only crossed 1 billion in the year 1800. We are richer, healthier, and live longer than ever before. Our cities are bigger and our buildings taller. We have cars and aeroplanes and we have strolled on the Moon. We have anaesthetics, the internet, air conditioning, artificial intelligence, and nuclear reactors. Billions of people today lead a life of greater luxury and comfort than any medieval king, and this process shows no signs of slowing. The veil of human ignorance is being lifted. What wonders will be invented next? Surely the human story is one of progress, perhaps with moments of decline but marked by an irresistible upward trajectory. Work remains to be done – a third of people alive today do not have access to a toilet, for example – but there is a general belief that we can and will set things right. To give you some sense of this pattern of material progress and its ubiquity I offer two statistics:

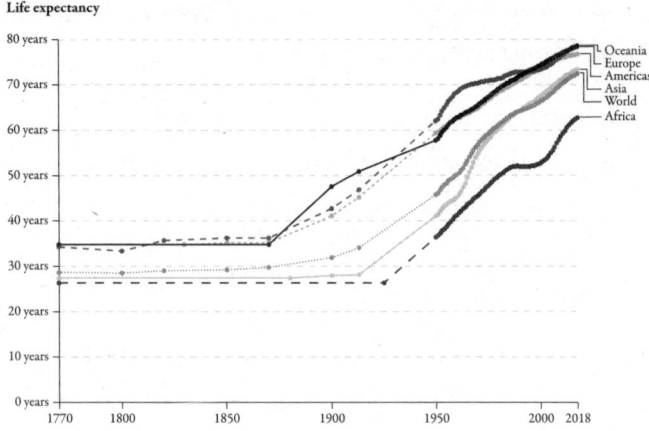

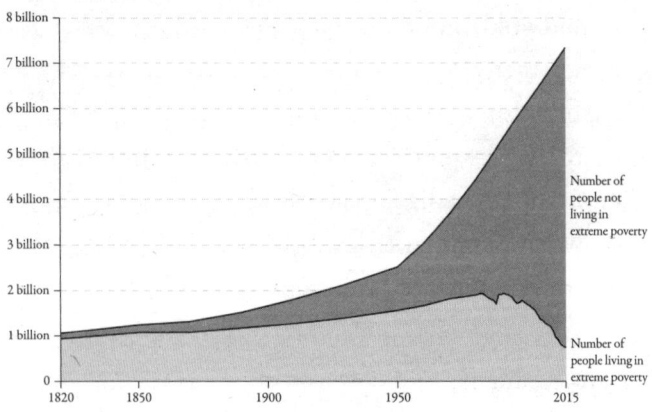

2. Decline

Most people care about family more than phones and believe love is more important than money. If we are speaking about the things that truly matter, the human story might have been one of decline – even as we become materially richer, we are becoming poorer in some more fundamental way. Think of Adam and Eve in a state of

pure bliss, who ate of the Tree of Knowledge and were exiled by God. As Milton wrote of their banishment:

> Some natural tears they dropt, but wiped them soon;
> The world was all before them, where to choose
> Their place of rest, and Providence their guide:
> They, hand in hand, with wandering steps and slow,
> Through Eden took their solitary way.[22]

Are we like Adam and Eve? In some real sense we humans *were* once in harmony with nature. Then the cognitive revolution happened. We invented language, law, and politics. We built walls, forged swords, and started slaughtering one another, thieving and committing genocides, plunging millions into squalor to raise up a lucky few, lusting after fame and gold, and destroying this once-green Earth in the process. Maybe there *was* a time of spiritual perfection, a time we have long left behind, sailing further every year from that island of natural harmony into a manmade ocean of blood. All the features of modern life – fashion, social media, careers, TikTok – might be signs of our regression. Every generation since the dawn of civilisation has believed the old days were better; are not 'golden ages' always in the past?

3. Cyclical

Certain scholars say civilisation follows set patterns of rise and fall, marked by the same signs of growth and symptoms of decline. Just as the Roman Empire turned to 'bread and circuses', so too will the United States. Another power will emerge, enjoy the limelight, and collapse, before another rises, thinking 'this time it will be different!', only to fade. We, like the seasons, revolve in an endless cycle.

Philosophers and sages have also wondered whether the whole

universe is eternally recurring. Some say that everything now happening has happened before, and will go on happening in exactly this way, forever. Others say the universe, though cyclical, never contains *quite* the same events. Think of it as like playing a video game half a dozen times. The story always concludes the same way even though no two playthroughs are identical. In Hindu cosmology the lifetime of a universe is called a *kalpa*. Each *kalpa* lasts four and a half billion years, after which comes *pralaya*, the destruction of that universe, followed by the creation of another universe. Has science done away with this sort of ancient speculation? No. Big Bounce Theory posits that our expanding universe will eventually contract and, upon reaching a state of near-infinite density, explode outwards again, in another Big Bang. According to Heat Death Theory the universe will go on expanding until energy becomes maximally distributed. Stars go out and black holes fade. All is darkness ... until, after enough time has passed, quantum tunnelling leads to the creation of another universe.

4. Nothing Changes

Maybe all this talk of 'progress, decline, and cycles' is misguided. Maybe there is no change whatsoever. Human nature has not altered one whit in the last 300,000 years. Some graffiti scrawled in the bars and bathhouses of Pompeii does more than a library of books to prove this.[23]

> *Romance:*
> Methe, a slave of Cominia from the town of Atella, loves Chrestus. May Pompeian Venus be propitious in her heart to them both and may they always live harmoniously.
>
> *Ribaldry:*
> Secundus likes to screw boys.

And, simply:
Aufidius was here.

Things around us change, but they do not represent real change. New countries are created and new machines invented – we use flushing toilets now! – but the fibre of our souls remains the same, and it is *that* which defines us. We fight the same spiritual and emotional battles our ancestors did thousands of years ago; we face the same struggle to do what is right. From the *Katha Upanishad*, an ancient Hindu scripture:

> As the sun, who is the eye of the world,
> Cannot be tainted by the defects in our eyes
> Nor by the objects it looks on,
> So the One Self, dwelling in all, cannot
> Be tainted by the evils of the world.
> For this Self transcends all![24]

Human nature, like the Sun, cannot be tainted – shaped, influenced, affected – by the material world. Our condition, fixed and imperturbable, has an apparent sea of change – technology, ideas, wars, countries, fashions, books, cars, politics – revolving around it. But we, at the centre, have not changed, do not change, and cannot ever change.

5. Constant Change

This theory finds an echo in that popular saying: history rhymes but it never repeats. Similarities, yes, but the same thing never happens twice. Progress might go on forever – but it might not. We experience decline – but it is reversible. Thus the decisions we make matter because the future is not certain, everything is unprecedented, and there is no set pattern. Empires have fallen; an everlasting empire could yet rise.

Even if human nature is unchanging, different political and cultural regimes emphasise or repress particular elements of that nature. We have always fought wars, but we have fought them for many different reasons. There are nuclear bombs now, so surely geopolitics will never quite be the same. It can be comforting, even an excuse for indecision, to prognosticate about cycles of history. More challenging is this uncyclical prospect: that the stakes are always high, that present and future are not bounded by past. As the ancient and rather mysterious philosopher Heraclitus wrote: 'You could not step twice into the same river; for other waters are ever flowing on to you.'[25]

6. Unknowable

To see which direction something is going you need a certain amount of information. Since we do not know how big the future is we cannot properly judge the present or the past. Consider these graphs:

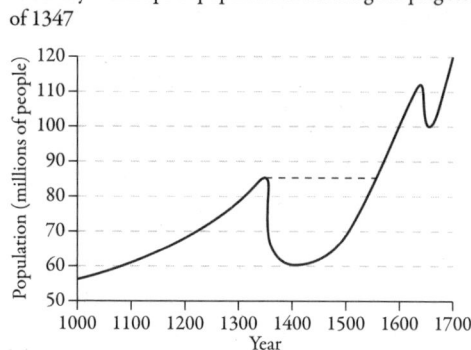

Recovery of European population following the plagues of 1347

The first graph charts the population of Europe throughout the Middle Ages, showing a sudden decline during the Black Death in the fourteenth century. The second graph charts global population

THE FIRST PILLAR OF THE CULTURAL TUTOR

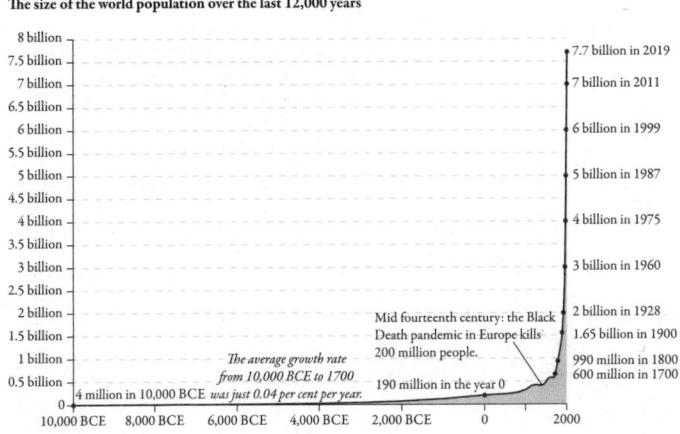

from 10,000 BCE up until today. Whatever conclusions we draw from the first graph would certainly change in view of the bigger picture. Similarly, whatever conclusions we make about history up until now may become equally inconsequential if it transpires that we have been dealing with an absurdly small sample size. Without a sure frame of reference we cannot state with certainty what the shape of history is. It remains – and always must remain– a mystery.

So, where are we in *The History of Humankind*? I ask you this because we must maintain perspective when thinking about history, as we have been doing throughout this first pillar. Right now certain national or international problems seem like the most important things in the world, perhaps the most important things that have ever happened. But as we say this about our various crises, so people said the same about the First and Second World Wars, the Industrial Revolution, the Black Death, and so on. And don't you think, for those Byzantine bureaucrats huddled by the walls of Constantinople as the Ottomans laid siege to the city in 1453, or for the librarians of

Baghdad when Mongols battered at the gates in 1258, nothing more important had ever happened? I invite you to read this letter, sent to the King of Carchemish 3,000 years ago:

> When your messenger arrived, the army was humiliated and the city was sacked. Our food in the threshing floors was burnt and the vineyards were also destroyed. Our city is sacked. May you know it! May you know it![26]

For the Mycenaeans, Hittites, and Kassites, whose societies were wiped out in a fifty-year hurricane of wars, mass migrations, and natural disasters known as the Bronze Age Collapse, the world as they knew it was literally ending. And yet here we are. Here *you* are, reading this book; here *I* am, writing it. So . . . what shape is history?

The Second Pillar of
The Cultural Tutor

Watching the Wheels

CHAPTER I

Where Does Zeus Live?

†

The Tao that can be told of is not the eternal Tao;
The name that can be named is not the eternal name.
— Lao Tzu, *Tao Te Ching*[1]

We have taken an open-eyed and curious stroll through history, visiting various times and peoples. Now the question arises: what forces influenced that history? That is the subject of this second pillar. And we begin where history begins — with mythology. All peoples have their myths, whether of creation or destruction, but in the twenty-first century it can be difficult to understand where they came from or why we ever told these strange and confusing tales. So let's try to see if we can 'get' what mythology was (and still is) all about.

According to the myths of ancient Greece there were twelve gods who lived on Mount Olympus. Here the poet Hesiod paints us a portrait of Zeus, their chief:

> From Olympus he came forthwith, hurling his lightning: the bolts flew thick and fast from his strong hand together with thunder and lightning, whirling an awesome flame. The life-giving earth crashed around in burning, and the vast wood crackled loud with fire all about.[2]

Zeus led the third generation of gods in revolt against the second generation, known as the Titans, overthrowing his own father, Cronos, in the process.* Another story tells how Zeus fell in love with a mortal woman called Alcmene, and that by him she gave birth to Herakles. When Herakles was being suckled by the goddess Hera – Zeus's wife, tricked into raising Herakles – he bit so hard she cast him off and her milk scattered across the heavens, creating the Milky Way.

The Origin of the Milky Way by Tintoretto (1580).

A strange story, though far from the strangest. But here's the rub: Mount Olympus is a real mountain in northern Greece, about fifty miles south-west of Thessaloniki. If the ancient Greeks believed that their gods lived on Mount Olympus, why didn't they look for them? Well, among the pinnacles of Olympus have been found potsherds, coins, and temples to Zeus and Apollo. So Greeks did go to

* Cronos had done the same to his own father, Uranus, even castrating him; it was from the sea-froth thrown up by the castrated Uranus's falling blood that Aphrodite (Venus to the Romans) was born; hence Sandro Botticelli's *Birth of Venus*. Sophisticated!

Mount Olympus, found no gods, but continued to worship them anyway. In which case, rather than asking *whether* they believed in these gods and their stories, perhaps we should ask: *in what way* did the Greeks believe in them?

There was a long-standing debate among ancient historians about whether they should include 'mythological history' in their work. In his biographies of the Roman emperors, Suetonius gleefully reports supernatural phenomena such as statues sweating blood. Herodotus, who wrote a history of the first Persian invasion, argued that the Greeks got their gods from the Egyptians, thus displaying what we might call an anthropological approach to religion. His contemporary Thucydides did not mention gods at all in his account of the Peloponnesian War. And the philosopher-poet Xenophanes of Colophon, even satirised religion by pointing out that the Ethiopians thought of their gods as black and Thracians as white, and that if horses had gods they would look like horses:

> Mortals deem that the gods are begotten as they are,
> and have clothes like theirs, and voice and form.[3]

Nor to forget Lucretius, a poet of the first century BCE, who wrote:

> More often, on the contrary, it is Religion breeds
> Wickedness and that has given rise to wrongful deeds.[4]

Many ancient Greeks knew that Zeus did not 'live' on Mount Olympus but worshipped him anyway, and others hardly seem to have believed in the gods at all. So did anybody believe that the gods *literally* lived on Mount Olympus?

Let us imagine ourselves as ancient Greeks – or *any* of our ancestors: on the Usumacinta River or the Great Steppe, in Scandinavian

snow-woods or on the red mountains of the Outback – and see if we can understand what 'literal belief' might have been like. Let us travel beyond the rise of cities, long before we had thrown up temples of porphyry and gold. Imagine yourself a lonely forager on some forsaken plain, far from friend or foe. This world you see is the only one you have known – and it is a world wholly without 'explanation'. Imagine *seeing* this world for the first time. How would you seek to understand it, to explain it? Would you not sense the motion of some greater being in thunder? Thomas Carlyle once pointed this out with frightening precision – that the world is genuinely miraculous if only we actually *think* about it, and that we don't really think about it only because other people have already done the thinking for us:

> It is not by our superior insight that we escape the difficulty; it is by our superior levity, our inattention, our want of insight . . . this world, after all our science and sciences, is still a miracle; wonderful, inscrutable, magical and more, to whosoever will think of it.[5]

We have electric lights, flushing toilets, and central heating – the lonely wanderer had nothing of that sort. Once we *feared* – now we are merely uncomfortable. Once we knew *solitude* – now we feel lonely. And whatever systemised joys we experience, be it a pay rise, mass entertainment, or early retirement, how could they compare with the primordial joy of a forager who has endured a winter of famish and frostbite and, seeing buds upon the branch, knows that spring has come at last? Nearly two hundred years ago John Ruskin, an art critic and philosopher, framed this argument perfectly:

> If [mythology] first arose among a people who dwelt under stainless skies, and measured their journeys by ascending and

declining stars, we certainly cannot read their story, if we have never seen anything above us in the day but smoke, nor anything around us in the night but candles.

We must sympathize, by an effort of imagination, with the strange people who had other loves than those of wealth, and other interests than those of commerce.[6]

Our vitality has been sapped by the miracles of modernity; our wide eyes have been closed by the drowsiness of a 'comfortable' life. On a clear night when the galaxies unfurled above you – without pre-packaged scientific explanations, without our parade of technologies – would you not have believed that the Aztec god Citlalatonac created those stars? When nights descended of a pure darkness we have never known, illuminated only by flame-light or Moon-glow, would you not have hoped for Helios – Greek god of the Sun – to ride forth in his chariot, banishing the fearful night with dawn? It is difficult now to conceive such a pure kind of existence. Consider this excerpt from the *Rig Veda*, a collection of Hindu hymns written some 3,000 years ago:

> O Dawn thou rulest over wealth.
> Thinking of thee, O joyous One, as her who driveth
> hate away,
> We woke to meet thee with our lauds.[7]

Would we sing these words? No: for we would have to actually pay attention to the Sun and find in its dawning a deeper meaning than the mere beginning of another day's work. Until we can comprehend a world of such supreme vitality and urgency, until we can forget newsfeeds and same-day delivery, we can neither say that the ancient Greeks were wrong to 'literally' believe in the Olympian gods nor

right. Perhaps we must accept that the world of mythology – now its age of creation has passed – is simply impenetrable for us.

And yet . . . if you visit (for example) the Church of Sveta Nedelya in Sofia, you will find people of an earnest faith walking unselfconsciously into candlelit chambers where grave-faced icons gleam in shadow. They whisper prayers to a Mary encased in silver, kiss her image, light candles for the living and the dead, and cross themselves as they leave the church-twilight for city streets – then pull out their phones and go back to work. Was the faith of the ancient Greeks, the Egyptians, or the Aztecs really so different? When a person believes something honestly it makes no sense to wonder whether their gods 'really' live on Mount Olympus. You may as well ask somebody today, 'Is the sky blue?' Unthinkingly we would respond, 'Obviously!'

Do you *believe* in the theory of evolution? No, you might say, it's a matter of fact, not belief. But have *you* studied the fossil record? No. You have taken as true what scientists have said. What about the Big Bang? Do you believe it *actually* happened? Yes, you say. Why? I ask. Because physicists have told us it did. But this theory, invented in 1931, was a radical departure from the established scientific consensus. The Big Bang Theory has since been modified and is facing fresh challenges. So which version of the Big Bang Theory do you accept? And, if a scientist discovered tomorrow that it didn't actually happen, would you change your mind? And so I ask you to wonder: how does your literal belief in the Big Bang differ from the honest belief of an ancient Greek in Zeus? If we laugh at our ancestors and call them ignorant we are guilty of false pride – it is sheer arrogance to believe that in 3,000 years our descendants won't see most of our modern science as little more than superstitious belief. I am not trying to convince you that mythology and science are

comparable worldviews here; my point is that we are not necessarily any more rational than our ancestors, and that even if mythology and science are fundamentally different, the way in which most of us believe in them might be the same. And besides, even if our ancestors' planet-devouring serpents seem like nonsense to us, what would they think of TikTok?

So: what *are* myths? Some psychologists have argued that they emerged as mirrors for the inner workings of the human mind; some historians have said that gods were but personifications of nature. Other experts have framed myths as justifications for rules or hierarchies, and some have explained mythology either as primitive science or as a kind of pre-modern mass communication intended to preserve and pass on truths. All these theories, though they contain kernels of truth, ultimately fail. Why? Precisely because each of them attempts to provide a unifying explanation for *all* mythology. Think of it this way: what single word could be used to describe *all* the different things we consume and believe in today? There isn't one. Even if we narrow things down it gets no easier. What do you use the internet for? Films, news, talking to friends, arguing with strangers, uploading or looking at photographs, ordering food, finding dentists' numbers, sharing spreadsheets, holding work calls, and watching videos strange, funny, informative, or unmentionable . . . all of this and more. So what is the internet for? *Everything*. Hardly a clear definition. But this is the broad-minded approach we must take when we think about mythology.

Is your belief in the Big Bang comparable to your enjoyment of superhero films? If not, then why should we think the ancient Greeks 'believed' in Perseus any more than a New Yorker believes in Spider-Man? You might say films are 'mere entertainment', but if that's true for you, why shouldn't it have been true for the ancient

Greeks? And, if our favourite films are *more* than mere entertainment, can you explain what they are? We use bland terms like 'media franchise' because, saturated in them, we think we know what those words mean. But, upon inspection, whatever clear meaning we thought they had melts away – it suddenly seems that our 'media franchises' aren't so dissimilar from ancient mythology. You presumably know that Batman is not literally real, but if the stories told about him do have some meaning to you, on what level does he exist in your worldview? There have been seventeen major films about Batman, most with different actors playing out wildly different variations on the same stories. If you can reconcile the existence of these different Batmen, possibly having a favourite while recognising that no interpretation represents 'the true version', and accept that some are merely entertaining while others offer you something more, then you may have more in common with the ancient Greeks than you thought.

Nor is it hard to imagine how a real man could have become Herakles. Think of the reverence for the footballer Diego Maradona, after whom streets and children are named, and whose boots museums treat like relics. Compare that to some great warrior 5,000 years ago who left behind him a trail of death, life, destruction, and awe. Within a few years the stories of his life have spread far – within a generation or two they have become fantastical. We have recorded evidence of Maradona's life and achievements, and this limits how far his mythos can be stretched. Not so with the man (or several men?) to whom Herakles' legend might be traced. Without recorded evidence, when the only way of sharing information was word of mouth or sculpture, it is easy to see how the life of a person might have been mythologised.

And the same is true of events. What if I told you about a

devastating flood sent to destroy all humanity, save one man who receives divine advice to build a ship? He takes his wife and children onboard, along with some animals, and survives the deluge. Do you recognise this myth? Noah's Ark, of course. Or not – it's the Greek myth of Deucalion. Or I might be describing the Sumerian legend of Atrahasis, or of Ziusudra to the Babylonians, or Utnapishtim to the Akkadians. Yes, Mesopotamia is where ancient Greek and biblical flood myths originated – a stupendous example of how myths spread from one culture to another, changing in detail but retaining the same structure and theme.

But where did the myth originally come from? In 1922 an archaeologist called Leonard Woolley led an expedition to the Sumerian city of Ur, where his team discovered a layer of mud four hundred miles long and one hundred wide separating two eras of construction. This could only have been the result of a colossal flood, dated roughly at 2900 BCE. We cannot say with certainty that this was *the* flood, but it does offer an explanation for the origins and centrality of a flood myth in Mesopotamia.

An obvious comparison here is the Second World War. Though recent and well documented, it has already taken on mythical significance. In Britain, the idea (true or not) that 'we stood alone' against Nazi Germany is an essential part of our national story. Just as generations passed and the flood that destroyed Ur conflagrated into a story of divine proportion, so too do we believe that the Second World War was an ultimate struggle between good and evil. And what about the Manhattan Project? No wonder the famous 2005 biography of Robert J. Oppenheimer is called *American Prometheus*. Perhaps Herakles does not seem so fabulous now.

The bright line we like to draw between ourselves and our ancestors is riddled with murk. Their 'myths', ranging from amusing

stories to tales explaining the origins of the cosmos, are not so far away from whatever singular word we might invent to describe *all* our science, art, morals, ideas, and online content at once. Accept this, and we can begin to understand both mythology and our ancestors a little better – their peculiar stories may even allow us to peer into that otherwise indecipherable gloom of the past. And there, finding a mirror in which we see ourselves staring back, we realise that the ultimate key to understanding history is not found in any book or theory, but in ourselves. We realise that all things that have always been in humankind are also in us.

CHAPTER II

Barba non facit philosophum

†

> The Brain—is wider than the Sky—
> For—put them side by side—
> The one the other will contain
> With ease—and You—beside—
>
> – Emily Dickinson, *632*

Philosophers are annoying people who write terrible books. This, at least, is the general view of them. However, from time to time, they *do* say interesting things. Then other people read those things, start believing them, and act on them. Thus philosophers are best understood, in rudimentary terms, as people who create ideas. Since ideas have surely guided and influenced history, investigating these idea-creators – the philosophers – must be worthwhile. So, to begin, an elemental question demands to be answered: what *is* philosophy?

Our word 'philosophy' comes from the ancient Greek words for love (*philo*) and wisdom (*sophia*), so philosophy means 'love of wisdom'. Who was the first philosopher? You may be tempted to say Socrates. This curious chap did not write anything down. Everything we know about him comes from his students, mainly Plato, who then tutored Aristotle. These three are the triumvirate of ancient Greek philosophy and, by extension, of Western thought.

But philosophy did not begin with Socrates. Before him were the likes of Thales, Pythagoras, and Parmenides. These were thinkers who refused to accept that everything was merely 'the work of the gods', who tried to rationalise our universe and understand its rules. We don't have time to investigate the conditions that gave rise to this philosophical inclination among the ancient Greeks – only, it is clear that whatever intellectual fire they lit, later turned into a blaze by Socrates, is still burning in all of us.

But philosophy was not born in Greece, or the West, or in any single place. Even as Socrates roved those Athenian streets, Confucius was hard at work in China and a continental philosophical awakening was underway in India. And long before them, before anybody whose name we can name, came the proto-philosophers who set this whole process in motion. Our world is built on the work of forgotten philosophers, those first-conscious humans who looked upon a flowery-flaming world where all was without name and somehow made sense of it. The only reason we can go about our daily business without withering in fright is because they have done the fretting for us.

Now, in the twenty-first century, the popular image of a 'philosopher' is somebody who sits in an armchair, doesn't know how to iron a shirt, and writes about things like morality. But Isaac Newton, who we now call a scientist, was considered a 'natural philosopher' in his day. Charles Darwin himself would have been called a natural philosopher had not the term by then been narrowed to its modern meaning, and so we call him a biologist. This change has not helped the public perception of philosophers – or done the world much good. Vivisecting knowledge and pedantically 'categorising' it into sealed-off '-ologies' is a worrying sign of our times. Wise words from the *Bhagavad Gita* – itself part of the *Mahabharata*, an epic

poem composed over 2,000 years ago and central to Hinduism – come to mind:

> When one sees Eternity in things that pass away and Infinity in finite things, then one has pure knowledge./But if one merely sees the diversity of things, with their divisions and limitations, then one has impure knowledge./And if one selfishly sees a thing as if it were everything, independent of the ONE and the many, then one is in the darkness of ignorance.[8]

Philosophy resists categorisation; it cuts across *all* fields. So if we want to understand what 'philosophy' is we must forget our limiting modern definition. To be a 'philosopher' is to think deeply ... about anything. It is not like medicine; without a medical degree, a doctor cannot practise. Studying philosophy is not a prerequisite for becoming a philosopher, and in itself doesn't make you one. As far as I can tell, based on the people throughout history who have been called philosophers, you are a philosopher if ever you have done any serious thinking. That, and that alone, is the only requirement. Hence the title of this chapter – *barba non facit philosophum* – a delightful Roman saying that means, 'a beard does not make a philosopher'.

We should not be impressed by anybody who describes themselves, or is described, as a 'philosopher', and should recognise that many who are never called it might be that very thing. That brooding bartender, the distant cousin who makes curious comments, the cab driver saying things that make your 'ragged Ronts all shiver and shake'[9] – any or all of these might be a philosopher. Even YouTubers, bearded or otherwise! I am not making this up. Any attempt to gather people who have been called a 'philosopher' and work out what they have in common yields one answer: it was not what they

studied, what they believed, or when they lived – it was simply that they *thought*, and *thought well*.

One example should help here. When Alexander the Great had finally made himself the undisputed master of Greece he held an assembly to which all Greeks were invited to collectively declare him their ruler. They came in droves, the great and the glorious, the statesmen and poets and generals, to pay homage. But one of these famous Greeks was late to the assembly – Diogenes of Sinope.

Diogenes by Jean-Léon Gérôme (1860).

Diogenes was a strange and notorious man who had fled to Athens from his hometown after being accused of forging fake coins. There, perhaps having had a revelation after his sins in Sinope, he set out to live a life of extreme virtue, exposing by his every action and word the inconsistencies, injustices, and hypocrisies of Athenian society. He lived in a clay barrel in the middle of the city and survived by begging. One of the earliest anecdotes tells of Diogenes begging in front of a statue. When asked why he was doing this, he replied, 'So I can get used to being ignored.' He was fond of a sharp remark,

Diogenes, but beneath the wit was inevitably concealed a deep conviction about the dignity of humankind – and a serious concern for how that intrinsic dignity can be corrupted by the artifices of society.

Diogenes was also given to what might be called practical jokes, though ones which were perhaps closer to philosophical performance art. He once went about Athens in broad daylight with a lantern. This caused a stir. When people asked him why, Diogenes replied, 'I am looking for an honest man.' Another story relates how Diogenes saw a young boy cupping his hands to drink from the river. Astonished, he threw away his bowl, exclaiming that he had not been living in true poverty as he still had one possession he did not need. He defecated in the theatre, urinated on people who insulted him, and regularly disrupted Plato's lectures. Not a pleasant man, but one can't help admiring his conviction.

Later in his life, Diogenes was captured by pirates and sold into slavery. There's an anecdote about that, too:

> ... on a voyage to Aegina he was captured by pirates under the command of Scirpalus, conveyed to Crete and exposed for sale. When the auctioneer asked in what he was proficient, he replied, 'In ruling men.' Thereupon he pointed to a certain Corinthian with a fine purple border to his robe, the man named Xeniades above-mentioned, and said, 'Sell me to this man; he needs a master.'[10]

He ended up in the city state of Corinth, and that is where he was when Alexander called his great assembly. Diogenes did not attend – so Alexander sought him out personally. I'll let Plutarch, an ancient biographer, tell you the rest:

> Alexander went in person to see him; and he found him lying in the sun. Diogenes raised himself up a little when he saw so many

persons coming towards him, and fixed his eyes upon Alexander. And when that monarch addressed him with greetings, and asked if he wanted anything, 'Yes,' said Diogenes, 'stand a little out of my sun.' It is said that Alexander was so struck by this, and admired so much the haughtiness and grandeur of the man who had nothing but scorn for him, that he said to his followers, who were laughing and jesting about the philosopher as they went away, 'But verily, if I were not Alexander, I would be Diogenes.'[11]

So, it seems, you needn't write a book – or lounge in an armchair – to be a philosopher.

But we must give credit where credit is due and admit that this 'thinking' business is not necessarily easy, and that devoting oneself to it does not always mean an easy life. Although these thinkers might sometimes seem like pedlars of nonsense, trying to convince us that free will does not exist, that neither you nor I exist, or even that nothing exists, their musings can get them into serious trouble. Just one example is Hypatia, a mathematician-philosopher who lived in the Egyptian city of Alexandria in the fifth century CE. Her political alignments and personal philosophy proved unpopular with the local patriarch, and when enough bad blood had been stirred up she was seized by a fanatical mob on leaving her home, dragged through the streets, and hanged. Quite some reward for daring to think.

And if some philosophers have been considered a danger to others, it is also true that philosophers are frequently a danger to themselves. Friedrich Nietzsche saw a horse being flogged in Turin, flung himself between the animal and its persecutor, and promptly collapsed; he suffered a psychological breakdown and never recovered his mental faculties. Empedocles of Akragas, who believed that the four elements of the universe were governed by the opposing forces of love and strife,

threw himself into Mount Etna in an effort to prove to his followers that he was immortal. He has not been seen since.*[12]

So, although philosophers may well lounge in their armchairs and think, time and again they have either driven themselves mad or been jilted out of their pontificating by jackboots banging at the door with a warrant for their arrest. But why? Because the role of a philosopher – and, remember, by this I mean *anybody* who does any serious thinking – is to see through the muddy heap of assumptions we all live by. Their purpose is to understand what is really going on, rather than merely accepting as true the things we all tend to believe and say simply because that's what we've been told. This is hard work, and often involves challenging the status quo – hence how frequently philosophers have been suppressed, by violence or other means.

That is why philosophers matter – and why their terrible books are sometimes worth reading. At every moment of our lives we are thinking and behaving according to an invisible cornucopia of *ideas*, vast and interconnected as the pearl-net of Indra. Money, law, privacy, property, language, nations, borders, elections, democracy, taboos, marriage, equality, liberty – where did these things come from? You won't find them in the mud and you cannot see them with a microscope; they were *created*. We accept them as given, as

* Little wonder that the ancient Romans, at least in the time of the Republic, were deeply sceptical of 'philosophy'. They saw it as a fundamentally Greek invention – something which served only to confuse, manipulate, and distract. As Plutarch said of Cato the Elder: 'Report spread far and wide that a Greek of amazing talent, who disarmed all opposition by the magic of his eloquence, had infused a tremendous passion into the youth of the city . . . Cato, at the very outset, when this zeal for discussion came pouring into the city, was distressed, fearing lest the young men, by giving this direction to their ambition, should come to love a reputation based on mere words more than one achieved by martial deeds.'

fundamental, without realising that, to take one example, 'borders' and the passports required to cross them only exist because of a framework of ideas that establishes (among other things) the existence of self-governing nation states. What is an 'election', and why does it give other people the right to make laws for us? Where did communism, fascism, socialism, conservatism, liberalism, capitalism, secularism, and all the other '-isms' come from? There would have been neither Bolshevik Revolution of 1917 nor Mao's Revolution of 1949 without the philosophy of Karl Marx; there would be no United States or Declaration of Independence without the philosophy of Polybius.* You can't open your phone without trading in the currency of ideas – ideas imagined and refined by philosophers.

We are sailing in an ocean of chaos, afloat in a hand-me-down ship of confusions, plugging leaks where we can, changing tack and altering course, ever replacing our captain and praying for the winds of some new and great *idea* to guide us. Philosophers cast those winds which blow our ship in one direction or another. Most of us cling to the beliefs we have been given. They seek to see further, shaking off the frost of inherited assumptions and looking with clear eyes upon distant shores. They convince us to change course, and we do – whether for good or bad we do not know until we come ashore.

* An ancient Greek historian who studied the constitution of the Roman Republic – we shall meet him again in a few chapters' time.

CHAPTER III

Snoozing on the Shoulders of Giants

†

> ... the King was greatly offended, and said, that then he should be under the Law, which was treason to affirm; to which I said, that Bracton saith, that the King might not be under man but is under God and the Law.
>
> – Edward Coke, *Case of Prohibitions*[13]

Aristotle divided philosophy into two parts. First was *ethics* – how a person should live. Second was *politics* – how to organise society. And when he composed his treatise on politics Aristotle wrote it from the perspective of a law-maker. He was right to do so. Because when we talk about politics we are really just talking about the law. What is a political manifesto if not a collection of proposed laws? One does not simply 'build a wall' or 'nationalise the railways'; one must pass a law ordering that a wall be built or proclaiming that the railways belong to the state.

Every social structure – the sport of football, a university, a nation – requires rules. Who decides when they have been broken and what they mean? A judge. Who enforces what the judge says? The police. Who makes these rules? The legislators. What decides how they are made? The constitution. And there you have it: a description

of every political system under the Sun. Simplified – but not untruthful. At heart politics is the making or unmaking of laws, laws that govern literally every aspect of our lives, from the shape of sandwich boxes to declarations of war.

Law has been a definitional feature of civilisation since its beginning. But, for better or worse, that is not generally how we think of it. What do you think of when you hear the word 'law'? Perhaps *aurum lex sequitur*, as the Roman poet Propertius said – 'law follows gold.'[14] Aren't lawyers, charging £500 per minute, vampires sucking blood from those with little blood to give? Add to that our culture of litigation – the familiar refrain of 'I will see you in court,' the imposition of life-ruining damages and costs – and it does seem that lawyers have hustled themselves into a position of parasitism. You're in good company if you think so. Four hundred years ago the reclusive English author Robert Burton called his country a 'pursemilking nation' of 'gowned vultures', where 'Our wrangling lawyers are so litigious and busy here on Earth, that I think they will plead their clients' causes hereafter, some of them in hell.'[15]

Insulting and denigrating lawyers is no new phenomenon. Why? One suspects that certain lawyers have simply given law a bad name – and have been doing so for a long time. So we must remember that televisual quippers and loophole scavengers do not represent the real heart of law. Take in their place what a judge called Lord Camden said two and a half centuries ago in the case of *Entick* v *Carrington*. A secretary of state, Lord Halifax, had sent the king's men to break into the house of John Entick, a writer accused of putting out seditious articles. This is what Camden had to say:

> By the laws of England, every invasion of private property, be it ever so minute, is a trespass. No man can set his foot upon my

ground without my licence, but he is liable to an action, though the damage be nothing; which is proved by every declaration in trespass, where the defendant is called upon to answer for bruising the grass and even treading upon the soil.[16]

That is law – not money-bagging, but the defence of a commoner against the right of kings to even 'bruise their grass' without good reason. Our much-maligned leech-lawyers can only come *after* law has already been established, as moths to flame. Law did not always exist; the rights and protections we now enjoy were beyond even the hopefullest dreams of our ancestors. So let us rewind the clock to those epochs whose stories are told on lumps of clay and in shattered bronze. I want you to see 'the law' with fresh eyes, to see how wonderfully inseparable it is from the things we cherish most in our society.

The Code of Ur-nammu is the world's oldest surviving set of laws. Ur-nammu was king of the Sumerian city of Ur, in modern Iraq, in 2100 BCE. Some of his rules are more progressive than we might suppose: 'If a man divorces his first-time wife, he shall pay her one *mina** of silver.'[17] More famous is the Code of Hammurabi, king of Babylon in 1750 BCE. In it we find the oldest statement of a principle called *lex talionis* – whereby perpetrators are punished according to their crime: 'If a man destroy the eye of another man, they shall destroy his eye.'[18] This sort of Mesopotamian jurisprudence may have influenced the laws of the Old Testament. From the Book of Exodus: 'And if any mischief follow, then thou shalt give life for life, eye for eye, tooth for tooth, hand for hand, foot for foot, burning for burning, wound for wound, stripe for stripe.'[19]

* An ancient unit of weight and, later, currency.

Is 'burning for burning' fair? It may have been a necessary principle as humankind struggled to establish order in a world without any. Change is slow. Even Solon, who helped introduce democracy to Athens, when asked whether he had given Athenians the best possible laws, replied, 'The best they would accept.'[20] A statesman called Draco had created the first Athenian constitution. From him we have gained the word 'draconian': when asked why punishment for murderers and thieves was the same, he said, 'thieves deserve death and murderers deserve worse, but I can think of no greater punishment for them.'[21]

Such severity makes us shudder now . . . but why? Because things changed and the meaning of 'justice' evolved. Take the *Corpus Juris Civilis*, a vast code compiled by order of the Byzantine Emperor Justinian in the sixth century CE. In it we find this sort of complicated spiel – rather different from the reciprocal justice of Hammurabi or Draco's ruthless rules: 'An action for triple damages is grounded when a plaintiff makes an overstatement of his claim in the writ of summons, in consequence of which the officers of the court take too large a fee from the defendant.'[22]

Procedure had emerged: a living body of laws and a legal system. In the *Corpus Juris Civilis* Justinian's codifiers also explained that this system was both written and unwritten, drawn from a variety of sources – statutes, plebiscites, imperial decrees, or previous judicial decisions – and based on a set of higher legal and moral principles. Much has happened since then, of course, and in different parts of the world at different times. But the general headline is this: over these past five millennia we dreamed an invisible thing, bubbling up through centuries of blood. What did we dream? The Rule of Law – the idea that we are governed by laws rather than individuals.

What is the alternative? Take this line, spoken by Hermes in *Prometheus Bound*, a play by the ancient tragedian Aeschylus:

Alas? That is the one word Zeus does not recognise.[23]

His meaning is that Zeus, as lord of the gods, is a tyrant who rules arbitrarily and gets whatever he wants with no law to stand in his way – all because he is the most powerful. This has been our real history also, until we placed law above man. Once upon a time there was only power; right and wrong, courts and human rights, did not exist. Imagine a society without laws. What would follow? Chaos or tyranny. Chaos because everybody would do as they pleased – which is *not* freedom, as the seventeenth-century philosopher John Locke put so aptly: 'The end of law is not to abolish or restrain, but to preserve and enlarge freedom . . . where there is no law there is no freedom.'[24] And tyranny because somebody would assume power

Bury Them and Keep Quiet, from *The Disasters of War* by Francisco Goya (1810–20).

and make themselves judge, jury, and executioner. No written codes, procedures, trial, or jury; only the will and whim of the strongest. The rule of law is the *opposite* of chaos or tyranny – and courts, judges, lawyers, and constitutions are its instruments.

We had come so far by the seventeenth century that a judge, a mere man-in-a-wig called Sir Edward Coke, could say to King James I that 'the King hath no prerogative but that which the law of the land allows him.'[25] Unlike Zeus, then, James did recognise the word 'alas' – law had stepped in to bridle the strong. Yes, somehow, things called 'rights' appeared. We all started to agree on the existence of intrinsic, essentially natural rules that set limits on what any government is allowed to do. No small thing, these 'rights' – they are what prevent your rulers from torturing you. With the Geneva Conventions, UN Declarations, and European Conventions, we have built something quite miraculous.

But we must never forget that 'rights' had to be raised, fragile as flowers, from the stony soil of tyranny. And so we must deal with laws reverently: how we make them, what they are, and how they are enforced.

We want good laws, but not endless laws – beware those who drown us in regulation, for as Tacitus said: 'The more corrupt a state, the more laws it has.'[26] And there can be few crimes worse – literally or morally – than law-makers breaking the laws they have made. This rots the vital foundation of trust upon which the rule of law stands. Erasmus wrote well: 'A good prince should punish none more severely than those who are corrupt in their administration of the laws, since the prince himself is the first guardian of the laws.'[27] No less dangerous are the strongmen who put themselves above the law, or those who believe that their cause justifies breaking it. To break just one law, even for a seemingly righteous cause, can launch a

vicious cycle of law-breaking that drags us all into the cesspool. Even those we hate must be treated according to the laws of the land – otherwise, where will *we* turn for protection?

When corrupt legislators drown us in pernicious legislation, when law-makers break their own laws, when strongmen cut them down and revolutionaries tear them up, justice melts and 'the law' becomes whatever the person with the biggest gun says it is. King Charles I was legally correct when he said to his executioners, 'You have no right!' – but there was nobody around to enforce the right he spoke of. A new government simply said, '*We* are the Law,' and chopped off Charles's head. Such a moment, Brennus-like,* eagerly awaits us whenever we lose sight of the rule of law.

A good society needs more than good laws, of course – I would not attempt to convince you otherwise. But recall what Dr King once said: 'It may be true that the law cannot make a man love me, but it can keep him from lynching me.'[28]

Justice . . . it was a dream, once, a dream that conflict might be settled in court rather than blood, a dream that would bridle tyrants, shield the weak, bolster peace, and fan the flames of freedom. No longer will it be the strongest who get what they *want*; all will get what they *deserve*. Justice. People have died for it; people have died for lack of it. Remember, always, that this lies at the heart of politics. We can imagine a society without phones, factories, football, Frenchmen, or Facebook, but we cannot imagine one without law. Why? Because that would be no society at all.

* Brennus was the leader of the Gauls who sacked Rome in 387 BCE and, when receiving his payment of gold from the Romans, threw his iron sword on to the scales – thus extracting more than he had originally asked for – simply because he could.

CHAPTER IV

Concerning Kakistocrats

†

> Let pride be taught by this rebuke,
> How very mean a thing's a Duke;
> From all his ill-got honours flung,
> Turned to that dirt from whence he sprung.
>
> – Jonathan Swift, *A Satirical Elegy*

This chapter is about politics – an obvious choice, possibly the first one that comes to mind when we wonder what forces have shaped our history. And the best place to start is with a rather direct and potentially troubling question: do you live in a democracy? *Demos* means 'people' in ancient Greek and *kratos* means 'power' or, less literally, 'rule'. Putting the two together gives us 'democracy', meaning 'rule by the people'.

That it is Greek tells you where this word was created: in ancient Greece, Athens specifically. But democracy did not emerge in one fell swoop. Rather, a succession of reformers – amid civil wars and tyrants grasping for power – did some reforming over the course of a century or more. First a man called Solon, one of the Seven Sages of Greece, who wrote in the sixth century BCE after his new laws had been enacted:

> To the mass of the people I gave the power they needed,
> Neither degrading them, nor giving them too much rein:
> For those who already possessed great power and wealth
> I saw to it that their interests were not harmed.
> I stood guard with a broad shield before both parties
> And prevented either from triumphing unjustly.[29]

He was followed by other reformers like Peisistratus and Cleisthenes, until by the beginning of the fifth century BCE an entirely new system – democracy – had emerged.

But only 'citizens' could vote, thus excluding women, the foreign-born, and slaves. What sort of democracy is *that*? And yet, in some ways, the Athenians had a purer democracy than we dare dream of. They selected citizens at random to serve on the city council, on juries, as ministers, and as members of the legislature. Suddenly Athenian democracy seems more like rule *by* the people than ours, where every few years we simply choose one particular section of a professional political class to rule over us.*

But this Athenian democracy was a bough cut off; modern democracies grew from a different seed. Polybius, a Greek historian who lived in the second century BCE, will help us here. He lamented that his people had done nothing but fight among themselves. The Romans, in contrast, he admired for their political stability. So Polybius decided to investigate:

* The Athenians also had a curious political process called ostracisation in which the people could exile a fellow citizen for a decade without trial. Voters wrote their chosen exile on shards of pottery called *ostraka* (paper was expensive), hence the name of the process. Its purpose was to use procedure, rather than violence, to prevent any one man from attaining too much power.

> For who is so worthless or indolent as not to wish to know by what means and under what system of polity the Romans in less than fifty-three years have succeeded in subjecting nearly the whole inhabited world to their sole government – a thing unique in history?[30]

He believed the keys to Roman success were reverence for ancestors, religious piety, military discipline,* and – crucially – an ingenious constitution. Polybius thought that the Greek city states suffered from an endless churn of political systems which he called *anacyclosis*. He argued that there were three pure forms of government: monarchy, aristocracy, and democracy. Each had a corrupt form: tyranny, oligarchy, and ochlocracy (mob rule), respectively. The pure form inevitably decayed into its corrupt form before being replaced, whether by coup or collective choice, by another pure form, which itself would soon decay, and so on.

Polybius deduced that the Romans avoided this cycle by creating a mixed constitution. The early years of the Roman Republic had been defined by endless conflict and compromise between patricians (the aristocrats) and plebeians (the commoners). This resulted in a constitution which mixed elements of monarchy (the consuls), aristocracy (the senate), and democracy (the assembly and the tribunes of the plebs) into one large system of checks and balances. It is from this Roman set-up that many modern democracies descend – the American founding fathers drew directly on Polybius' work. America, in its laws and architecture, was supposed to be a new

* Read in Polybius of Roman military practices like 'decimation' and 'running the gauntlet' – both of them now phrases in common parlance.

Roman republic, and who can say it has not succeeded?* Of course, there are other democratic models – constitutional monarchies, semi-presidential republics, parliamentary republics – that emerged separately, and most countries in the world today operate under one of these systems.

So we can talk about different kinds of democracy... but are we missing the point? Perhaps we should ask, 'What's so good about democracy, anyway?' In the twenty-first century to say 'I don't believe in democracy' is heresy – even the most shameless dictators dare not criticise democracy, and inevitably pretend their rule is democratically justified. But why? We must not be afraid to ask what we actually *mean* and *want* when we use the word 'democracy'; is it rule by the people we truly believe in, or something else? Take another illuminative Greek concept: *isocracy*, meaning equal political rights. Might it be this, rather than the right to elect a representative who may not act in our interests, one who loyally follows the party line, a party run by unelected officials and influenced by donations, that we value more? What sort of democracy are we really living in? Perhaps some of the systems below seem more familiar, or are at least mixed in with what we think of as our own version of 'rule by the people':

Democracy	▷	Rule by the people
Ochlocracy	▷	Rule by the mob
Plutocracy	▷	Rule by the wealthy
Bankocracy	▷	When banks have immense power and influence
Tyranny	▷	A single ruler with absolute power, above the law

* In one way or another, that is. We might approvingly quote Tacitus, whose account of a rebellion against Roman rule has a Caledonian leader saying: 'To ravage, to slaughter, to usurp under false titles, they call empire; and where they make a desert, they call it peace.'[31]

Theocracy	▷	Rule by a religious elite
Digitocracy	▷	Rule by digital and technical experts
Algocracy	▷	Rule by algorithms
Bureaucracy	▷	Rule by unelected officials
Particracy	▷	Rule by one or more dominant political parties
Noocracy	▷	Rule by the wise
Kakistocracy	▷	Rule by the worst and least competent

Every political system is a smorgasbord of arrangements. It's hard to name a country that is not at least somewhat plutocratic. And, although it is called one thing, a system may in truth be another – the nations of our world may not be official bureaucracies, but immense power is clearly wielded by unelected spreadsheet-spanglers. And what about algocracy? Much of what we see is seen online, but we do not 'find' it ourselves – it is shown to us by a prejudiced algorithm that influences how we think, behave, and vote. Perhaps you live in a kakistocracy? On that we may agree – a rare thing in politics.

We are drowning in newsroom babblers, incorrigible influencers, and 'concerned citizens' who prey on our instinctive fears and manipulate us into worrying about politics and the state of the world. In the same way that Apple seeks to convince us that we need their newest phone, media mountebanks convince us that we need to fret about 'this' or 'that', even though forty-eight hours ago a locust-plague of leading editorials were feasting on a different soon-to-be-forgotten scandal. We live in an attention economy whereby the more time we spend on a particular website, the more adverts we are shown, and the more revenue they consequently make. Thus algorithms feed us content that is more likely to keep us engaged – and, because of the way our brains function, what keeps us engaged is what makes us angry. Every *ping* is fine-tuned for sensationalism, not truth or joy.

THE SECOND PILLAR OF THE CULTURAL TUTOR

I am not trying to say that political problems aren't real, just that we will never lack people to tell us about them – and that many of these problems are overstated. Instead, my aim is to offer some consolation against the anxiety-inducing news of today, a shield against fearmongers, a scythe to cut down drivel-deliverers, by looking at what has gone before. Below is a selection of historical political difficulties. We may think that the political situation we find ourselves in is unique to our times, perhaps worse than it has ever been – but the truth is that we have seen it all before. This should, alongside giving consolation, encourage us; if we have solved similar problems before, we can surely do so again.

Are your politicians corrupt? It was no better in 349 BCE, at least according to the Athenian statesman Demosthenes:

> Some of them who were poor have become rich ... have provided themselves with private houses more imposing than our public buildings; and the lower the fortunes of the city have fallen, the higher theirs have risen.[32]

Are they insincere? Four hundred years ago the Elizabethan playwright Thomas Dekker described in his splendidly colourful way how most of us feel right now about our politicians:

> You must understand that the Politick Bankrupt is a Harpy that lookes smoothly, a Hyena that enchants subtilly, a Mermaid that sings sweetly, and a Cameleon, that can put himselfe into all colours. Sometimes he's a Puritane, he sweares by nothing but Indeede, or rather does not sweare at all; and wrapping his crafty Serpents body in the cloake of Religion, he does those acts that would become none but a Devil.[33]

What about partisan politics? Both the Brothers Gracchi – Tiberius and Gaius, politicians active in the Roman Republic in the late second century BCE – were murdered by mobs on the streets of Rome because they supported the common people against exploitation by landowners. And, as Plutarch tells us of Tiberius' death, this partisanship was really about personal agendas rather than political principles: '... the combination against him would seem to have arisen from the hatred and anger of the rich rather than from the pretexts which they alleged.'[34]

Do you recognise in your society what Tacitus said about the reign of the emperor Domitian, who ruled Rome from 81 CE until his assassination fifteen years later? It is a lengthy quote, but worth reading in full for the sheer force of Tacitus' condemnation – and how closely it matches what many people feel to be true today, for one reason or another:

> By that fire the voice of the Roman people, the freedom of the Senate and the moral consciousness of the human race were wiped out; even teachers of philosophy and all honourable studies were banished, so that nothing decent might be encountered anywhere. We have indeed left an impressive example of subservience. Just as the Rome of old explored the limits of freedom, so have we plumbed the depths of slavery, robbed by informers even of the interchange of speech. We would have lost our memories as well as our tongues had it been as easy to forget as to be silent.[35]

What about rising jingoism and people thoughtlessly clamouring for war? Read Thucydides and find talk of men and boys at the Athenian harbour drawings maps of Sicily in the dust, planning one imaginary invasion after another. The slaughter of civilians?

THE SECOND PILLAR OF THE CULTURAL TUTOR

Eight hundred years ago a man called Arnaud Amalric was sent by the pope to besiege a French town called Béziers, where several hundred heretics had taken refuge. When the town refused to surrender Amalric said this, thereby sanctioning the massacre of some 20,000, 'Kill them all. God will recognise His own.'[36]

As for incompetence and nepotism – accusations endlessly thrown at contemporary governments – there are no shortage of precedents. Consider the *Méduse*, a French ship travelling to Senegal in 1816. Her captain, who had barely been at sea for the preceding two decades, was appointed because of his loyalty to the new regime in France. During the voyage his floundering got the *Méduse* into serious trouble and the crew and passengers had to abandon ship. Though most of them boarded lifeboats, 147 passengers were put on a hastily constructed raft, to be towed by the captain's lifeboat. But the raft was cut adrift and, amid unspeakable horrors, only fifteen of the 147 survived. Two later wrote an account of their ordeal:

> Those whom death had spared in the disastrous night which we have just described fell upon the dead bodies with which the raft was covered, and cut off pieces, which some instantly devoured... Some ate linen... A sailor attempted to eat excrements, but he could not succeed.[37]

And so let Théodore Géricault's masterpiece – *The Raft of the Medusa*, painted in 1819 and based on the survivors' account – remain an eternal monument to the evils of incompetence and nepotism, which were the direct cause of this tragedy.

Housing policy? Well, rent always goes up and never down. That, at least, is what the chronicler William Harrison heard from the working men of Elizabethan England: 'Lords seek to bring their

The Raft of the Medusa by Théodore Géricault (1819).

poor tenants almost into plain servitude and misery... doubling, trebling, and now and then seven times increasing their fines.'[38]

What is the point of all this? First: to remind ourselves that 'news' and 'truth' aren't always synonyms, that real problems are rarely those fed to us by algorithms, and that the most important matter for any generation is to discern what political problems *really* deserve our attention in the present day. Second: consolation. It may be disheartening to discover that humanity's political problems are chronic, but there is comfort in knowing we have faced – and sometimes overcome – them before.

CHAPTER V

You, Me, and Signor Cremonini

†

> . . . restless thoughts, that like a deadly swarm
> Of Hornets arm'd, no sooner found alone,
> But rush upon me thronging, and present
> Times past, what once I was, and what am now.
>
> – John Milton, *Samson Agonistes*

In 1609 an Italian called Galileo Galilei started to believe a conspiracy theory called heliocentrism. It was created in 1543 by Nicolaus Copernicus, a Polish astronomer who believed that the Earth revolves around the Sun. This conflicted with the established view of the Catholic Church and of all astronomers since antiquity, who held that the Earth was fixed at the centre of the universe. Galileo was undeterred. In 1610 he wrote *The Starry Messenger*, which described his research and seemed to propose a heliocentric model. This made Galileo something of a celebrity intellectual, and his work prompted discussion around Europe. But he was accused of subverting biblical scripture and his critics called for an investigation into these 'Galileists'. In 1613 Galileo wrote a letter to the mathematician Benedetto Castelli, which was then copied and circulated, commenting on the relationship between scripture and science. It was a direct answer to his accusers:

> Though the Scripture cannot err, nevertheless some of its interpreters and expositors can sometimes err in various ways... I do not think it necessary to believe that the same God who has furnished us with senses, language, and intellect would want to bypass their use and give us by other means the information we can obtain with them.[39]

Galileo wanted reconciliation between religion and science. But a copy of his letter was sent to the Inquisition – an organisation set up by the Church to root out heresy – and they launched an investigation. It could have been worse. Cardinal Inquisitor Bellarmine simply told Galileo to stop writing about heliocentrism. And he did... for a decade. But Galileo was emboldened when one of his supporters, Maffeo Barberini,* was elected Pope Urban VIII in 1623.

Galileo told Urban of his plans to defend heliocentrism again; Urban asked him to consider both sides of the argument. Thus the book Galileo wrote took the form of a dialogue between three people: one is neutral, one of them argues for heliocentrism, and the other for geocentrism. By Christmas 1629 it was finished. But when *Dialogue Concerning the Two Great World Systems* was submitted to the authorities it was clear to them which side of the argument Galileo favoured. Who was Salviati, the defender of heliocentrism in the book, if not Galileo himself?

> We have in our age new accidents and observations, and such, that I question not in the least, but if Aristotle were now alive, they would make him change his opinion.[40]

* Also a patron of the great sculptor Gianlorenzo Bernini; see his busts of Barberini for some sense of the cardinal's character.

THE SECOND PILLAR OF THE CULTURAL TUTOR

The defender of geocentrism, whose name translates as 'Simpleton', seems to be based on a philosopher by the name of Cesare Cremonini who had refused to look through Galileo's telescope. This speaker was treated less charitably:

> Therefore Simplicius, come either with arguments and demonstrations of your own, or of Aristotle, and bring us no more Texts and naked authorities, for our disputes are about the Sensible World, and not one of Paper.[41]

The Chief Licenser, a man called Riccardi, was asked by Galileo's supporters to hurry publication; his enemies were working to have the book pre-emptively banned. Galileo's optimism faded: 'The months and the years pass, my life wastes away, and my work is condemned to rot.'[42]

However, after Galileo had revised the preface and conclusion at Riccardi's request, his *Dialogue Concerning the Two Chief World Systems* was finally printed, in 1632. It sold out and reignited debate across Europe. So we can only imagine how Galileo felt when six months later the Pope ordered printing of the *Dialogue* to cease. The Inquisition launched another investigation and Galileo was summoned to the Vatican. At seventy years old he made the journey to Rome, where he was held in custody while appearing before a committee of ten cardinals in a trial that lasted months. Had not Grand Inquisitor Francesco Barberini refused to condemn Galileo his punishment might have been worse. Alas, seven of the ten did condemn him; his book was banned and he was imprisoned. Galileo appeared before the Inquisition one last time, wearing only a white shirt of penitence, and kneeling before them delivered a lengthy statement written for him, condemning his life's work and calling heliocentrism false:

> I, Galileo . . . have been pronounced by the Holy Office to be vehemently suspected of heresy, that is to say, of having held and believed that the Sun is the centre of the world and immovable, and that the Earth is not the centre and moves . . . Therefore, desiring to remove from the minds of your Eminences, and of all faithful Christians, this vehement suspicion, justly conceived against me, with sincere heart and unfeigned faith I abjure, curse, and detest the aforesaid errors and heresies, and generally every other error, heresy, and sect whatsoever contrary to the said Holy Church.[43]

In late 1633 Galileo was released from custody and permitted to live in Arcetri, a Tuscan village, remaining there under house arrest until his death in 1642.

But this is not just 'a set of facts'. There *is* a room filled with powerful men who blow their noses, murmur to one another, and spy on their rivals. Before them kneels a man in a white shirt, a famous old man, frail and bitter. The Inquisition has shown him their 'instruments of torture'. Picture them in front of you – not words but scalpels, nails, and brands, and know that these iron tools will be thrust into your flesh unless you do as told. We must understand that what happened to Galileo was as real as the day you are living now. And he crumbled – who would not? He said what he was told to say even though he did not believe it. What was the tone of his voice? What were the Inquisitors' expressions: smug, triumphant, guilty? Everybody knew he was lying – but that did not matter. The Inquisition had won. And they could have inflicted no greater punishment on Galileo than to extract this lie.

Galileo was just an astronomer who thought his fellow men would rejoice to learn more about God's universe. And what was

his reward? Humiliation. Imagine him – alone, having gone blind, haunted by his denial of what he knew to be true, faced every day by the thought that this truth would remain forever repressed. In his own words, written in 1632, when summoned to Rome for the trial:

> I curse the time devoted to these studies in which I strove and hoped to move away somewhat from the beaten path. I repent having given the world a portion of my writings; I feel inclined to consign what is left to the flames and thus placate at last the inextinguishable hatred of my enemies.[44]

A fragile dream shattered; a fledgling sparrow fallen in the frost!

I am not trying to lionise Galileo, nor to villainise the Catholic Church;* stability is precious and Urban *was* open to gradual change. Besides, there are others who have suffered more than Galileo for challenging authority. But his case is peculiarly interesting because we all now accept without a second thought that the Earth orbits the Sun. Our civilisation is built on these 'second thoughts', all of which were once 'no thoughts' and then 'first thoughts'. So here lies the thrust of the matter: though Galileo has become a hero, he would not have felt like one. Under house arrest in Arcetri, looking over the Tuscan hills, he wrote upon the walls of his bedroom, 'and yet it moves' – an afterword to the recantation delivered during his trial when he was made to say that the Earth is fixed at the centre of the universe.

What solicitude those words demand of us! Galileo did not know that four centuries later he would be worshipped as an icon of science and a model of bravery, that statues of him would be installed in universities across the world to inspire students, while

* Galileo's case is so famous precisely because it represented the worst of the Church's repression of science. Religious heretics were the true enemy of the Inquisition; they were the ones burned at the stake.

Urban and his Inquisition, in their own time all-powerful, would come to be regarded as a stain on the conscience of humanity. *That* is what 'history' looks like. We revere our heroes for having dared challenge authority, but none of us quite understand how hopelessly they died. Truth won, did it not, in the end? For Galileo truth lost. It is only posterity that makes his story a happy one.

But this realisation is also troubling. For if we recognise Galileo as a hero, we must somehow deal with the fact that we may now be condemning others who are doing exactly what he did; we simultaneously praise him for subverting accepted views and punish those who subvert our own accepted views. Had the trial of Galileo occurred in the twenty-first century he would have been called a conspiracy theorist; had we been seventeenth-century Italians, we would have welcomed the arrest of Galileo Galilei.

Our view of history is warped by the fact that Galileo helped create the society we live in, that his views have become our views. Thus we inevitably and mistakenly read ourselves into history as being on the 'right side'. Though you and I might believe we would have joined the minority who voted against the prosecution of Socrates, or been one of the three cardinals who refused to condemn Galileo, in all likelihood we would have been in the majority who sentenced one to death and banned the books of the other. So *why* is Galileo a hero and *why* was the Inquisition villainous? Is it because he defended the truth and they tried to bury it? No. By treating Galileo as the hero *because* he was right, and Urban as the villain *because* he was wrong, we miss the point entirely. It wasn't the accuracy or inaccuracy of Galileo's theory that made his arrest wrong – it was the fact that he was arrested at all. This isn't about whether the Earth revolves around the Sun; it's about how we deal with 'dangerous ideas'.

In 1638 Galileo heard the voice of a visitor, an Englishman

introduced as Signor Milton, who later recalled: 'There it was that I found and visited the famous Galileo, grown old, a prisoner to the Inquisition, for thinking in astronomy otherwise than the Franciscan and Dominican licensers thought.'[45]

This was John Milton, then thirty years of age, a pamphleteer whose epic poem *Paradise Lost* was ahead of him, who would serve in Oliver Cromwell's republican government, like Galileo go blind, and after the fall of the Commonwealth find himself threatened with imprisonment. After meeting Galileo he wrote a critique of pre-publication censorship called *Areopagitica*. It presents a potential solution to this problem we have identified: how to find the Galileos of our own day?

Milton first outlines the danger of censorship in general:

> If it come to inquisitioning again and licensing, and that we are so timorous of ourselves, and so suspicious of all men, as to fear each book and the shaking of every leaf, before we know what the contents are . . . it cannot be guessed what is intended by some but a second tyranny over learning.

Then argues that considering what is wrong helps us to see what is right:

> Good and evil we know in the field of this world grow up together almost inseparably . . . Since therefore the knowledge and survey of vice is in this world so necessary to the constituting of human virtue, and the scanning of error to the confirmation of truth, how can we more safely, and with less danger, scout into the regions of sin and falsity than by reading all manner of tractates and hearing all manner of reason? And this is the benefit which may be had of books promiscuously read.

And, finally, he says we only learn the truth by testing it – not so different from the very scientific method used by Galileo: 'That which purifies us is trial, and trial is by what is contrary.'

How do we distinguish villains from heroes? Time may do it for us. But can we so complacently risk condemning ourselves and future generations to centuries of ignorance? There is a world in which Galileo was never vilified and the Inquisition's verdict corrected the course of history; had one or two things been different, we might still believe the Sun revolves around the Earth. Milton gives us one possible solution to this riddle: let us hear 'dangerous ideas' and not think so little of ourselves that we feel we cannot interrogate them, weigh up the evidence, and decide what is right. Our only alternative is to line up alongside Cesare Cremonini and refuse to look through Galileo's telescope. They say you shouldn't meet your heroes because you will be disappointed; the truth is that we shouldn't meet our heroes because we will vote for their execution.

CHAPTER VI

Napoleon versus Refrigerators

†

Was this the face that launch'd a thousand ships,
And burnt the topless towers of Ilium?

– Kit Marlowe, *Doctor Faustus*

Do you know what happened in 1066? British readers may have some idea. To Americans I could ask the same about 1776, or 1789 to the French, or 1868 to the Japanese. To classicists I ask: what happened in 480 BCE and 476 CE? To one and all I ask: what about 1492, 1914, and 1991?

The year 1066 was when William the Bastard came, saw, and conquered England. 1776 was American Independence, 1789 the French Revolution, and 1868 the Meiji Restoration. In 480 BCE the united Greeks repelled King Xerxes' invasion; in 476 CE the final Western Roman emperor was deposed. In 1492 Columbus arrived in the Americas; in 1914 the First World War started; in 1991 the Soviet Union collapsed. These are not just 'important political events' – they are the events we judge *most important*, the fulcrums upon which we believe the axis of history has tilted. Few of us know many dates by heart. But, if we do, it is revolutions, declarations of independence, wars, and leaders rising to or being dragged from power. This seems reasonable – but there may be other forces at

work, harder to perceive, of which 'major political events' are only consequences.

We talk about globalisation as a political or economic force. But globalisation would be impossible if not for the means to trade and communicate globally. Without shipping containers, for example, there could be no transit on the scale needed for the world to work as it presently does. Think about it: anything you own that has come from abroad was almost certainly brought to your country in a shipping container. The phone in your pocket is assembled from bits mined, designed, and fused together on three or four different continents. So is the shipping container at least equivalent in importance to something like the fall of the Austro-Hungarian Empire? Almost every single building constructed in the last hundred years has been built on foundations of concrete; there would be no Empire State Building, nor any New York, nor any 'modern city' whatsoever without it. But it is always statesmen and politicians who have been labelled the most important figures in the stories of these 'modern cities', even though they would have no cities to speak of if not for all that literally foundational grey stuff.

The name of Columbus is writ large on history, but who would he have been without the compass? And how could he have organised an expedition without letters, paper, ink, quills, and writing itself? These are all necessary preconditions to everything he did. No political policy, however radical or stringent, was ever so revolutionary as the invention of the printing press. Europe's great Protestant Reformation simply did what Gutenberg's machine made possible, perhaps even inevitable. If you work online, then you could not do that work without a computer. We talk about capitalism, communism, and liberalism (rather than shipping containers, printing presses, or servers) as if 'ideologies' are what render things possible

or impossible, but it is machines and technologies – not 'isms' – that allow us to operate in a global world and speak with people on the far side of the Earth. One starts to think that 'politics' is nothing more than a response to whatever revolutionary technology has most recently been invented.

And this may also be true of the people we regard as the movers and shakers of civilisation. Cyrus, Alexander, Caesar, Charlemagne, Saladin, Timur, Abbas, Napoleon: these are the superstars of history, about whom we make films and write books. Meanwhile Cai Lun, Nicolas Appert, and Joseph Aspdin are names that are unlikely to prompt even a scratch of the head. But these people might be more important than any warlord or great ruler. Did Alexander do anything so Earth-shattering as inventing paper, like the Chinese court-craftsman Cai Lun? One cannot even begin to comprehend the total influence of paper. The development of canned food by Nicolas Appert in 1804 might have reshaped the world even more radically than Marx. How many millions has it lifted out of starvation? And, consequently, how much bigger is the world's population? To take it further: the workforces necessary to sustain an industrial economy might have been impossible without food preservation on an equally industrial scale. Forget French Revolutions and Years of 1848; that tin can on your shelf is what created the modern world! Even the First World War might not have happened without this method of food preservation. How else to feed millions of soldiers? So, even as we go blue in the face arguing about Kaiser this and Field Marshal that, we cannot forget how the battalions were sustained in the field. Does that mean that Nicolas Appert is to blame for the First World War? Not exactly. Rather, he helped create a new world wherein it became possible – and politicians then had to deal with the possibilities of this new world. Such is the power of inventors.

But why, if inventors may have done more to shape civilisation than kings and statesmen, do we pay them so little attention? Politics deals in people and the narratives they spin – it's showbiz for the ugly, after all. *People* and *actions* are what make a good story – and we don't just love stories; we need them. But the development of new technologies is less about people and their actions than about abstract concepts and the finer details of material science. Thus the invention of modern concrete, say, is not easily made into an appealing narrative. Or, to put it another way, 'Napoleon' has more of a ring to it than 'refrigeration'. Besides, the consequences of most technologies are slow to reveal themselves, unpredictable, and almost invisible; it is only decades later that we connect the dots and realise just how radically things have changed. Could the inventors of the combustion engine have known that their work would eventually cause mass unemployment for farriers? Returning to concrete, even if the narrative dots could be connected, it would make for lacklustre drama. No Hamletian soliloquys or Jacksparrovian swashbuckling here – only the slow drying of grey slop. More exciting to see Oliver Cromwell storm Parliament! Yet one might fairly argue that concrete has reshaped Britain in profounder ways than Cromwell did. Well, we won't soon be flocking to see Joseph Aspdin fiddling with bags of sand on the silver screen. Some inventors have been celebrated in stories and films – Nikola Tesla, J. Robert Oppenheimer, and Alan Turing – but these exceptions may just prove the rule. All this matters because our instinctive preference for actors in a historical drama over tales of technological development also defines how we understand the rest of our past, present, and future.

There is a disarmingly simple question snarling at the heart of this chapter: why do things happen? Easily asked; difficultly answered – we have a Sphinx, an ancient and indomitable riddler, in the soul of

our civilisation. For although we want to discern why things happen, and keep coming up with reasons why they do, a clear answer refuses to reveal itself. Hence there are a thousand different answers to questions like 'why did the French Revolution happen?' But it is, even if difficult and rarely conclusive, a vital question. The most tempting answer, though the least appealing because it doesn't have the clarity of a single solution, is that all these forces of religion, law, politics, philosophy, economics, and technology – along with geography, biology, and whatnot – have worked together. Two explanations can be true at once. Alexander's conquests were significant – and so was the invention of the phalanx that made them possible. The Yalta Conference, which took place at the close of the Second World War and set the geopolitical stage for decades to come, was a twentieth-century turning point – and so was the invention of the transistor.

I'm not saying that politics and the people who practise it aren't sometimes the prime mover. Materials and technology cannot 'do' anything on their own. Concrete cannot pour itself; computers rely on our input. Much has been said in recent years of 'demagogues' – politicians who tell the public what they want to hear – and a connection has often been made with the internet. Thus some say technology is to blame for the fractured politics of our age. Well, cold comfort, there was demagoguery long before social media. Proof enough is the word itself – again, an ancient Greek word. Hyperbolus was exiled from Athens in 415 BCE *because* he was a demagogue. Fake news, too, precedes the internet – the enemies of Erasmus subtly altered his books and his letters and printed them in his name. That was in the 1520s. So politics seems to be with us, and in much the same form, whatever technologies we do or do not possess. After all, Genghis Khan got on well enough without aircraft carriers.

So an easy answer eludes us – those Sphinx-eyes glitter in the darkness and promise the prize of understanding if only we are wise enough to discern it. Single causes are rarely to be found; we must be sceptical of those who say they have found one. It is hardly compelling to answer a question with 'There are many reasons . . .', but we would be foolish to ignore the truth because it isn't as simple as we'd like. Conqueror or machine, each has their role in the unfurling and ever-unpredictable drama of history. All I propose is that the next time you open a refrigerator, consider for a moment that this innocuous machine might have done more to change our world than Napoleon and all his wars.

CHAPTER VII

Why is the World Going Grey?

†

And dropping bitter tears against a brow
Striped with dark blood: for all his face was white
And colourless, and like the withered moon
Smote by the fresh beam of the springing east

– Lord Tennyson, *Le Morte d'Arthur*

The world is always changing, but why? So far in this pillar we have talked about mythology, philosophy, law, individuals, politics, and technology – some of the forces that have driven the wheels of history. Now let's look at a specific change and see if any of these are to blame – or thank – for it. Can we defeat the Sphinx and solve the riddle? I give you a proposition: the world is going grey.

Statistics bear out what you may already feel to be true – that the world is less colourful than it was. Three quarters of cars produced globally are painted in greyscale, up from one third fifty years ago. The British paint manufacturer Dulux reports that some shade of grey (such as Polished Pebble, White Mist, or Chic Shadow) has been its bestselling paint for a decade. Neutral colours are currently regarded as the go-to for furniture and interior design, and the industry standard for every new building is that its interior be painted exclusively in white and its carpets grey. Look at any photo

from the twentieth century and you will see what a world of colour we have (for good or bad) left behind. 'Dark and gritty' has become the motto of modern televisual entertainment; contrast Technicolor historical epics of the 1960s, saturated and shimmering, with the grimy historical films of today. Marvel is now recognisable by its washed-out colour grading; the yellow highlights on Batman's suit are gone; even Superman's red and blue have been replaced by a sort of slate grey.

The world is also becoming less detailed. Once, the average house had real wooden floorboards rippling with grain. Wallpaper, tablecloths, and upholstery were patterned with gladioli, peony, and bluebell. In the past we decorated everything, be it table-feet, doorhandles, or cutlery – no longer. This is also true digitally. Microsoft's former default font, Times New Roman, was replaced by Calibri, and Calibri has now been supplanted by Aptos. Thus serifs have melted and the written word itself has

literally become less detailed. Corporate logos have also been simplified and graphic design is now dominated by simple geometry and textureless blocks.

A study by the Science Museum Group sheds sparkling light on this. They analysed 7,000 objects created over the last two hundred years – phones, clocks, fans, cigarette cases, pens, typewriters, televisions, radios, books, DVD cases – and produced a two-century timeline of the colour and shape of these objects. Their conclusion was clear: the things in our world have become overwhelmingly greyer, less detailed, and more box-shaped. To be precise: less than 10 per cent of the colours of objects produced in the year 1800 were greyscale, and in 2020 that percentage has risen to 70 per cent. We are living in the age of minimalist design, colourless and unornamented: furniture is rectangles composed of rectangles and crockery is smooth white. This is also true of architecture. Compare any 1990s McDonald's with one built recently, and in that contrast the change our physical world has undergone proclaims itself most loudly.

Judgement of minimalism I leave to you; I only ask you to consider the clear fact that the world *is* slowly going grey, and to wonder, 'Why?' Here are some possible reasons.

1. Economics

Capitalist consumerism is simple: get as much as you can for as little as possible. The inevitable result is blandness. Why waste resources adding cornices to ceilings? All 'decoration' incurs financial, material, and temporal costs. The colossally influential Viennese architect Adolf Loos recognised this over a hundred years ago, saying: 'Ornament means squandered manpower and

thus squandered health. It has always been so. But today it also means squandered material and both together mean squandered capital.'[46]

Counterintuitive as it seems, capitalism may actually prohibit us from designing things as carefully as medieval weavers or Victorian cutlers. Loos also said, quite rightly: 'Every era is thrifty in its way. The eighteenth century spent a great deal on food and saved a lot on cleanliness. It is a stinking century. You can even smell it in its furniture.'[47] We certainly spend more on cleanliness than the rotters of the eighteenth century; it is in decoration and colour that we have become thrifty. Our economic priorities are set – the world is grey and plain because we are not willing to pay for colour and form.

Besides, to appeal to the widest possible market a cupboard must be neutral and without personality; that way nobody can object to it. But the sum of all tastes is no taste. The question 'what if *they* don't like it?' may well have killed design, such that any designer who now sticks their head above the parapet will be minced by the system. William Morris noticed this happening one hundred and fifty years ago. It has, presumably, since only got worse:

> You may call him an artist if you will . . . but a capitalist will be apt to call him a 'troublesome fellow,' a radical of radicals, and, in fact, he will be troublesome – mere grit and friction in the wheels of the money-grinding machine.[48]

2. Globalisation and Standardisation

In the past we were separated by distances not easily bridged. Now we communicate instantaneously. People have 'meetings' with

colleagues on four continents. Everything being so interconnected, trends spread faster. And, crucially, our global web means that we use the same tools. Concrete is one example. Software is another. How many people use Microsoft Word? Nearly one and a half billion; Microsoft holds 90 per cent of the word-processing market share. And is Word a *neutral* processor? No. It encourages us to do certain things and limits us in doing others; there are only so many fonts or templates. Word also corrects our writing and 'suggests' improvements. So, with all of us using a single processor, our documents end up looking the same. This principle also applies to design software. Is it really surprising that graphic designers, all using the same non-neutral tools and working in an instantaneously interconnected design environment, end up with similar results?

Tech			Fashion		
Revolut	»	Revolut	BALENCIAGA	»	BALENCIAGA
facebook	»	FACEBOOK	BURBERRY	»	BURBERRY LONDON ENGLAND
Google	»	Google	Yves Saint Laurent	»	SAINT LAURENT
Microsoft	»	Microsoft	Berluti	»	BERLUTI
airbnb	»	airbnb	BALMAIN PARIS	»	BALMAIN PARIS
Spotify	»	Spotify	RIMOWA	»	RIMOWA
Pinterest	»	Pinterest	DVF DIANE VON FURSTENBERG	»	DIANE VON FURSTENBERG
ebay	»	ebay			

velvetshark.com

And, regarding the design of physical objects, we need only mention that there is more regulation now than at any point in history. This is a blessing inasmuch as it makes the world safer, but

it also flattens differences and suffocates variation. Many of those wondrous objects we see in museums it would now be illegal to manufacture; blandness is unwittingly enforced by law.

3. Technology

In the past we made things from oak, elm, chestnut, spruce, terracotta, mother of pearl, goatskin, bronze, lapis lazuli, copper, limestone, ironstone, granite, marble, porphyry, flax, and silk; now we make most things from plastic or steel. The Science Museum Group attributed particular importance, in the greying of our world, to this change in materials. One need only compare the warm tones of a nineteenth-century telegraph machine – from russet and amber through milky white and dusky pink – to the cold colours of an iPhone to understand the significance of material. And notice, most amazingly of all, that there are also literally fewer colours on an iPhone than a telegraph machine.

The colours of natural materials are infinite in their depth and variation and cannot be re-created synthetically. Thus, whatever designers hope to design and whatever consumers dream of consuming, if we are bound by plastic and aluminium it is physically

impossible for the world to be as colourful or textured as it was. Look around you, in your home and on the street, and consider what materials you see. How much of what you see around you is synthetic? No chrome doorhandle can possess the rich colours and deep texture of even a battered iron bolt.

For some idea of what we are missing and to provide a fuller picture of how radically the material of our world has changed, you need only read the passage from *De Architectura* – an architectural treatise written 2,000 years ago by Vitruvius – where he describes how different paint pigments were produced: royal purple from the shells of Murex snails off the coast of Tyre; pauper's purple from bilberry mixed with milk; indigo from Selinusian chalk dyed with woad; yellow ochre from Athenian silver mines. That kaleidoscope has been replaced by plastic paints concocted in a laboratory.

We live in an age of mass manufacture. Whenever we humans make anything by hand we decorate it, meaning that those things are covered in details of one sort or another... but machines make everything now, and with machines we design them. The natural role of decoration has therefore been voided. Loos, again, noticed this: 'As ornament is no longer organically connected with our culture, ornament is no longer an expression of our culture.'[49]

In short: old materials and old methods have steadily been eliminated to the extent that our 'enlightened' world has unavoidably condemned itself to standardised colourlessness and synthetic texturelessness.

4. Psychology

This meme, sent to me by a friend several years ago, captures rather well the condition of modern humankind.

We are overloaded with information. That is not a casual observation; it is literally true, and studies have confirmed it – to nobody's surprise. Never before in history has the average human been fed so much 'content', as we euphemistically call it. Thus, overfilled with data, we crave simplicity. For a brain terrorised by emails, messages, memes, videos, articles, headlines, images, and adverts, the colourless and undetailed design of our architecture and furniture is a relief. It has nothing to say and asks nothing of us. Perhaps we do not want less colour; perhaps we simply need it. The above meme (all irony here duly noted) is quite right to describe our information exposure as a '24/7 onslaught'; slaughter it is, pummelling our brains into pixellated mush haunted by howls of digital nonsense. Jackson Pollock was a troubled man and he dealt with his troubles by painting; his art has become a mirror of the modern

mind. Many might find a plain white surface desirable after such violent fusillades of colour. Maybe we cannot be blamed for finding comfort in blandness.

5. Nature

We take inspiration from our surroundings. And, once, humankind was surrounded by nature. Greek vase-painters drew vines on their pots and medieval carpenters carved clovers of the field on their benches – because these were the forms they knew. As William Morris wrote: 'Pray do not forget, that any one who cuts down a tree wantonly or carelessly, especially in a great town or its suburbs, need make no pretence of caring about art.'[50]

But our cities have now grown so large you could go a lifetime without seeing so much as a dandelion. We could no longer write like the ancient poet Theocritus once did, for we no longer know even the names of flowers:

> . . . a fountain he espied,
> And rushes growing green about its side.
> There rose the sea-blue swallow-wort, and there
> The pale-hued maidenhair, with parsley green
> And vagrant marsh-flowers.[51]

The digital world has sucked us into yet another dimension. We pass all our waking hours in it, permanently looking at anything *other* than flowers or clouds. So, blind to the endless variation of nature's colours and decorations, we lack the capacity to design things of colour or detail. The sharp geometry of the metropolis and the blankness of the internet are all we have for our inspiration. Little wonder, if our surroundings are grey and colourless, that our design

is in keeping. Consumers have also been afflicted by this, because we cannot ask designers to create something we do not know we lack. The more we are surrounded by minimalism, the less we are aware of anything else – and therefore, perhaps, we cannot create a demand for it either.

6. Fashion

Critics and commentators peddle theories because that is how they make a living, selling you the latest 'big idea' about why the most recently happening 'thing' is, in fact, happening. But perhaps they are just making these things up . . . perhaps! The other theories forwarded here about hidden systems, the ripples of technology, or our broken communion with nature – are they all claptrap?

See, our world was maximalist – meaning the opposite of minimalist – until quite recently. Most domestic interiors were awash with colour and texture until the 1990s. Think, for example, of the colours of the 1970s, which were so garishly bright that we wonder now how anybody ever lived with them. So, after a maximalist century, it surely makes sense that the pendulum of fashion has swung the other way. This has happened before. Renaissance architects took pride in the fact that their buildings were so much *simpler* than the Gothic excess of those they replaced. Then came the wild fripperies of the Baroque, itself supplanted by the simplicity of Neoclassical architecture. We waxed bored of this too, and gargoyles made a flying comeback in the age of nineteenth-century maximalism, when even sewage plants were decorated with wrought-iron fleurs-de-lis.

Humanity is unable to put up with anything for long and soon trips headlong towards its opposite. As Lucretius sang:

> And there is nothing that exists so great or marvellous
> That over time mankind does not admire it less and less.[52]

Perhaps our minimalist age is simply a lurch of fashion, a response to the maximalist age out of which we have only recently emerged. Perhaps, regardless of consumerism and our psychological response to it, we will soon grow bored of colourless boxes and start playing with colour and form again.

The world is going grey. Can we figure out why? Does any '-ology' give us an answer? A challenge, Herculean if ever a challenge was, to work it out, to discern *why* anything ever happens at all. There are innumerable forces at work in this universe of ours, half of them invisible and half of those seen still misunderstood. The wheels of the world roll on and many hands vie to crank the handle. I leave you to decide which have been the most important in our past – and to wonder which should be most important in our future.

The Third Pillar of
The Cultural Tutor

The Language of the World

CHAPTER I

Why Doesn't Ron Weasley Live in a Minimalist Mansion?

†

And 'mid the storm that dies and swells
By fits—in hummings softly steals
The music of the village bells,
Ringing round their merry peals.

— John Clare, *December*

Would the Harry Potter films be different if the Weasleys lived in a minimalist mansion, all glass and chrome, rather than a tottering barn-house? We might ask the same question of Snow White's seven dwarves and their cottage in the woods, or of Luke Skywalker's Tatooine farmstead. *Of course* it would make a difference. Then we have our villains' gloomy lairs. One suspects that Sauron would be less threatening if his burning eye, rather than glaring down from an iron tower, peeked out from the windows of a fisherman's bungalow. Equally, the Malfoys would surely seem less snotty if their baronial manor was an ivy-clad parsonage instead. Obviously! But why are *buildings* so integral to these cinematic worlds?

It is with this question that we begin our investigation of architecture. This chapter will lay down a few foundations. Those that

follow will explain some different kinds of architecture and address its deeper nature. I hope you will see, while reading this pillar, why architecture matters so much, why it deserves more attention than you might have previously given it, and how much bigger the world becomes when you know a thing or two about the buildings around you.

Back to our question. First: it would not make sense for the Weasleys to live in a Bauhaus villa because they could not afford to. This is the 'canonical' reason, I suppose. And so we learn about the Weasleys simply through the building they live in: they are relatively poor, generations of their family have lived here, and their tastes are old-fashioned. Crucially, we grasp all this both unconsciously and instantaneously. Or take the elves in *The Lord of the Rings*. Without knowing anything else about them, the architecture of Rivendell – elegant and inspired by the flowing forms of flowers – tells us, at one glance, that this is a highly sophisticated culture. In short: buildings tell the story of the people who live in them.

But there is more to this than world-building. I quote Aristotle, substituting 'cinema' for his original 'drama', because what he said of one is true of the other:

> [Cinema], then, is a representation of an action that is worth serious attention . . . in language enriched by a variety of artistic devices . . . by means of pity and fear bringing about the purgation of such emotions.[1]

Everything film-makers do, whether dialogue or colour grading or set design, is intended to make us feel a particular emotion and think a particular thing. The Shire is where *The Lord of the*

Rings begins; we are supposed to feel, like Frodo, at peace before a perilous quest, and so it must be tranquil, charming, and safe. How to make us feel that way? Architecture. The Hobbits live in cottages with colourful round doors, connected by quaint stone bridges and cobbled paths. Even if everything else remained – the flute music, the costumes, the dialogue – but this setting was replaced with, say, the stagnant cesspools and soot-stained bricks of a Victorian slum, the 'Shire' would not feel so homely. The emotions we experience on seeing it would be different. Minas Tirith and its glittering marble emanates grandeur; the jagged obsidian tower of Isengard oozes evil. Why architecture gives rise to these instinctive impressions is for much the same reason that a meadow is more comforting than a barren hillside – fundamental laws of nature are at work.

So buildings are important to cinema because they influence our emotions, convey identity, and reveal history. But this is only true of architecture in films because it is also true of architecture in real life. That may sound brutally obvious, but it is a fact we forget far too frequently – a fact we always have in mind when designing fictional worlds, but which seems to have been forgotten when designing real buildings. Would you rather live in a house with windows or one without? It doesn't matter which you prefer or why – it only matters that there *is* a difference. Because, if there is, we must admit that architecture has the power to affect us, and that directing this power – choosing what effect the things we have no choice but to build will have on us – is of immense importance.

'Very well,' you might say, 'but what *is* architecture?' The eternal mark of human civilisation is buildings – for where there are

buildings we also find religion, government, commerce, and entertainment. One can imagine a civilisation without AirPods or cars; one cannot imagine a civilisation without architecture. We *need* houses, schools, roads, temples, sewers, bridges, and train stations. Truly, for the rest of time, be there any huddle of *Homo sapiens* upon the face of this planet or any other, there will always be architecture. I quote Le Corbusier (who we shall get to know very well) for the first time: 'Architecture is one of the most urgent needs of man, for the house has always been the indispensable and first tool that he has forged for himself.'[2]

So architecture is not merely 'designing buildings' – it is the art of building the world we must live in. From this realisation five further conclusions reveal themselves.

1. Architecture is the chronicle of civilisation. It tells how a society worked and what its people believed in. The might of the Pharaohs is obvious from the sheer scale of their tombs, the Pyramids. The rise of democracy tracks the construction of parliaments bigger than palaces. Whereas people once laboured in the fields, we now do desk jobs, hence the size of our office buildings; we have moved from an agricultural to a bureaucratic society. Consumers are more important than rulers now; we build factories, warehouses, and malls instead of royal tombs and castles. Entertainment means more than religion; we build stadiums rather than temples. If humans want something they will build it, and so whatever architecture people leave behind reveals who they really were – buildings say far more about a given people than whatever they said or wrote about themselves. Just as actions reveal a person's deepest nature, architecture is the window to the soul of any society.

2. Architecture is the most intrusive and impactful form of art.* You might not read the same novels I read, nor listen to the same music, but we are born into this world and have to live and work somewhere – in buildings. Architecture is unique because it *imposes* itself on us. And so, architects of the present or future, should you be reading these words, let John Ruskin remind you of the extraordinary opportunity you have been given – and remind us all of the standards to which we must hold our architecture:

> We frequently are led, by wise people, to consider what responsibility may sometimes attach to words, which yet, the chance is, will be heard by few, and forgotten as soon as heard. But none of *your* words will be heard by few, and none will be forgotten, for five or six hundred years, if you build well.[3]

3. Architecture operates in the background. Art it may be, but architecture is not art in the same way as literature, music, or cinema. I have said – and will say until my dying breath – that architecture has the power to influence how we feel, think, and behave. But an architect cannot make us cry like a playwright can; architecture lacks the clarity and directness of a play, book, or film. These are things we read and watch. Not so with architecture; it is simply *there*, invisibly but interminably present at every moment of our lives, influencing us in subtle and endless ways.†

* And so architects, unique among artists, are *always* working in service of others. Even when designing their own house other people still have to live near, walk past, and look at it.
† One may look at a building, of course, for hours – even months – and enjoy and learn a lot. The best architecture always rewards such attention.

4. Architecture is fundamentally collaborative; an architect cannot build alone. Whatever they design will only become a real thing once engineers, bricklayers, carpenters, plasterers, plumbers, electricians, scaffolders, and decorators have done their noble work – and regulators have done their regulating.

5. Architecture is the most stubborn form of culture. Look around you: these buildings are five years, five decades, five centuries, even a thousand years old. The words we use and the ways we live have changed, even our morality and our gods have changed – the buildings remain. Were a fifteenth-century Northumbrian transported to 2025, they would not recognise smart phones, universal suffrage, or data scientists, but place them before Durham Cathedral and (even notwithstanding its several renovations) they would say, 'I know this.'

We may now state six qualities of architecture.* It is:

 i. Powerful
 ii. Necessary
 iii. Imposing
 iv. Background
 v. Collaborative
 vi. Enduring

Does the nature of architecture tell us anything about how it should look? The colossally important ancient Roman architect Vitruvius (more on him shortly) believed every building must have *utilitas*, *firmitas*, and *venustas* – usefulness, strength, and beauty.

* This is not an exhaustive or definitive list by any means. Rather, it is intended to draw out architecture's deeper nature and point out some things you may not have noticed or considered before.

His ideas are summarised well by Andrea Palladio, another highly influential architect who lived in the sixteenth century: 'For one could not describe as perfect a building which was useful, but only briefly, or one which was inconvenient for a long time, or, being both durable and useful, was not beautiful.'[4]

Convincing, no? But three other words might come to mind when we think about how buildings should look. In 1896, in an article entitled 'The Tall Office Building Artistically Considered',* an American architect called Louis Sullivan wrote:

Form ever follows function.[5]

'Ever' elided, this mantra – form follows function – has been adopted as the slogan for any design that prioritises usefulness over appearance, and for the belief that aesthetics are a bonus but not a necessity. But this is not what 'form follows function' means. Sullivan meant that a thing's appearance should be guided by what that thing is supposed to do, *not* that its appearance is irrelevant. Put simply: different types of building have different aesthetic requirements. A rather different proposition!†

In that article he was writing, specifically, about skyscrapers, which first emerged in the late nineteenth century. Initial efforts to design them might charitably be described as confused; they looked like stacks of smaller buildings. Sullivan realised that the chief quality of a skyscraper was its 'loftiness', that *this* was the function

* One hardly anybody has ever read – if they had, they wouldn't quote it so often!
† Sullivan's mantra was by his own admission known in ancient times. Leon Battista Alberti, an artist and architect of the Early Renaissance, said as much over four centuries earlier: 'And the Use of Edifices being various, it was necessary to enquire whether one and the same Kind of Design was fit for all Sorts of Buildings . . . I therefore began to examine . . . what sort of Beauty was proper to each Edifice.'[6]

to which its form must be adapted. So he emphasised his skyscrapers' vertical elements over the horizontal.*

But we can pursue this further. In 1929 Hugh Ferriss, a visionary draughtsman who helped shape the skyline of New York, published a book called *The Metropolis of Tomorrow*. In it he wrote:

> ... architectural forms necessarily have other values than the utilitarian or even others than those which we vaguely call the aesthetic. Without any doubt, these same forms quite specifically influence both the emotional and the mental life of the onlooker. Designers have generally come to realize the importance of the principle stated by the late Louis Sullivan, 'Form follows Function.' The axiom is not weakened by the further realization that Effect follows Form.[7]

Ferriss's point is that, because architecture can and does influence how we feel, the way it makes us feel is therefore part of its function. What Ferriss believed has since been confirmed by serious study and investigation: we human beings are observably happier, sadder, relaxed, nervous, more creative, or less productive (amid a thousand other emotions and behaviours) depending on how the buildings around us have been designed and how they look. 'Effect follows form' is surely a noble and useful way of thinking, one we ignore at our peril.

We cannot say that people are owed great art, but we can say that people are owed great architecture. Why? Because the stakes with architecture are terribly high – its contrasting capacities for blessing or hurting our lives are both monumental. And so, although I do

* And notice, of course, that 'form ever follows function' did not prevent Sullivan from adding swathes of decorative terracotta to his buildings.

believe we must welcome strange and novel buildings, on the whole we might agree with what William Morris said of architecture a century and a half ago:

> It will not be an esoteric mystery shared by a little band of superior beings; it will be no more hierarchical than the art of past times was, but like it will be a gift of the people to the people, a thing which everybody can understand, and every one surround with love, it will be a part of every life, and a hindrance to none.[8]

CHAPTER II

Cor magis tibi sena pandit

†

'Go up, Urshanabi, onto the wall of Uruk and walk around.
Examine its foundation, inspect its brickwork thoroughly –
Is not even the core of the wall of kiln-fired brick,
And did not the Seven Sages themselves lay out its plan?'

– from *The Epic of Gilgamesh*[9]

Once upon a time all cities looked different. That is why, if you walk the streets of any old town, you can tell where in the world you are simply by looking at its buildings. Now the situation has reversed. A litany of variation has become a sea of monotony, where identical box-shaped buildings and glass towers dominate every city in every nation in every corner of the Earth. This evolution is the subject of our enquiry: why and how did it happen? To answer such a startling question we must return to the dawn of human civilisation.

What was the first thing humankind ever built? Imagination, used judiciously, may let us hazard a guess. Picture yourself as some prehistoric human among jungle, mountain, or plain. It is raining, and you need shelter. You must *build*. And so, if you are in the jungle,

you gather branches, lean them against each other, and cover them with broad leaves. Crude, perhaps, but it works, and there is dignity in that. What if you find yourself in the woodless mountains? Rocks. You stack them. Draughty within, but dry. Well, neither timber nor stone is to be found on the plain. What to do? The human who first plunged their hands into the bluish sludge of the river bank and brought forth clay could not have imagined what a revolution they were instigating. Moulded, left to bake in the Sun, and blue has turned red: bricks.

Each of our ancient builders was trying to solve the same problem, but depending on where they were they had to use different materials and therefore solve that problem in a different way. This is how humanity has built for most of history, and it has a name: vernacular architecture. This is not a 'style' but a way of building – the way that defines all those old towns we find so charming. It has three underlying principles: limitation, tradition, and necessity.

First, limitation. In the past we could only build with whatever we could find: bamboo, slate, flint, limestone, sandstone, granite, marble, mud, clay, reeds, peat, turf, oak, pine, cedar – even ice. These resources are not evenly distributed around the world and the result was natural variety in regional architectures; old towns look different to each other partly because they were built with different materials. And this material limitation did not disappear until relatively recently. Even as the peoples of the world began to mix and trade, it was still not easy to get things from abroad. Why else did seventeenth-century Londoners *rent* pineapples to show off at dinner parties? We can take it straight from the horse's mouth – this particular horse being William Harrison, who wrote a description of Tudor England in the 1570s, and among other things observed:

The ancient manors and houses of our gentlemen are yet and for the most part of strong timber . . . Those of the nobility are likewise wrought with brick and hard stone, as provision may best be made.[10]

Six words: 'as provision may best be made'. Even in sixteenth-century England architecture remained limited by the availability of materials. Given stone, Tudor masons could throw up King's College Chapel, but stone was expensive so they largely built with wood or brick. These material limits reveal themselves even in the smallest of details. Look at the south door of Verona Cathedral in Italy, created by a mason called Pelegrinus in the early twelfth century. Notice that the columns on the upper tier are different sizes and also different kinds of stone; the lower columns are also slightly different sizes.

Such inconsistency is unthinkable now, but it was thinkable then because Pelegrinus simply had to make do with whatever marble columns he could get hold of.

The global consequence of 'as provision may best be made' was thatched cottages in Lincolnshire in the UK, slate cottages in Snowdonia, mudbrick towers in Wadi Dawan, adobe mosques in the Sahel, marble temples in Ionia, tufa bridges along the Adige, reed houses in the Hawizeh Marsh, stave churches in Scandinavia, walls of red sandstone at Skara Brae, and whitewashed villas in the hills of Castile.

Second, tradition. Despite what I have just said, certain materials *are* very common. One finds reeds all over the world, and so we find thatched roofs in Britain, Iraq, Cambodia, and Korea. Why, then, do they look different? A less globalised world inevitably finds more divergent solutions; even something as simple as joining two blocks of wood can be done a thousand ways. In the twenty-first century what is discovered in Taiwan can be shared in Texas that same day. But once upon a time a particular way of doing something tended to remain where it emerged. And we must remember that these were not professional architects or engineers in the modern sense, with 'official qualifications' and suchlike. The solutions they found, whether for weaving reeds, moulding bricks, carving lintels, or buttressing walls, were learned 'on the job' and passed from master to apprentice. What one generation learned or preferred in their methods or decoration was passed down to the next, and therefore highly localised methods and decorations emerged. Religious and cultural traditions also informed these local construction practices: tilemakers of Isfahan patterned their tiles differently to those of Delft; Christians of Krasnodar painted their icons differently to how Hindus of Tiruchirappalli engraved their gods.

Third, necessity. People in different parts of the world were usually trying to solve slightly different problems. In deepest Russia it was cold, but in deepest Mexico it was hot – their buildings had to deal with these challenges. Take the steeply gabled roofs of German and Scandinavian houses. Why so steep? To prevent snow from building up. The courtyards of Morocco, loggias of Italy, and high ceilings of Spain were designed to mitigate the heat of their climate. Thus the shape and design of these old buildings were always a direct response to what people needed from them.

Variation flows naturally from all these forces, these three principles, taken together. A wealth of regional idiosyncrasies is the obvious consequence. Local materials, local ways of using them, and local needs. This is the matrix that meant no two communities built in the same way – each had its own architectural language, its own 'vernacular'. You can see how this produced a sense of identity. It gave the world texture; all was different and interesting and idiosyncratic. This is why tourists flock to old towns. It is in narrow Siena streets, in the squares of Isfahan, and in the temple gardens of Kyoto, that we find what seems to be the real Italy, Iran, or Japan. Vernacular creates a more diverse world, and a world with stronger ties of belonging and heritage. History and culture seem to live in those flowery balconets, blue-tiled *iwans*, and timber-shadowed footpaths.

But we must remember that thatched roofs (to give one example of a typical, charming bit of vernacular) were not designed to be charming; function was their purpose. We had to stop rain coming in and warmth flowing out; those thatched roofs are the grand achievement of a hundred generations' trial and error trying to solve this problem, of a hundred generations' gathering and weaving of marsh-reeds. I do not mean that these people were not aware of or

did not care about beauty, only that thatched roofs were, above all else, practical.*

Back to the question of why variety has faded into monotony. We still build according to those practical principles that guided vernacular architecture; the difference is that what is 'available, local, and necessary' has changed. Plastic and concrete are ubiquitous and readily available; we can import steel from China and cement from Vietnam. So these are the materials we now use, because they are cheap and appropriate for the job at hand. We also have schools of architecture and faculties of engineering; we have systematised 'methods' and 'best practices' on an international scale and we are regulated, quite literally, down to the nails. Globalisation means standardisation – and the homogenisation of architecture.†

But the discussion does not end there. 'Vernacular' is important not only because it helps us understand the past and the present – it may also have something to do with our future. There is a lot we could learn from the vernacular as we endeavour to solve the problems of modern urban design. We are miserable in our grey and identical cities; communities are shattering; there's no 'there' there. The character, charm, and identity of vernacular offer a solution. What about the environment? Vernacular architecture is sustainable

* What thatcher would not have thought their thatching a splendid sight? What joiner would not have sensed a shadow of divinity in their thrusting eaves? These are as close to objective beauty as you can find, for they draw directly on the beauty of nature. And that is the very reason for some of the trouble with our modern-day architecture. We have timber, clay, marble, and reeds in nature – but where does one find plastic or steel among the hills and forests? Even iron is deeply natural. I would have written at length about this, but to do so would merely have been an inferior restatement of John Ruskin's *The Work of Iron*.

† Hence we have reached the paradoxical situation whereby illiterate medieval workmen could design more charming buildings than we with our nuclear power, World Wide Web, and advanced design software. Unlucky!

not only because of its materials – wood versus concrete, reeds versus plastic – but also because it adapts to local climate rather than relying on power-gobbling radiators and cooling devices. And, you realise as you wander through any old town, vernacular architecture has human scale. It was built for people whose technology had not yet allowed them to travel in an hour by car a distance that would once have taken two days by foot. We walk around these old towns feeling strangely happy – we *walk*! These towns were designed for humans, not cars. Vernacular architecture brings with it a wealth of other sociocultural and economic advantages for ordinary people; traditionalists, progressives, conservatives, and socialists, whatever their differences, overlap here if nowhere else.

Let us leave this chapter, metaphorically, via the Porta Camollia in Siena, Italy, an old stone gate on which is written *Cor magis tibi sena pandit* – 'to you Siena opens her heart'. Is this not the truth of vernacular architecture? It is a triumph of love! Knotted beams, worn slab-lintels, and weathered bricks that bear the impression of the honest work of humankind raising ourselves up from the balefulness of an unsheltered world – and even creating beauty thereby.

CHAPTER III

Order and Freedom

†

> Nothing the best of artists can conceive
> but lies, potential, in a block of stone,
> superfluous matter round it. The hand alone
> can free it that has intelligence for guide.
>
> – Michelangelo, *Sonnet XV*

Let's talk about architectural 'styles'. What is a style? When somebody consciously chooses to build in a particular way. So a style is defined by rules, motifs, and principles. Plenty of books about architecture are filled with talk of styles, and knowing about them is helpful inasmuch as it helps us talk more precisely about buildings. But knowing them does not mean we *understand* architecture, because architecture is not just a list of rules or the simple matter of outward appearance. 'Styles' can only take us so far – there is always something deeper to be investigated.

But it will be useful, I think, to cast our eyes over the two 'styles' we hear mentioned most often: Gothic and Classical. This should help you make better sense of other works about architecture and, more importantly, it should help you realise what *you* think and feel about the buildings around you.

Classical architecture

A Greek invention! By the fifth century BCE the Greek way of building – partly inherited from the Egyptians, Mesopotamians, and Mycenaeans – had developed into a sophisticated, codified, self-conscious style. It was fundamentally *trabeated*. This means its basic unit was the 'post and lintel', two pillars supporting a beam. Like so:

To this ancient template, which originated in wooden rather than stone buildings, much was added. The posts became columns and the lintels became entablatures, and above them was set a pediment. These elements taken together form an 'order'.

The Greeks developed three orders: Doric, Ionic, and Corinthian. To these the Romans later added Tuscan (or Etruscan) and Composite. Here are all five arranged by complexity:

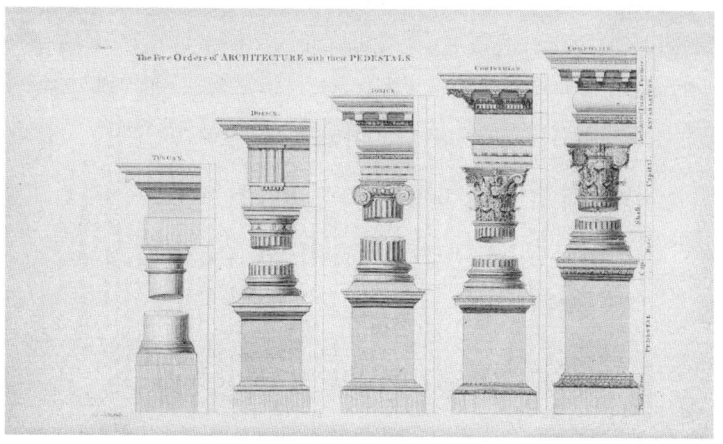

Tuscan, Doric, Ionic, Corinthian, Composite orders.

Now for the P-word... *proportion*. The Greeks thought that proportion was the heart of beauty, and so their architecture had a system in which each element was precisely proportionate to every other. Vitruvius said this was drawn from the human body; each part of our body is, indeed, proportionate to every other. Hence Leonardo's drawing of the *Vitruvian Man*. True or not, the point is this: proportion reigns supreme in Classical architecture. Vitruvius wrote unflinchingly: 'There is nothing to which an architect should devote more thought than to the exact proportions of his building with reference to a certain part selected as the standard.'[11]

Proportion was applied to everything, including the distances between columns – intercolumniation – which meant that the thickness of the columns was increased according to the increasing distance between them. Yes, these Greeks crafted a fabulously subtle system, whittling columns down even by fiftieths where necessary:

> ... columns at the corners should be made thicker than the others by a fiftieth of their own diameter, because they are sharply

outlined by the unobstructed air round them, and seem to the beholder more slender than they are. Hence, we must counteract the ocular deception by an adjustment of proportions.[12]

Little wonder Greek temples 'just look right', as we say, trying to find words for a phenomenon we cannot see but only sense. Such is the magic of proportion, relying on the strange truth that in this universe certain arrangements of form are naturally pleasing to us.

Each order also had strict rules for decoration. There was some variety, even experimentation, but on the whole Greek decoration did not stray from these rules. Consider with what specificity Vitruvius describes an Ionic capital – a capital being the part at the very top of a column:

> The faces of the volutes must recede from the edge of the abacus inwards by one and a half eighteenths of that same amount. Then, the height of the capital is to be divided into nine and a half parts, and down along the abacus on the four sides of the volutes, down along the fillet at the edge of the abacus, lines called 'catheti' are to be let fall. Then, of the nine and a half parts let one and a half be reserved for the height of the abacus, and let the other eight be used for the volutes.[13]

Thus we observe another critical fact about classical architecture: it is standardised. Hence Leon Battista Alberti (a revolutionary fifteenth-century architect) stated, innocently but tellingly, that those who carved the decorations for buildings were mere servants, inferior to the master designer with his great mind: 'For it is not a Carpenter or a Joiner that I thus rank with the greatest Masters . . . the manual Operator being no more than an Instrument to the Architect.'[14]

What about the Romans? Their architecture was influenced by the Etruscans, an ancient civilisation that dominated Italy before them. But it was, above all, in thrall to the Greeks. Even though the Romans introduced the rounded arch, they kept it subservient to the post and lintel. Wherever we find a Roman arch we also find, around it, pilasters and entablatures. Rarely did Romans depart from those Greek rules of proportion and decoration.

The arch was important, however, as it did enable the Romans to build on a greater scale than the Greeks ever could. It also meant that Roman buildings looked somewhat different; with the arch, particularly in their viaducts and great bridges, they produced a distinctively Roman version of Classical architecture.

Much of what we know about Greco-Roman architecture we know through that man I have been liberally quoting: Vitruvius. He was an architect and military engineer who worked for Julius Caesar and later wrote a treatise for Augustus entitled *De Architectura*. This is the only surviving architectural treatise from the ancient world. Read this, if nothing else, to grasp what 'Classical architecture' is all about.*

In 1414 the manuscript hunter Poggio Bracciolini found a copy of *De Architectura* in the library of a Swiss monastery and, on publishing it, triggered an architectural revolution. When Classical architecture was revived in fifteenth-century Italy its adherents read Vitruvius with scrupulous reverence. They also wrote their own treatises, partly based on Vitruvius and partly on their own investigations of Roman ruins. An illustration from Andrea Palladio's *Four Books on Architecture* (published in 1570) illustrates

* Vitruvius is also a humble, friendly, and unwittingly eccentric chap who goes off on frequent, entertaining tangents about astronomy, meteorology, and poetry; *De Architectura* is a shockingly enjoyable read.

the complexity (verging on pedantry?) of Classical architecture. He explains the exact proportions of every element annotated here:

But the Renaissance revival of Roman architecture did not fully adhere to all its rules. Rather, Renaissance builders borrowed the language of Classical architecture – as architectural historian John Summerson so famously put it – and with it wrote new sentences. This was followed in the late sixteenth century by an even more liberal and extravagant interpretation: the Baroque. Then, in the eighteenth century, dawned the new age of Neoclassicism,* with architects designing buildings that the Greeks and Romans themselves might conceivably have built. Picture the British Museum in London or La Madeleine in Paris; these are Greco-Roman temples in all but name.

Classical architecture, first with the Greeks, then with Hellenistic empires, then Rome, spread across Europe, North Africa, and the Middle East – you would have found exactly the same sorts of buildings in Libya, Britain, Bulgaria, and Jordan. What happened to it?

* All architecture inspired by Greece and Rome is technically Neoclassical, but the revival of the eighteenth century adhered to it more stridently, and is therefore capitalised to make the distinction.

In the Eastern Empire it developed into a wholly new style, the Byzantine, and in Western Europe the Classical melted away after the fall of Rome. From its ruins a new style emerged: Carolingian, so called because it emerged under Charlemagne, King of the Franks in the ninth century. From this sprang Romanesque architecture (called Norman in Britain because it was the Normans who brought it there). Both Carolingian and Romanesque borrowed the round Roman arch. But there was a key difference: it was liberated from post and lintel. In Carolingian and Romanesque design the arch stands alone, not boxed in by pilasters and entablatures. This is *arcuated* rather than *trabeated* architecture. Like so:

Gothic architecture

Something else was stirring. There may have been influence from the Norsemen; there was a clear influence from the Byzantines; there was undoubtable influence from the Middle East. The pointed arch arrived in Europe, stronger and more adaptable than the rounded arch. Thus, in the twelfth century, Gothic architecture* was born – and within a hundred years it had conquered the continent.

* This name was invented by Renaissance scholars to disparage the 'ignorant' architecture of the Middle Ages, 'Gothic' referring to the Goths who sacked Rome.

Wells Cathedral, Somerset.

But Gothic architecture is not defined by the pointed arch alone. Recall that Classical architecture has consciously imposed rules; Gothic architecture has no such 'rules'. Whereas you can read the treatises of Vitruvius, Alberti, or Palladio and come away with a 'correct' understanding of Classical architecture, there is no guidebook to Gothic. Gothic was organic, prone to evolution, and infinitely varied. So while the unfathomably influential sixteenth-century Classical architect Andrea Palladio could aver, 'I have not been accustomed to allow to the length of Halls lesse than twice their breadth, or twice and ¼',[15] no Gothic master cleaved so slavishly to proportion: naves, aisles, clerestories, towers, and chapter houses could be all manner of length, breadth, or height. Nor did Gothic builders have any problem with asymmetry – a sickening prospect for Vitruvius! This explains why the appearance of every single Gothic building is different. And

recall what Alberti wrote about operatives being instruments of the architect. Nothing could be further from the truth in Gothic architecture. Look at any medieval cathedral: it is decorated – capitals, misericords, choir screens, spandrels, jamb-figures, and gargoyles – with an uncategorisable variety of forms. The masons were allowed to follow their own creative inclinations, and therefore the decoration of every single Gothic building is also different.

The Parthenon in Athens, because of the standardisation of classical rules, can be held up as an example of perfect Classical architecture. No such exemplar is possible with Gothic; any given cathedral can only represent the perfection of a particular *species*. And we cannot say a sparrow is more perfect than a swallow, can we? This is why Ruskin said, with such conviction:

> . . . let the whole system of the orders and their proportions be cast out and trampled down as the most vain, barbarous, and paltry deception that was ever stamped on human prejudice . . . if it be good work, it is not a copy, nor anything done by rule, but a freshly and divinely imagined thing. Five orders! There is not a side chapel in any Gothic cathedral but it has fifty orders.[16]

Gothic architecture evolved as the centuries wore on: towers grew taller, windows larger, piers thinner, stonework more elaborate. But its underlying principles – principles that were not codified, but by which its builders lived – remained the same. Nobody has explained them better than Ruskin:

1. **Savageness**: individual masons were allowed to make their own decorations, regardless of their relative skill.
2. **Changefulness**: the empowerment of individual masons and lack of standardised rules led to endless variation.

3. **Naturalism**: inspiration was taken directly from nature rather than from established decorative rules.
4. **Grotesqueness**: the wild imagination of the Middle Ages that produced gargoyles and similar decorative features.
5. **Rigidity**: the pointed arch led to verticality; all thrusts upwards.
6. **Generosity**: every surface is covered in decoration: sculpture, mosaic, painting, stained glass.

So the Gothic was a ceaselessly adapting style – and it therefore resists simple classification. This explains why William Morris wrote the following; it is a lengthy quote, but one that summarises the Gothic for us perfectly:

> The cant of the beauty of simplicity (i.e., bareness and barrenness) did not afflict it; it was not ashamed of redundancy of material, or super-abundance of ornament, any more than nature is. Slim elegance it could produce, or sturdy solidity, as its moods went. Material was not its master, but its servant: marble was not necessary to its beauty; stone would do, or brick, or timber. In default of carving it would set together cubes of glass or whatsoever was shining and fair-hued, and cover every portion of its interiors with a fairy coat of splendour; or would mould mere plaster into intricacy of work scarce to be followed, but never wearying the eyes with its delicacy and expressiveness of line. Smoothness it loves, the utmost finish that the hand can give; but if material or skill fail, the rougher work shall so be wrought that it also shall please us with its inventive suggestion. For the iron rule of the classical period, the acknowledged slavery of every one but the great man, was gone, and freedom had taken its place; but harmonious freedom.[17]

This Age of Gothic was extinguished by the Renaissance; Gothic architecture lacked the rationalising rigour of the Classical and was accordingly deemed barbarous. I do not say Alberti and his ilk were correct; but it *is* true that Gothic and Classical are very different ways of building. Still, the medieval way had its own renaissance: the nineteenth-century Gothic Revival, when architects tried admirably to revive those principles expounded by Ruskin, and Gothic train stations, banks, and parliaments suddenly rose from the colonnades of four centuries' Classical dominance.

And there, for now, we take a breath. Much has been left untouched; there has been no space, woefully, for Mughal, Safavid, Song, Armenian, Maya, Edo, Sudano-Sahelian, or Dravidian architecture. I only mention what I have not mentioned to remind us that Gothic and Classical are but two of many architectures – something often forgotten, wilfully or otherwise. In any case, I hope that what I have written will mean that, the next time you see or read about Classical or Gothic, they will have some clear context and make more sense. Of both styles I have endeavoured to give you their heart: classical is order, Gothic is freedom.

CHAPTER IV

On the Origins of Barnacles

†

After a battle of thirty years I have emerged the victor:
I have liberated humanity from superfluous ornamentation.

– Adolf Loos, *Nevertheless*

All that talk of Classical and Gothic might seem irrelevant now – because our ways of building have changed. So a new question arises: where did modern architecture come from?

The nineteenth century is in full swing. This is the age of revivalism: neo-Gothic, Neoclassical, neo-Byzantine, neo-Moorish, neo-Baroque, neo-Renaissance, neo-Romanesque.* From Delhi to Detroit, Paris to Prague, and Moscow to Montevideo, buildings inspired by the past are rising. Some are faithful to former times. Some take liberties. Some smash together old styles into chimeras. Take the world-famous Neuschwanstein Castle in southern Germany as the supreme example of Revivalism. This is not a medieval fortress – it was built in the 1870s for the mad but tender

* The prefix 'neo', by the way, essentially means 'revived' – thus, if a building is 'neo-Gothic', that means it was built in a time after the original days of Gothic had passed. An ancient Roman building is simply Classical; a twentieth-century building in the same style is Neoclassical.

King Ludwig of Bavaria as a piece of architectural fan fiction to the Middle Ages. Put briefly, nineteenth-century architecture is in thrall to history.

But the world is changing. Industrial revolutions. Democratic revolutions. Populations soaring. Cities growing. Trains. Electricity. Cars. Globalisation. Like a snake struggling to shed its skin, human civilisation is transmuting... time to shed the skin of old architecture also? A certain Swiss architect called Le Corbusier wrote later, as the age of Revivalism was on the cusp of collapsing:

> We are dealing with an urgent problem of our epoch, nay more, with *the* problem of our epoch. The balance of society comes down to a question of building. We conclude with these justifiable alternatives: *Architecture or Revolution*.[18]

The first revolt against Revivalism was a movement called Art Nouveau. Translated from the French it means 'new art' – and that's exactly what it was: a fresh approach to all art and design. It started in

Belgium in the 1890s* and soon conquered the world. Subgenres emerged in different countries – the *Jugendstil* in Germany, the *Stile Liberty* in Italy – but they were united by certain core principles, and all spoke to a continental desire for something *new*. Think of it, above all, as a revolt against convention. A convention is something you do because that is the way it has always been done, regardless of what you might think or feel about it. So, unlike Revivalism, Art Nouveau sought novel forms and methods. Aesthetically, it was defined by flowing curves, sinuous shapes, and asymmetry; everything is twisting, twirling, and intertwining like fronds of bougainvillea. You need only look at a few Art Nouveau balconies, doorways, or windows and you will see this. Art Nouveau might have been grounded in certain traditional principles, but these designs were not conventional. They were freshly inspired, authentic, confident, and loving: the signs of a living school of art.

Maison Saint-Cyr, Brussels.

* It was heavily influenced by the British Arts & Crafts Movement, which had started earlier and placed particular emphasis on reviving the motifs and practices of medieval design. There had also been the rise of Impressionism in France, and other nascent forms of modern art. So Art Nouveau was part of a much broader artistic awakening.

So this was an era of languid luxury, flower-shaped furniture, and stained-glass lampshades. But not for long. An event horizon loomed, the Big Bang of our modernity: the First World War. After 1918 nothing was the same again – a generation betrayed by their society had no reason to believe anything it had taught them. Religion, literature, architecture . . . all was tainted, all was up for grabs. Still, in the end, most people were optimistic. The world had crawled through unspeakable hell and survived. Yes, we had just about managed this catabasis.* Economic recovery, radical ideas, new inventions: radio, cinema, even talk of nuclear power. Thrilling! And yet there was a heedlessness to this age of optimism. The Roaring Twenties they were, a reckless ignorance of futurity, an ultimate *carpe diem* in which part of that generation, like Antony awaiting the coming Octavian, seemed to say: 'Let's mock the midnight bell.'

The spirit of an era is always intimately connected with its architecture, and the curious psychology of that interwar age was expressed in a single style: Art Deco.† This was something like a second act to Art Nouveau, another movement of decorative decadence, rich design, and sumptuous materials. But gone were the curves: Art Deco was defined by straight lines and bold, machinery-inspired shapes, somehow still intimidating and futuristic even now. Here, for the first time, America led. Think of the Empire State and Chrysler buildings, the 'cathedrals of commerce' in Chicago and New York, and you will have an immediate grasp of what Art Deco was all about.

But. Even when those Belgians were getting hot under the collar

* A delightfully precise word that refers to a downward movement or descent; for example, a journey through the underworld.
† Its name comes from an exhibition held in Paris in 1925, the Exposition internationale des arts décoratifs et industriels modernes.

with their fabulous iron grilles, another revolution was taking place in Vienna. Enter Adolf Loos. In 1910 this witty and peculiarly bitter man delivered a lecture called 'Ornament and Crime', in which he set down his life's thesis:

> I have reached the following conclusion which I give to the world: the evolution of culture is equivalent to the removal of ornamentation from utilitarian objects.[19]

This did not only go against the grain – it fundamentally disagreed with what everybody, for centuries, had thought architecture was. Loos believed that buildings should be functional, i.e. robust and convenient, and nothing more. In 1910 he designed the Steiner Haus in Vienna. It is hard to believe that this building is a century old, but it is only so familiar because it was a prophecy of everything that would soon follow. Little wonder Loos suffered opprobrium in Vienna for his aggressively simple, totally unornamented, whitewashed design.*

* Loos, instead, and quite admirably, believed in the beauty of pure material: 'Bear in mind that noble material and good work do not merely compensate for a lack of ornament but are far superior to it in terms of exquisiteness . . . A fine material is a miracle of God.'[20]

The very distaste for blind worship of the past that had given Art Nouveau its life was taken to its logical extreme by Loos. A man out of time? Maybe. But his work was popular with a group of radical architects who came together in Germany at a design school called Bauhaus, founded in 1919. The Bauhaus creed was simple: find a style, not only for architecture but for all design, to suit the materials (concrete, steel, plastic) and methods (mass manufacture) of the industrial world. These Bauhaus artists received relatively little attention at first, perhaps because, as Le Corbusier wrote:

> The right state of mind does not exist. The state of mind for mass-production of houses, the state of mind for living in mass-production houses, the state of mind for conceiving mass-production houses. Everything must be begun from the beginning, nothing is ready.[21]

But sociopolitical and economic forces were drawing the world into that age of mass production – and Bauhaus was waiting in the wings. Their campus, designed by founder Walter Gropius in 1926, is a physical manifesto for how this mass-produced world would look. Like Loos's Steiner Haus, it seems utterly normal to us because of the vast influence it has had; we cannot grasp how radical it was at the time.

Associated with the Bauhaus was a Swiss architect called Charles-Édouard Jeanneret, better known by his pseudonym Le Corbusier. His book *Vers une Architecture*, published in 1923, has become the bible of modern architecture. It is a querulous treatise, part poetry, part polemic, and filled with gnomic mantras – quite unlike that of voluble Vitruvius. There is also much forward thinking in it: Le Corbusier noticed, for example, that people continued to build with thick walls and small windows, as they had done for centuries, even when reinforced concrete and plate glass rendered this unnecessary. Like Loos,

he held up the fruits of industrialism – grain silos and ocean liners – as examples of what architecture could become if freed from the shackles of the past. But Le Corbusier went further. He was an apostle of industrialism and advocated for an absolute standardism whereby we would all live in identical cities and identical houses. You will not be surprised to learn his opinion of Art Deco: 'The desire to decorate everything about one is a false spirit and an abominable small perversion. The religion of beautiful materials is in its final death agony.'[22]

How did these radicals conquer the world? In 1933 the Nazis shut down Bauhaus and its architects fled, taking their ideas with them. Then came the Second World War. How to rebuild a destroyed world and house the Earth's booming population? Bauhaus and Le Corbusier had a solution: using concrete and steel, functional and unornamented, we could build quickly, cheaply, and at scale. This form of postwar Modernism – now much maligned – came to be known as the 'International Style' because of its prevalence around the world. But we must remember that not everybody in the past lived in charming cottages or Baroque townhouses. Consider the photograph on the facing page, taken in the Netherlands in the 1930s. This is the sort of thing modern architecture 'replaced' – truly, modern architecture is what gave the world a roof over its head.*

But even if Bauhaus and Le Corbusier had found a way to build cheaply and on a large scale, that doesn't explain why we stopped

* Every movement goes through an awkward and dangerous phase about one generation after its decline; it reaches the point where it is not new, and therefore not exciting, but also not old and therefore worthy of preservation. In the period between the 1950s and the 1970s revivalist architecture fell into this category and Victorian Britain was half demolished in the rising tide of Modernism. In the US it was buildings like the old Penn Station that were subjected to wrecking balls. We are now doing the same to 1960s architecture – Brutalism is being wiped off the face of the Earth. In all cases this is tragedy. No building should be demolished any more than a book should ever be burned.

building *anything at all* in the styles of old. Why couldn't there also be a Gothic university, a Neoclassical parliament, or a Byzantine train station mixed in with the glass towers? Well, six decades ago people were living in the detritus of a maximalist age – and so the minimalism of the International Style was exciting. Its plain surfaces seemed futuristic in comparison with florid Victorian terracotta. My point is that the rise of modern architecture was not only an economic necessity, as some suggest – it was very much a conscious aesthetic choice as well.

In 1984 King Charles III, then Prince of Wales, called Peter Ahrends' proposed extension to the National Gallery in London 'a monstrous carbuncle'.* Three years later he said the Luftwaffe had done less damage to London than Modernist architects. I won't comment on his opinions, but it must be admitted that in some sense he had a point: a total architectural revolution *had* taken place. We need only compare a handful of skyscrapers built before and after the Second World War to see this.

* I always misremember the quote as barnacle. And, like all *mondegreens*, I prefer my misremembrance.

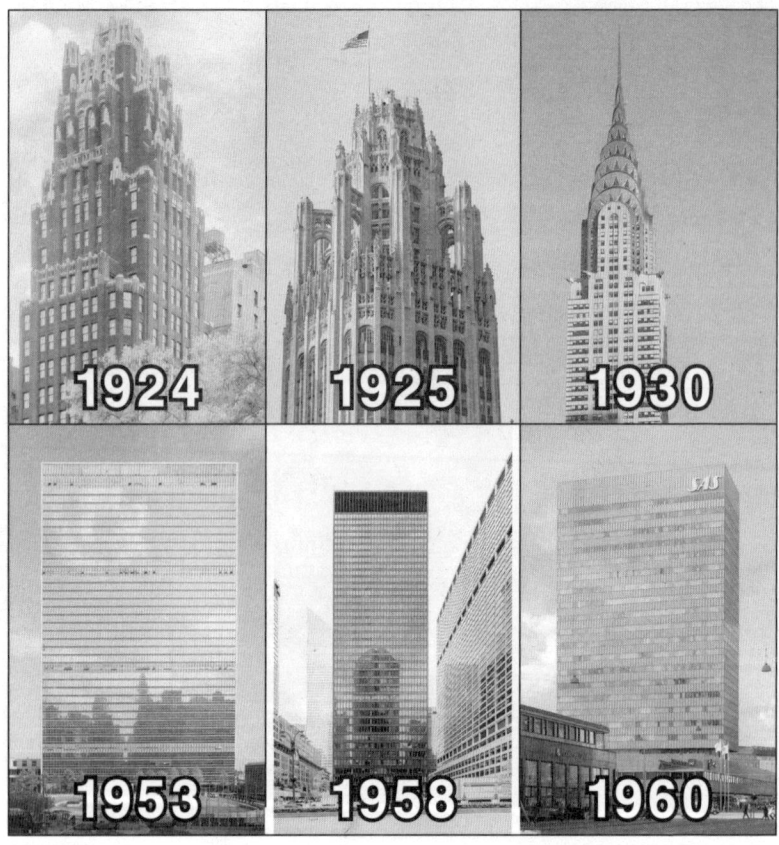

Whatever architecture had been, it was no longer. As Le Corbusier wrote:

> If we set ourselves against the past, we are forced to the conclusion that the old architectural code, with its mass of rules and regulations evolved during four thousand years, is no longer of any interest; it no longer concerns us: all the values have been revised; there has been revolution in the conception of what Architecture is.[23]

THE THIRD PILLAR OF THE CULTURAL TUTOR

The chickens of Loos finally came home to roost. Revivalism, Art Nouveau, Art Deco, and a hundred more styles were suddenly swept away. I will not survey the subgenres that have emerged since the 1950s – Brutalism,* Postmodernism, Deconstructivism, and so on – because the headline in the twenty-first century is simple and clear: functionalism reigns. Loos's once radical belief that decoration is unnecessary has now become the accepted view, consciously and unconsciously, of architects and designers. Whether that is for good or for bad I leave you to decide; I only hope to have explained where our modern architecture came from, that we may understand it better and judge it truly.

* How I would love to redeem true Brutalism from its condemnation and convince you, Shocked Reader, that it is the greatest architecture our postwar world has ever produced!

CHAPTER V

Je sais quoi

✝

And the twelve gates were twelve pearls: every several gate was of one pearl: and the street of the city was pure gold, as it were transparent glass.

– from the Book of Revelation

A single building is one thing – a collection of buildings, arranged into a town or city, is another. How do we put all those buildings together in the best possible way? This is architecture also, and this is our subject now: urban design.

It may seem like a non sequitur, but I ask you to read these words of a Frenchman called Jules Ferry:

> We weep with our eyes full of tears for the old Paris, the Paris of Voltaire, of Desmoulins, the Paris of 1830 and 1848, when we see the grand and intolerable new buildings, the costly confusion, the triumphant vulgarity, the awful materialism, that we are going to pass on to our descendants.[24]

When do you think this was written? Recently, after some unpopular work of gaudy Modernism? Not so. It was written over a century ago. So what are these 'intolerable new buildings' that have been passed on to us? Isn't Paris the world's most beloved city?

Statistically, at least, that is true – Paris is the world's number one tourist destination. And there has surely never been a city where so many millions long to live, whose streets we dream of calling our own.

But is there anybody who does *not* want to live in a beautiful city?* The purpose of urban design is, I believe, to create these beautiful cities. Where to begin? We could talk about Hippodamus of Miletus, who laid out Piraeus in a grid in the fifth century BCE, establishing a Greco-Roman model that would last one thousand years. And what of Dinocrates, who designed Alexandria for Ptolemy, heir to Alexander in Egypt, whose plan endures to this day? There was also the famous round city of Baghdad, laid out with radiating boulevards by the planners of the Abbasid Caliph al-Mansur. But we return to and begin with Paris. For although I revere whatever magic is left in the world, we must dispense with any Parisian wizardry lingering in our hearts. There is no *je ne sais quoi* to Paris, nor Venice, nor Kyoto, nor New York. A beautiful city is a thing that *can* be built, not only dreamed, if we pay attention to how these places were made.

Paris, 1853. Napoleon III is emperor. He has a grand ambition: 'Let us apply our efforts to embellishing this great city. Let us open new streets, make the working class quarters, which lack air and light, more healthy, and let the beneficial sunlight within our walls.'[25]

Why? Paris, for centuries one of Europe's foremost cities, had become overcrowded, filthy, and plagued. It was this Paris and the plight of its citizens that inspired Victor Hugo's *Les Misérables*: 'So long as there shall exist, by reason of law and custom, a social

* I don't mean 'beautiful' in the narrow sense of aesthetically pleasing but in the broader sense of a city that is well run, healthy, prosperous, safe, and joyous.

condemnation, which, in the face of civilization, artificially creating hells on earth . . . books like this cannot be useless.'²⁶

Napoleon sought to change this. So he appointed as 'Prefect of the Seine' a visionary engineer and designer called Georges-Eugène Haussmann – and charged him with the renovation of Paris. The project began in 1853, and although nearly complete twenty years later, it would not be finished until after the First World War. Haussmann (who had been given immense power) annexed the suburbs around Paris, increasing the number of arrondissements from twelve to twenty, and the city's population from 400,000 to 1.5 million. Twenty thousand buildings were demolished and replaced by more than 30,000 new ones. Hundreds of streets, mostly medieval, were destroyed. The older streets had been as little as five metres wide; the new boulevards were at least twelve and in some places twenty-four metres wide. Sewers, aqueducts, and street lighting were installed. Major architectural works were commissioned, among them the Paris Opéra, the Gare du Nord, and the Church of St Augustine. Parks inspired by those of London were established: Bois de Boulogne in the west, Bois de Vincennes in the east, Parc de Buttes-Chaumont in the north, and Parc Montsouris in the south. Over the course of seventeen years 600,000 trees were planted. Haussmann also enacted strict rules for the apartments that would line his boulevards: height and width limitations, specific designs, and a stipulation that they must be made from Lutetian limestone. Each building was supposed to feel like part of a broader, cohesive whole – hence the peculiar 'oneness' of Paris.

So, over several decades of expenditure and construction – much to the chagrin of Napoleon's political opponents, who were so vociferous he was forced to sack Haussmann, and to the annoyance of Parisians disturbed by daily digging – the Paris of today was

consciously created, brick by beam and sewer by stone. There was no magic. Haussmann had a plan, declared *'Je sais quoi!'*, and Napoleon gave him the money and authority. A beautiful city emerged and the world fell in love with it – what Monsieur Ferry said about 'awful materialism' has, in the century since, become preposterous.

Things were much the same in nineteenth-century Barcelona. There, too, a medieval city had been transformed during the Industrial Revolution into a capital of squalor: 200,000 people squeezed into just 2 square kilometres, for since 1714 any construction within half a mile of the walls – the range of cannon fire – had been forbidden. Eventually the city council permitted the demolition of the medieval walls and announced a project to expand the city: the Eixample. Enter Ildefons Cerdà, a civil engineer obsessed by urban planning who had quit his job to perform topographical studies of Barcelona. This was, it seems, the right man at the right time. In his monumental *General Theory of Urbanisation*, Cerdà wrote that new technology had made a new kind of city both possible and necessary:

> I realised that the applications of steam power for travel had signalled the end of an era for humanity and the beginning of another . . . We are in the throes of a true transition – a period that may vary in its duration, depending on the characteristics of the struggle that is underway between the past with its traditions, the present with its interests, and the future with its noble aspirations and new beginnings.[27]

Cerdà's proposed plan for Barcelona – including its famous square blocks with their corners cut away, called *mansanas*, which allowed turning room and visibility – despite machinations which saw it rejected, accepted, and then modified, was put into motion. A blueprint shows how far-reaching it was: everything in black represents

medieval Barcelona and its surrounding villages as they stood in 1855; everything else would be newly built.

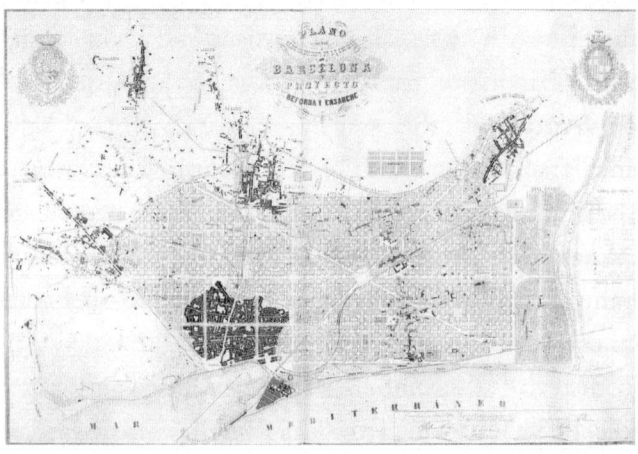

A further flashpoint came when Barcelona was chosen to host the 1888 Universal Exposition. In preparation, the old citadel was demolished and replaced with the Parc de la Ciutadella, and a great many buildings which survive to this day were built, including the redbrick Arc de Triomf, designed by Josep Vilaseca i Casanovas. What had started with the Eixample, a bold urban renewal project, was morphing into something more. Suddenly, Barcelona and Catalunya had an architectural style all of their own, rather drily called 'Catalan Modernism', which was in some sense a sub-genre of Art Nouveau. Spurred by a burgeoning sense of regional identity, a crop of architects – Antoni Gaudí, Lluís Domènech i Montaner, and Josep Puig i Cadafalch foremost among them – rose to the challenge of designing this new Barcelona. Gaudí's work – Sagrada Família, Casa Batlló, La Pedrera – may be the most famous, but they represent a small portion of the wildly idiosyncratic architecture that filled Catalunya in the decades after the Universal Exposition.

Barcelona had come a long way from the cramped medieval city of five decades earlier; the Renaixença, or Catalan renaissance, blossomed in the wake of Cerdà's visionary plan. He had prepared his city for the future and, even incidentally, through the many who followed in his footsteps, given it the thing that all cities dream of: an identity. Architects, urban planners, engineers, artists, politicians, city councillors–they knocked their heads together and *built* something. The Catalan generations of Cerdà and Gaudí, of the Eixample and Renaixença, inculcated a creed of architectural, civic, artistic, and urban values that continue to define much-loved Barcelona. This, and the story of Paris, should give us hope: it *can* happen!

Of course, not all attempts to design cities from the top down have worked; the utopian tower blocks of the twentieth century are hardly praised as 'ideal' these days. In the 1920s Le Corbusier proposed a new design for Paris, the *Ville Radieuse*: sixty identical, colossal skyscrapers. It did not happen, but his urban theories were put into global practice after the Second World War, hence our ubiquitous highrises and highways. We are rightly critical of these modern cities, but – in their defence – they may have been a logical outcome. For most of history we walked or used horses, which limited the size of cities. The invention of trains then allowed them to grow larger, and what started with the train reached its apotheosis with the car – personal transport machines travelling twenty miles in twenty minutes let cities become colossal.

We must also remember the squalor of places like Paris and Barcelona in the nineteenth century. People, understandably, wanted a way out of that – and suburbia seemed like a solution. Hence William Morris wrote this in 1892: 'I want every homestead to be clean, orderly, and tidy; a lovely house surrounded by acres and acres of garden. On the other hand, I want the town to be clean,

orderly, and tidy; in short, a garden with beautiful houses in it.'[28] This was inspired by the same situation faced by Haussmann and Cerdà; London in Morris's day was another hive of scum and villainy. Even as the beautiful buildings of St Pancras and Whitehall went up, tens of thousands wallowed in despair. The work of social campaigner George Godwin, a precise and compassionate man, gives you some idea of Victorian London's destitution:

> . . . thousands of families live, if it may so be called, in underground rooms in various parts of the metropolis. In many instances there is no other place except the cellar for the reception of the dust and other refuse, which are often allowed to remain for many weeks before they are removed. In these subterranean apartments, too, cesspools or badly appointed water-closets are often to be found. Many cellars are deeper than the neighbouring drain. In some instances the drain is broken and the sewage leaks into the place.[29]

This, and a picture taken by photojournalist Jacob Riis of New York in the 1890s, shows us what we must bear in mind when we condemn the urban design of the twentieth century – *that* was the oppression out of which millions were raised by concrete highrises. They may not be pretty, but (as stated in a previous chapter, and important to restate here) they did not wholly replace Baroque palaces or quaint cottages; it was abject misery they replaced. Judged by the basic criterion of providing decent housing for the people at large, it would be wrong to call Modernist urban design anything other than a success. And yet, aesthetically, those projects have been a failure – dreams of concrete and cars, of suburbia and highrises, have become nightmares.

We must also recognise that not all 'beautiful' cities are the

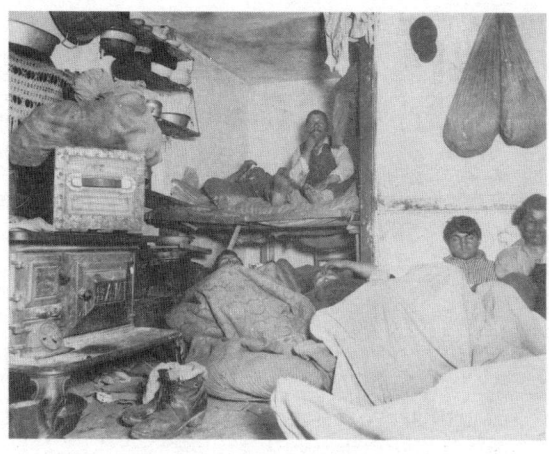

work of planners. No single mind or committee planned the myriad Venice canals or Veliko Tarnovo in Bulgaria; no single mind or committee *could* have planned them. If we let people 'get on with it', then out of the chaos emerges not infrequently a palimpsest of delight. With 'organic' urban planning one wave of construction gives way to another, one style to a second, all as one technology is replaced by some new invention, until a city of winding streets and wildly varying architecture emerges, one *nobody* would have designed with a blueprint but which everybody finds charming. However, strange as it sounds, such cities are now illegal. The regulatory demands of fire safety, traffic circulation, ease of access, hygiene, and sustainability mean that those narrow Edinburgh closes, the jettied houses of Edirne in Turkey, or the clustered towers of Al Hajarayn in Yemen, are legally unbuildable.

But that does not mean, when designing a city, we should leave it all to chance. There *is* science behind the magic of a beautiful metropolis, and there are usually clear reasons why one town feels lively, another boring, one charming, another oppressive – and we have control over them. There are certain obvious factors like

architectural style, size, transport, crime, cleanliness, and so on, but there are also others, less obvious, you may not have considered.

Take the question of use. 'Mixed use' is where different kinds of buildings — residential, commercial, educational, civic, religious, cultural, entertainment, transport — are mixed together. The opposite is 'single use', in which each zone of the city serves only one of these purposes. Whether our cities are mixed or single use influences not only how they function but how they feel. And what about population density — how many homes are needed in any given area? Suburbs are low density whereas apartment blocks are high density. Topography is also strangely important — *where* we build is almost as important as how we build. What makes a town like Bagnoregio in Italy, Constantine in Algeria, or Venice so interesting? Location. Hilltops, cliffsides, rivers, tidal islands, gorges: these are all geographical features that make urban environments and their architecture more interesting.

And is there any city that would not be improved by trees? They reduce street temperature, block wind, improve privacy, purify air, give sanctuary to wildlife, mitigate floods, and encourage people to spend time outdoors. They are also beautiful — a boon for our emotional and spiritual health.

The opposite is true of modern street lighting. We evolved according to the day–night cycle; intense light keeps us awake. Hence the replacement of orange sodium-vapour street lights with white LEDs has been both an aesthetic *and* a physiological catastrophe. We are more awake, more stressed, more confused, and less healthy because of them. Orange is firelight, orange is dusk, orange is the light of the night!

We conclude with something entirely mundane and therefore of the supremest importance: street furniture. Go outside and

notice how much *stuff* is strewn about: telegraph poles, post boxes, benches, bus stops, bins, signs, bollards, drainpipes, the road itself, the pavement. This is street furniture, not buildings but the inevitable froth of urban settlement. Somebody *designed* all these things – a fact we often forget! And we also forget that there is no specific way these things have to look; there is no reason for them to be boring. In the 'pleasant' bus stop, the 'nice' fence, the 'whimsical' lamp post, the 'charming' drainpipe – not beautiful, perhaps, but at least minimally aesthetically interesting – lies much of the magic of the metropolis.

We go on building. The question has never been whether we build but what and how. So we stumble towards the dream of a beautiful city, tussling with the demands of commerce, population, and bureaucracy. Our cities may no longer be those 'hells on earth' of Hugo's time, but wherever they have sent us spiralling into depression, atomised our communities, and made us into machines, unwaking and yet unsleeping in a forest of glass, we must remember that the 'beautiful city' need not only be a dream or a thing we travel to see – such cities *can* be consciously designed, built, and lived in.

CHAPTER VI

Aircon Revolution

†

And now, the God of Tempests swift unbinds
From their dark caves the various rushing winds:
High o'er the storm the power impetuous rides,
His howling voice the roaring tempest guides...

– Camões, *The Lusiads*

Have you ever been to Amsterdam? It's beautiful, they say. Thousands of photos confirm this report. Who wouldn't want to see those slender houses lining the canals of this venerable Netherlandish city? Those Dutchmen knew something about how to create charming

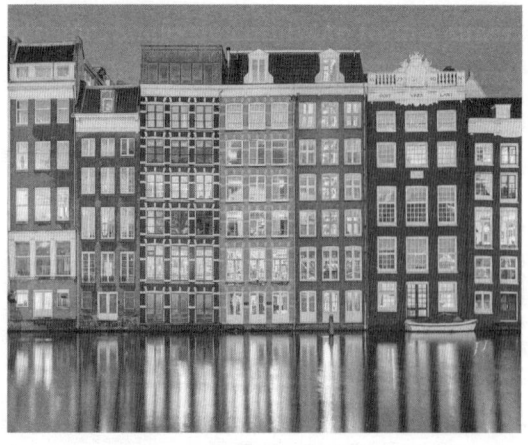

architecture – charming they are, almost whimsical and Wesandersonian, those narrow homesteads like technicolor dominoes.

Or not. In seventeenth-century Amsterdam, then one of the commercial hearts of Europe, access to waterways was extremely desirable. So desirable that the city council imposed a tax on canal frontage. Thus properties were built tall, deep, and narrow; those charming Dutch houses were the product of a financial rather than an aesthetic decision. In which case, what if all the other buildings we so love – be they Gothic, Classical, Byzantine, Safavid, Dravidian, Baroque, or Brutalist – were just the result of taxes, regulations, economics, technologies, and politics?

There are two ways in which architecture is shaped by forces other than the conscious adoption of a 'style'. The first is *direct*. Recall that what and how we build has always been limited by our knowledge and the materials we can access. Wherever there are cheaper and quicker ways of building, we adopt them. The great Gothic cathedrals, the sublime stepwells of India, the tiered Aztec pyramids, Haussman's Parisian boulevards – all would have looked different if their builders had had access to stainless steel and lifts.

Another direct force is regulation. Nobody can simply 'build'; there are codes and inspectors who demand we build in a particular way. This is not a recent phenomenon; there are even building regulations in Deuteronomy: 'When thou buildest a new house, then thou shalt make a battlement for thy roof, that thou bring not blood upon thine house, if any man fall from thence.'[30] Augustus set a height restriction on *insulae*, Roman apartment blocks, of seventy feet. After the Great Fire of London new regulation demanded that streets be wider, river access not blocked, and forbade thatching. What am I driving at? Any building regulation, civic or religious,

whether of material or size or shape, or of something as apparently inconsequential as the positioning of windows, inevitably influences how that building will look, even if this eventual appearance was not intended by the regulators. Architecture and styles do not exist in a vacuum.

We talk of legendary architects like Peter Parler, Donato Bramante, or Frank Lloyd Wright, but what of the bureaucrats? Think of an Art Deco skyscraper. What comes to mind? Probably the Empire State Building, the iconic shape of which is defined by its setbacks*; it looks like a waterfall of masonry. But those setbacks were essentially mandated by the 1916 New York Zoning Resolution. This was enacted after the construction of the Equitable Building, which rises one hundred fifty metres sheer from the sidewalk, blocking light and air from street level. So a defining aesthetic quality of Art Deco skyscrapers, and of Art Deco design more broadly – notice how 1930s radios imitate that 'waterfall' – turns out to be the consequence of a building code regarding public health.

* Meaning that its upper storeys are further back than its lower storeys.

Figurative art – art that depicts humans or animals – is forbidden in mosques. This is called aniconism. So Islamic artisans found other ways of producing beauty than by altarpieces or sculptures depicting religious figures; they turned to geometry, colour, and pure pattern. Hence mosques are filled with gorgeously elaborate arrays of tessellated tiles, kaleidoscopic constellations of ceramics, and *muqarnas* – a complex method of decorating arches or domes with tiers of miniatures niches. They may well give us an impression of divinely inspired beauty, but in practical terms all these things were the result of talented artists figuring out how to deal with aniconism.

Nasir al-Molk, Iran.

Building regulations are stricter and more numerous now than at any point in history. This is all to the good, we may say, because it means new buildings are better designed not to fall or burn down, they are accessible, and have running water. So regulations are a boon for our safety – but they also mean that the architecture and urban design we love most is now illegal. France's Mont-Saint-Michel and its clustered towers, Italy's Verona and its

narrow streets, or Yemen's Shibam and its mudbrick highrises: all are impossible to build in our modern regulatory environment. The inspectors would say, 'Down with this atrocity!' and point to something like the requirement in the United Kingdom that non-ground-floor windows must be at least 1.1 metres from the floor. William of Volpiano, an architect of Mont-Saint-Michel, did not have to worry about such requirements. Some people wonder why we cannot build like our ancestors once did. In part, so it seems, for our own safety's sake.

The non-architectural forces that shape architecture can also be *indirect*. By this I mean they are part of the socioeconomic, political, and cultural backdrop against which our buildings are built. Labour is vastly more expensive now than ever before. This has a significant effect on how we build. And it is partly thanks to de-industrialisation (for example) that so many little European cities are now 'charming' – they were decidedly less charming when a death-field of chimneystacks cluttered their skylines and factory-smog had children coughing blood in the cot.

But the biggest indirect context shift in recent architectural history was, I suggest, the invention of an American engineer in 1902. His name was Willis Carrier and he was trying to help a New York publishing house with the problem of inconsistent humidity in its factory. For them he created a bulky machine that could regulate both humidity and temperature – air conditioning. Its possibilities quickly became apparent and soon enough the bulky machine had been scaled down in size, scaled up in production, and become affordable. Recall, from the chapter on vernacular architecture, that for centuries our biggest challenge was suiting buildings to local climate; this was what produced the steep gables of German cottages, the *jalis* of India, and the loggias of Italy. Thanks to air conditioning,

a house in Bulgaria can now have the same design as one in Brazil. Le Corbusier and the Bauhaus architects may have been revolutionaries, but their 'style' is impossible without this invention; walls of glass would have led us to freeze in winter and roast in summer could we not press a few mitigating buttons. Think of Dubai. This is the veritable metropolis of the future, a thicket of impossibly tall towers glittering like jewels in the desert . . . *the desert*. Without air conditioning the modern city of Dubai could not exist. We might say the same of Singapore or Hong Kong. Even down to the disappearance of chimneys from our roofs and fireplaces from our bedrooms, Willis Carrier's invention has reshaped how this world of ours looks far beyond any individual architect or style.*

My aim here has been to suggest that architecture is less a question of style and more of context. But I will not leave you with the troubling proposition that architecture is merely the consequence of everything *but* architecture. Even when our options are limited by external forces, we still have room for manoeuvre. It was a brutal oversimplification to say that those slender Netherlandish houses arose from a financial rather than an aesthetic decision. Those burghers, though limited by tax burdens, still sought to build decent and pleasing homes *within* those limitations.

Sometimes the best architecture does not result from the intention to 'create beautiful buildings' so much as in finding clever solutions to difficult problems. 'The absence of limitations is the enemy of art,' said Orson Welles. He may not have had seventeenth-century Dutch tax law in mind, but he was right. We must neither deny architects praise for their successes nor absolve them of blame for

* And entirely reshaped global politics and economics, too – a subject of too great importance to address now.

their failures. Even after that New York Zoning Resolution of 1916, people like Raymond Hood and Hugh Ferriss designed buildings which were both legally compliant *and* beautiful.

So all this talk of context is not an excuse to shrug our shoulders and let architecture follow whatever path the lowest common denominators send it down. That is only one option, and by far the worst. Another is, like those Netherlandish burghers or Turkish tile-painters, to make the most of the cards we have been dealt.

CHAPTER VII

The Temple of the Golden Pavilion

†

And even now we no longer understand them.
We no longer know how to read their silent language.
— Auguste Rodin, *The Cathedral is Dying*

In Kyoto, Japan, there is a temple called Kinkaku-ji, otherwise known as the Temple of the Golden Pavilion. Like all the best Japanese architecture it is interwoven with its surroundings. The Gothic cathedrals of France or the Ottoman mosques of Istanbul, say, stand *apart* from the world. They could be taken to pieces and rebuilt elsewhere with little loss of effect. Not so with Japanese temples.

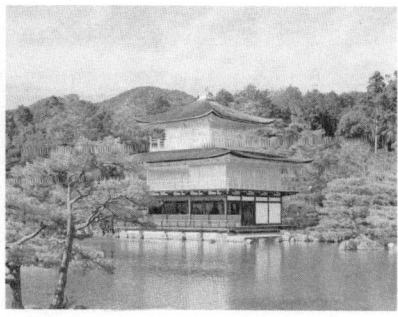

Consider the setting of Kinkaku-ji: half-cloaked in the treeline and jutting out into the mirror-water of a many-isled lake, all

things green in summer, flaming in autumn, submerged in white by winter, pink and budding green again in spring. The seasons roll on, the entire scene evolves, and the temple's atmosphere with it. Put Kinkaku-ji anywhere else and it would become a different building. At times it is difficult to tell where Japanese temples begin and nature ends. Whereas the Christian and Islamic builder shuts out the world with walls of marble and seems to say, 'There ends nature, here begins the domain of God and man' and throws up his temple within that enclosure, the Japanese builder extends heavy eaves and drapes his temple in shadow so light of day alone sets a boundary, and spreads around it paths, bridges, lanterns, gardens, low walls, and shrines, as though these were the roots and the temple a tree, growing out of and inseparable from its setting.

Why are we talking about Kinkaku-ji? It was built in 1397 as part of a villa for the retired shōgun* Ashikaga Yoshimitsu. Legend says he lived a life of luxury while the people of Kyoto endured famine. When Yoshimitsu died his pious son converted the building into a Zen Buddhist temple. Sixty years later, during the Ōnin War, the entire complex was burned down – with the exception of a gilded pavilion at its edge, our Kinkaku-ji. It survived for another five centuries until, in 1950, it was burned to the ground by a schizophrenic monk,† after which the temple was rebuilt *exactly as it had been*. So I ask you: how old is this temple?

The history of Kinkaku-ji recalls an ancient philosophical quandary regarding Theseus, the mythological founder of Athens, who defeated the Cretan Minotaur. Legend says the ship on which he returned from Crete was kept in the Athenian harbour. Over

* A *shōgun* was a military commander-in-chief appointed by the emperor from the twelfth to the late nineteenth century.
† Novelised intoxicatingly by Yukio Mishima in 1956 in *The Temple of the Golden Pavilion*.

the years, as it deteriorated, the people of Athens replaced its rotten planks and rigging. Centuries later, the ship of Theseus still floated in the harbour, but none of its original parts remained. So was it the same ship on which Theseus sailed from Crete, or was it a different ship? This question can also be asked of buildings after extensive renovation or rebuilding.

Here's what Douglas Adams (of *The Hitchhiker's Guide to the Galaxy* fame) had to say about Kinkaku-ji:*

> I remembered once, in Japan, having been to see the Gold Pavilion Temple in Kyoto and being mildly surprised at quite how well it had weathered the passage of time since it was first built in the fourteenth century. I was told it hadn't weathered well at all, and had in fact been burnt to the ground twice in this century. 'So it isn't the original building?' I had asked my Japanese guide.
>
> 'But yes, of course it is,' he insisted, rather surprised at my question.
>
> 'But it's burnt down?'
>
> 'Yes.'
>
> 'Twice.'
>
> 'Many times.'
>
> 'And rebuilt.'
>
> 'Of course. It is an important and historic building.'
>
> 'With completely new materials.'
>
> 'But of course. It was burnt down.'

* Adams' guide says the temple burned down twice in the twentieth century; this was either a mistake on his guide's part or of Adams' recollection – the temple only burned down once, though it has been renovated several times. Anyway, this error does not remotely affect his conclusion.

'So how can it be the same building?'

'It is always the same building.'

I had to admit to myself that this was in fact a perfectly rational point of view, it merely started from an unexpected premise. The idea of the building, the intention of it, its design, are all immutable and are the essence of the building. The intention of the original builders is what survives. The wood of which the design is constructed decays and is replaced when necessary. To be overly concerned with the original materials, which are merely sentimental souvenirs of the past, is to fail to see the living building itself.[31]

A revelation! So this is one side of the argument: a building's age is not defined by when its bricks were mortared, its timbers cut, or gables painted, but when its design was first imagined. Take the Great Cloth Hall of Ypres, in Belgium. It was designed and built in the fourteenth century, destroyed during the First World War, and rebuilt stone for stone by 1967. There are also the old towns of Warsaw, Dresden, and Frankfurt, all razed during the Second World War and since rebuilt. Or the Salvation Cathedral in Moscow, demolished by Stalin and reconstructed after the fall of the USSR, or the 4,000-year-old Ziggurat of Ur, partially rebuilt under Saddam Hussein. And what of the Ise Grand Temple in Japan? First constructed 2,000 years ago, it is ceremonially taken down and rebuilt every twenty years with new wood from the same sacred forest from which its timbers were first taken.

Are these 'original' buildings? Perhaps it doesn't matter. Thirty years ago, certain architects opposed the reconstruction of Dresden's eighteenth-century Frauenkirche on grounds of 'artificiality' – they thought that to build in the architectural style of a previous age

would make it a kind of aesthetic fake. They were ignored, thankfully, and the Frauenkirche sparkles again. Douglas Adams' perspective is persuasive.

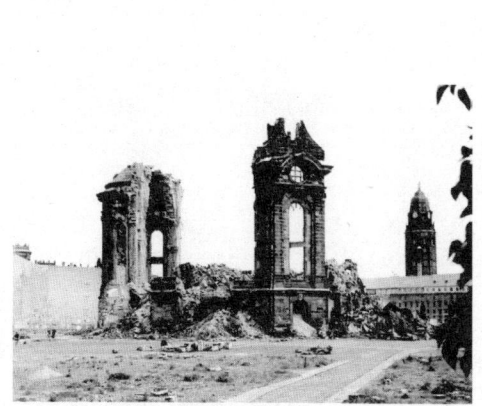
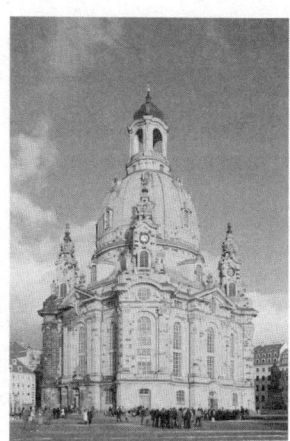

But here is the alternative view, given by John Ruskin:

> ... the greatest glory of a building is not in its stones, or in its gold. Its glory is in its Age, and in that deep sense of voicefulness, of stern watching, of mysterious sympathy, nay, even of approval or condemnation, which we feel in walls that have long been washed by the passing waves of humanity. It is in their lasting witness against men, in their quiet contrast with the transitional character of all things, in the strength which, through the lapse of seasons and times, and the decline and birth of dynasties, and the changing of the face of the earth, and of the limits of the sea, maintains its sculptured shapeliness for a time insuperable, connects forgotten and following ages with each other, and half constitutes the identity, as it concentrates the sympathy, of nations; it is in that golden stain of time, that we are to look for the real light, and color, and preciousness of architecture ...[32]

Ruskin believed 'restoration' was impossible, that we should not meddle with whatever old buildings we have been lucky enough to inherit, and that preservation is the best we can do; 'Design' can never make up for age. Think of it this way: what makes the Pyramids interesting? If it was merely their shape and size, the Luxor Las Vegas would be equally noteworthy. And if the Great Pyramid of Khufu were built today – as the private tomb for a head of state, no less! – it would be universally condemned as vulgar. But nobody looks at Khufu's tomb and thinks that now. We are filled instead with awe. Why? Because when the Great Pyramid of Khufu was built there were still woolly mammoths wandering the Earth; Julius Caesar is closer in time to the iPhone than to the Pyramids of Giza. They look on, inscrutable, from an epoch before epochs, from a time so far removed we can scarcely comprehend their ancientness. We, looking on, realise our smallness. Such is the power of time.

The quandary posed by Kinkaku-ji, our architectural Ship of Theseus, is not idle philosophy. It is another way of asking the urgent question of how we should deal with the thousands of buildings left behind by previous generations whose fate must be decided: football stadiums, banks, car parks, churches, parliaments, metro stations, and homes. To neglect them, maintain them, repurpose them, or restore them to what once they were – these are our options.

Ruskin might have said it was better to leave Kinkaku-ji a cindered wreck. There *is* dignity in ruin, after all. To see the grey skeleton of Whitby Abbey on the cliffs above the churning North Sea, speaking to us almost indecipherably through fog both literal and metaphorical, stirs a feeling no living building ever could. The prospect of a restored or repurposed Whitby Abbey seems sickeningly artificial. And yet I have been lucky enough to visit Verona and its Roman arena, which is still in daily use – and when I saw Verdi's *Aida* there it was the

bathrooms that struck me most. Cubicles, toilets, washbasins, all within stonework set 2,000 years ago. This was no museum piece but a structure with *purpose*. Another example: the Dutch village of Bourtange, shaped like a star. Why? Because it was built within the walls of an eighteenth-century 'star fort'. How many other ruined fortresses and castles might also become such wonderfully unique towns or homes?

Then again, on Nebet Tepe – one of the seven hills of Plovdiv in Bulgaria – lie the unintelligible ruins of a Thracian citadel. There are no plaques, barriers, or aircon units. Instead, scattered on the dusty hilltop at twilight, lovers embrace, youths smoke and dance, and solitary wanderers stroll among the graffitied and daily-eroding masonry of the redoubt. Here is a kind of life you do not get by museumification or by designation for a particular 'use'. You sit on an ancient stone with axe-marks left by its quarrier 3,000 years ago and watch the sunset over the Rhodopes, over the clay roofs of Old Plovdiv, over the concrete canyons of the Soviets – and history is no longer 'history', a thing sealed off to be analysed and understood; it is simply the indivisible and ever-continuous present in which we are living.

But in rainy Lugo – amidst the forests and farms of Galicia in northern Spain, more like Wales than the Sierra Madre – we find what is claimed to be the only fully intact set of Roman walls in the world. And, sure enough, the old town is surrounded by a wall four kilometres in circumference, in places sixty feet tall, with six gateways to the *ruas* of Lugo, where honest bars teem every night. People walk their dogs along these walls, go running, stroll, hang out; these *murallas* are a major part of city life. How did they survive? The walls of Lugo have been restored from time to time; they do not stand 'as the Romans left them' but as the people of Lugo have maintained them since the Romans left. The real Roman walls, left to rot like those of London, would have melted into the urban fabric and disappeared from view or use.

So would you let architecture crumble, unmarked, and become part of the landscape, an invisible but eternally truthful part of modern life? Would you preserve it, maintaining faithfully what our forebears bequeathed us? Would you pay for a ticket and be guided through the empty windows of a broken castle, with plaques telling you what it *was*? Would you have it restored, in an attempt to recreate something lost? Or would you have it repurposed, houses built within, even a gallery, restaurant, theatre, or office, so that whatever it was, it becomes something else?

If we refuse to answer these questions then various 'committees' or unscrupulous property developers will do the answering for us – and we will simultaneously find the jewels of history being demolished and boring solutions rising where fabulous things might have been done. Everything (*literally everything*) we build will one day be looked on with that 'Ship of Theseus' question in mind; the very building in which you are currently sitting or standing will share the same fate also.

The Fourth Pillar of
The Cultural Tutor

Apocalypse and Genesis

CHAPTER I

Cavalry in the Refectory

†

Out of Ymir's flesh was fashioned the Earth,
And the mountains were made of his bones;
The sky from the frost-cold giant's skull,
And the ocean out of his blood.

– from the *Vafþrúðnismál*

Art. Three letters; an infinitude of meaning. In the first four chapters of this pillar I will talk about art in its narrower sense – painting and sculpture – and in those that follow we will take on its broader meaning, with particular focus on design and literature.

Now, as soon as we delve into the world of art it is abstract words like 'Impressionism', 'Symbolism', and 'Realism' that greet us. Yes, books about art are filled with '-isms'. They can be confusing for people new to art and are often misleading for those already interested in the subject. No movement can paint a picture; only a person can do that. Any '-ism' is just a useful (though sometimes reductive) way of classifying a group of people doing things at a particular time and in a particular way. So here I will try to avoid them and instead talk about specific artists and the specific times in which they lived.

Still, the most obvious question with which to begin is surely: *what is art?* A vexing question, but one that vexes us more than it should.

You and I both know art when we see it. There *are* occasions when it isn't clear whether something is 'art', but there is an old legal saying that 'hard cases make bad law'.* So I think we should keep the definition simple. John Ruskin defined art as something like 'the human hand, heart, and mind united in creation'. By this he meant that a work of art is something produced when our skill, emotion, and intellect are all used to make it.† This works for 99 per cent of what we generally call art – and it very rightly casts the scope of art broad, including everything from the grandest of murals to the humblest of chairs.

Where does art get its meaning from? William Shakespeare gives us an answer. In *A Midsummer Night's Dream* the King of Athens, Theseus, has just watched a play. Somebody comments on how badly the play has been performed. Theseus responds, consolingly: 'The best in this kind are but shadows.' What did Theseus – and Shakespeare – mean by this? That the art is always secondary to our living reality, that art can only ever draw meaning from that reality.

Consider the painting here by Edward Landseer, the most popular 'animal painter' of nineteenth-century Britain. It's called *The Old Shepherd's Chief Mourner*.

It is an incredibly moving work of art; it seems to be every cute dog video rolled into a single image. But this picture would not have the same meaning if dogs were not real, and could not have been painted at all had Landseer not been so fond of dogs and understood the bond we can form with them. We may love the picture, but we could not love it fully if we did not already love dogs. Or, if someone did not love dogs, was perhaps even indifferent to animal cruelty, this

* The question 'what is art?' is fascinating and can lead to some wonderfully bizarre places. But I think we can also get too bogged down in the question; too comprehensive an attempt to answer it isn't really the best way to begin.
† Our word 'art' comes from the Latin *ars*, which literally means 'skill'. A useful fact, perhaps.

picture – by showing what seems to be real emotion on the part of the animal, having lost its beloved master – could change their mind. But either situation is only possible *because* the painting depicts some small part of real life, and therefore helps us to understand it better.*

This reveals something else about the nature of art, as Ruskin pointed out by contrasting it with science: science deals with things as they are in themselves and art deals with things as they relate to humankind. This is another way of saying that art is about 'meaning' while science is about 'facts'. The geologist tells us that mountains are formed of granite or limestone, when they were formed, whether they are still rising or being worn away. An artist, meanwhile, shows us their beauty, might, and mystery. We do not learn geology from Albert Bierstadt – a nineteenth-century American landscape painter – but we do seem to learn something higher and more essential than the bare facts of science can tell us.†

* This isn't just true of 'representative art', meaning art which depicts our world in a recognisable way. Even abstract art relies on the fact that we are living creatures with feelings and intellects, and that these can be stirred by pure colour and form.
† This isn't about 'better' or 'worse', just about the different roles played by science and art.

Albert Bierstadt's painting of the Matterhorn versus the real thing.

If you compare any famous work of art with the real place it depicts, you will notice that the painting never shows that place as it 'actually' looks. But that is not, and never has been, the function of art. Edvard Munch's *The Scream* does not resemble any 'actual' person, but as a portrayal of anxiety it is gallingly accurate; it is a 'shadow' of the real feeling, made in reference to an emotion we all recognise and giving

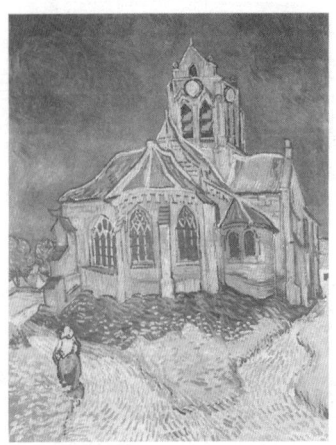 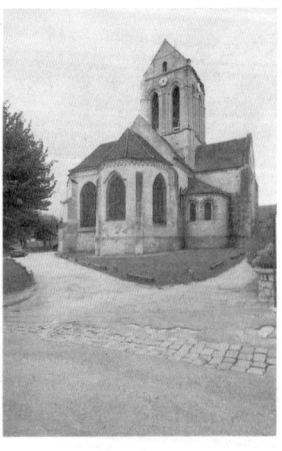

Vincent van Gogh's *Church at Auvers* versus the real church.

comprehensible form to something that is itself without visible form. Such is the power of art; such is the source of art's meaning to us.

That is some brief theory about the nature of art. Helpful, I hope, but rather abstract. And so I believe the next question we must ask is *where* rather than *what*. Because all art was created at some point, in some place, by some person. You don't *need* to know the context of an artwork to delight in it, but knowing context is incredibly helpful whenever we want to really understand what art is and why we make it. Let me show you what I mean.

Where is *The Last Supper*? I long assumed it was in a gallery. No. *The Last Supper* is where it always has been: on the wall of the refectory at the Convent of Santa Maria delle Grazie in Milan, where Leonardo painted it over the course of four years at the behest of Duke Ludovico Sforza. Much has happened to it since, including the installation of a door below the figure of Christ, whose feet were destroyed in the process. Two hundred years ago, when the French conquered Milan during the Napoleonic Wars, they used the refectory as a stable. It has also flooded several times, been used as a prison, and been bombed. But more surprising than any of these facts

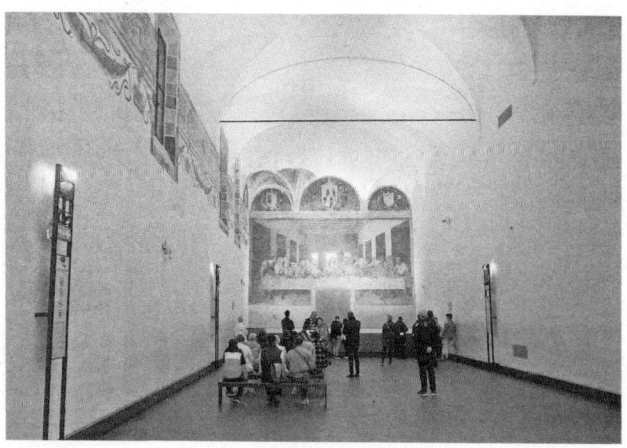

is that monks once ate their bread and drank their wine beneath the gaze of Jesus and the Apostles. The painting was not in a gallery, behind glass or rope, as something to be pondered. It was a part of ordinary life – at breakfast, no less!

How did the *Mona Lisa* end up in the Louvre? Not how Vincenzo Peruggia, the Italian who stole it in 1911 and consequently shot it to fame, thought; it wasn't plundered by Napoleon. Leonardo took it to France himself when he was invited there by King Francis in 1516. And so Lisa Gherardini, the subject of the most famous portrait in history, never saw it finished. Nor was Leonardo ever paid by her husband for the commission. He was a silk merchant called Francesco del Giocondo who wanted to celebrate moving into a new family home with his wife. Yes, the *Mona Lisa* was commissioned as a minor piece of domestic art.

Michelangelo's *David* was not supposed to be in a gallery either. When in 1504 he finished carving that block of marble known colloquially as 'the colossus', the authorities realised that it could not be lifted to the roof of the cathedral where they had wanted it to be displayed. So instead they placed it outside the Palazzo Vecchio, Florence's town hall, with *David*'s face turned towards Rome. There, unsurprisingly, the statue became a symbol of the city. Only in the nineteenth century was *David* finally moved inside, to its present location, the Galleria dell'Accademia.

My point is this: there were no 'galleries' for most of human history. Art was not something one found in a 'Museum of X' or 'National Gallery of Y'. Art was *everywhere*. Streets lined with frescoes, housefronts with carving, squares with statuary, every corner with a saint in their niche – *that* was art. There was the church or temple or mosque, decorated inside and out with stained glass, sculpture, murals, mosaics, and ceramics – *that* was art. And in the

houses themselves, whether of yeoman or burgher, there were family portraits, rugs, carved dressers, patterned pots, tapestries, icons, and candlesticks – *that* was art. What would be the point of galleries in a world like that? People had art in their homes and on their streets, and the 'great works' were to be found in places of worship, town halls, tombs, or palaces.

Galleries and museums only really started appearing in the last two centuries, and a blessing though it is to have them, they can sometimes prevent us from fully 'getting' art. Until 2021 a terracotta relief of the Madonna had been gazing down on a dingy Florentine street for six centuries, much beloved of one generation after another who looked to her for good luck. Experts then decided it was the work of the fifteenth-century sculptor Donatello and the Bargello Gallery bought it for more than a million euros. That Donatello's Madonna was originally 'public art', a shrine for passers-by, should tell us in one bright flash the trouble with galleries: they lack context.

The Parthenon Marbles, which once adorned the temple of Athena on the Athens Acropolis, are now in a museum. How could we hope to understand those sculptures without seeing them in their original, purposive setting? This is an obvious problem with religious art, but it goes further. Imagine if the Statue of Liberty were in a gallery (a rather large gallery, admittedly). It would no longer be that symbol of freedom welcoming migrants who have arrived in New York in the hope of a better life. There might be a plaque on the wall telling us so, but we would never *feel* it among the whispers of an air-conditioned gallery. Across our long history art was never separate from society or compartmentalised within it; it was part of all things, diffused throughout like sugar in milk, not separated like oil from water.

Where is the world's oldest art? Caves from Indonesia to France are decorated with ochre daubings of pigs and stencilled handprints, some of them 40,000 years old. Art's genesis was by the firelight. When a human has time to spare (and even when they do not) they *create*. Art has always been used to decorate our homes, to remember the dead, adorn places of worship, record history, or simply pass the time. Pieter Brueghel the Elder designed prints for Hieronymus Cock to be sold to the burghers of sixteenth-century Antwerp to decorate their homes, Ogata Kōrin painted flowers on silk *byōbu* to be used as room dividers by merchants of eighteenth-century Kyoto, and Ustad Mansur painted pictures for the delight of seventeenth-century Mughal princes. Michelangelo was asked by Pope Julius II to paint the ceiling of the Sistine Chapel, the existing ceiling of which – depicting the night sky – Julius did not like. Michelangelo said yes and was paid 3,000 ducats for his four years' work – and even stopped working for six months when they stopped paying him!

None of this was capital 'A' art destined to be looked at in a

gallery, in a carefully curated order, with plaques and queues of tourists, and no abstract '-isms' had anything to do with it. All of it was art unencumbered by analysis, as it existed and was created, ever with a purpose, in this physical universe of ours, by human beings with pigments, brushes, bronze, marble, ink, silk . . . and a great deal of sweat, blood, and backache.

And so art becomes the inescapable expression of every age, whether we like it or not, consciously or otherwise. It is the inevitable reflection of who a people were and want to be, of what they have seen, felt, learned, hated, feared, and loved. This is the inheritance of every living person, the vital *thing* in which we will find, if we look for it, something of ourselves, something higher, more powerful, thrilling, disturbing, or beautiful.

For there *is* so much in this life, and it may be that art will help us find it. Painting, like literature or cinema, can reveal part of yourself you did not know was there. It may invite you into yourself and deepen your humanity. It may expand your soul by taking you somewhere you have never been and, looking at the world from this new vantage point, find your feelings and thoughts about the world forever changed. Or, at its humblest and perhaps best, it may simply help you to appreciate and see more clearly the things you have always been surrounded by – flowers, friends, street corners, or the Moon – yet better. Three letters only; an infinitude of meaning.

CHAPTER II

Love!

†

When old age shall this generation waste,
Thou shalt remain, in midst of other woe
Than ours, a friend to man, to whom thou say'st,
'Beauty is truth, truth beauty,—that is all
Ye know on earth, and all ye need to know.'

– John Keats, *Ode on a Grecian Urn*

We have learned something about the nature of art . . . but how does somebody begin a journey into this world? For most of my life I didn't much care about art; I didn't really understand what it was or what it was for. Much of it seemed like the frivolous froth of a long-gone high society, and culture is so oversaturated with images of the most famous artworks – like Leonardo's *Mona Lisa* or Michelangelo's *David* – that I could never really look at them for what they are. The same is true of Vincent van Gogh's sunflowers or Claude Monet's water lilies. They have become such fixtures of popular culture that they hardly seemed to be 'art' at all.

Even when curiosity pushed me to look into painting and sculpture – somebody had asked me who my favourite painter was and I, embarrassed, had no answer – I quickly became lost among complicated scenes depicting stories I didn't recognise or that litany

of nudity that passed in the nineteenth century for establishment art. It was off-putting and only confirmed what I suspected – that 'art' was a pretentious racket. But nothing could be further from the truth. Think (to give just one example) of the iconoclast mobs of the so-called Beeldenstorm, when crowds of enraged Protestants tore down Catholic art in the sixteenth century. They battered in the doors of churches and hacked away the faces of the statues within, smashing stained-glass windows and setting fire to chancel screens. Was this 'high society' froth? No – for these people art was a matter of life and death.

Still, getting into art is made unnecessarily difficult by art-writing. Precisely because it deals with things as they relate to humans, and because each human is different, art is open to some interpretation – and therefore vulnerable to nonsense. This explains why you get an awful lot of drivel in the art world. Here is one example from Walter Pater – a nineteenth-century critic and novelist whose work is generally gorgeous – of the kind of writing that can put people off:

> She is older than the rocks among which she sits; like the vampire, she has been dead many times, and learned the secrets of the grave; and has been a diver in deep seas, and keeps their fallen day about her.[1]

What was Pater referring to? The *Mona Lisa*. Writing like this gives the impression that paintings are a mystical book readable only by wizards to whom the sacred magic of culture has been revealed. But these proclamations, perhaps because they sound clever, end up getting repeated. Thus we get conventionalised opinions, as when people say the Sistine Chapel represents the pinnacle of Western civilisation, which upon investigation turns out to be a radical claim not easily justified. Who put these thoughts in our heads?! You do

not have to like the *Mona Lisa* – you can say, and should if you so think, 'It is boring.'

Every critic has an opinion and they will try to convince you of it by means fair or foul. They may be right; I only say we must decide for ourselves. Some write about art lovelessly and some can never see anything in a painting but politics. Left or right wing, it matters not; art deals in truths deeper than ideology, and no artist – no human – can be reduced to a set of opinions. So do not be intimidated by elitism in art or by those who seek to gatekeep it. Art belongs to *you* – and you already have everything you need to 'understand' it: your eyes, mind, and heart.

Do critics matter at all? If we accept the uncontroversial statement that the things we consume influence how we think, feel, and behave, it surely matters what sort of art we collectively declare to be good. Because, when we agree that a certain kind of art is good, more of that art will be created – and go on influencing us. Thus, art being a moral and cultural force, the duty of the critic becomes a moral and cultural duty also. By helping us to collectively decide what is worth praising, criticism shapes both the future of art and the future of art's effect on society. Critics also have a role in the present, sifting through the vastness of things created and pointing us to what we might otherwise miss. And, just as important, critics can save artworks from being forgotten, so that future generations will benefit from their preservation – or even rifle through the past and bring back forgotten works from obscurity.

The best critics can also help us understand and evaluate art. J. M. W. Turner may have said of Ruskin, his biggest supporter: 'He knows a great deal more about my pictures than I do; he puts things into my head, and points out meanings in them that I never

intended',[2] but insightful criticism *can* illuminate something in the artwork that the artist did not realise was there. Creation is hardly guided by calculating reason. The whole point of the Greek Muses – nine spirits who inspired and guided artists – was that humans are sometimes possessed by forces they cannot wholly perceive. As Plato wrote in one of his dialogues, *Phaedrus*:

> But he who, having no touch of the Muses' madness in his soul, comes to the door and thinks that he will get into the temple by the help of art—he, I say, and his poetry are not admitted; the sane man disappears and is nowhere when he enters into rivalry with the madman.[3]

So much for critics – but we can also do plenty of that critical work ourselves. Let's say you're looking at a painting now. How to think about it?

One of the first mistakes we often make is to look at all paintings and sculptures as if they are fundamentally the same thing, or at least trying to do the same thing. But think, for comparison, of the different reasons we use cameras: making films, television shows, documentaries, videos of places we visit, videos of ourselves, of birthdays, of frogs, and of things too prurient to print. All these videos, though they share the same 'medium', are trying to achieve different things – the same is true of painting. A thirteenth-century Serbian icon, a third century Alexandrian mural, a papal portrait, the illuminated manuscripts of Iona, a Safavid picture-book: all these are 'painting', but they are no more related than *Charlie Bit My Finger* is to *Andrei Rublev* – to the discredit of neither. Their medium is the same; their nature and purpose can hardly be compared. So that is the first step, I think: taking a picture on its own terms.

Next: consider these words of John Ruskin: 'Painting, or art

generally, as such . . . is nothing but a noble and expressive language, invaluable as the vehicle of thought, but by itself nothing.'[4]

Art is and always has been a language we use to say something. Thus the question of whether a given work of art is good or bad becomes one of what it is trying to say (i.e. the meaning) and how well it communicates that meaning (i.e. the technique). This method works because it unites the message of art with its medium. People often ask whether art can be 'good' if its meaning is evil, the most obvious example here being something like Nazi art. A painting could be technically impressive, and altogether beautiful, but there seems to be something instinctively wrong about praising such a painting if it promotes an evil cause. Using our method we *can* say it is not good art – because, though it speaks well, what it says is bad.

Let's put this method into practice with a few case studies. First, Hasui Kawase. He was a twentieth-century Japanese artist who made *ukiyo-e*, traditional woodblock prints. Kawase's technical genius was in portraying the atmospheric effects of weather and light, and it is these things he wants to tell us about. He wants to help us revel in the splendid solitude of rain at night, in the perfect stillness of

summer heat, in the cool splendour of dawn – or, in this case, the magic of falling snow.

Second, the world-famous Frida Kahlo and her painting *The Two Fridas*. In it, as with the majority of her art, Kahlo is telling us something primarily about herself. Precisely what she is telling us does not quite matter right now; evidently, even at first glance, it is viscerally revealing. Kahlo's style, at once childlike and dreamlike, gives her work an astonishing intensity. This sort of art seems to implore us to have the courage to look at ourselves without fear of what we might find, faults and anxieties all, and by extension to realise that the well of suffering we see in ourselves might also be inside the hearts of others – thus asking us to have empathy with our fellow human beings.

Third, John Martin, a nineteenth-century British painter who specialised in colossal scenes of high drama, often drawn from history – such as the eruption of Mount Vesuvius – or the Bible. This one is called *The Destruction of Tyre* and was painted in 1840. What Martin wants to tell us about is biblical scripture, specifically

the destruction of the ancient city of Tyre by God for its sinfulness. Martin has crafted for us a compellingly epic painting with his trademark forks of lightning and apocalyptic grandeur. But we needn't know anything about the Bible for it to have an impact on us; there is a broader message at play, of humankind's ultimate fragility in the face of nature's might.

Fourth is Ma Yuan, a medieval Chinese painter. Unlike in Europe at the time, where landscapes weren't regarded as a genre of their own, landscape painting was considered the highest form of visual art in China. Here we see *Clouds Rising from the Green Sea*, one of several paintings he made depicting the rivers and seas of his country. All extraneous details have been removed; Ma Yuan gives us a reduced and essentialised vision of the rolling waves. And rolling they are – there is a remarkable sense of movement here, of depth and flow. You can almost hear the mist rising, feel its dew upon your face. All this without any obvious adherence to what we often call 'realism' – a few brushstrokes of ink, expertly placed, suffice.

Now for something completely different. A painting called

Improvisation: Deluge by Wassily Kandinsky, from the year 1913. This is, in the broadest sense, abstract art. Kandinsky was interested in paintings that had no outward meaning, that were not obviously 'about' anything in the way the other paintings in this selection are. Does this make it just a pattern? Not necessarily. Kandinsky used music as a comparison. No musical note is ever 'about' anything – it is purely abstract – and yet music still makes us *feel*. Perhaps colour can do the same. Just as musical notes have an immense variety, so

too colours are infinite in their variability – and that is before we even consider how they are laid on the canvas, in what quantities, what combinations, and what shapes. Kandinsky was a master colourist, and this wild-swirling work of art may, if you look into it long enough, produce those same internal feelings, almost primordial – feelings without name or 'aboutness' – we get from music.

Finally: Giuseppe Arcimboldo, a brilliantly bizarre Italian painter who worked and lived in the sixteenth century at the court of the Holy Roman Emperors. He liked to paint human faces made of animals, plants, or inanimate objects. What was his purpose? Perhaps he was seeking to explore an emerging philosophical worldview, one that had replaced the old medieval ways. Transforming the seemingly solid form of a human face into random objects might be a representation of his society's increasingly scientific mindset, one by which people had ceased to see themselves or the universe as divinely unified wholes and instead viewed them as solely material things composed of analysable constituent parts. Or not! Maybe it was entertainment – and nothing more.

As I said, artists may not always be fully attuned to what they are creating, and it is everybody's right to find their own meaning in a painting. For a work of art, once made, exists alone in this universe; it is an object created which we may take either in the context of its creation or wholly on its own terms. Both are legitimate and you can take your pick. You may see something completely different in these six paintings than I do. And, if you think they are rubbish, that is also fair – because many paintings *are* rubbish.

In conclusion: you do not need to 'understand' or even 'know about' art to get into it. Yes, we gain a lot when we are familiar with the language of art, the dates and places and technical terms, the 'things to look for' – but the eternal and only necessary beginning is to fall in love with art. We must be able to say, as John Donne once did:

> First, we lov'd well and faithfully,
> Yet knew not what we lov'd, nor why.[5]

CHAPTER III

An Oak Tree

†

The flesh is sad, Alas! and I've read all the books.
Let's go! Far off. Let's go!

— Stéphane Mallarmé, *Sea Breeze*[6]

In 1974 an artist called Michael Craig-Martin installed his latest work at the Rowan Gallery in London. It was an almost-empty room painted white with a small glass shelf supported on matte-grey brackets fixed exactly 253 centimetres high on one of the walls. On this shelf was a glass of water. Craig-Martin's installation was called *An Oak Tree* and it was accompanied by an explanatory leaflet.

An Oak Tree was purchased by the National Gallery of Australia in 1977 and a replica has since been installed at London's Tate Gallery. It is an example of conceptual art. This is where whatever we are looking at is supposed to make us consider an idea. It is a primarily intellectual rather than emotional, spiritual, or sensorial form of art. The physical object itself, or any technique and skill involved its creation, are irrelevant, because concept and not craft is the purpose.

Another example is *Work No. 227: The lights going on and off* by Martin Creed. It was created in 2001 and for it he won the Turner

Prize, Britain's most prestigious art award. The installation consists of an empty room with the lights going on and off. Other famous examples are Tracey Emin's *My Bed*, an unmade bed surrounded by the detritus of daily life; Damien Hirst's *The Physical Impossibility of Death in the Mind of Someone Living*, a tiger shark submerged in a glass cabinet filled with formaldehyde; and *Comedian* by Maurizio Cattelan, a banana Sellotaped to a wall. I pass no judgement on *An Oak Tree*, but this is clearly not the sort of thing that was once regarded as art. Why are there now rooms with flickering lights in our galleries? It's time to talk about what is sometimes called, somewhat loosely, 'modern art'.*

* Terms like 'modern art', 'contemporary art', and 'conceptual art' all have different, specific meanings in the art world. Generally, however, people call everything unusual 'modern art'. For ease – and to avoid spending too much time talking about definitions – whenever I say 'modern art' I am using the phrase in its colloquial sense.

For most of history art existed in one place at one time. You could only see the ceiling of the Sistine Chapel if you went to the Vatican. But photography was invented in the 1840s and within a few decades anybody, anywhere in the world, could own a perfectly accurate representation of the Sistine Chapel ceiling. They may not have known what it 'smelt like', as Robin Williams says in *Good Will Hunting*, but they certainly knew what it looked like. Altarpieces once venerated in the candle-haze of the chapel were taken out of their religious context and printed on postcards. No wonder we started asking 'What is art?' – and pushing its boundaries – precisely when we started seeing it outside the places it had always been.

This is also true of music. Once upon a time you could only hear an orchestra if there was an orchestra in front of you. How can we hope to understand Gregorio Allegri's *Miserere*, originally performed just once a year, and only in the Sistine Chapel, when we now hear it playing over advertisements for trainers?

Nevertheless, the French poet Paul Valéry wrote of what a blessing this change – the invention of sound recording – was for humanity:

> Formerly we could not enjoy music at our own time, according to our own mood. We were dependent for our enjoyment on an occasion, a place, a date, and a program. How many coincidences were needed! Today we are liberated from a servitude so contrary to pleasure . . . I sincerely hope we are not moving toward such excesses in the magic of sound. Even now one can no longer eat or drink at a café without being disturbed by a concert. But it will be wonderfully pleasant to be able to transform at will an empty hour, an interminable evening, an endless Sunday, into an enchantment, an expression of tenderness, a flight of the spirit.[7]

Do you now see what a miracle your headphones are?

Valéry also wrote:

> We are still far from having controlled visual phenomena to the same degree. Colour and relief are still rather resistant. A sunset on the Pacific, a Titian in Madrid cannot yet be enjoyed in our living room with the same force of illusion as a symphony.[8]

That has now come to pass: we can watch a Pacific sunset on a Warwickshire winter's night and we can see Titian anywhere. In 1935, in *The Work of Art in the Age of Mechanical Reproduction*, Walter Benjamin spoke of the 'aura' that comes with seeing art in person, and how that 'aura' had been destroyed by photographic reproductions. This does seem to have happened. When everybody can have their own reproduction of a Leonardo, Titian, or Turner (and now we can get high-quality images of them online) the unique experience of seeing a work of art, in one place at one time, is undermined.

Still, it remains a common mistake to say that photography therefore *replaced* artists,* hence the departure of art from so-called 'Realism' and our embrace of the weird and wonderful. This may have been true for portraitists, but we hardly started sticking photographs to church walls instead of painting them! Photography changed the context of art, not art itself; photography did not *replace* artists, it *liberated* them from the narrower contexts they had always been working within. Fauvism, Primitivism, Pointillism, Cubism, Suprematism . . . in the wake of artists' liberation a tidal

* Early on, people did fear this. In 1859, Charles Baudelaire, speaking for thousands, wrote: 'The photographic industry is the refuge of every would-be painter . . . I am convinced that the ill applied developments of photography, like all other purely material developments of progress, have contributed much to the impoverishment of the French artistic genius.'[9]

wave of '-isms', increasingly experimental, swept Europe and the United States.* Then, in 1917, Marcel Duchamp submitted a urinal to an exhibition in New York City, signed 'R. Mutt' and entitled *Fountain*. Conceptual art was born.

Duchamp's joke is still making us laugh a century later, and every flickering bulb in a gallery is a restatement of what he did. But the public, on the whole, don't seem to care for conceptual art – they were happy with Monet, and still are. A new generation of artists and critics loved what Duchamp had done, however, and started producing or praising other works squarely intended to shake up established views; whoever could be most shocking was crowned a genius. As George Orwell said of the 1920s, when all this really

* Were these '-isms' really so new? What is 'abstract art' if not *pattern* – the dogtooth of a Norman door; the tessellated tiles of the Alhambra – other than the difference that one has been installed in a gallery and is doted upon as 'high art', and the other was drawn in the margins by a monk, or woven by a carpet-weaver of Kashan. The Renaissance pursuit of pure 'Realism' induced a madness which has corrupted our view of everything not made in that tradition. Picasso was only a revolutionary within a small circle, only a revolutionary within the context of sixteenth- to nineteenth-century European art.

got going: 'If you threw dead donkeys at people, they threw money back.'[10]

So a new kind of art, more suited to our photographic world, emerged. The 'aura' taken away from paintings and sculptures is irrelevant to a form of art that asks us, above all, to think. Remember: with conceptual art it is the *idea*, not the object itself, that matters. Our manner of seeing art became non-physical; our art became non-physical – *conceptual* – also.

As stated, the emergence of conceptual art – and of contemporary art more broadly – caused a split: the general public still love bronze statues, landscape paintings, and portraits; artists favoured by the critics and awards panels prefer discarded tyres. George Orwell noticed this gulf opening in the 1940s, here in reference to Salvador Dalí:

> [Traditionalists] would flatly refuse to see any merit in Dalí whatever... their real demand of every artist is that he shall pat them on the back and tell them that thought is unnecessary. But if you talk to the kind of person who can see Dalí's merits, the response that you get is not as a rule very much better... If you say that you don't like rotting corpses, and that people who do like rotting corpses are mentally diseased, it is assumed that you lack the aesthetic sense.[11]

What happened? Perhaps art became sealed off, an institution compartmentalised *within* society rather than syncreted *throughout* it, as art had once been. Thus, separated into a silo of their own without any obligation to cater to 'public taste', artists could do whatever they wanted – and the critics and curators applauded. Does this mean that contemporary art is a con? Maybe... though maybe a con can be art! It's true that less skill is (usually) required

in taking a knife to a canvas than painting one, but audacity itself is the very currency of such art.

Well, it's easy to poke fun at bananas taped to walls and that sort of thing. Plenty of contemporary art is marvellous; plenty is ridiculous. More troubling is the gulf, alluded to, between the art establishment and the public. But I think there is something more useful and interesting we can talk about – which is *why* art has changed so radically. We have already spoken about the impact of technology, but I think there was a more serious thorn in the heart of humankind, a set of facts that better explain the rise of conceptual and contemporary art.

Consider these lines from *The Renaissance*, a book by Walter Pater published to much controversy in 1873:

> Our one chance lies in expanding that interval, in getting as many pulsations as possible into the given time . . . Of this wisdom, the poetic passion, the desire of beauty, the love of art for art's sake, has most; for art comes to you professing frankly to give nothing but the highest quality to your moments as they pass, and simply for those moments' sake.[12]

What was happening? People were becoming self-conscious about 'art' in a way they never had before. Remember what we said about art and context. In the past it was made for churches, temples, streets, or homes; nobody ever had to wonder what art's 'purpose' was. Think of Fra Angelico painting the walls of the Convent of San Marco so that the spirits of the monks, guided by their eyes, might be lifted a little closer to heaven. But in the nineteenth century we started making art specifically *for* galleries. Most of what was produced remained traditional, but it makes sense that, cut off from any clear purpose other than the creation of art for the seeming sake of it, a great many

artists became more self-conscious and therefore more experimental. When Leonardo's notes on art were collated and published they were entitled *A Treatise on Painting*; when Michael Craig-Martin published his own treatise it was called *On Being an Artist*. Notice the change in subject: from *art* to *artist*. The severing of art from purpose may have found its logical conclusion in *An Oak Tree*.

But that is not all, and may not even be the most significant factor. Because, in the late nineteenth century, everything was transforming. Pater spoke for a world that changed too much, too fast, for an echelon of society that became too rich, too quickly. And this was a process that, in the twentieth century, went stratospheric: cities metamorphosing into metropolises, countrysides devoured, populations soaring, neutrons discovered, Black Holes theorised, ships like iron castles billowing over oceans, cars, skyscrapers – and all this culminating in a war unlike anything we had ever known. The generation that lived through all this – and found themselves half destroyed in the trenches – had no reason to trust the 'traditions' or 'values' of a society that had smothered them in mustard gas. And *psychologically* they were devastated. Then, with the atomic bomb, it all happened again. Say what you will about the warlords of old, but they struggled to kill more than a few thousand on any given day; we have taken to killing thousands by the minute, if not by nuclear warheads then with gas chambers or state-orchestrated famines. It makes sense, given the unutterable chaos and violence of humanity's last hundred years, that art – which inevitably expresses the mindsets and spirits of an age – changed in keeping. So perhaps *that* is what the strangeness of contemporary art truly expresses: a society that nearly committed suicide, a society whose foundational assumptions cracked apart, where art suddenly had nothing to latch on to.

CHAPTER IV

Through Marble Darkly

†

This dread, these shadows of the mind, must thus be swept away
Not by the rays of the sun nor by the brilliant beams of day,
But by observing Nature and her laws.

– Lucretius, *On the Nature of Things*[13]

Rather than learning *about* art, let's see what we can learn *from* art. After all, I have claimed that art is the inevitable expression of the life and times of the people who made it – but is that true? To investigate, I offer you a series of sculptures. Let's see what they can tell us about ages past. For, as William Morris wrote: 'Who can say how little we should know of many periods, but for their art? History (so called) has remembered the kings and warriors, because they destroyed; Art has remembered the people, because they created.'[14]

1. A death mask

Too much art analysis aims at obscurities. Let's focus on simple deductions, which can be the hardest to spot precisely because of how fundamental they are. Here you see the funerary mask of Tutankhamen, a pharaoh of the Eighteenth Dynasty of Egypt, who

died in 1323 BCE. It is made from a range of gold-copper alloys, each varying in purity, inlaid and encrusted with lapis lazuli, obsidian, carnelian, turquoise, amazonite, quartz, and glass. Upon its shoulders is inscribed a protective spell from the Book of the Dead.

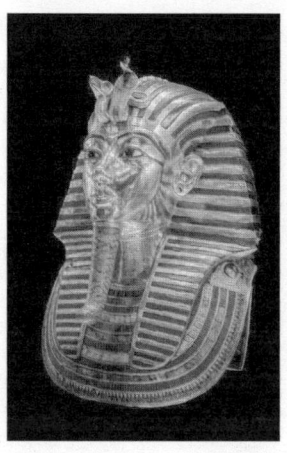

What can we learn from this mask? The Egyptians who made it were clearly highly skilled craftsmen; its finish is technically perfect, even 3,000 years later. We can also deduce that this was a rich kingdom (such a quantity of gold and gemstones!), that its kings were revered, and that – given those incantations – it was a ritualistic society. 'Obvious!' you say. Maybe, but my simple point is that this one mask tells you a great deal about the ancient Egyptians even if you don't know anything else about them.

2. Mesopotamia and Crete

Here are two sculptures, one made by the Sumerians of Mesopotamia in 2500 BCE and one by the Minoans of Crete in 1500 BCE. The Bull-Headed Lyre of Ur is a musical instrument; the Minoan bull is a

rhyton, for drinking wine or pouring libations. Bulls were obviously of some significance to both societies; they were primarily agricultural, so it's unsurprising that sheep, cattle, and oxen feature prominently in so much of their art and religion. Think of the earliest books of the Bible: we are told Abraham 'was very rich in cattle, in silver, and in gold.' Cattle before gold! Bulls evidently meant far more to Sumerians and Minoans than they do to us – and their art tells us so.

3. Three figures

From left to right: a bronze of a priest made in 1200 BCE in the kingdom of Shu in China; the so-called 'Dancing Girl of Mohenjo-Daro', made in 2000 BCE by the Indus Valley civilisation; the limestone Warrior of Hirschlanden, made in the sixth century BCE in northern Europe.

They all depict humans, but they are hardly 'realistic'. Were these artists incompetent? No. With their elongated bodies, neither the priest nor the 'Dancing Girl' were *intended* to be realistic, while the Warrior of Hirschlanden, with his huge legs and contorted torso,

cannot have been a serious attempt at 'Realism' either. So why did these artists choose *not* to create realistic statues? Maybe what interested them was not the outward appearance of a person or type of person. Rather, it may have been *inner* qualities they considered most important. This would surely explain the exaggerated and 'unrealistic' style used to express that inner nature, or to symbolise the role of somebody like a priest or warrior.

4. From Greece to Rome

Consider the *Diadumenos*. This is a Roman copy, but the original was made by Polycleitus, a sculptor from fifth-century BCE Athens. Here we see an athlete wrapping a ribbon of victory around his head – a familiar scene for attendees of the ancient Olympic Games. I could tell you that victorious athletes were regarded as having been blessed by the gods, but you can see that in Polycleitus' work. Now compare it with a statue made by the Romans of Cato the Elder, a statesman and philosopher who lived in the second century BCE.

Though the *Diadumenos* is lifelike, it has entered the realm of idealism. We don't see the face of an individual so much as the face of generically ideal man. All is harmonious and proportionate. The expression is distant, almost severe in its serenity, even god-like. This was the ideal of beauty to which Greek statues of the time were calibrated.

Cato, meanwhile, has the idiosyncratic features of a real person – he could be recognised from this likeness. But, it seems, the Romans also went beyond being merely lifelike, only rather than pursuing ideal beauty they pursued ideal ugliness. And it isn't warts and all for the sake of it – this ruggedness was considered a sign of noble character. Cato opposed Hellenisation and believed that Rome relied on men who were hard-headed, agricultural, warlike, and frugal. Thus Cato's uncompromising bust is, by design, the perfect counterpoint to Polycleitus' Apollonian athlete.

Can we conclude that a Greek was sophisticated and philosophical, and worshipped beauty, while a Roman was honest, rough, and pragmatic? They would each *want* us to think that. So even if these

statues don't represent what those societies were actually like, they do tell us how they thought of themselves.*

5. San Zeno or San Giovanni

On the left are the bronze doors of the Basilica of San Zeno in Verona, made by two anonymous master metalsmiths in the late eleventh and early twelfth centuries. On the right are the bronze doors of the Baptistery of San Giovanni in Florence, made in the early fifteenth century by Lorenzo Ghiberti and known as 'The Gates of Paradise', a name given by Michelangelo himself.

These two works of art are made of the same material, in roughly the same region, and depict similar subjects – scenes from the Old Testament. But the masters of San Zeno were concerned above all with narrative clarity. It was the truth of the stories of the Old Testament they sought to convey. Ghiberti, one senses, wanted to create something beautiful in its own right. The panels of San Zeno have

* The time has come to share a shocking fact: a white marble statue would have looked unfinished to a Greek or Roman. Why? Because, originally, they were painted. This is worth some serious rumination, not least because ever since the Renaissance we have falsely assumed these sculptures were meant to be pure marble, thus Michelangelo's *David* and suchlike. A curious accident of history, and one that has led to much misinterpretation.

an almost brutal roughness that speaks of a culture emerging from the Dark Ages, while those of San Giovanni tell of a sophisticated civilisation full of confidence. Which of the two was more *pious* is revealed by their emphases. We do not admire the craftsmanship of San Zeno; we focus on the stories. We admire the majesty of Ghiberti's work; do we forget what it was intended to show?

6. Renaissance revolution

On the left: jamb-sculptures from Chartres Cathedral in France, carved in the twelfth century. On the right: Michelangelo's *David*, unveiled in Florence in 1504. The statues of Chartres have neither Greek idealism nor Roman forcefulness. They are, in a word, plain. But we should not be surprised. Medieval people, recall, took a dim view of humanity. As Thomas à Kempis wrote: 'Today man is, and tomorrow he will be seen no more. And being removed out of sight, quickly also he is out of mind.'[15]

Little wonder the stonemasons of Chartres paid no heed to physical beauty.

That being the case, what do we make of Michelangelo's *David*? A colossus, naked and idealised, his face rapt with concentration, every sinew rendered. Man, as he had been in antiquity, was triumphant once again. *David* shall not be 'quickly out of mind' – he does not represent piety so much as humankind's potential for greatness, like Hector 'to be remembered among men for some glorious deed hereafter'. By seeing *David* in contrast with the sculptures that preceded him we grasp in an instant what the Renaissance was all about.

7. The Return of the Olympians

Another straightforward deduction – though often, one suspects, wilfully ignored. What statues line the halls of medieval palaces and guard the gates of Gothic cathedrals? Saints, angels, prophets, and demons: Christian art. But Gianlorenzo Bernini, the most influential sculptor of seventeenth-century Europe, carved figures from classical mythology. Pagan scenes previously blasphemous had become fashionable. Thus Europe, however Christian it was after the Renaissance, was clearly not as devoutly Christian as it had been in the Middle Ages. Whereas once the tombs of the Venetian dukes

(for example) were simple sarcophagi engraved with crosses, they later became miniature temples piled with Greco-Roman deities. On the left we see the tomb of Doge Marino Morosini (1253) and on the right that of Doge Bertuccio Valier (1708). You do not need me to point out the difference.

8. Truth

This is the Bronze Head of Ife, created at some point in the fifteenth century by artisans in the court of King Obalufon Alayemore in modern Nigeria. European archaeologists initially refused to accept that it could have been made in West Africa. They believed Africans were not capable of sophistication and peddled theories about lost Greek cities. Alas, books can deceive and people sometimes let prejudice close their eyes, but heads of bronze cannot lie. There *was* a sophisticated civilisation in West Africa – more than one! We can draw a simple but profound conclusion: art is *proof* and art is *truth*.

9. Reason versus romance

Antonio Canova was among the most celebrated Neoclassical sculptors of the early nineteenth century, and here he puts US president George Washington in the regalia of a noble Roman general. Every inch of this marble, pure as hoar frost, tells us what Washington sought to emulate and how Canova and his contemporaries thought of themselves. This was the Age of Reason, of rationalising political science and classicising ideals of human nature.

Then we have Auguste Rodin, the most famous sculptor of the late nineteenth century. Gone is that snowy marble and gone is that intellectual repose. His statue portrays a man called Andrieu d'Andres, one of the Burghers of Calais who sacrificed themselves for their city during the Hundred Years' War. But this is more than an individual; we seem to see a primordial creature somehow representing *all* humans.

Here, in the restlessly worked forms of Rodin, we see the culmination of the Romantic imagination: *feeling* cut off from time or

place, from any philosophy or political agenda. It is perfectly non-reasoning and resolutely emotional; it is the opposite of Canova's rational, enlightened, imperial marble. Though he wrote them nearly a century before Rodin thumbed his clay, these lines of Shelley could well have been composed by that clay:

> ... this Whole
> Of suns, and worlds, and men, and beasts, and
> flowers,
> With all the silent or tempestuous workings
> By which they have been, are, or cease to be,
> Is but a vision;—all that it inherits
> Are motes of a sick eye, bubbles and dreams;
> Thought is its cradle and its grave, nor less
> The Future and the Past are idle shadows
> Of thought's eternal flight—they have no being:
> Nought is but that which feels itself to be.[16]

10. Sports, symbols, saints

I present to you three sculptures and ask if they seem familiar. Thierry Henry outside the Emirates Stadium in London; *Melancholy* by Albert György; Revd Martin Luther King Jr above the west door of Westminster Abbey in London. All of them were made in recent decades.

Yes, they *are* familiar. The Greeks worshipped their athletes and carved heroic likenesses of them; we now fill our cities with statues of our sporting heroes. Our ancestors didn't care for 'realistic' depictions of humanity but for art which spoke to inner truths; György did not seek to create a 'realistic' human being in *Melancholy* but aimed at a deeper expression of emotion. In the Middle Ages they placed saints upon their cathedral doors; Dr King, a Christian martyr, has taken his place there also. It may be that our art has not changed quite so much as we are sometimes led to believe.

I have been banging the context drum hard, but I must end with the caveat that it is important not to see art as nothing more than the expression of politics, economics, or religion. Art does express those things, but that is not all – and we are under no obligation to consider them. Art can stand alone, free, uninhibited. It was Alida Valli, playing the character of Anna Schmidt in Carol Reed's 1949 *The Third Man*, who said that 'a person doesn't change the more you know about them.' She could have said the same about art. By viewing art only as a sort of historical artefact we close our eyes to the fulness of its delight, depth, terror, wit, and truth.

If Mozart's music moves you but you have no notion of Habsburg politics in eighteenth-century Vienna, does that make his music any less moving? Does Rodin's statue of Andrieu d'Andres merely represent the romanticising tastes of the late nineteenth century, or does the downcast face of the figure express some universal image of human weariness – and of effort, hope, life? Do the ceramics of the Taj Mahal only speak of the Mughal prohibition of religious art that portrays humans or animals? I pray for that poor soul who looks upon those glittering walls of pink and white and sees only *rules*.

Art is always bound, in part, by context – a context that may, as time rolls on, vanish and be sealed off from us. But art has, inevitably, something eternal and timeless in it that can be seen by anybody. A symphony, a statue, a poem – these things exist in their own right, like stars, apart from the Earth, and we can receive their light without knowing from what far-off galaxies, perhaps already dead, they shine.

CHAPTER V

The Lesser Arts

†

Then first he form'd the immense and solid shield;
Rich various artifice emblazed the field;
Its utmost verge a threefold circle bound;
A silver chain suspends the massy round;
Five ample plates the broad expanse compose,
And godlike labours on the surface rose.

– Homer, the *Iliad*, Book XVIII

Somebody designed this book you are holding. Somebody designed the font of the words you are reading.* Your laptop, clothes, glasses, watch, coffee mug, furniture, the street signs, the cars, the window you are looking through. All these things only exist because someone has made them, and there is nothing made that has not also been designed. Traditionally, a distinction is drawn between 'fine arts' and 'lesser arts'. The first comprise painting, poetry, sculpture, music, theatre, architecture, cinema, and photography, and the second are about creating the things we use. You use a frame, not a painting; you use a door knocker, not a sculpture; you use a camera, not a movie. But all these things – frames, door knockers, cameras – can

* To be specific, Jean Jannon in the year 1621.

also be aesthetically pleasing in some way. Our phones are works of lesser art. The rose-gold case that caught your eye? That is the power of the lesser arts: to make lovely the things we use. A world that pays no heed to the lesser arts, then, will be an ugly world indeed. Paintings are few and far between, but the things we use are everywhere.*

Once upon a time there was no such thing as 'mass production' or 'machines'; everything was made by hand. And when we make things with our hands we inevitably decorate them: when baking pies we press their edges to make a pleasing pattern; we fill our notebooks with doodles. Apply that to the making of literally everything and you begin to understand why William Morris wrote of the Middle Ages: 'When a man turned the wheel, or threw the shuttle, or hammered the iron, he was expected to make something more than a water-pot, a cloth, or a knife: he was expected to make a work of art also.'[17]

It is popular now to say that 'anything can be art', and the strangest thing of all is that, eight hundred years ago, people believed the same thing. In the past everything was a 'work of art' because it was made by hand. Think of Achilles' shield, famously described by Homer, or the elaborate parade armour of Henry II of France, crafted by the goldsmith Étienne Delaune, or even the dragon-shaped prows of Norse ships. Benvenuto Cellini, one of the most famous Renaissance artists, is best remembered for a salt cellar! There is no artefact, unearthed from soil or hauled from seaweed, that is not *somehow* a work of art. Thus our museums are jam-packed with the detritus of daily life. Charming detritus, affectionately made, gratefully used, still delighting us after their retirement to the glass cabinet: incense burners, gates, door handles, hairpins, inkpots,

* There is also a new form of lesser art: digital design.

desks, carpets, curtain rails, lamps, even drainpipes. The craftspeople who made them did something 'great' artists could not – they beautified the world at large.*

But during the Industrial Revolution the workshop was replaced by the factory. Designers in their studios designed; labourers, treated like machines, were set to assemble these designs exactly as they were told to. Gone was the joy of creation and the liberty of personal art. It was because of this fall of the crafts that, in the second half of the nineteenth century, artists set themselves to resurrecting the practices of yore. This generation was led in Britain by William Morris, who urged 'designers' to get back to the potter's wheel and *make* things. This was a pan-European awakening and it helped pave the way for Art Nouveau and Art Deco. So these movements represented something like a revolt of artisans against industrialisation – and we have not yet grown bored of their work, be it the vases of Émile

The *Mercury Streamliner.*

* It is also true that the medieval carpenter (for example), free to carve whatever fancies they imagined upon their benches, was happier in their work than a modern operator assembling prefabricated parts.

Gallé, the balconies of Hector Guimard, the cabinets of Eugène Gaillard, or the lamps of René Lalique. Even their trains were works of art – and we now look with envy on those retired locomotives.

Then again, of all the people alive in the 1920s, how many could afford one shard of glass blown by Tiffany & Co.? No, Nouveau and Deco could not last. It was the artists of Bauhaus who sought, in the end successfully, to find a new way of designing things suited to the world of industrial mass production. Ludwig Mies van der Rohe designed his Barcelona Chair, Marcel Breuer his Wassily Chair, and Christian Dell his Molitor Grapholux Lamp. These were all steel or plastic, stylish and smooth, ready to be mass-produced for the people at large. Such minimalism – done right, done purposively – is wonderful.

But back to Morris, who in 1880 had written this: 'For whereas all works of craftsmanship were once beautiful, unwittingly or not, they are now divided into two kinds, works of art and non-works of art.'[18]

This observation might also be made of the twenty-first century – we no longer seem to believe that a bookcase, spoon, train, or ticket machine can be art. Think of air-conditioning units. We put them everywhere. In the past this would have been seen as an opportunity to make the world more beautiful, not less. Alas, these grey or white boxes are inconceivably bland. No medieval craftsman would have designed them like that, nor any designer of Art Nouveau or Bauhaus. Each of these schools, despite their differences, agreed that any given thing could be a work of art. We shrug and say 'there is no other way' when somebody points out the ugliness of air-conditioning units. There *is* another way, and if we are to cast off our plague of blandness it begins by accepting that an air-conditioning unit can, strange as it sounds, be art.

When George Gilbert Scott designed his famous red phone box

in the 1920s* we were already well into the days of industrial mass production. But, with those subtle mouldings, it *is* ornamented. A few well-placed lines – not Baroque spoof – are all it takes. And so these phone boxes, long after being made obsolete by mobile phones, remain on the streets of Britain. Why? Because people like them. That is what happens when lesser arts are done right; a little ornament is no crime and people are much the happier for it. Meanwhile the unornamented phone boxes of the 1980s are, rightly or wrongly, condemned as eyesores. And who has not admired the cast-iron lamp posts of yesteryear? Well, these were *also* mass manufactured. The whole history of the lesser arts cries out to us, 'Bland design is not necessary!'

It shouldn't be controversial to say that, in the twenty-first century, the people of Japan are particularly admired for their work in the lesser arts. Their bowls (to pick just one example) are beloved. Why? Not just because they *are* handmade, but because they *look* handmade. Each of these curious ceramics with their misshapen rims and crackled glaze are, we believe, unique, and thus they have character and charm. They are not blankly 'functional' but are somehow living, reflective of nature, and quite beautiful. This is in direct contrast to the starkly standardised, uniformly manufactured objects with which we are usually surrounded.

But there is more going on. In the past people tended to look after their possessions. We toss them away, often out of boredom rather than because they are broken, though even then we rarely seek to have them repaired. Obsolescence is the currency of consumerism. If we demand maximum choice and maximum cheapness, the objects of lesser art cannot be beautiful and the people who

* There were several models, not one, but we can set aside those details here.

make them will not enjoy their work. Is consumerism incompatible with a full embrace of the lesser arts? It seems unlikely that we can wholly return to the handmade days of old, but wherever people have no creative input in their work we are both demoralising them and losing much that we might gain, all for the sake of standardisation and consumer choice.* Consider what William Morris said, so exquisitely and persuasively, on a winter's night in 1877:†

> To give people pleasure in the things they must . . . use, that is one great office of decoration; to give people pleasure in the things they must . . . make, that is the other use of it.[19]

We *must* use things and so we *must* make things – but, if both making and using them is boring at best and straightforwardly unenjoyable at worst, what is the point in using or making them at all? Why bother sustaining a consumer culture when neither what or how we create with it brings joy to our lives? That is the full force of Morris's point.

There *are* instances where function is all that matters, but these are rare. Settling for blandness when we could instead have something joyful or interesting makes our lives needlessly boring – and the true cost of boredom, of being surrounded by blandness, is a crushing of our imagination and withering of our humanity. So let us look to the message of the Middle Ages, of Fatimid Damascus, Bauhaus Dessau, and Art Deco New York. *Anything* can be beautiful,

* And we must not forget that whatever is 'Designed in California' is also 'Made in China'. The only reason we can choose from eighty different kinds of suitcase is because there are people making them for us, labouring in miserable conditions, without any say in their work, and paid so little it doesn't bear thinking about.

† 'What? Quoting William Morris again?' Should I quote somebody else for the sake of variety? Where Morris said it best I would be doing you a disfavour not to share his words.

a work of art in its own small way, whether a train, lamp post, doorbell, drainpipe, or turnstile. We *can* produce air-conditioning units that future generations will look on with admiration, as we do the 'ordinary things' of ages past. Hasten the rise of the lesser arts to the role only they can fulfil: making the world at large more beautiful, our labour more enjoyable, and every passing moment of our brief lives a little less tedious, a little more delightful.

CHAPTER VI

Humpty Dumpty and Homer

†

> I am like the centre of a circle,
> equidistant from all points on the circumference.
> — Dante, *La Vita Nuova* [20]

Another kind of art now: poetry. And let's jump into the thick of things: I think you should write a poem. Truly. What is the point of education if it does not lead us to joy and help us understand ourselves better? Poetry can do that. So the purpose of this chapter, though it may seem odd, is to help you write a poem.

But there is a broader purpose here. Poetry can be notoriously difficult to 'get'. Well, by looking at poetry from the inside – from the point of view of the poet – you will 'get' poetry much more quickly than by reading analyses or studying the history of verse. If you have ever wondered what the point of poetry is, why we write it, and what all the fuss is about, I hope this chapter will answer those questions. Because poetry matters – it is a wonderful thing, a global phenomenon by which humankind has for thousands of years been preserving in verse its deepest fears, strangest hopes, and holiest truths. And by saying 'poetry' I also include the lyrics of popular songs and rap. This is nothing new. Even the great Edwardian literary critic Arthur

Quiller-Couch* observed that the origins of English poetry (for example) lay with folk-singers and ballad-writers.

The first question is: why should you – or anybody – write a poem, or write anything at all? The only possible reason is *because you have something to say*. Now you understand the first ever human poet, whoever they were, living millennia ago. Let's call them the Ur-Poet. This Ur-Poet was compelled to say something: to express a feeling, relate an event, or explain some discovery. Or, to put that another way, they needed to say something they believed to be *truthful*. There are few ways we can hope to understand our most distant ancestors, but in needing to say something truthful we can understand one another, this Ur-Poet and us.

So that is where poetry began and where every poem must begin.

Why did Enheduanna, the first named writer in human history, write her hymns to the goddess Inanna 4,000 years ago? Because she had something she needed to say: that she had faith in Inanna, that she feared and loved her:

> O my Lady,
> Beloved of Heaven,
> I have told your fury truly.
> Now that her priestess
> Has returned to her place,
> Inanna's heart is restored.[21]

Consider this, then, the oldest lesson: better to be heartfelt but unpolished than sophisticated but hollow. Our goal must be, as it was written on the Temple of Apollo at Delphi:

ΓΝΩΘΙ ΣΑΥΤΟΝ ~ KNOW THYSELF

* It was he who coined the cutting line of advice to authors – 'murder your darlings'.

If you can figure out, even haltingly, what you think and what you feel, you have the beginnings of a poem. Consider W. H. Davies, the Welsh Super-Tramp, whose prosody (the patterns of rhythm and sound) was conventional but whose thoughts were clear enough to grant him enduring popularity:

> What is this life if, full of care,
> We have no time to stand and stare . . .[22]

It all sounds very paint-by-numbers, but what Davies felt triumphs over his prosodic shortcomings. And here is Lizzie Siddal, writing in the nineteenth century:

> Yet keep thine arms around me, love,
> Until I fall to sleep;
> Then leave me, saying no goodbye
> Lest I might wake, and weep.[23]

Despite the simplicity of her verse, our hearts are melted by the clarity and depth of her feeling. Or take the War Poets. Even if they had the talent they had not the time to become masters; not enough time because they were young men who wrote in the thick of battle. In all of this they experienced things most of us cannot comprehend:

> I, that on my familiar hill
> Saw with uncomprehending eyes
> A hundred of thy sunsets spill
> Their fresh and sanguine sacrifice,
> Ere the sun swings his noonday sword
> Must say good-bye to all of this;
> By all delights that I shall miss,
> Help me to die, O Lord.[24]

THE FOURTH PILLAR OF THE CULTURAL TUTOR

Though nobody would call William Noel Hodgson subtle, nobody could call him anything other than soul-stirring. He overheard his own thoughts, looked into his heart at the darkest of moments, and returned to share what he discovered.

So let this be your aim: not pretty words or smooth verse but the simple expression of the truth as clearly as you can see it. How? Describe things as they are. Don't try too hard. Don't be self-indulgent. Arthur Rimbaud, a young French poet of the nineteenth century, was sometimes guilty of this despite his extraordinary talent.

> It is a green hollow where a river sings
> Madly catching on the grasses'
> Silver rags; where the sun shines from the proud
> mountain:
> It is a small valley which bubbles over with rays.
>
> A young soldier, his mouth open, his head bare,
> And the nape of his neck bathing in the cool blue
> watercress,
> Sleeps; he is stretched out on the grass, under clouds,
> Pale on his green bed where the light rains down.
>
> His feet in the gladiolas, he sleeps. Smiling as
> A sick child would smile, he is taking a nap:
> Nature, cradle him warmly: he is cold.
>
> Odors do not make his nostrils quiver;
> He sleeps in the sun, his hand on his breast,
> Quieted. There are two red holes in his right side.[25]

We can only assume his bait-and-switch was aped from Victor Hugo's *Demain dès l'aube*.

Tomorrow, at dawn, at the moment when the day
 breaks,
I will go. You see, I know that you are waiting for me.
I will go through the forest, I will go across mountains.
I cannot stay away from you any longer.

I will walk eyes fixed on my thoughts,
Without seeing anything outside, without hearing a
 noise,
Alone, unknown, back hunched, hands crossed,
Sad, and the day for me will be as the night.

I will watch neither the gold of the evening
 setting sun,
Nor the faraway sailboats descending upon Harfleur.
And when I arrive, I will put on your grave
A bouquet of green holly and heather in bloom.[26]

Both seem to be conventional poems but at the end subvert expectations. Who did it better? Rimbaud piles up imagery packed with adverbs, adjectives, and metaphors. Hugo does no such thing – he speaks of mountains rather than 'proud' mountains, for example. It seems that where Rimbaud simply revels in the conceit of tricking the reader into thinking the subject of the poem is alive, Hugo genuinely feels the bitter irony in how similarly a person goes to their loved one whether they are living or in a grave.

Rimbaud writes of rivers singing and valleys bubbling, and refers to grass as silver rags. Compare that to how William Wordsworth deals with nature (and his thoughts and emotions also) – by describing plainly what he sees and feels:

> Once again
> Do I behold these steep and lofty cliffs,
> That on a wild secluded scene impress
> Thoughts of more deep seclusion.[27]

Wordsworth does not mess around with overwrought similes; he just gives us what he saw. And this is part of the magic of *haiku*, a form of Japanese poetry with three lines and a set number of syllables in each. With so little space there is no room for frivolity. They can be wonderfully allusive and even mysterious, *haikus*, but their brevity precludes overwrought language. By Kobayashi Issa:

> The snow is melting/and the village is flooded/with children[28]

Poetry is and always has been, above all else, truthful. This fact is proven by translated poetry. Because, however admirably rendered in another language, we can never fully convey the linguistic texture of the original. And *yet* – it does not matter. So when Sappho sang:

> Like a sweet-apple
> turning red
> high
> on the tip
> of the topmost branch.
> Forgotten by pickers.[29]

our English cannot convey her Greek. But what Sappho said, however brief, bites hard; the truth and strength of her thought overcomes any barriers of translation.

Poetry is unlike ordinary speech; it often has stanzas, rhythm, meter, rhyme, prosody, alliteration, and so on. These are helpful

tools for a poet – because the second thing our Ur-Poet tried to do was make their truthful expression *memorable*. And there are certain laws of language that mean, if you arrange sounds in a particular way or place the stress on words in a certain order, what is said stays with us. A line from Thomas Gray:

> The paths of glory lead but to the grave.[30]

Once read, you cannot forget those words – they *stick*. More so, certainly, than to say, 'no matter how successful you are you cannot avoid death.'

Nonetheless, many poets get caught up in pretty images or clever conceits and lose sight of what they are trying to say. The risk associated with poetry is the same one that attends all creation: *convention*. Your mind, like mine, like everybody's, is filled with words and ideas that belong to other people. We say what other people say, think what they think, and do what they do, without ever stopping to ask whether it is correct. To write poetry you must learn to see the world with fresh eyes. In practical terms, this means you should not mention the rose in connection with romance before you have asked yourself whether a rose has anything to do with love. You've probably come across a lot of poetry that mentions the rose, and you conclude it must be romantic, beautiful, red. Stop – and look at a rose properly. Only then consider whether or not to include it in a love poem. Homer called the Aegean 'wine-red', but that does not mean we have to. Avoid becoming one of those poets who is, as Montaigne wrote, 'tempted by the charm of an attractive phrase to write about something they had not intended'.[31]

Consider a few astonishing lines – precise and profound – from the Victorian poet Elizabeth Barrett Browning:

> But when a soul, by choice and conscience, doth
> Throw out her full force on another soul,
> The conscience and the concentration both
> Make mere life, Love.[32]

What impression do you get? That Browning was under the invisible control of convention, that we are reading the feelings and words of *other* people? No. She selected the words she wanted to use and fully expressed her own thoughts. And that is poetry: *your* judgement – perhaps guided by external factors, though experienced first-hand – used to select fitting words, arranged appropriately, even if unordinary and distinct from everyday speech, so as to elevate them into something *more*.

Strike up, if you dare, the ancient drums of poetry! But don't be too ambitious. Try two lines, maybe four. Find a single thought you want to express and focus on it. Labour over the words and their arrangement until four truthful lines have emerged.* If you can do it once, you can do it again. Sir Philip Sidney, an Elizabethan knight and poet of love, warns us of our fate if we do not at least try:

> But if—fie of such a but!—you be born so near the dull-making cataract of Nilus, that you cannot hear the planet-like music of poetry; if you have so earth-creeping a mind that it cannot lift itself up to look to the sky of poetry . . . I must send

* Here, by way of pudding's proof, I offer my own attempt:
 Of love I may say, loving and having been loved:
 Two are not united, becoming one, in love.
 Rather, the truth, one becomes two – and twice over,
 As each lover is made themselves and another.

you in the behalf of all poets:—that while you live in love, and never get favor for lacking skill of a sonnet; and when you die, your memory die from the earth for want of an epitaph.³³

CHAPTER VII

Is *Hamlet* True?

†

But ancient beauty slumbers, and men forget
Whatever has not been yoked to echoing streams
 of song

– Pindar, *Seventh Isthmian Ode*[34]

What is literature?* A good question. How might we answer it? The best way, I think, is to remember that the Immortal Bard, William Shakespeare, was once just a Warwickshire Shithouse and an Upstart Crow, son of a Stratford glovemaker, just another Elizabethan playwright slumming it in the flea-bitten theatres of Tudor London. He was a showrunner and part-time actor, one of the Lord Chamberlain's Men, a writer writing for pay and eager to retire when enough dough had come his way. He went back to Stratford-upon-Avon at forty years of age and made his daily bread in peace with his wife, Anne Hathaway, leaving her his 'second best bed' in his final will and testament.† Not so far away the Countess

* I mean literature in the narrower sense – what we call poetry, drama, and novels.
† Whether this was a private and affectionate joke between the two, a disparagement, or an entirely serious bequeathal we do not and will never know. Of the three I cannot decide which I would it rather be; the first is most touching, the second most instructive, and the third most funny.

of Pembroke, Mary Sidney, was translating Psalms, Petrarch, and *Triumphs* – and penning plays of her own. Matsuo Bashō wandered seventeenth-century Japan in search of success, and gained it with his poems; he found celebrity unsatisfying and became a hermit. Wandering once more as a travelling monk-poet, without thought for the approval or otherwise of the literary cliques in Chūō, he was, we are told, much more at peace with his circle of disciples. Reaching Ōgaki, he wrote these words

> the rough sea/stretching out towards Sado/the Milky Way[35]

and spent three years editing *The Narrow Road*, which was published posthumously to critical acclaim. Joseph Conrad, half dead in some Frisian port, alighted a Belgian steamer destined for the Congo and there saw Hell, returned to London, finding there in the chimney-clogged and sick grey twilight of the Thames a darker Hell, and wrote *Heart of Darkness*. The young Chinua Achebe in the 1960s decided he would write a better story of Africa – *Things Fall Apart*. Homer, before he went blind, looked down from the cliffs of Chios, imagined the Greeks setting sail and at the evening feast recited a canto of what was to become *The Iliad*. Dante Alighieri, a political exile from Florence, was taken in by the Italian nobleman Cangrande della Scalla in Verona, and had hardly completed the *Paradiso* before he was refused a professorship at the university and so went through the marshes to Ravenna, where, struck down with malaria, he died and was buried. Marina Tsvetaeva felt full-swell the passions of a land in revolt, the blood and snow of a Moscow divided – and, from both, drew passion. Roberto Arlt boozed with stevedores at the dock-taverns in Buenos Aires, and scrawled his mad novels there, and Jorge Luis Borges, somewhere across the city, surrounded by rival circles of intellectuals in their cafés, composed

his careful stories. Marcel Proust was a living man, once, and bad reviews made him weep!

So this is literature: things that have been written by various people – priests, prophets, poets, playwrights, lonesome scholars, village entertainers – for various reasons, in all places and in all corners of the Earth, which our ancestors deemed interesting enough to preserve and pass on to us. Literature is, put simply, the stories that have survived.

Sometimes, though, their survival was a matter of luck. It is only because a scroll of linen was found in a heap of Alexandrian rubbish that we have certain fragments of Sappho, so highly regarded in ancient Greece that they called her the Tenth Muse. We only know about Enheduanna because priests of later generations inscribed her hymns on clay tablets – tablets then lost in the dust and by chance unearthed thousands of years later:

> The compiler of the tablet is Enheduanna.
> My lord, that which has been created here no one
> has created before.[36]

Thus we know it was she who started the tradition of literature in whose wake emerged the Hebrew Bible, everything Greek or Roman, and all since descended from them.

But *what are* all these stories, all these novels and plays and poems? We know they are not exactly 'history'. Raymond d'Aguilers, who took part in the First Crusade, journeyed from Toulouse to Jerusalem and chronicled what he saw so people waiting for news back home (and posterity) would know what had happened. Four centuries later the Italian poet Torquato Tasso wrote a fictionalised account of the First Crusade – the epic poem *Jerusalem Delivered* – and turned Godfrey of Bouillon into its protagonist, even though

as a matter of fact he was not. But more people have read Tasso's version of the First Crusade than that of Raymond d'Aguilers. Equally, more people are familiar with mythologised tales of the Trojan War than with historical accounts of Ionian Revolt. Homer makes for better reading than Herodotus, it seems. More people have read the novels of Gabriel Garcia Márquez than have read a history book about Colombia; more have read Umberto Eco's *The Name of the Rose* than academic papers by the same author. It seems that, on the whole, we are drawn to stories rather than works of non-fiction.

Why? One theory suggests that cognitive biases, whereby our brains take a shortcut around rationality, have played a role. We evolved them to filter information more quickly and therefore help us make swifter decisions. Think of a shadow leaping out from the bushes; no time to analyse whether this is an actual threat – better to instinctively flee. Some speculate that our manifold cognitive biases, which affect the way we process information, mean we remember, understand, and enjoy stories more than hard facts, concepts, or statistics. Hence (for example) we read *Aesop's Fables* to children rather than giving them abstract moral lectures.

Does this theory hold water? Are stories and their popularity just the product of cognitive biases? Is literature simply a more efficient method of imparting *information*? No! What was there in the work of that 'queasy undergraduate',* 'village explainer',† 'tadpole of the lakes',‡ 'large shaggy dog',§ or 'solemn ass braying'¶ that you

* Virginia Woolf on James Joyce.[37]
† Stein on Pound.[38]
‡ Byron on Keats.[39]
§ R. L. Stevenson on Whitman.[40]
¶ D. H. Lawrence on Melville.[41]

found informative? Did you get your economics from Dante, your physics from Dickens, your geometry from Aeschylus, your engineering from Spenser, your logic from Bolaño, or – God forbid! – your history from Homer? A thousand times *no*. There is nonesuch literature that maketh learned the literate; for that we have our textbooks, manuals, papers, diplomas, and exams. I know from Márquez that the squares of the Colombian coast are lined with almond trees, but is *that* the sum of what we take from his novels?

I do not mean there is nothing we can learn from literature; clearly and obviously there is. But I don't think that explains why we love stories so much. Rather than giving us facts – think of pure history, science, self-help, or reportage – literature contains *universal truths*. A description of how Henry VIII married six times and broke away from the Church in Rome seems limited; we can draw some lessons from it, but the facts of the narrative speak only to Henry and his times. Scientific theories, meanwhile, are changeful and abstract – think of how one theory disproves another. Einstein turned the world upside down in 1905, but one day Einstein will be subsumed and *his* science will become, like Heraclitus' theory that the world is made of fire, water, earth, and air, outmoded. In literature, meanwhile, we find a mirror to ourselves. As the eighteenth-century critic (and dictionary compiler) Dr Samuel Johnson wrote of Shakespeare:

> He holds up to his readers a faithful mirror of manners and of life. His characters are not modified by the customs of particular places . . . or by the accidents of transient fashions or temporary opinions: they are the genuine progeny of common humanity, such as the world will always supply, and observation will always find . . . In the writings of other poets a character is too often an individual; in those of Shakespeare it is commonly a species.[42]

Hamlet does not teach us about Elizabethan England or medieval Denmark, and it does not present abstract theories. What we 'learn' in that play is human nature: the hidden motivations that lurk behind our actions, the dangers of thinking too much or too well, the burdens of family and the ways we seek to cast them off, the weirdness of love and the mad ends it drives us to. And there is no 'point' to this, no 'goal'; we see it all playing out and gather, as instinctively as watching real life unfold, these lasting impressions of humankind.

Percy Shelley, shortly before he drowned off the coast of La Spezia, wrote an essay called *The Defence of Poetry*. Its focus is poetry but it touches on fiction – and its function – in general:

> Poetry thus makes immortal all that is best and most beautiful in the world . . . and veiling them, or in language or in form, sends them forth among mankind . . . Poetry redeems from decay the visitations of the divinity in man.[43]

Shelley argues that there is something more than 'reason' at work in fiction, something more essential and lasting than the imparting of facts. It is instead, like life itself, *experientially* truthful. The anonymous author of an ancient treatise called *On the Sublime* put it best when they said, describing how it feels to read something extraordinary:

> A lofty passage does not convince the reason of the reader, but takes him out of himself. That which is admirable ever confounds our judgment, and eclipses that which is merely reasonable or agreeable.

Literature, at its finest, simply deepens us. It broadens our imaginations and opens our hearts beyond any specific moral

code, ideology, or social context.* As Virginia Woolf wrote, so magnificently:

> Yet who reads to bring about an end, however desirable? Are there not some pursuits that we practise because they are good in themselves, and some pleasures that are final? And is not this among them? I have sometimes dreamt, at least, that when the Day of Judgment dawns and the great conquerors and lawyers and statesmen come to receive their rewards—their crowns, their laurels, their names carved indelibly upon imperishable marble—the Almighty will turn to Peter and will say, not without a certain envy when He sees us coming with our books under our arms, 'Look, these need no reward. We have nothing to give them here. They have loved reading.'[44]

Literature is, always has been, always will be – until, as Horace said, 'we shall die and all our works with us'[45] – a great conversation, a congregation of our greatest writers, of all epochs and nations, offering us their discoveries from inward and outward searches. And this is a conversation, time-honoured by the ages, in which you can take part: to learn what you are, to discover what you were, to hope what you might be.

* As Shelley goes on to say: 'The great instrument of moral good is the imagination; and poetry administers to the effect by acting upon the cause . . . A poet therefore would do ill to embody his own conceptions of right and wrong, which are usually those of his place and time, in his poetical creations, which participate in neither.'

The Fifth Pillar of
The Cultural Tutor

Magic is Real

CHAPTER I

On Calculating the Circumference of the Earth

†

Chorus: This was a goodly gift thou gavest them.
Prometheus: Yet more I gave them, even the boon of fire.
Chorus: What? radiant fire, to things ephemeral?
Prometheus: Yea—many an art too shall they learn thereby!

– Aeschylus, *Prometheus Bound*

You are reading a book; you would not be doing this if you were not able to read. An obvious statement – but it is easy to take reading for granted. We must remember that once upon a time most people could not read, and that for most of human history there was no such thing as reading. Little wonder the Vikings regarded runes – their writing system – as magical. As retold for us in the tenth-century *Hávamál*, the great god Odin pursued knowledge of these runes and by learning them came to master eighteen spells that made him both mighty and wise:

> Hidden Runes shalt thou seek and interpreted signs,
> many symbols of might and power,

by the great Singer painted, by the high Powers
 fashioned,
graved by the Utterer of gods.[1]

Think about it, even for a moment, and you will realise that writing and reading *are* miraculous. Somehow, by looking at peculiar shapes, whether made of ink or pixels, thoughts are transmitted into our brains, things we understand and act on, things that fundamentally change us and change the way the whole world works. Is this not magic? A few strange spirals scratched into a sheet of paper, first put there by somebody who died centuries ago, may contain something that makes us weep or causes revolutions. *Where* is it contained in those symbols, exactly? And *how* do we draw images or ideas out of them? It confounds explanation or comprehension; could we ever dream of anything more magical than this?

Still, without writing we could rely on speech, you might say. But we could not speak, nor could we understand speech, unless we knew how to speak. Language itself! And nor could we write, read, talk, or listen – *know* or *understand* – if we could not think. Far beyond all the specifics of history or art, far upstream of the details of literature and philosophy, much deeper than the surface quakings of politics, there is thinking, speaking, and writing. And so this pillar is about these three things, their importance, and some suggestions for how to get better at them. Because everything else in this book, in any book, online, in the metropolis, or in the world, flows from this triumvirate.

Two thousand years ago a man called Eratosthenes calculated the circumference of the Earth to within 1 per cent of the real figure, and he did it without computers, satellites, or telescopes. On Midsummer's Day he planted a stick in the ground at Aswan, a city in

the south of Egypt, and measured the angle of the shadow cast by the Sun at noon. The following year he planted the stick in the ground at Alexandria, a city directly north of Aswan and therefore on the same meridian. At Alexandria, the shadow at noon on Midsummer's Day was longer. He divided the distance between the two cities by the difference in the length of the shadows cast and concluded that the circumference of the Earth was 252,000 *stadia*, or about 25,000 miles. That is what being able to think can do. And what about Albert Einstein? The nature of the universe revealed itself to him because he was able to hold in his mind its facts, then weigh, cross-reference, interrogate, and discern through deep contemplation a literally Earth-shattering conclusion. No wonder Sallust, a Roman historian who lived in the first century BCE, commented:

> Of the advantages of person and fortune, as there is a beginning, there is also an end; they all rise and fall, increase and decay. But the mind, incorruptible and eternal, the ruler of the human race, actuates and has power over all things, yet is itself free from control.[2]

Still, neither you nor I could talk about Sallust (nor Vitruvius or Tacitus, nor any Romans I have quoted) if not for Charlemagne. This great king could not write, though he tried hard to learn – but he did know the importance of literacy. Thus, under his patronage in the ninth century – during those 'Dark Ages' – there were thousands of monks hard at work copying out by hand the surviving books of ancient Rome. They were stored in monastic libraries and in the fifteenth century it was these Carolingian manuscripts, preserving the culture of antiquity, that gave rise to the Renaissance and thereafter the Scientific Revolution, the Enlightenment, the Industrial Revolution, and our modern world. Such is the power of literacy, then;

it brings societies back from the dead and charts new courses for human civilisation.

Truly, the most important thing we ever invented was language – thereafter *Homo sapiens* melted bronze, baked bricks, built cities, promulgated laws, composed poetry, invented the wheel, and set foot on the Moon. From nothing but dust and berries we have created the internet! The history of human progress tracks directly on to innovations relating to communication. Language, writing, paper, the printing press, the scientific method, the internet – all these have dragged us forward. If, at this very moment, everybody in the world forgot how to speak and write, society would collapse within hours. How are parcels delivered? How do political assemblies make decisions? How do teammates on a pitch communicate? How do you send emails, message your friends, learn of the news? How does the bricklayer know what bricks to lay? How do you decide what to eat for dinner? Forgive this eruption of questions, but they are not rhetorical. I am driving at the fact that there is nothing we do which does not absolutely rely on thinking, speaking, and writing. What is civilisation but a constellation of humans' thoughts made manifest? Every brick, computer, system, and dollar are thoughts brought into existence and communicated among human beings.

Surely, then, we ought to become good at doing these things, and struggle ceaselessly to help those who have not been given the chance to do so, both for our own sakes and for society's. A better-educated population is harder for politicians to manipulate; a better-educated population produces better politicians. From boardroom meetings to the classroom, from solving a national crisis to parking disputes with neighbours, from seeking to resolve geopolitical catastrophe to achieving one's dreams, all things are handled better by people who can think clearly, speak effectively, and write

well – the world's problems are downstream of our collective ability to do these things. Wars ended sooner, peace established lastingly, tyrants toppled, cruelties condemned, poverty overthrown, hunger quenched, oppression overcome. We would also, simply, get along better with one another and find our way in life much sooner. I don't mean to be flippant by comparing great with small, global upheaval with everyday concerns – the wind that ruffles your hair is the same wind that wears down mountains. As Montaigne said: 'The mind of Julius Caesar that planned his military campaigns in Gaul and Spain was the same mind that planned his amorous affairs.'[3]

Education goes amiss when it prioritises facts over principles. We would not teach the bees how to make honey; they need only know where to find the flowers and they will bring forth sweetness. The truest education is one that teaches people to think, speak, and write. Thus educated we can understand ourselves and our place in the world, can find meaning, hopefully peace, do right and steer clear of wrong. Erasmus, one of the greatest forces for civility in our history, rightly said: 'The main hope of a state lies in the proper education of its youth.'[4]

So proper education is not only the loading-up of facts or the accumulation of knowledge; it is the nurturing of a whole human, mind and spirit and heart. It does not matter if you know what 'supercilious' means; better that we can think calmly about the problems with which we are confronted, speak clearly and persuasively of the solutions we have found, and write both to clarify our own thoughts and to carry them further than voice alone ever could. But not only this! Education is being able to stand up for what is right, being able to love, knowing when *not* to speak – all of this and more. Books are often the substance of learning; never are they its end.

Of course, thinking, speaking and writing are not a replacement for action. We are not well educated if we cannot stop talking when the time comes to lay bricks. Theory and practice together are what make learning whole. Or, in the thundering words of Thomas Carlyle:

> Doubt, Desire, Sorrow, Remorse, Indignation, Despair itself, all these like helldogs lie beleaguering the soul of the poor day-worker, as of every man: but he bends himself with free valour against his task, and all these are stilled, all these shrink murmuring far off into their caves . . . The blessed glow of Labour in him, is it not as purifying fire, wherein all poison is burnt up, and of sour smoke itself there is made bright blessed flame![5]

Yes, labour is blessed. And, bearing that always in mind, know this: if you can think clearly, speak truthfully, and write well, you have learned everything you will ever need to know. The humanist ideal of the Renaissance holds that every living person has within them a deep well of intellectual, emotional, and spiritual potential. That is true, but it is not guaranteed we will reach it. The purpose of this triumvirate, and of education as a whole, is to help us do so – and therefore our great endeavour must be to bring such learning to all those who have been robbed of it by circumstance or misfortune.

CHAPTER II

A Mind of One's Own

†

A Stranger here,
Strange things doth meet, strange Glory see,
Strange Treasures lodg'd in this fair World appear,
Strange all and New to me
— Thomas Traherne, *The Salutation*

How much time can any of us honestly say we have spent thinking about the things we profess to believe?* We are asked a question and respond instinctively, either processing the answer as we talk or, more commonly, and without realising, we repeat things we have heard other people say. Not that there is anything wrong with saying things other people believe; the trouble arises when we have not come to this conclusion ourselves. Countless arguments are simply the result of saying things we do not really believe; we do not understand the view we are espousing and can therefore neither explain nor defend it properly. Worse is when we make decisions based on these thoughts without realising that they were placed there by another. Urgently, then, we must admit: we are often driven by ideas

* If you totted up the numbers they might be astonishingly small – literally no more than a few minutes, over the course of a lifetime, spent *actually* thinking about and interrogating our beliefs.

without knowing what they are or where they came from. So this chapter is, as you may have guessed, on the subject of thinking.

Is murder wrong? 'Yes,' you respond. 'Why?' I ask. 'Well . . .' you say. It is a hard question, because we rarely think about the *wrongness* of murder. How long have you spent pondering the morality of murder? Perhaps you have never even thought about it – and yet would state with unshakeable confidence that it is truly *wrong*, that you would not do it, that anybody who does should be punished. This is a strange state of affairs: to have a belief that, though it guides us in life, we have never once really examined. This might also be true of our political views: how long do we spend thinking seriously about taxes, borders, rights, property, democracy, electoral systems, environmental regulation? We read or listen to other people and, finding their opinions appealing, adopt them. Even our everyday opinions are poached: football fans say, 'Mbappé is better than Haaland,' because that is what some pundit once claimed. As I have said throughout this book, the past continually shapes the present in myriad ways – the layout of our streets, the colours of our kits, and the words we speak. To this list we must also add our very own thoughts.

We have been blessed with minds to think, to understand, to guide ourselves through this universe. And so, if the mind – or the intellect, call it what you will – is the thing that makes humanity what we are, shouldn't we learn to use it well? But to bring ourselves out of the cave and into the light, as Plato said, requires work. For even if we accept that thinking is important we must also admit its difficulty. Socrates made it his chief business to encourage thinking and insisted, perhaps to our surprise, that 'thinking' is simple. But we are relentlessly drawn to complexities and confusions, even against our will. If our mind is a mirror to reflect the world, our tendency is to smudge it with 'theories' and 'considerations' until

nothing shines back. Many books are needlessly long and filled with specious concepts. Our emotions make us happy one day and sad the next, suddenly nervous, now slothful; our biology drives us through hunger, illness, exhaustion; we're prone to self-interest, jealousy, hatred, passion, and prejudice. You can see why reaching that simplicity of thought alluded to by Socrates is, in truth, so hard to reach. We are ill-perceiving beasts, some little lamp of reason aglow within, but battered by storms of emotion, biology, and randomness.

So how on earth does one do this 'thinking'? A question not easily answered! We can at least set out some principles to guide us in the right direction. First: the great Thomas à Kempis advises us to rise above emotional impulses, above the impressions of a single moment. We must seek clarity of mind:

> Trust not thy feeling, for that which is now will be quickly changed into somewhat else. As long as thou livest thou art subject to change, howsoever unwilling... But the wise man, and he who is truly learned in spirit, standeth above these changeable things, attentive not to what he may feel in himself, or from what quarter the wind may blow.[6]

Second, Thomas More – Chancellor of England in the sixteenth century, but much more besides. In a book called *Utopia*, More describes the voting system of a fictional people called the Utopians:

> One rule observed in their council is, never to debate a thing on the same day in which it is first proposed; for that is always referred to the next meeting, that so men may not rashly and in the heat of discourse engage themselves too soon.[7]

The point? Thinking takes time. And though the time we spend in contemplation is not equally productive, five minutes of lucid

thought are usually the result of an hour's struggle. Thinking is like climbing a mountain and, reaching the summit, seeing suddenly the brightly lit plains until now concealed. Though, once that thought is revealed, we must also reflect on and inspect it rather than simply taking it as we find it.

And, as thinking takes time, we should be wary of accepting an entire system of beliefs – an ideology – in one go. You might call yourself a socialist and argue that the railways should be nationalised, but do *you* believe that? You might call yourself a conservative and say that immigration must be reduced, but have *you* decided this is a good idea? How tempting, when we read something in Karl Marx or Edmund Burke that seems to us utterly correct, to then take everything else they say as truthful also. We are most vulnerable when we read or listen to somebody we admire; our intellectual guard is down and ideas can easily be smuggled into our brains, transforming us into ideological zombies. No, we must interrogate each element – each belief – of an '-ism' separately.

This leads us to a third principle, artfully explained by Arthur Schopenhauer:

> Even if occasionally we had been able very easily and conveniently to find in a book a truth or view which we very laboriously and slowly discovered through our own thinking and combining, it is nevertheless a hundred times more valuable if we have arrived at it through our own original thinking. Only then does it enter into the whole system of our ideas as an integral part and living member.[8]

There is little to add other than to say: take heed. Schopenhauer goes on:

> Scholars are those who have read in books, but thinkers . . . are those who have read directly in the book of the world. The book-philosopher . . . starts from those authorities in that he constructs for himself an entire system from the opinions of others which he has collected in the course of his reading. Such a system is then like an automaton composed of foreign material, whereas that of the original thinker resembles a living human being.[9]

'An automaton composed of foreign material' – that is what we become when we do not think for ourselves; that is what we *are* when we do not ask ourselves: 'Do I believe this to be true?' Schopenhauer is right to warn us about books, for they cast the most dangerous spell of all. Truly, bad books are worse for your brain than beer. A hangover wears off with time, but without conscious effort the stupor induced by parasitical ideas does not fade. We must learn to notice when we are saying something that is not really our own opinion.

Let's imagine we have followed these first three principles: calmed our minds, taken time to think, and thought for ourselves. Now, a fourth, explained by John Milton:

> I cannot praise a fugitive and cloister'd vertue, unexercis'd & unbreath'd, that never sallies out and sees her adversary . . . that which purifies us is triall, and triall is by what is contrary.[10]

Do not let your thoughts be 'cloistered'. Take them into the world and put them on trial, whether through speech or action, for then you will discover whether you have understood them properly and, if you pay attention, whether they are right. This is one of the great benefits of conversation; we can refine our thoughts by sharing them with others and arriving, together, at a better place. That, at least, was how Socrates did it.

A final principle flows from Milton's. It is explained here by Michel de Montaigne, quoted earlier, a sixteenth-century Frenchman who lived in his castle-tower and wrote witty, wandering, introspective essays. He was one of the simplest and therefore greatest thinkers who ever lived. Of many wise things he said, this is among the wisest:

> I find I am much prouder of the victory I obtain over myself, when, in the very ardour of dispute, I make myself submit to my adversary's force of reason, than I am pleased with the victory I obtain over him through his weakness.[11]

We have calmed our minds, taken time to think, thought for ourselves, put our thoughts on trial – now we must, if we find they are not truthful, put them aside. It is difficult to admit we are wrong because it feels like a personal failure; it feels like we have 'lost'. But this is not a battle between you and another person, or between your ideology and another. It is about the *truth*, and that belongs to all humankind – as Montaigne says so wonderfully:

> Truth and reason are common to everyone, and are no more his who spake them first, than his who speaks them after: 'tis no more according to Plato, than according to me, since both he and I equally see and understand them.[12]

We should welcome being wrong. Why? Because realising we are wrong means we have come closer to being right. And that is the beauty of Montaigne's subversion – it *is* a victory, not a defeat, when we admit to being wrong. Finding truth is success; holding obstinately to untruth is failure. So the key to thinking is remaining humble, always ready to admit wrongs, and remembering forever with Thomas à Kempis: 'If it seems to thee that thou knowest many things, and understandest them well enough; know for all that, the things thou art ignorant of still are more.'[13]

CHAPTER III

The Grain Merchant of Rhodes

†

It pleases me as much to doubt as to know.
— Dante, *Inferno*

The previous chapter was about thinking in theory; this chapter is about thinking in practice. For as we go about this real world, trying to think, there is an awful lot that can go wrong. Here I offer you five 'lamps' – guiding principles rather than strict rules – which might be helpful in the endless struggle to think well.

1. Ethics

In 44 BCE the Roman statesman Cicero wrote a treatise called *On Duties*. In it he proposed 'ethical test cases'. These were imaginary problems where his ideas about morality could be put on trial. One of his proposed tests went like this:

> Suppose a time of dearth and famine at Rhodes, with provisions at extortionate prices; and suppose that an honest man has imported a large cargo of grain from Alexandria and that to his certain knowledge also several other importers have set sail from Alexandria, and that on the voyage he has sighted their vessels

laden with grain and bound for Rhodes. Is he to report the fact to the Rhodians or is he to keep his own counsel and sell his own stock at the highest market price?[14]

What should the merchant do? Cicero argued that his duty was to inform the citizens of Rhodes about the incoming provisions and sell his own at a fair price. Just because something is useful does not make it right, Cicero believed. Rather, he says, 'what is morally wrong can never be expedient.'

Whether you agree with Cicero's conclusion or not, the broader point is this: thinking is not about abstract problem-solving. For what use is thinking if it does not help us discover what is right and wrong? This is ethics – philosophy applied to behaviour. Socrates thought that this was the only true purpose of philosophy. We must ask: 'for what purpose am I thinking?' Thought itself is neither here nor there, is worthless; what matters is *why* we are thinking at all and *where* it is leading us. Otherwise (at best) we will be like those fools described by the Roman poet Pacuvius: 'I hate men who jabber about philosophy but do nothing.'[15]

2. Faith

When considering a point of view with which we disagree it is tempting to present that view in its weakest form. We do this either because we think it will make 'winning' easier or out of hatred and fear. *That* political position seems foul and we cannot conceive of any 'reasons' for holding it other than evil ones. We owe it to ourselves to rise above this tribal outlook. Instead we must believe that the person we disagree with has thought about their view and has their reasons for adopting it. Then, if we like, we can try to persuade

them of a different conclusion. Even if their view has been warped by prejudice, greed, or ego (as ours may have been also), we are better off trying to convince them to see – and adjust to – those forces. As if calling somebody an '-ist' would ever make them change their mind! No, it forecloses the chance of them listening to *you* in good faith ever again. Only when we try to understand and listen to another's view in this way can we expect our own views to be likewise heard. Just think how annoying it is when somebody else refuses to accept we have any reason for believing what we do other than malice or stupidity. Thomas à Kempis advises us well:

> Endeavour to be patient in bearing with other men's faults and infirmities whatsoever they be, for thou thyself also hast many things which have need to be borne with by others . . . We are ready to see others made perfect, and yet we do not amend our own shortcomings.[16]

That said, we must also learn to recognise when we are speaking with somebody who has no interest in having a good faith discussion. Better to remain silent then, or we will be dragged through the mud also. Wise words from the Book of Proverbs come to mind:

> Answer not a fool according to his folly,
> lest thou also be like unto him.[17]

3. Epitimaeus

Timaeus was a historian from Sicily who lived in the fourth century BCE. He was proud of his knowledge of dates, places, and names. And so he delighted in pointing out the errors of other historians. Polybius said of him:

> Timaeus' special boast, the thing in which he outvies other authors and which is the main cause of the reputation he enjoys, is, as I suppose we all know, his display of accuracy in the matter of dates and public records.[18]

Thus he was nicknamed 'Epitimaeus', a play on his name that meant 'Fault Finder', because his corrections were regarded as pedantic, trifling one-upmanship. Do not be like Timaeus. He was a bookworm who mistook facts for meaning.*[19]

The point here is that we must not confuse *knowledge* with *understanding*. If I know the dates of the tenures of every Roman consul, and can list the works of the great Roman writers, even quote them, and remember who built the Pantheon and when, this does not mean I understand ancient Rome. Better someone who gets those dates wrong but has contemplated deeply the nature of those times. Facts are not unuseful – they are vital! But Lionel Messi knowing the history of his sport, or aerodynamics, or Newtonian laws of motion, is not what makes him such a magnificent footballer. Pedantry is merely a tool for intimidating or impressing others, and one that can impair our ability to form true judgements and act rightly. What did Thomas à Kempis say?

> I had rather feel contrition than be skilful in the definition thereof.[20]

* Montaigne confessed, and so must I: 'Do I not the same thing throughout almost this whole composition? I go here and there, culling out of several books the sentences that best please me, not to keep them (for I have no memory to retain them in), but to transplant them into this.'

4. Fortune

If somebody finds success we instinctively believe that (if not because of inherited advantages) it was due to their individual methods, self-imposed rules, and personal endeavour. But here we ignore the role of randomness (in recent terminology; ancients called it Fortune). Pindar noticed the habit of assuming that successful people are themselves responsible for what they have achieved two and a half thousand years ago:

> His prosperous life the witless tribe
> To his own prudent aims ascribe.[21]

Similarly, we overestimate our general ability to distinguish correlation from causation. We see a successful person and assume they can impart useful knowledge – but that relies on them being able to identify what was operative in their success. With hindsight we retrofit narratives or grab instinctively at whatever *seems* relevant. A major part of thinking is simply being aware of our limitations – accepting that we don't know more than we do know.

5. Truth

We must welcome the truth wherever we find it. And therefore we must listen with special care to those with whom we disagree. Truth resides not with any one party, ideology, or group, but is, if not always equally, dispersed among them. Extremism – by which I mean indissoluble certainty that one's 'side' is perfectly right – has always been the bane of humankind. To Thomas à Kempis again, I turn:

> Who is so wise as to have perfect knowledge of all things? Therefore trust not too much to thine own opinion, but be ready also to hear the opinions of others . . . Ask not, who hath said this or that, but look to what he says.[22]

Listen to conservatives *and* progressives; search out the left-wing *and* the right-wing media. Kempis continues:

> We ought to read devout and simple books as willingly as those that are high and profound. Let not the authority of the author be in thy way, whether he be of little or great learning; but let love of simple truth lead thee to read.[23]

To close one's mind to the possibility of changing it is like entering cryosleep. How did you arrive at your current point of view anyway? You were not born with it, and no doubt your views have changed since you were a teenager. So, accepting that your views *have* changed, what leads you to believe that you have now arrived at the unalterable truth? We must always remember that we might be wrong and actively search out the proof – perhaps from people we least wish to receive it from – and examine our opinions.

Alas, our preference for affirmation leads us astray. We do not always want to know the real truth and feel more comfortable sticking with our present opinions. This is not helped by the fact that humanity has long been plagued by a cabal of 'sluggards and unthrifties' (as Erasmus said) 'which more regard the taking of money than the profit of their scholars'.[24] Perhaps I am one of these sluggards! If so, judge me as I deserve. Accept only that it takes one to know one, for there *are* unthrifties at large. We must be ever on guard against those who stand to profit from the sale of appealing truths.

CHAPTER IV

Stage and Salvation

†

For so great it seems were the graces and charms of his oratory, that as soon as he began to speak and beg his life, none of them durst touch or so much as look upon him; but hanging down their heads, every one fell a weeping.

– Plutarch, *Parallel Lives*[25]

The city is in chaos. Troubling news has arrived. Rumour spreads. Murmurs, then arguments. Streets fill. Suddenly there are thousands gathering in the square. Police arrive. Political leaders. The people are anxious, raucous, insatiable. Speaker after speaker climbs the platform and addresses the crowd – to no avail. They are abused, laughed at, ignored. The soldiers look to their commander, who looks to the politicians. Will they intervene? Another speaker rises. He calls for action and is applauded by his supporters; his opponents cry out. Blood is running hot. Jostling. Chaos. A slender man with an overbite climbs the platform. 'He's here!' somebody shouts. The crowd falls silent and stares at this man – who surveys them in turn, clears his throat, raises his arms, and begins to speak:

> It should be the duty of all speakers, men of Athens, to give no expression to their hatred or their partiality, but to put forward just what each thinks the best counsel ... But since there are speakers who are impelled to address you, either as partisans or from some other motive, whatever it may be, you citizens who form the majority ought to dismiss all else from your minds, and vote and act in such a way as you think will best serve our city.[26]

That was Athens in 341 BCE. A letter from King Philip of Macedon had arrived. He demanded the withdrawal of Athenian soldiers from a region called the Chersonese. The speaker was Demosthenes, regarded by Greeks and Romans alike as the greatest orator of the ancient world.

This scene is one with which you may be familiar. It is a scene that has been played out ceaselessly since the dawn of civilisation: the people gather and await some speaker. What Demosthenes did in 341 BCE the Revd Martin Luther King Jr did in 1963 from the steps of the Lincoln Memorial – only when Dr King spoke it was an entire nation that listened and, afterwards, the world. Oliver Cromwell spoke to only a few hundred when he dismissed the Rump Parliament in 1653, but it was a speech, brief as winter daylight, whose ripples rocked the Ship of Ages:

> It is high time for me to put an end to your sitting in this place, which you have dishonoured by your contempt of all virtue, and defiled by your practice of every vice; ye are a factious crew, and enemies to all good government ...[27]

The power of speech to change our minds and rouse our hearts will never fade. We are still, like those anxious Athenians on the Pnyx, hoping to be inspired. Now, as ever, one feels that all it takes to set

the gears of war grinding or stop them in their tracks, to liberate people or condemn them to misery, is a single speech.

In conclusion, and put simply: learning to speak well is a very good idea. And this kind of study has a name: rhetoric. In the ancient world rhetoric was nothing less than the art and science of communication. It was compulsory education for all young Romans and Greeks of a certain class. One could not achieve anything in public life without the ability to persuade others. Dozens of rhetorical guides and textbooks and glossaries have survived, along with an unreadable quantity of speeches. All those names you recognise – Julius Caesar, Mark Antony, Cicero, Cato, Pericles – were great orators; it could not have been any other way.

Demosthenes on the Shore by Eugène Delacroix (1859).

But rhetoric did not die with the fall of Rome. It lived on throughout the Middle Ages and was studied with renewed vigour in the Renaissance, as scholars and princes around Europe did their best to imitate Cicero. And, in the twenty-first century, rhetoric is alive and kicking. The word may have become a dirty one, but

rhetoric itself thrives in parliaments and pubs, in court rooms and kitchens, in advertising agencies and writer's rooms. There is not a person alive who does not, even unwittingly, use rhetoric: writing an email, arguing about football, composing a play, copywriting, any YouTube video. Wherever we use words in an attempt to persuade, inspire, guide, warn, or entertain – that is rhetoric.

At its finest, rhetoric has been a force for good. It is by speaking persuasively that truth has spread, that ideas of liberty and justice have taken hold of our imaginations and been codified in our laws. An idea, however good, is still just an idea. How does it spread from one person to another? Through words. Rhetoric is a flame that kindles souls. Human rights were a dream until somebody dared speak them. The sixteenth-century Reformer Philip Melanchthon was well aware of this – having seen an idea take hold of a continent – and wrote:

> What do you believe was on the mind of the ancient Romans that they called the arts of speaking *humanitas*? They judged that, indisputably, by the study of these disciplines not only was the tongue refined, but also the wildness and barbarity of people's minds was amended.[28]

Rhetoric is the only force with sufficient power to change our minds. A threat of violence, however vicious, or a sack of gold, however fat, may convince someone to do something or support someone, but when the gun is in somebody else's hands and the coffers ring empty, our obedience and loyalty are quick to evaporate. Demosthenes and Dr King, with their words, made us *believe* that the world could be better. We heard their words and neither blade nor cheque could change what they set in motion. History is, in some sense, a sequence of speeches. Money breeds mercenaries

and violence tyranny; speech alone has the power to unite us, not bound without choice or because of expedience, but as free people linked by shared belief. Thus said Erasmus:

> It is no great achievement to burn a man; to change his mind is a miracle.[29]

But, like any superpower, rhetoric is not always a force for good. We may praise certain orators because we agree with their cause, but ignoble causes have also been advanced by rhetoric. Was not Adolf Hitler a masterful rhetorician? Plato stated in his *Gorgias*:

> Rhetoric, it seems, is a producer of persuasion for belief, not for instruction in the matter of right and wrong. And so the rhetorician's business is not to instruct a law court or a public meeting in matters of right and wrong, but only to make them believe.[30]

Plato was concerned that rhetoric had no intrinsic moral value. He suggested it was simply a tool that, by its nature, lent itself more to evil; whereas simple speech lets us see a speaker's real intentions clearly, the very guile of rhetoric lets bad people shroud their malice and deceive us. Maybe Plato was right. After all, among the masters of modern rhetoric (ignoring the obvious choice of politicians) are those marketing gurus whose sole purpose is to make us buy what they are selling even when we do not need it.

But Quintilian, a Roman lawyer and tutor of rhetoric, disagreed: 'I do not merely assert that the ideal orator should be a good man, but I affirm that no man can be an orator unless he is a good man.'*

Either way, what neither Plato nor Quintilian doubted was that people skilled in rhetoric possess immense power. And it is now

* From Quintilian's *Institutio Oratoria*, the greatest guide to oratory ever written.[31]

more important than ever, because the internet has given everybody a speaker's platform from which to address the crowds, crowds no longer of thousands but of millions. More than one twenty-first-century public figure has had their career launched by a single interview or speech. And, just as they did in the Athenian Assembly, the Roman Senate, or the Doge's Palace, our politicians continue to give speeches and debate in their chambers, swaying our elections and making our laws. In some deep-rooted way we *want* to believe something, and we are simply waiting for an orator to tell us what that something is. So remember this: the study of rhetoric is not only useful in that it allows us to speak more convincingly; it is also a shield against those who seek to manipulate us. When we hear politicians, intellectuals, preachers, and polemicists say one thing, we can understand that they are really saying something else. Rhetoric makes us better speakers – and better listeners.

We return to the beginning: Demosthenes. Though he was Philip's greatest opponent and prolonged his conquest of the Greeks by two decades, Philip and then Alexander were victorious in the end. So it is through his speeches that Demosthenes has lived on. Not only because of his rhetorical mastery but because of his passion for liberty and fearless resistance to foreign domination, Demosthenes has rightly become an enduring icon of freedom. From the second *Philippic*:

> All kinds of inventions are designed for the protection and security of cities—palisades, walls, trenches, and every kind of defence. All these are made with hands, and involve expense as well. But there is one safeguard which all sensible men possess by nature—a safeguard which is a valuable protection to all, but above all to a democracy against a tyrant. And what is this? It is

distrust. Guard this possession and cleave to it; preserve this, and you need never fear disaster.[32]

Perhaps you can understand why the anonymous author of *On the Sublime* wrote of Demosthenes: 'Yes, it would be easier to meet the lightning-stroke with steady eye than to gaze unmoved when his impassioned eloquence is sending out flash after flash.'[33]

But this is not about Demosthenes; it is about you. Because you, too, can learn to speak with such flashes.

CHAPTER V

'You talking to me... Cicero?!'

†

> And hark! how blithe the throstle sings!
> And he is no mean preacher;
> Come forth into the light of things,
> Let Nature be your teacher.
>
> – William Wordsworth, *The Tables Turned*[34]

So... how to speak well? Fortunately for us, people have been asking that question for 3,000 years. Over these millennia a number of rhetorical devices have been collated, a sort of toolkit for helping us to speak better – more clearly, memorably, persuasively – whether on stage or in daily life. Here are just some of them.

Antimetabole

Antimetabole is the repetition of words or phrases in successive clauses, but with the order reversed. This forms an A-B-B-A pattern. A famous example comes from John F. Kennedy:

> Ask not what your **country** can do for <u>you</u>, but what <u>you</u> can do for your **country**.

Anthimeria

Anthimeria is the substitution of two linguistic elements. The most common form is replacing a verb with a noun, or vice versa:

> You should <u>book</u> the flight.
> I had a good <u>sleep</u> last night.
> Iniesta provided the <u>assist</u> for Messi.

'Book', usually a noun, becomes a verb; 'sleep' and 'assist' have gone the other way. Recent examples include 'hashtag' or 'google' as verbs; in these you can see how anthimeria tracks the evolution of language and technology. Novel uses of anthimeria are a way of subtly breaking the rules and of making your words memorable – just think how much it has done for Google's brand that their very name is now a part of everyday speech.

Polyptoton

Polyptoton is the repeated use of words which share the same root, for example 'destroy', 'destroyer', 'destroyed', and 'destruction'. It can be a form of wordplay:

> Not only is the **judge** not **judicial**, but the <u>arbiter</u> is not even <u>arbitrary</u>.

Or it can give a speech a rhythmic elegance. Consider this layered polyptoton in Shakespeare's *Troilus and Cressida*:

> The Greeks are **strong** and <u>skillful</u> to their **strength**,
> *Fierce* to their <u>skill</u> and to their *fierceness* valiant;

And, of course, it helps in coining a memorable phrase:

Absolute power corrupts absolutely.

Paradiastole

This is where a vice is reinterpreted as a virtue. Think:

It's a feature, not a bug.

And here's how paradiastole was described by the sixteenth-century scholar Henry Peacham in *The Garden of Eloquence*:

> When by a mannerly interpretation, we doe excuse our own vices, or other mens whom we doe defend, by calling them vertues.

Like most devices, this is more than a gimmick; it touches on something fundamental about the human condition and how we learn to deal with our lives – as when somebody supports a sports team that is perpetually struggling and claims this endless suffering as part of what makes supporting that team so meaningful.

Apophasis

The Greeks and Romans were no less scurrilous than we are; apophasis is where the speaker mentions something by saying they don't want to mention it. As when Cicero said of Catiline:

> What? when lately by the death of your former wife you had made your house empty and ready for a new bridal, did you not even add another incredible wickedness to this wickedness? But I pass that over, and willingly allow it to be buried in silence, that

so horrible a crime may not be seen to have existed in this city, and not to have been chastised.[35]

Though, I suppose, the most famous recent example of apophasis comes from Donald Trump:

> Why would Kim Jong-un insult me by calling me 'old', when I would NEVER call him 'short and fat'?

Hendiatris

An isocolon is when consecutive clauses use the same number of words or syllables. The most common form is the tricolon, which has three parallel elements, as when Caesar declared:

> *Veni, vidi, vici.*
> (I came, I saw, I conquered.)

Related is hendiatris, which also features three elements, though these needn't have the syllabic regularity of the tricolon. Instead, working off the inherent memorability of threes, the hendiatris is about expressing one idea in three ways. Take France's legendary national motto:

> *Liberté, égalité, fraternité.*

They are three different words, and each has a different meaning, but they all speak to the same idea of an enlightened political system . . . and it's catchy. No coincidence so many mottos or famous lines are a hendiatris. As Mark Antony proclaimed:

> Friends, Romans, countrymen, lend me your ears!

And Abraham Lincoln in his Gettysburg address:

> . . . of the people, by the people, for the people . . .

The motto of the Olympics also takes this form:

> *Citius, altius, fortius.*

And that modern platitude:

> Live, laugh, love.

Enallage

Enallage is an intentional grammatical mistake. This works for a simple reason: it stands out. Rules by their nature accustom us to regularity. We usually try to stand out in a way that accords with those rules, but what if we just ignored them? Whenever grammatical rules are broken it is like nails on a blackboard; we are forced to notice. Such was the thinking behind Apple's slogan in the 1990s.

It should be 'differently' rather than 'different'; the former is an adverb, the latter is an adjective. Apple's campaign is now the stuff of legend and, by using enallage, they were practising what they preached. Other examples from advertising include 'Simples', as spoken by the Russian meerkat and mascot of Compare the Market,

or Subway's 'Eat Fresh'. Not to forget 'Thunderbirds are go!', of course, or that little alien when he said, 'E.T. phone home.'

Aporia

To the philosopher, aporia is a state of deep intellectual uncertainty reached when it turns out you don't understand something you thought you did.* To an orator, it is the expression of doubt about what action to take. Think of Hamlet's famous lines:

> To be, or not to be, that is the question:
> Whether 'tis nobler in the mind to suffer
> The slings and arrows of outrageous fortune,
> Or to take Arms against a Sea of troubles,
> And by opposing end them

This is different to procatalepsis, where a speaker pre-emptively responds to potential criticism of their argument. Aporia, by contrast, is open-ended. It works because the audience wonders why a speaker would cast doubt on themselves. We feel they are thinking out loud, that this is no longer a pre-prepared speech but that we are in the thick of it, part of some intellectual, emotional, or spiritual struggle; we are engaged.

From Rome to Oz

I hope you can see that rhetorical devices are neither random factoids nor dry crumbs of antiquity; they are useful tools. And to drive home how omnipresent and effective these devices are, I think we should take a detour into the world of cinema:

* Familiar!

You talking to me?
– *Taxi Driver*

Rhetorical questions – those asked without expectation of an answer – have a name: *erotema*. Travis Bickle, played by Robert de Niro, is also speaking to an imaginary person, a device called *epistrophe*.

Bond. James Bond.
– First appeared in *Dr No*

When we repeat a word with another word between them it is called *diacope*. Here it turns the simple act of a character saying his name into something iconic.

I'm walking here! I'm walking here!
– *Midnight Cowboy*

Are you not entertained? Are you not entertained?
– *Gladiator*

It's alive! It's alive!
– *Frankenstein*

Three examples of *epizeuxis* – the repetition of a single word or short phrase. You wouldn't expect that simply repeating a line could have such an effect, but it does.

Toto, I've a feeling we're not in Kansas any more.
– *The Wizard of Oz*

Meiosis is when a person downplays something that is clearly momentous. This is distinct from *litotes*, where you make a positive statement by using a negative. The best example is saying 'not bad' instead of 'good'. Although, usually, *litotes* is rather more ironic. To

say, 'you aren't the most punctual person' is really a way of saying, indirectly, that you are one of the least punctual people I know.

> Fear leads to anger. Anger leads to hate. Hate leads to suffering.
> – *Star Wars Episode I: The Phantom Menace*

Anadiplosis is when we begin a clause with the word that ended the previous clause: anger to anger and hate to hate.

> Patience you must have, my young Padawan.
> – *Star Wars Episode V: The Empire Strikes Back*

Yoda again – this time his trademark inversion of word order: 'patience you must have' rather than 'you must have patience'. A supremely simple trick that lends Yoda an aura of great wisdom and, just as importantly, gives him a unique manner of speaking. Inversion of normal word order is called *anastrophe*.

> I'm going to make him an offer he can't refuse.
> – *The Godfather*

Imagine how much less memorable, how much less sinister it would have been, had Don Corleone simply said, 'I will intimidate him.' What we have instead is *euphemism* – a roundabout, less visceral way of saying something unpleasant. Like many of the best devices, *euphemism* works because it draws on our imaginative faculties.

> You don't understand! I coulda had class. I coulda been a contender. I coulda been somebody. Instead of a bum. Which is what I am.
> – *On the Waterfront*

There are a handful of rhetorical ploys in this legendary speech. It begins with *ecphonesis*: a short exclamatory phrase. Then we have

a *tricolon* – three consecutive phrases, all of the same length and structure. And the whole thing taken together is an example of *parataxis* – where we speak in short sentences without conjunctions such as 'and' or 'but'.

> If you let my daughter go now, that'll be the end of it. I will not look for you. I will not pursue you. But if you don't, I will look for you, I will find you, and I will kill you.
> – *Taken*

This monologue by Bryan Mills, played by Liam Neeson in *Taken*, has become one of the most well-known and parodied film quotations of all time. There may be a rhetorical reason: *anaphora*. This is where we begin a series of clauses with the same words, in this case 'I will'. And notice another *tricolon* in action at the end.

> You either die a hero or live long enough to see yourself become a villain.
> – *The Dark Knight*

We end with the simplest device of all – and yet, centuries later, still the most effective: *antithesis*. This is when we contrast opposites within the same sentence: hero versus villain, live versus die.

I had considered including excerpts from ancient textbooks for students of oratory, passages from Aristotle, or a breakdown of how Greeks and Romans structured their speeches, according to tenets laid down by Cicero and Quintilian, to illustrate how rhetoric is about far more than devices like these – but I think there is something more useful I can do. It begins by asking: what sort of voice do you need to be a good speaker? Loud enough to project in a large room? Crystal clear and silky smooth? No. There are

countless historical figures famed for their oratory who had speech impediments. Just consider what Plutarch said of our old friend Demosthenes:

> . . . he had, it seems, a weakness in his voice, a perplexed and indistinct utterance and a shortness of breath, which, by breaking and disjointing his sentences, much obscured the sense and meaning of what he said.[36]

When Demosthenes first spoke in public he was ridiculed, partly because he mumbled and lisped, partly because his speeches were boring. But where many would have been disheartened, Demosthenes got to work:

> The indistinctness and lisping in his speech he used to correct and drive away by taking pebbles in his mouth and then reciting speeches. His voice he used to exercise by discoursing while running or going up steep places, and by reciting speeches or verses at a single breath.[37]

Demosthenes, as I have said, became one of the most formidable speakers in history. I mention this story because public speaking scares many people; we think 'it isn't for us'. But if, like me, you have a habit of mumbling, I hope this story of Demosthenes will inspire you to think otherwise.

Have you been convinced to study rhetoric? If not, I offer Plato, who in *Phaedrus* described rhetoric as: 'the art of enchanting the soul'.[38] By linking language to our innermost selves he lands on an interminable truth: speech beats at the heart of human civilisation. Who, then, would not gain from studying it?

CHAPTER VI

Objective Considerations of Contemporary Phenomena

†

My letters! all dead paper, mute and white!
And yet they seem alive and quivering
Against my tremulous hands which loose the string

– Elizabeth Barrett Browning, 'Sonnet 28'

Where are your thoughts? You cannot touch or see them – only sort of *sense* them – and they appear seemingly at random. Making something coherent out of these intangible wisps is difficult, and even when you manage to thrash out a few conclusions they are easily forgotten. No wonder we are prone to saying stupid things! Enter writing: the act of taking those tangled thoughts out of your head so you can literally see them more clearly. Whenever you are faced with a problem – professional or personal, emotional or intellectual, spiritual or romantic – writing down your thoughts will help solve it.

The etymology of the word 'sentence' is revealing here. It comes to us, via French, from the Latin *sententia*, itself from *sentio*, which means (among other things) 'to think'. Quintilian explains: 'The ancient Latins called whatever they conceived in the mind, sententia, "a thought".'[39]

This brief etymological journey reminds us that writing *is* thinking, and almost always a better way of doing it than in our heads. This fact is baked into our language: the word we use for the fundamental structure of writing – the sentence – refers not to a grammatically correct set of words, but to an expressed thought.

Writing is vital, not only for would-be novelists but for everybody. So how does one write well? The internet is a bazaar of writing advice; a Google search returns nearly one and a half billion results. The odds of it all being good are (obviously) negligible. Besides, most is too specific and tries to lay down too many rules. This is nonsense. A boring world it would be if there were one correct way to write – imagine a world where every flower was identical. Arthur Quiller-Couch was spot on:

> It follows then that Literature, being by its nature personal, must be by its nature almost infinitely various . . . *Quot homines tot sententiae*. You may translate that, if you will, 'Every man of us constructs his sentence differently.'[40]

Engrave that upon your doorpost and show it to anybody who tells you what verbs not to use and suchlike. Writing is more than following rules, and is by definition individual. Always bear that in mind and do not be afraid of disregarding advice, whoever gives it.*

Still, there are some principles of writing, operating on a higher level than rules, stars to guide us rather than gaol-guards to bind

* We are too obsessed with rules these days, with turning everything into a 'science' or 'system' that can be quickly understood and applied mechanically. Remember Plato: 'But he who, having no touch of the Muses' madness in his soul, comes to the door and thinks that he will get into the temple by the help of art—he, I say, and his poetry are not admitted; the sane man disappears and is nowhere when he enters into rivalry with the madman.' Skill and rules are never enough; we humans have a mad and mystical side also, and it is in the balance of these two halves that all our greatest work is brought forth.

us. And there is one shining brighter than all, best expressed by Sir Philip Sidney in his sonnets of *Astrophil and Stella*:

> Biting my truant pen, beating myself for spite,
> 'Fool,' said my Muse to me, 'look in thy heart, and write.'[41]

As soon as we ask, 'What should I write about?' we are already losing. Writer's block (and bad writing) is usually the result of trying to write about the wrong thing. *Look in thy heart, and write.* Let love – whatever fascinates or angers you – be that which moves your hand. With writing, the question of 'what?' is more important than 'how?'.

This also means writing what *you* need to write, not what you think others want to hear. We must try to be authentic rather than original. 'Originality' has no intrinsic value; to seek it is usually vanity. It looks *outward* because its explicit purpose is to be different from other things; authenticity, meanwhile, looks *inward*, because its goal is truth regardless of what others are saying or doing. This was true 2,000 years ago, and remains so; the author of *On the Sublime* pulled no punches here: 'Now all these glaring improprieties of language may be traced to one common root—the pursuit of novelty in thought.'[42]

This leads us to what John Ruskin said when delivering the inaugural speech at the Cambridge School of Art in 1858:

> To be taught to write or speak – but what is the use of speaking, if you have nothing to say? To be taught to think – nay, what is the use of being able to think, if you have nothing to think of? But to be taught to see is to gain word and thought at once, and both true.[43]

That is the foundation. We may be eloquent, but if we do not see the world – engage with it, observe it, and live in it – eloquence is worthless. If we are to write we must have something to write about. And whether that is something gratingly mundane or fabulously grand does not matter; what matters is that you have *noticed* a thing in this universe of ours. Here, and only here, is where writing begins.

I don't mean to say that there are no technical principles of writing. As a writer, words are all you have, and without a command of language you will use the wrong words. A command of language is what makes your writing a mirror to the mind's eye, what allows you to say precisely what you want and actually intend to say. Too often writers use words they don't really mean to because they don't know the right ones. Good writers use words purposively, not because they can't think of anything else. Inaccurate words lead to unclear thinking. Quiller-Couch called this jargon – abstract, generic, needlessly complex language – and pointed out the danger it poses:

> So long as you prefer abstract words, which express other men's summarised concepts of things, to concrete ones – which are as near as can be reached to things themselves, and are the firsthand material for your thoughts – you will remain, at the best, writers at second-hand. If your language be Jargon, your intellect, if not your whole character, will almost certainly correspond. Where your mind should go straight, it will dodge.[44]

George Orwell sang from the same songsheet in *Politics and the English Language*, an essay that is, despite being eighty years old, startlingly relevant today. Orwell first shares this passage from Ecclesiastes, a gorgeous description of the role played by fortune in human life:

> I returned and saw under the sun, that the race is not to the swift, nor the battle to the strong, neither yet bread to the wise, nor yet riches to men of understanding, nor yet favour to men of skill; but time and chance happeneth to them all.[45]

He then imagines how this would have been written in the twentieth century:

> Objective considerations of contemporary phenomena compels the conclusion that success or failure in competitive activities exhibits no tendency to be commensurate with innate capacity, but that a considerable element of the unpredictable must invariably be taken into account.[46]

That is what happens when you use prefabricated language. Rather than 'I think', you say, 'in this case I am of the opinion that'. And when you do this – copying, even unconsciously, the words of others – you end up thinking the same thoughts. Remember: writing is the closest thing we have to thinking. So if we all see the world differently, we surely need to express ourselves differently also.

Does this mean we should only use simple language? You know the sort of thing people advise: Write simply; It doesn't need to be poetry; Don't use a thesaurus; Clear, not clever; Fewer commas. Hemingway said of his own famously laconic style that being concise is to forgo saying what we already know, and therefore that one must know a great deal to write simply. It worked for Hemingway, but there are other ways to write. Quintilian argued that plain language is not always enough, making the fabulous point that beautiful writing is – precisely because of its beauty, and because we are more attentive to something we are enjoying – more effective.

Of course, a profusion of pretty words can be used to disguise a lack of meaning. This habit, called circumlocution, was criticised by Quintilian as writing at its worst. This explains why Paul Graham wrote in an influential 2021 essay called 'Write Simply': 'When you write in a fancy way to impress people, you're making them do extra work just so you can seem cool.'* Quite right. But the emphasis must be on trying to impress rather than writing fancily. There is nothing wrong with 'fancy' words provided you use them properly. All overwriting is ugly; all beautiful writing is effective. The pursuit of pure function demeans language, intellect, and soul – it corrupts writing by stultification. Do we want our essays to be written like manuals for microwaves? I think not. The term 'fancy' is loaded; it speaks of frivolity. But some so-called 'fancy' words get at concepts or feelings we cannot otherwise express – they can be *more* precise. We shouldn't think so little of our readership as to treat them like children, nor so little of ourselves to not hope to create something useful *and* beautiful. We shouldn't shy away from this challenge; or, as Quintilian asks, are we really so afraid of falling?

> Some, again, make the contrary practice their study, shunning and shrinking from all such charms of composition, and approving nothing but what is plain, and humble, and without effort. Thus, while they are afraid that they might sometimes fall, they are always creeping on the ground.[49]

* Dr Johnson, writing some two and a half centuries ago, offers a haymaker of a response: '. . . vanity inclines us to find faults anywhere rather than in ourselves. He that reads and grows no wiser, seldom suspects his own deficiency; but complains of hard words and obscure sentences, and asks why books are written which cannot be understood?'[47, 48]

Onwards. Perfectionism is a burden for many: you write, rewrite, edit, delete, and start again; you're never satisfied.* Here is an antidote from *On the Sublime*:

> Is it not worthwhile to raise the whole question whether in poetry and prose we should prefer sublimity accompanied by some faults, or a style which never rising above moderate excellence never stumbles and never requires correction? . . . A mind always intent on correctness is apt to be dissipated in trifles; but in great affluence of thought, as in vast material wealth, there must needs be an occasional neglect of detail. And is it not inevitably so? Is it not by risking nothing, by never aiming high, that a writer of low or middling powers keeps generally clear of faults and secure of blame? whereas the loftier walks of literature are by their very loftiness perilous?[50]

To write you must let go of the search for perfection, casting off the burden of 'correctness' and no longer fearing mistakes. *Just write.* Trust your instincts. Let your unreadable mind-patterns guide your words. Don't stop to check where you are going, whether it makes sense, what anybody thinks – write your way, fearlessly, into that brave disorder.

A far more galling scenario than our heroes disappointing us is the one where we disappoint them. This is another principle from *On the Sublime*. Rather than retreating from the greats, we must let their greatness stimulate us to raise our own standards:

* The supreme difficulty with writing is that it is an act of exclusion. To choose one word is to choose it over another. In English there are something like half a million words; a formidable prospect! And it isn't only words: it is also the things we write about. Choosing to write about one thing excludes others . The first draft of this book was 249,000 words – more than double the length it is now.

> Therefore it is good for us also, when we are labouring on some subject which demands a lofty and majestic style, to imagine to ourselves how Homer might have expressed this or that, or how Plato or Demosthenes would have clothed it with sublimity, or, in history, Thucydides. For by our fixing an eye of rivalry on those high examples they will become like beacons to guide us, and will perhaps lift up our souls to the fulness of the stature we conceive.
>
> And it would be still better should we try to realise this further thought, 'How would Homer, had he been here, or how would Demosthenes, have listened to what I have written?' For what higher incentive to exertion could a writer have than to imagine such judges or such an audience of his works, and to give an account of his writings with heroes like these to criticise and look on?[51]

We can easily fool ourselves, but it is far harder to fool the greats. Next time you write something, imagine handing it over to your authorial hero – pick a paragraph and consider what they would say about it. With such a frightful prospect in mind you may find it within yourself to think a little harder and write a little better.

Two thousand years ago a Greco-Syrian satirist called Lucian wrote a lengthy letter to his friend, now generally titled 'The Way to Write History'. In it, Lucian explains with bitter and brilliant irony his dissatisfaction with the literary trends of the day, much of which rings true today. Lucian also gives some broader precepts for writing. Here, for example, and most wonderfully, he sets out every writer's north star:

> But the general principle I would have remembered—it will ever be on my lips—is this: do not write merely with an eye to

the present, that those now living may commend and honour you; aim at eternity, compose for posterity, and from it ask your reward; and that reward?—that it be said of you, 'This was a man indeed, free and free-spoken; flattery and servility were not in him; he was truth all through.' It is a name which a man of judgement might well prefer to all the fleeting hopes of the present.[52]

Now there is a call to arms – write for all time, for the truth, not for the flattery of the present!

But I end on a personal note: heed not the high priests of productivity who say that habits are the key to unlocking the door of success. Let the quality of a work alone stand as testament to the methods of its creator. And if you are a night-writer like me, I offer by way of Byron a retort to all who chastise you for rising late:

> I say, the sun is a most glorious sight,
> I've seen him rise full oft, indeed of late
> I have sat up on purpose all the night,
> Which hastens, as physicians say, one's fate;
> And so all ye, who would be in the right
> In health and purse, begin your day to date
> From daybreak, and when coffin'd at fourscore,
> Engrave upon the plate, you rose at four.[53]

CHAPTER VII

Ough, Ough, Ough, Ough, Ough, Ough, Ough, Ough

†

We have everything in common with America nowadays except, of course, language

– Oscar Wilde, *The Canterville Ghost*

Do you know the story of the Tower of Babel? It comes from the Book of Genesis. All humanity, save for Noah and his family aboard their Ark, has been destroyed by the Flood. Now, as generations pass, we go forth and multiply once again:

> And the whole earth was of one language, and of one speech. And it came to pass, as they journeyed from the east, that they found a plain in the land of Shinar; and they dwelt there. And they said one to another, Go to, let us make brick, and burn them thoroughly.
>
> And they had brick for stone, and slime had they for mortar. And they said, Go to, let us build us a city and a tower, whose top may reach unto heaven; and let us make us a name, lest we be scattered abroad upon the face of the whole earth.
>
> And the LORD came down to see the city and the tower, which the children of men builded. And the LORD said,

Behold, the people is one, and they have all one language; and this they begin to do: and now nothing will be restrained from them, which they have imagined to do. Go to, let us go down, and there confound their language, that they may not understand one another's speech.

So the LORD scattered them abroad from thence upon the face of all the earth: and they left off to build the city. Therefore is the name of it called Babel; because the LORD did there confound the language of all the earth: and from thence did the LORD scatter them abroad upon the face of all the earth.*[54]

Why have we taken this Babylonian detour? Because thinking, speaking, and writing are all linked, defined, and restricted by language. So let's take a step back from our investigation of how to use it – and ask, instead, 'What is it?' And the best place to begin, I think, is with four letters – ough.

English has notoriously strange spelling. 'Ea' is pronounced differently in 'bread', 'break', 'earth', 'heart', 'meat', 'tear', and 'tear'. 'Horse' and 'worse' don't rhyme, but 'base' and 'bass' do, while 'ghoti' could be pronounced *fish*.† Meanwhile each of these 'ough's is pronounced differently:

bough	lough
cough	tough
dough	thorough
hiccough	through

* Remarkable, is it not, the brevity of this passage? These 235 words have told a story of greater consequence than most manage in a lifetime of writing. A potent reminder that you need only a few words to say a lot.

† For example: *gh* from 'cough', *o* from 'women', *ti* from 'patience'.

THE FIFTH PILLAR OF THE CULTURAL TUTOR

Languages whose written form corresponds to their pronunciation are called phonemic. In a phonemic language you hear a word and know how it is spelled or read a word and know how to say it. What happened with English? Its origins lie in Old English, a Germanic language brought to Britain by the Anglo-Saxons in the fifth century. After that came the Vikings with Old Norse, and then in 1066 the Normans arrived with Old Norman French, a Romance language. French dominated as the language of the ruling class while Middle English – a mix of Old English and Old Norse – was the common tongue. This explains why English words relating to government have French origins ('court', 'judge', 'jury', 'parliament') and also why English has so many synonyms – they come from different languages! 'Freedom' is Old English whereas 'liberty' is Old French. When Gutenberg's printing press was brought to England by William Caxton in the 1470s printers had to choose spellings for their texts, thus creating a Middle English orthography (i.e. spelling system) which forms the basis of modern English spelling.

But Middle English was phonemic, so what happened? The 'Great Vowel Shift' is what happened. This was a process, lasting several centuries, whereby pronunciations slowly changed into the ones we use today. 'Out' was once pronounced *oot*, for example. But even while their pronunciation changed, Middle English spellings did not. And when Dr Samuel Johnson compiled his dictionary in 1755, the first comprehensive dictionary of the English language, he didn't update or standardise spelling so much as codify its existing discrepancies. Most languages, however, *have* been standardised. Throughout the nineteenth and twentieth centuries institutions around the world worked to unify the divergent linguistic traditions of their countries, simultaneously an act of nation-building and an

effort to improve literacy; consistent phonemic languages are easier to learn. And these processes are either recent – in 1996 German-speaking countries agreed a linguistic reform – or still ongoing, like the notorious Académie Française. Many languages have been or are being monitored and modified, but English is not one of them. So the reason 'ough' can be pronounced eight ways is that English has been allowed to evolve organically and has never been reformed from the top down.

What is the point of this story? It shows us that language is not fixed or neutral. It is an ever-changing thing created thousands of years ago and passed down to us. We have inherited language, just like any cathedral or temple – and so it is something we can also renovate, rebuild, extend . . . or damage.

Take the spelling differences between British and US English; they are no accident of history.

Colour	▷	Color
Realise	▷	Realize
Metre	▷	Meter
Analogue	▷	Analog
Aeroplane	▷	Airplane
Foetus	▷	Fetus
Judgement	▷	Judgment
Cancelled	▷	Canceled
Jewellery	▷	Jewelry
Programme	▷	Program

In the early 1800s an American called Noah Webster decided to create a dictionary. Partly because a standardised spelling system would be better for education, partly to create a distinctly American orthography and achieve linguistic independence from Britain. In 1828 he published the *American Dictionary of the English Language*, complete with 70,000 words. Webster made manifold changes to Dr Johnson's spellings, including the replacement of -our with -or, -ise/-yse with -ize/-yze, -re with -er, -ce with -se, and -ll with -l. In the introduction to his dictionary Webster explains that his priorities were simplification, consistency, pronunciation, and etymology. Here's one example of a change he made:

> There is another class of words the orthography of which is not uniform, nor fully settled, such as take the termination *able* to form an adjective. Thus Johnson writes *proveable* with *e*, but *approvable* and *reprovable*, without it. So *moveable*, but *immovable* and *removable*; *tameable*, but *blamable*, *censurable*, *desirable*, *excusable*; *saleable*, but *ratable* . . . I have reduced all words of this kind to uniformity.[55]

Webster, unsurprisingly, did not mince words. And though an admirer of Johnson, he was ready to point out mistakes:

> Nothing in language is more mischievous than the mistakes of a great man. It is not easy to understand why a man, whose professed object was to reduce the language to some regularity, should write *author* without *u* and *errour* and *honour* with it! . . . this inconsistency runs through his work, and his authority has been the means of continuing it, among his admirers, to this day.[56]

Noah Webster's dream was to create a rational, consistent, useful, unifying, independent American orthography. His dream was

realised; Britain and the USA will forever spell the same words differently. When planes were invented Britain ended up with 'aeroplane' and the USA with 'airplane', following Webster's orthography. American by design! You see, then, that we can change and manage our language if we want to. The only question is . . . should we?

William Shakespeare spelled his name at least six different ways. Six! But, if I had written about Shakspeare, Shakespear, or Shakspere in this book, people would have called it a mistake. Perhaps some reviewer would have said, somewhat wittily, 'he cannot even spell Shakespeare!' Even you, Dear Reader,* might have also wondered how such a blatant typo could travel so far. And you might wonder about the quality of the rest of this book if I could not manage to spell the name of the most famous playwright who ever lived. All this, while the man himself spelled his own name that way! You might begin to suspect that 'correct spelling' is something of a con . . . might! Well, this book deserves to be criticised for many reasons, but spelling is *not* one of them. To correct another's spelling (or pronunciation) is just false pride; it is no sign of wisdom to spell well, only pedantry. Some say 'correct spelling' shows professionalism, and they are absolutely correct. But is *professionalism* our highest virtue? We must be troubled when a

* I suddenly remember (and wish to share with you) an amusing passage from Thomas Dekker on the false flattery of calling readers 'dear': 'AND why to the Reader? Oh good Sir! theres as sound law to make you give good words to the Reader, as to a Constable when he carries his watch about him to tell how the night goes, tho (perhaps) the one (oftentimes) may be served in for a Goose, and the other fitly furnish the same messe: Yet to maintaine the scurvy fashion, and to keepe Custome in reparations, he must be honeyed, and come-over with Gentle Reader, Courteous Reader, and Learned Reader, though he have no more Gentilitie in him than Adam had (that was but a gardner) no more Civilitie than a Tartar, and no more Learning than the most errand Stinkard, that (except his owne name) could never finde anything in the Horne-booke.'[57] Too right!

programmer from Silicon Valley says Shakespeare cannot spell — worse, when their systems suggest Shakespeare can be 'improved'. Try it. Copy and paste some Shakespeare into Word and look at those jagged red lines in action. Troubling!

If we can understand one another, does it matter if we spell differently? Our differences are what add character to this world; embracing those differences inculcates individuality and spurs creativity. Human beings are better than standardisation. And so, though it does have a place, we must beware the illusion of 'correct spelling'. This language, created and passed lovingly on by your forebears, is now yours to do with as you see fit!*

What is the future of language? I said that it is an inherited thing — and so, unfortunately, as with any building, we can also demolish it. The number of languages in the world is decreasing. There are, by the latest estimate, a little over 7,000 living languages, 3,000 of which are endangered, while there were more than 10,000 only a century ago. By the dawn of the twenty-second century 90 per cent of the world's languages will have died. This is an almost inevitable consequence of globalisation. When the world was divided by time and distance it made sense that each region developed its own tongue. But now, in an interconnected world, language is flattened like everything else; all is drawn towards a standard. Most old and dying languages are spoken by old and dying people — people who have so much to teach us! For a language may have a unique concept, a word, or way of speaking, and therefore an entirely unique mode

* Quiller-Couch said well: 'It is better to err on the side of liberty than on the side of the censor: since by the manumitting of new words we infuse new blood into a tongue of which (or we have learnt nothing from Shakespeare's audacity) our first pride should be that it is flexible, alive, capable of responding to new demands of man's untiring quest after knowledge and experience.'[58]

of thinking also. If that language dies then we also lose its concepts, words, or ways. What a tragedy for humankind to lose something we have managed, against all odds, to create.

It may be that we are heading toward a world language, one we will take to distant planets with us and thereby create a metaphorical and literal universal language. For the moment, however, that remains speculation. What we can say is that English will not be spoken until the end of time. Latin was once the lingua franca of Europe and people read Cicero in his own tongue; the age of Latin has now ended and we read Cicero in translation. Perhaps English will, like Latin, have something of an afterlife. But, I suspect, if you are reading this book in the year 5024 CE, it will not be in English – and it is translators alone who will have helped you read these words.

We return to Babel. God was wise to defeat us with the curse of tongues; divided by language, cooperation is impossible. But we overcame this division – because of translation. Without translators, where would we be? Through their work I have been able to read the *Upanishads*, the novels of Yukio Mishima, the poetry of Guido Cavalcanti, the *Song of Roland* and *Poetic Edda*, the travelogues of Ibn Battuta and letters of Erasmus, the histories of Polybius and biographies of Plutarch – and much else besides. You may have read these books too, or read others books written in foreign tongues; you might be reading this book in a language other than English. But this goes beyond the books we have read as individuals: all our lives have been changed, our world shaped, our thoughts formed, by things written in other languages. It is translators who grease the wheels of civilisation, who make each culture a cog that may interlock with others and roll humanity onwards. Engineering, chemistry, medicine, maths, philosophy, geography – all these fields also rely on translation. Our world might have been an archipelago of

cultural and intellectual islands, divided by oceans of language, but translators have built the bridges that we may work together.

In 1604 King James commissioned a committee of forty-seven to translate the Bible into English. These translators wrote a Note to the Reader. In it they provide a defence of translation as a force for civility, unity, peace, and progress. I quote it at length here:

> But how shall men meditate in that which they cannot understand? How shall they understand that which is kept close in an unknown tongue? as it is written, *Except I know the power of the voice, I shall be to him that speaketh a barbarian, and he that speaketh shall be a barbarian to me* . . . Translation it is that openeth the window, to let in the light; that breaketh the shell, that we may eat the kernel. Indeed without translation into the vulgar tongue, the unlearned are but like children at *Jacob's* well (which was deep) without a bucket or something to draw with: or as that person mentioned by *Esay*, to whom when a sealed book was delivered with this motion, *Read this, I pray thee*, he was fain to make this answer, *I cannot, for it is sealed.*[59]

Marvellous – and moving. Without translators we would be living in darkness, in a barbarous world where we would despise speakers of incomprehensible tongues and know nothing of them, unable to pool our knowledge or unite. But that is not, thankfully, our world. Linguists and translators have opened the window and let in the light, giving us humanity's collective wisdom won by hard trial and error down the millennia – the book has been *un*sealed!

The Sixth Pillar of
The Cultural Tutor

How to Live (and How to Die)

CHAPTER I

The Trial of Socrates

†

> You have pondered, Nachiketas, on pleasures, and you have rejected them. You have not accepted that chains of possessions wherewith men bind themselves and beneath which they sink.
>
> – from the *Katha Upanishad*[1]

Education is not only about the accumulation of knowledge. Its purpose, above all, is to help us learn how to live and how to act. But there are many ways of living and many ways of doing, endless problems to wrangle with and abundant joys to discern. So these seven chapters will offer just a few of those ways, and will attempt to illustrate how the things I have covered in this book – history, art, poetry, philosophy, and the rest – all have their role to play in helping us to make sense of the world and ourselves.*

We begin with a story.

Socrates asked too many questions. So in 399 BCE, at the age of seventy, he was put on trial by his fellow Athenians. The charges?

* Universities take their name from *universitas*, a Latin word meaning 'the whole'. No single subject gives us an answer, neither science nor art nor any of their subdivisions alone. All types of education and all possible fields of human inquiry are just different sides of the same object.

Corrupting the youth and offending the gods. Socrates denied having taught anybody anything and said people wanted him punished because his questioning had exposed their ignorance. He admitted that those who listened to him, especially the youth, had gone on to question their parents – but argued that he did not tell them to do so:*

> Young men . . . come about me of their own accord; they like to hear the pretenders examined, and they often imitate me, and proceed to examine others; there are plenty of persons, as they quickly discover, who think that they know something, but really know little or nothing; and then those who are examined by them instead of being angry with themselves are angry with me. This confounded Socrates, they say; this villainous misleader of youth!—and then if somebody asks them, Why, what evil does he practise or teach? they do not know.[2]

Socrates was sentenced to death, before a jury of 501, by a margin of just thirty votes. His punishment was delayed and he was given a chance to escape . . . but he refused. Socrates believed that living the right way was more important than merely living, that death was preferable to doing the wrong thing:

> I would rather die having spoken after my manner, than speak in your manner and live . . . The difficulty, my friends, is not to avoid death, but to avoid unrighteousness.[3]

Socrates was not a philosopher who sat in his study writing books, and he did not work at a university. He liked to sing, dance,

* Plato was at the trial and wrote an account of it called the *Apology of Socrates*, which is worth reading in full. It is from this that Socrates' words are quoted.

drink, and laugh with his friends – though never *too* much. He had little money and no power, nor did he seek them. He was neither an ideologue nor an extremist, neither conservative nor revolutionary. He was merely Socrates, who asked 'why?' and 'how?' and 'what?' He spoke simply and spent his time on the streets talking to princes and beggars. And when he was sentenced to death by his countrymen he accepted their verdict and drank the poison hemlock like wine. A life well lived? One struggles to disagree.*

The Death of Socrates by Jacques-Louis David (1787).

Almost one thousand years after the death of Socrates another man suffered the same fate. His name was Boethius and he had risen to the role of *magister officiorum*, something like a chief of staff, under King Theoderic of Italy. All came crashing down. A senator was accused of plotting against the king and Boethius spoke in his defence. Theoderic, paranoid about a conspiracy cooked up by the

* Perhaps you can understand why Michel de Montaigne so revered him, writing: 'Truly it is much easier to speak like Aristotle and to live like Caesar than to speak and live as Socrates did.'[4]

Byzantines, had the two arrested and asked the Senate to put them on trial – a test of their loyalty. Boethius was sentenced to death by his friends.

But in his cell, awaiting execution, Boethius had a revelation. He wrote a short book about it, *The Consolation of Philosophy*. In it he imagines a conversation with Philosophy, personified as an ethereal woman, who explains why he should be happy despite his situation. She presents an argument with several stages of increasing profundity:[5]

1. History shows how unpredictable events are and how suddenly things change. This is the Wheel of Fortune, which lifts us up and casts us down at random. And yet we can draw hope from it:

 > Good times pass away, but then so do the bad. Mutability is our tragedy, but it's also our hope. The worst of times, like the best, are always passing away.

 Furthermore, unexpected changes of circumstances are always good:

 > All fortune is good fortune; for it either rewards, disciplines, amends, or punishes, and so is either useful or just.

2. Boethius, even in prison, still has blessings. His sons and his father are healthy and successful; he still has sustenance, shelter, and books. However much we think we are suffering, there are others far less fortunate:

 > How many people exist, do you reckon, who would think that they were in heaven if they enjoyed the merest fraction of the fortune which is still yours?

3. But few people are truly happy. Everybody is always lacking one thing and concerned about another:

> Human welfare is a constant cause of worry, for it never wholly prospers and it never remains constant. One man has abundance of wealth, but is ashamed of his inferior origins; another is celebrated for his noble birth, but is beset by domestic poverty. One man is richly endowed with both nobility and wealth, but laments his life as a bachelor; a second is happily married but childless; a third is blessed with a family, but the failings of a son or daughter cause him distress.

And, what's more:

> . . . the most fortunate people are also the most squeamish. Even trifling reverses detract from the sum of happiness of those who are most privileged.

4. Philosophy concludes that placing value on external things will never satisfy us. She asks Boethius if, when he was rich and powerful, he was ever completely happy; he admits he was always worried about something. Philosophy goes on to dismantle the pursuit of material things: those with power or wealth fear losing them; those who pursue fame are pursuing an illusion; physical pleasures leave us unfulfilled.

> Out in the fields hundreds of his oxen plough, but still the furrows of anxiety are deep in his creased brow, and he worries about those riches he can't take with him.

5. Since external routes to happiness can never make us truly happy, the real source of happiness must be internal. What is

internal can never be affected by what is external; it is beyond the Wheel of Fortune:

> One's virtue is all that one truly has, because it is not imperilled by the vicissitudes of fortune.

6. Philosophy argues that only that which is good can make us happy, and therefore that being a good person is the route to happiness. So if people do bad things it is they who suffer most, because what they have done is, logically, a result of unhappiness. Boethius does not hate those who betrayed him; he pities them.

7. If we are truly happy, then no external factors, however bad, can ever change that. Nothing bad can happen to a good person:

> If a person derives that glory from an external source, some other person of circumstance could deprive him of it... but the wise man's crown will not tumble or wither, for no outsider's wickedness can pluck from honest hearts the glory that is theirs.

> Nothing is miserable unless you think it so; and on the other hand, nothing brings happiness unless you are content with it.

And so, facing death, Boethius was *not* miserable; he found happiness precisely when his life had reached its nadir.

The stories of Socrates and Boethius show that what we believe influences not only how we act but how we feel. As Montaigne wrote: 'The surest sign of wisdom in a man is a constant state of cheerfulness.'[6]

So this is a strange fact we must reckon with – that, as Boethius

said, a person's feelings can be insulated against the external world. Among those who resisted Nazism was a student from Munich called Sophie Scholl. At the age of twenty-one she was found guilty of treason for distributing anti-war leaflets. Scholl was offered freedom if she renounced her opposition. Simply by speaking a few words her sentence would have been nullified. This is what she said:

> How can we expect righteousness to prevail when there is hardly anyone willing to give himself up individually to a righteous cause? It is such a splendidly sunny day, and I have to go.[7]

In February of 1943 Sophie Scholl was executed by guillotine. It was because of what she believed that she could meet her end with such frightful courage. Frightful, I say, because her courage should frighten us out of our complacencies; history shows that those who listened to their conscience are the people who have dealt best with the inevitable trials of life.

Seven months later another dissenter was executed: Franz Jägerstätter. He was an Austrian farmer who refused to swear the Hitler Oath. Jägerstätter did say he would serve in a non-violent capacity, but he refused to fight. They condemned him for treason. Like Scholl he was given a final chance to renounce his beliefs. Jägerstätter refused:

> Neither prison nor chains nor sentence of death can rob a man of the Faith and his free will.[8]

It sounds counterintuitive to say that neither prison nor sentence of death can rob us of our faith or free will, but Socrates would have agreed. This is the spirit of Prometheus, chained to a rock and tortured by Zeus for giving fire to mankind but who never once begged for mercy, whose defiance triumphed over Zeus's power. The

conclusion I offer is that life is not about avoiding death. If all the decisions we make are predicated on living longer we are playing a losing game. As Xenophon recalled of Socrates when his friends tried to help him escape:

> Afterwards, when his companions wished to steal him out of prison, he would not follow their lead, but would seem to have treated the idea as a jest, by asking 'whether they happened to know of some place outside Attica where death was forbidden to set foot?'[9]

Our ultimate goal must be to live well rather than live long. Montaigne put it best:

> The utility of living consists not in the length of days, but in the use of time; a man may have lived long, and yet lived but a little. It depends upon your will, and not upon the number of days, to have a sufficient length of life.[10]

The truth? A good life is always long enough.

CHAPTER 11

When Xenophon Met Mulan

†

Water, water, every where,
And all the boards did shrink;
Water, water, every where,
Nor any drop to drink.

– Samuel Taylor Coleridge,
The Rime of the Ancient Mariner

In 401 BCE a man called Cyrus, brother of the Persian king Artaxerxes III, went to Greece and raised an army of 10,000 mercenaries. They marched east and six months later arrived near Babylon. There they fought for Cyrus beside his other troops. Cyrus charged into battle and was killed. Night fell. The Greeks made camp and, next day, their leaders were invited to meet Artaxerxes. They were ambushed and killed. Back in camp, on some barren hillside, the Greeks were despondent: leaderless, a thousand miles from home, surrounded by hostile forces. They did not even light fires; they awaited their certain fate.

Among them was a young soldier called Xenophon. He could not sleep . . . and had a revelation:

Why am I lying here? The night advances; with the day the enemy will be upon us . . . but here we lie, as though it were time to rest and take our ease. I too! what am I waiting for? a general to undertake the work? and from what city? am I waiting till I am old enough? I shall never be old enough if today I do nothing.[11]

So Xenophon gathered the officers, roused them to action, and led the Greeks over two long and arduous years back home. This expedition is retold in the *Anabasis*, Xenophon's account of what happened.

His were the words I said to myself on a blustery afternoon three years ago. One moment of clear thought among a million of murk was all I needed. Xenophon's words made sense. 'Am I waiting till I am old enough?' I quit my job. And, in debt to anybody who had made the mistake of lending me money, decided it was high time to pursue what I loved, hoping I could pay back my friends and family while doing it. Now I am here, writing this book – here you are, reading it.

But it was not only Xenophon who brought me the clarity of mind to begin this journey; there was also *Mulan*, the 1998 Disney film, that I had watched endlessly as a child. Somehow, strange and silly as it sounds, when I took off my work uniform I felt like Mulan cutting her hair before riding to war in the dead of night. Here was a rare moment: I felt free as a bird. That was the day Xenophon met Mulan – and I went along for the ride.

Why am I telling you this? Maybe, if I hadn't read Xenophon or watched *Mulan*, I wouldn't have quit. My point is: the things you watch and read have the potential to change your life and change *you*, for better or worse, even in the most unexpected ways. This means, of course, that we need to think very carefully about what we consume. That is the subject of this chapter.

When Europeans first met the people of South America they called them barbarians. Montaigne did not approve: 'There is nothing barbarous and savage in this nation, by anything that I can gather, excepting, that everyone gives the title of barbarism to everything that is not in use in his own country.'[12]

He was right – we are creatures of coincidence. Why else would I say beans on toast is a decent meal? Because I was born an Englishman. As Herodotus said: 'Everyone without exception believes his own native customs, and the religion he was brought up in, to be the best.'[13] We have all been shaped by the conditions of our upbringing and the things we have consumed. But we *can* change, we *can* be radically reshaped – for good or bad – by the things we do and consume. Art, because we perceive immediately in one image what twenty books could not explain, provides wonderful examples of this.

Grant Wood, of *American Gothic* fame, did not always paint 'like that'. Only a few years before 1930 (the year he painted *American Gothic*, taking his sister and dentist as models, transforming overnight from an Iowa dauber into an all-American superstar) Grant Wood was just another Impressionist wannabe. But in 1928 he visited Germany, saw there the paintings of a fifteenth-century artist called Hans Memling, and had an epiphany. Gone were the blurred lines of Impressionism; in came the smooth finish of the Netherlandish Renaissance. This was a total transformation in his style (and, afterwards, his life) – all because he happened to see the paintings of Hans Memling.

Vincent Van Gogh. Three words that call to mind vivid and swirling colours. But Van Gogh did not always paint that way; his art from before 1886 is unrecognisable. What changed? He went to Paris and saw the impasto flowers of Adolphe Monticelli and the

Reflections at Ville d'Avray (1920) and *The Midnight Ride of Paul Revere* (1931), both by Grant Wood.

bright colours of Paul Gauguin. A door, previously invisible to him, had opened – and he flung himself through it.

Farm with Peat Stacks (1883) and *Wheatfield with Cypresses* (1889), both by Vincent Van Gogh.

There would be no *Hamlet* but for Shakespeare having read François de Belleforest's translation of Saxo Grammaticus' *Gesta Danorum*, nor any *Coriolanus* without Plutarch or Thomas North having translated Plutarch and Shakespeare having read North. History, too, is shaped by coincidences of consumption. Had not Charlemagne seen in Ravenna

the mosaics of San Vitale showing the Emperor Justinian, showing what real kings look like, he might never have been inspired to preserve and spread surviving works of antiquity, nor to build his own palace or have himself declared Holy Roman Emperor. It turns out you need only visit a certain building to change your life!

But there is an easy mistake to be made here – that the experience itself is what matters. This may be true up to a point, but any given thing is meaningless if it just bounces off us. It is not so much the nature of an experience as what we make of it that is important. Think of Marcel Proust, one of the most famous novelists of the twentieth century. He was a sensitive and reclusive man who hardly had any 'dramatic' experiences to speak of. But what is the most famous moment from *In Search of Lost Time*, Proust's masterpiece and generally ranked among the best dozen or so novels ever written? When its protagonist dips a madeleine into a cup of tea. Proust makes so much of this moment that it trounces all the thousands of writers who write of ostensibly 'interesting' or 'exciting' subjects without really understanding or reflecting on them. Proust himself, it seems, knew as much:

> But genius, and even great talent, springs less from seeds of intellect and social refinement superior to those of other people than from the faculty of transforming and transposing them . . . genius consisting in reflecting power and not in the intrinsic quality of the scene reflected.[14]

We must experience things and learn to let them leave an impression. For even the smallest moment can change your life if only you give it real attention. Perhaps you have never noticed how often, how swiftly, the sky changes every day. This is only the most obvious example, and so many more come to mind that it is

almost frightening. In some sense, we only survive by *not* paying attention. To walk through a graveyard would crush us – the loves, hatreds, fears, failed hopes, forgotten moments amassing – if we tried to think about it in its entirety. So we must close ourselves off, else life becomes unbearably profound. This is true always, at every moment of the day. But isn't it better to expose ourselves to this terrible brightness shining forth from all things than to wrap our hearts in lead in the hope of getting through another day without trouble? The former risks destruction – the latter promises survival, albeit dead and cold, perhaps no life at all. So, which shall it be?

Think of that most ancient joy, the kiss. We spend weeks – months, years – waiting for it to finally arrive. How many times have we imagined it, this kiss, and in how many different scenarios? Ah, we dream! The kiss lasts hardly more than a few seconds. Was this worth years of dreaming? I think so. And, afterwards, we are filled with a nuclear delight for a week, a month, even longer. All problems seem more small, less large, after the kiss. We smile away the anxieties. Taxes? They can wait! Worries bounce off us. We grow impulsive. Even years later it lingers at the back of our minds, an impression waiting to be recalled at will or by chance at some familiar scent – of burnt coffee, of rain on a summer-baked tennis court – and that moment subsumes us once again. A single minute of time becomes a fulcrum around which our lives spin. The joy itself is shockingly brief, but like even the smallest pebble its ripples spread – and, if not for the interruptions of gravity or air resistance, would continue literally forever. Well, we die also. But the kiss carries us to that deathbed and even keeps us company upon it. One moment of joy! We must allow this happiness to consume us, like a conflagration, and refuse to let doubts douse those flames of delight. True enough, we know that as the happiness burns us up the fire may burn out – and cold ashes

THE SIXTH PILLAR OF THE CULTURAL TUTOR

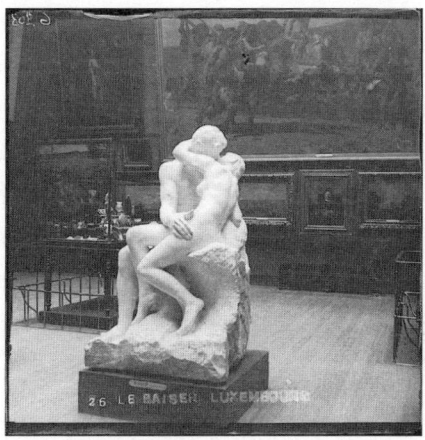

The Kiss by Auguste Rodin (originally 1882).

shall be a kind of despair. But this is the risk we must accept; it is the unavoidable risk of joy, love, and all other passions.

So it is not just the things we consume or the places we go that rechart our life's course. It is also the people we meet. Where would I be without my dear friend Harry? Would there have been a Michel de Montaigne without an Étienne de La Boétie? Blessed thou art to have a friend of whom you might say, as Michel did of Étienne: 'If you press me to say why I loved him, I can say no more than because he was he, and I was I.'[15]

Cast your mind back to Vincent van Gogh and how his art was transformed by what he saw in Paris. We readily accept that such transformations are possible – but it is much harder for us to accept that our own lives also offer such possibilities for transformation.

Every day: 4 million YouTube videos; 100 million Instagram posts; 3 million articles; 11,000 books. Every day more content is created than a human being is able to consume in a lifetime. And most of this content is carefully calibrated to keep us scrolling;

all that matters is our attention, that our eyes remain glued to the glowing box. 'Content, content, everywhere, and not a thought to think!' Too often, I fear, we let ourselves be cowed by an endless stream of 'current affairs' that informs us in needlessly gruesome detail of various murders or celebrity scandals, all of it supposedly worth our undivided attention and day-long ruminating. This sort of thing is addictive – but it means we forget that we can, like Wordsworth, go outside and find there a whole other world:

> . . . yet still the solitary cliffs
> Wheeled by me—even as if the earth had rolled
> With visible motion her diurnal round!
> Behind me did they stretch in solemn train,
> Feebler and feebler, and I stood and watched
> Till all was tranquil as a dreamless sleep.[16]

You are a burning-living *thing* of atomic genesis, dear Reader, magically alive in a cold universe! So shall we let ourselves spend all these precious days chained to the news and content cycle? It is obvious that the things we consume have some serious effect on who we are and what we do – so obvious we fail to realise it. That 'life-changing' friendship, that 'chance meeting', might happen *today*. Our Memling, our La Boétie awaits, if only we would open our eyes and put down our phones from time to time – or, at least, when using this fabulous 'internet' broaden the scope of our exploration. For ours is a wide world and we do ourselves an injustice by not choosing more selectively the things we 'consume', risk never blossoming into our fullest selves by not reaching less cautiously for unfamiliar experiences, risk living a shallow life by not reflecting deeply on what we have seen and drinking in the million details that even the triflingest moment possesses.

CHAPTER III

Revenge of the Stoics

†

> I forgot that I was a son of kings,
> and I served their king;
> and I forgot the pearl,
> for which my parents had sent me,
> and because of the burden of their oppressions
> I lay in a deep sleep.
>
> – from The Acts of Thomas

We must set the scene. For me, the most terrifying words in the Book of Job are those spoken by Satan when God asks him where he has been:

> From going to and fro in the earth, and from walking up and down in it.[17]

Satan has not been sitting on his fiery throne in the Underworld; he has been, to put it euphemistically, out and about. This is a frightening metaphor for the fact that mundane evils surround us, that we become bored, anxious, confused, and lost. But *why* must there be evil and unhappiness in the world? It is an old question.

The Greeks sought to solve this problem with their philosophies, the Indians with theirs, and we now seek to answer with our

TedTalkers, online productivity experts, and wellbeing gurus. That we want to avoid the bad and find the good is clear. The question has always been: what *is* good, what *is* bad, and how do we pursue the first while avoiding the second? There are a thousand 'ways of being' – every generation has attempted to craft some sword to slay our dragons, and we're no different.

Will the latest book advising us to atomise our habits, take

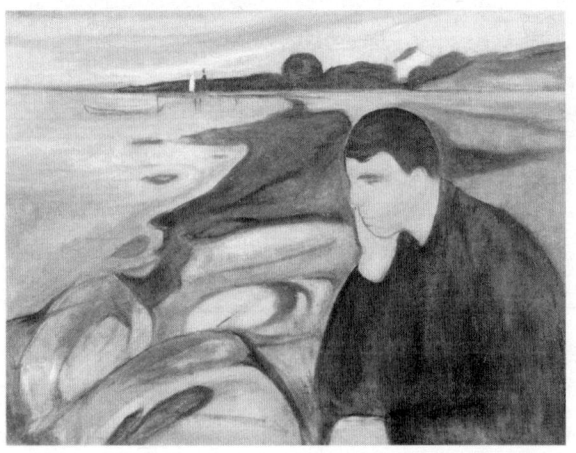

Melancholy by Edvard Munch (1894).

regular ice baths, or prioritise our productivity paths show us the 'way to be'? Maybe. But I think we are too ready to believe that a simple life hack can give us all the answers, too eager to get *more* for *less*. Will 'side gigs' sort us out? Will 'four-hour work weeks' bring us joy? Will new methods of breathing or more efficient models for note-taking finally answer the question plucking, thornlike, in your deepest heart of hearts? To be clear, I am talking about that genre called either Self-help or Self-optimisation. Some of these books are obviously worthwhile, and have evidently done good for the world. But they can go too far: are we nothing more than programmes in

need of fine-tuning? Is our humanity, in the end, just a thing to be 'optimised'?*

But, you might say, what were the letters of Seneca if not a Roman self-help column? Is not the Bible filled with rules and mindsets? So too Plutarch's *Moralia*. Machiavelli's *The Prince* was self-optimisation for Renaissance rulers, and Cicero wrote more self-help books than I could list. Castiglione's *The Book of the Courtier* was the sixteenth-century equivalent of Dale Carnegie's *How to Win Friends and Influence People*, containing such gems as: 'Practise in everything a certain nonchalance that shall conceal design and show that what is done and said is done without effort and almost without thought.'[18] Well, it does seem to be true that one of these old ways – an ancient kind of 'self-help' – *has* recently returned: Stoicism. In truth, there are probably more Stoics now than at any point in the last sixteen hundred years. Remarkable.† And if one school of ancient philosophy has something to offer in the twenty-first century, might others also be useful? Could there be, for example, a Cynic revival? Forget whatever you think 'cynic' means. In ancient

* Imagine we combined every single 'Big Ideas' or 'Self-help' book into a single, vast volume. How many times do you think words like romance, adventure, or beauty would be mentioned? I think the tendency of modern 'self-help' leads us away from experiencing the full depth of life, both its good *and* its bad. Consider the poetry of Alan Seeger, a soldier writing in the trenches of the First World War, who seemed to understand the underlying *intensity* our lives can have – an intensity which, it seems, 'self-help' leads us away from:
 'There we drained deeper the deep cup of life,
 And on sublimer summits came to learn,
 After soft things, the terrible and stern,
 After sweet Love, the majesty of Strife.'

† That being said, modern Stoicism is devoid of the broader and more foundational concepts of ancient Stoicism regarding things like the immortality of the soul; it has been whittled down to practical advice rather than a fundamental conception of how the universe works.

Greece *kynikos* meant 'like a dog'. This word, *kynikos*, was used to describe a group of men and women led by somebody you may remember: Diogenes. He was a pupil of Socrates and he believed that we have more than enough when all we have is our mind and body. As it was written in the *Cynic Epistles*:

> Reason is a guide of the soul, a beautiful work, and the greatest good to men. Therefore seek how to acquire this for yourself. For then you will hold fast to a happy life along with this possession.[19]

Diogenes rejected social conventions and went about aggressively subverting them. He slept in a clay barrel and owned nothing but the rags on his back, because he believed human beings did not need the froth of civilisation – laws, systems, politics. Cynicism, as a school of philosophy and way of life, flies in the face of our modern world, directly addressing the concerns that many of us have about life in the twenty-first century.

But there is a bigger problem here,* a problem with any and all schools of philosophy, self-help gurus, or ideas about self-optimisation. To explain what I mean we should read some advice from history's three most famous Stoics.

Marcus Aurelius wrote: 'Never esteem anything as of advantage to you that will make you break your word or lose your self-respect.'[20]

* And several other minor ones, including the possibility that the major achievement of the self-help industry (ancient *or* modern) is convincing us that we need help in the first place. It's worth asking: why do we need to be more productive? I can *say* that I would beat Tyson Fury in a fight – and getting into the ring would furnish us with a swift answer. But with self-help there is no 'getting into the ring', because the difficulty of measuring one's joy or success in life lets people get away with quackery. We become *hooked* on self-help, repeat customers asking like Oliver for 'more, please', thinking if we are just that half-percent more effective we will at last find peace. But the market does not reward lasting solutions. If a self-help book does all it promises, what hope is there for sequels?

And Seneca: 'Our plans miscarry because they have no aim. When a man does not know what harbour he is making for, no wind is the right wind.'[21]

And Epictetus: 'When I see someone in anxiety, I say to myself, "what can it be that this fellow wants? For if he did not want something that was outside of his control, how could he still remain in anxiety?"'[22]

All this Stoic advice wasn't merely intended to be useful – each statement you have just read was the logical result of a wide-ranging and complex set of beliefs about how the world works, the nature of good and evil, and the state of the soul. My point is that no advice exists alone – it is *always* the consequence of a broader view about the universe. Even advice about when to drink coffee or how to sleep better is built on a worldview; and so, I think, we must wonder about the worldviews of our self-help gurus and apostles of productivity before we take their advice. Everybody has a Heaven and a Hell – we just need to figure out what they are. Ask yourself this question and do not be misled to stand on the foundations another has built for you. As William Blake wrote, so clearly and powerfully:

> I must Create a System or be enslav'd by another Man's
> I will not Reason & Compare: my business is to
> Create.[23]

But when we start to ask such questions, when we try to figure out what stands at the foundation of our worldview, we might suddenly wonder . . . *is* there any meaning? Well, a nihilist would say life has no meaning; neither God nor gods exist; there is no such thing as objective truth; knowledge does not exist, nor morality, nor even objects themselves. And they would provide reasons, some convincing, for this view! To figure out whether they are right or wrong is

not our purpose here; my point is simply that we have issues of great magnitude to consider, and that to pursue more efficient methods of note-taking is very much the thin end of the stick. Still: would you stand with the nihilists – or search elsewhere?

The French writer Albert Camus was fascinated by the ironic tension between humanity's yearning for meaning in a universe without any. This he called 'the Absurd'. How to deal with it? Not by hiding, escaping, or deluding, but by *living nonetheless.* For Camus the mythical King Sisyphus, doomed to roll a boulder up a hill each day and watch it roll back each night for all eternity, offered a perfect analogy for the human condition. In the context of this myth, Camus stated, providing a perfect description of Absurdism: 'One must imagine Sisyphus happy.'[24]

Or, if not the Absurdists, would you agree with Cratylus? He was an ancient philosopher who believed words were meaningless, refused to speak, and simply waggled his fingers instead. Democritus never left his house without laughing, while Theocritus could never look on his fellow humans without weeping. Does the world make you laugh or cry? We may stand to benefit from habits, atomic or platonic, but maybe Walter Pater, that mangled Epicurean, was right when he said:

> To burn always with this hard, gemlike flame, to maintain this ecstasy, is success in life. In a sense it might even be said that our failure is to form habits: for, after all, habit is relative to a stereo-typed world . . . What we have to do is to be for ever curiously testing new opinions and courting new impressions, never acquiescing in a facile orthodoxy . . .[25]

Pater's point? That you should be fearless in pursuit of yourself – that we shouldn't be scared of trying different things or of finding

'ways of being' that do not accord with what the people around us are, for the most part, doing.

There can be no doubt that modern 'self-optimisation' helps us to find a place *within* a particular kind of system. But might there be something to life beyond this narrow veneer of life in a consumerist-capitalist society? Well, far be it from me to suggest that in the *Upanishads* might be found better 'ways of living' than in the latest Amazon bestseller. It may not be easy to tread alternative paths, but we all know nothing worthwhile is easily got, and 6,000 years of philosophy have more to give us, one trembles to argue, than the 'life-changing methods of journalling'.

I am not saying that all self-help is nonsense. What works for you I cannot convince you does not. Besides, we are all different and our general problem is a belief in catch-all solutions. My argument is simply that we humans are creatures of great depth, creatures with wide horizons in our hearts, and that modern self-help seems to address a very narrow scope of this vast potential, and seems to focus on the most material of its elements.

Indeed, it's hard not to notice that in the books that have survived the chaos of time, that all generations across the world have found most useful, there is very little advice about finance, dating, or health – and yet that is what *our* books are now filled with. Do you recall much talk of productivity in Montaigne, Seneca, or the *Bhagavad Gita*? Did the Buddha ever say anything about portfolios? Admittedly there is *some* talk of these topics in the timeless books of all nations. But, wherever we find it, their material 'advice' is simple and briefly stated. As it was inscribed on the Temple of Apollo at Delphi: ΜΗΔΕΝ ΑΓΑΝ – NOTHING IN EXCESS. I think that covers it.

We are all looking for something. Where to find it? I only

urge you not to let your spark be snuffed by the acceptance of easy answers or a mistaken belief in the pursuit of productivity, optimisation, and good habits.* If we are brave enough to seek elsewhere, to look a little deeper, we may find ourselves living a broader and brighter life than we ever imagined was possible – and those glorious words of the thirteenth-century poet Jalāl al-Dīn Muhammad Rūmī will finally make sense to us:

> . . . Awakened, he
> Will laugh to think what troublous dreams he had.[26]

* 'But what do you believe, Mister Scholar?' Yes, it is easy to poke holes and harder to mend them. And that may be my role: a gadfly to sting your hind and have you turn around. If you pushed me I would only say: 'οὐ φροντὶς Ἱπποκλείδη – HIPPOCLEIDES DOESN'T CARE'. But I mostly walk Aristotle's *Via Media* – too much science or too much art is a bad thing. These days, at least, we have mostly the former. But no science will allow honey to come forth from the carcass of a lion, and yet we find, if we look, that honey *doth* emerge from the strangest of places.

CHAPTER IV

The Art of Doing Nothing

†

For the sake of life to cast away the reasons for living
– Juvenal, *Satire VIII*

I can think of few things more spurious than the idea that we will ever 'stop working'. Thus it was written in the Book of Genesis, when Adam and Eve were banished from Eden:

> Cursed is the ground for thy sake; in sorrow shalt thou eat of it all the days of thy life; Thorns also and thistles shall it bring forth to thee; and thou shalt eat the herb of the field.[27]

And long before the Bible there was the *Epic of Atrahasis*, a Mesopotamian creation myth:

> After she had mixed the clay,
> she summoned the Anunna, the great gods.
> The Igigi, the great gods, spat upon the clay.
> Mami made ready to speak,
> and said to the great gods:
> 'You ordered me the task and I have completed it!
> You have slaughtered the god, along with his
> inspiration.

> I have done away with your heavy forced labour,
> I have imposed your drudgery on man.'[28]

The Greeks told a similar story. From the *Works and Days* of Hesiod:

> For the gods keep hidden from men the means of life. Else you would easily do work enough in a day to supply you for a full year even without working.[29]

Mesopotamians, Israelites, and Greeks agreed: humankind was born to labour. In their day, this made sense: every granary would wax empty without replenishment. And yet, in the twenty-first century, even though a minuscule percentage of the population works in agriculture, we are all still working. In the 1960s the end of work was predicted in much the same way as apostles of artificial intelligence do now:

> In automated industry, not only manual workers, but also secretaries and most middle-level managers will have been replaced by computers . . . According to one estimate, only 10% of the population will be working, and the rest will, in effect, have to be paid to be idle.[30]

Sure enough, artificial intelligence will soon do much of the work we presently do.* But what is history if not one long procession of delegating work? Wheel replaced cart-hauler; plough the furrow-digger; alarm clock the knocker-upper. What has happened whenever we delegate work to machines? We invent more work. Once upon a time there was only agriculture. Now we have coders, visual effects artists, podcasters, copywriters, and consultants. Not so

* Though we will probably just use AI to simulate a world without AI.

long ago none of these jobs existed and their work didn't need doing. It is our nature to find work. Even if the governments of the world united to create a global state in which we all received food, water, shelter, and electricity for free, and we were given enough money to do whatever we liked, we would still find novel ways of labouring. We would *make up* work, things ridiculous and fanciful to our ancestors but, for us, suddenly, a matter of life and death.

No doubt Marx and Engels were right that the rise of capitalism doomed millions to wage slavery. But the conclusion of this nineteenth-century evil, whose shadow looms large even now, should not be that work or wages are constructs of the conniving industrialist mind. Work and wages are the eternal truths of life on Earth. Our hunter-gatherer ancestors hunted and gathered; that was their work and the food resulting from it their wages. That does not mean all work is intrinsically good, of course; people deserve good work and for it they deserve fair wages – cash, parings of the pork, or even of that greatest wage: meaning. Sadly, for a long time now we have been forcing people to 'melt down fleas for their tallow' – that is, do gruellingly unpleasant and frequently pointless work. Where do you think your iPhone came from? Miserable labour is the bane of humankind and relieving people of awful work should be among our foremost priorities – rather than by way of antidote fomenting a culture of celebrity worship and fetishising financial success. Little wonder we seem to be living through a crisis of unhappiness when (among other causes) we stuff our heads with delusions of amassing either followers or material possessions rather than letting ourselves – or even being able to – enjoy decent and noble work.*

* Perhaps our obsession with 'more' has arisen because of the work we generally now do. Whereas our ancestors' labour yielded observable results, this is no longer true. The joiner planes wood, and after a day of sawdust and oil has made a chair. But most of

I do not mean to say that ideal work is simply good fun; ideal work gets at something deeper than that. When you climb a mountain there is much sweat and pain, but this is a kind of suffering that somehow seems worthwhile. It is clearly not pleasant, perhaps not even enjoyable, but nor does it feel pointless or wholly miserable. It's the same with rightful labour. Michelangelo struggled when he bent over backwards (he did not lie down, as it is often thought) to paint the ceiling of the Sistine Chapel. Four years of daily discomfort, but also of creative delirium, little delights, and pride. In those four years Michelangelo lived out the truth of *Laborare est orare*, an old monks' motto meaning 'Work is worship'. But this sort of labour does not belong to artists alone. It belongs to every person who finds purpose in their work, be they surgeon, bricklayer, plumber, teacher, constable, soldier, shopkeeper, florist, baker, butcher, bus driver, electrician, gardener, or gaffer. Labour is inevitably most meaningful when we know there is a reason for what we do, that it is necessary. Then we are like the bees, collecting their pollen and producing honey, as Virgil writes: *Sic vos non vobis* – 'This we do not for ourselves'.

But the prize of labour is not only crops or bags of coins; it is also the rest we earn. This is the counterpoint to work, the crucial element that brings harmony, that moment equivalent to reaching a mountaintop after hard ascent. Rest: to lay one's head down, knowing that today you have done all you need to do, to the best of your ability, and so to have earned your sleep. For sleep is, in the words of Sir Philip Sidney:

us now send emails, make phone calls, enter data into spreadsheets, and at the end of the day find that some numbers on a screen have changed. It is surely harder to draw meaning from this digital labour than work which leaves its mark, hour by hour, in the material world. Perhaps this also makes us more vulnerable to delusions of wealth and celebrity?

THE SIXTH PILLAR OF THE CULTURAL TUTOR

> ... the certain knot of peace,
> The baiting-place of wit, the balm of woe,
> The poor man's wealth, the prisoner's release,
> Th' indifferent judge between the high and low.[31]

And when we know that this rest, this nothingness of pure respite, has been rightfully won, we can put off tomorrow's anxieties because today's have been overcome. The day we stop working is the day humankind ceases to be: we will no more enjoy rest without work than work without rest. It is our nature!

But we do not rest properly today; we no longer know the meaning of 'doing nothing.' Smartphones have given us an infinite source of distraction. When are we without them? One hundred years ago things weren't so different: people had their faces in the papers, listened to the radio, or read the latest pulp fiction. Our inclination to labour becomes an inclination to be always occupied with *something*, and if we were always bad at doing nothing, phones have only made it more difficult by giving us the entire world in our pocket. The internet co-opts our attention. Sometimes we have to say: 'Enough, the time has come to do nothing!' But what does nothing look like? It is *not* meditation; meditation is focused nothingness. Look instead at the 'doing nothing' of Vincent van Gogh's farmers (see next page). No phones to occupy their attention, no messages in need of reply, no headlines demanding to be read. Pure tranquil repose, hard earned after a morning of scythes and sheathes.

Or think of these lines from 'Pine-Trees and the Sky: Evening' by Rupert Brooke:

> Then from the sad west turning wearily,
> I saw the pines against the white north sky,

Very beautiful, and still, and bending over
Their sharp black heads against a quiet sky.
And there was peace in them; and I
Was happy, and forgot to play the lover,
And laughed, and did no longer wish to die;
Being glad of you, O pine-trees and the sky![32]

That is the true wage of true labour. To stand and stare, sit and snooze, wander, lost in thought, without aim, dreams flickering before our mind's eye. Give your poor brain some time off! Rarely do you remember anything you have seen in your scrolling, and yet those things you have seen – memes, shorts, reels, infographics, headlines – are in your brain. Information overload causes

psychological problems, but still we load our mental carts higher and higher. Little wonder wheels creak and axles break.

Just as I write these words at the close of a winter's day, the sky outside is rolling over from milk-white to pure and pale blue. Grey clouds scud down from the north – and are now flaming with the light of the setting Sun. The garden grows dark and gloom gathers among the boughs. What was the glittering of midday frost has dimmed to a glinting among shadows. Venus shines in the firmament, now Mars. Arcturus and the stars emerge. Slow but certain nightfall. Then: thick fog rises. The stars fade. A flock of geese, invisible, calling out.

All that, and I would have missed it had I let my phone, or my books, or the writing of this book distract me. Nature rewards reflection. We must try harder than ever now, with our cities of glass, our digital universe of voice and song, like William Blake:

> To see a world in a grain of sand
> And a heaven in a wild flower,
> Hold infinity in the palm of your hand,
> And eternity in an hour.[33]

There is nothing humanity can make that is as complex or majestic, sublime or grotesque, as nature. As John Constable said: 'No two days are alike, nor even two hours; neither were there ever two leaves of a tree alike since the creation of the world.'[34]

It is clear (and has been proven beyond doubt) that we are happier, more peaceful, in nature. Still, there are things other than nature that we can wonder at. Ours is a wide world, a wide and blazing world of miracles and mysteries. Have you ever looked at a stapler, seen what an impossibly complicated contraption it is? Try – and it will leave you dumbfounded. The letter A itself would

astound us if we ever gave it real thought, that strange little gable with a single crossbeam, immanently ancient-seeming, commencing our alphabet with its primordial trill of the vocal cords.

So take those doubts that haunt your days, the hopes and stresses, the endless loop of information and the infinite cycle of content . . . leave it behind. Walk in the woods or, lacking them, set foot in the streets, without headphones and without purpose. Even sitting down – *without* your phone – will do. There, in nature or town or just at home, your mind free and unbounded, the time has come for doing nothing – for rest and wonder.

CHAPTER V

Ten Duovigintillion Years

†

And we are here as on a darkling plain
Swept with confused alarms of struggle and flight,
Where ignorant armies clash by night.

— Matthew Arnold, 'Dover Beach'

Stormclouds of war gather in the east. Bomb-thunder. Cities levelled. Soldiers marching. Regional conflicts threaten to spiral; the deathly flower of global war may bloom. All hangs in the balance. Can we trust our politicians to find the needle of peace in this haystack of hatreds? Even peace cannot halt the flow of molten ice. Deluge. Inferno. Forests drenched in flame and mountainsides glittering with embers. Meadow to ash, metropolis to wasteland. We cannot afford to live. The collapse of economic order. Plagues haunt us. Diseases of the flesh and also of the mind. Driven to despair, neurotic and overwhelmed, we are killing ourselves. Extremism shakes off the frost of old slumber and rises from its tomb. The world is no longer at ease.

What to make of our times, of the chaos and fear of life in the twenty-first century? Well, let me outline for you a brief, speculative history of the future. The number given is years from now:

1. 12,000: the Svalbard Global Seed Vault in Norway reaches its lifespan.
2. 17,000: the oscillation of Earth's poles will cause the Sahara to become tropical.
3. 26,000: Chernobyl will return to normal levels of radiation.
4. 50,000: Niagara Falls will have eroded all the way to Lake Erie.
5. 1 million: footprints left by *Apollo* astronauts on the Moon will fade.
6. 10 million: the Red Sea will flood the Rift Valley and a new ocean will divide Africa.
7. 90 million: the Rings of Saturn will have disintegrated.
8. 100 million: the world's largest cities will have become fossilised layers in the Earth.
9. 300 million: all the continents will merge into a new supercontinent.
10. 800 million: because of the Sun's increasing luminosity most of Earth will have become a barren desert and life will only exist in the oceans.
11. 900 million: carbon dioxide levels will fall to the point where photosynthesis is no longer possible; plant life will die out.
12. 1 billion: animal life will have died out and only single-celled organisms remain; the Voyager Golden Records launched in 1977 – containing a history of Earth – will degrade and become unrecoverable.
13. 2.8 billion: any remaining life on Earth will become extinct.
14. 3.5 billion: all remaining water will evaporate and the Earth's surface temperature will rise to 1,130°C, hot enough to melt rock.
15. 8 billion: the Earth and Moon will fall into the Sun as it approaches the climax of its red giant phase.

16. 150 billion: the universe's expansion will cause all galaxies beyond what was the Milky Way to disappear beyond the cosmic light horizon.
17. 10 duovigintillion: the universe will be empty; photons, baryons, neutrinos, electrons, and positrons will fly around, rarely encountering one another.
18. At a point in time too incalculably distant to be written in numbers the universe will reach its final energy state and... another Big Bang *may* occur.

I do not think this imagined history of the future will convince our governments to forge lasting peace. But it should encourage us, at the very least, to maintain perspective. And just as the sheer scale of the future helps us in that endeavour, the past is equally effective at reframing the problems of the present day. Because things have seemed to be ending before. One need only look at photographs from 1945 – of Tokyo obliterated, then rebuilt to become the world's largest city – to see what catastrophes we have overcome.

In the early months of the First Crusade in 1096, an unofficial 'People's Crusade' arose. When they travelled through Germany they attacked the Jews. First at Speyer and Worms, then Mainz. There the Jews turned to Bishop Ruthard for protection. He

sheltered them in his house. The Solomon bar Simson Chronicle tells us what happened next:

> They all arose, man and woman alike, and slew one another. They were all slaughtered, and the blood of the slaughter streamed into the chambers where the children of the Sacred Covenant had taken refuge. They law in rows, babes and aged men together, gurgling in their throats in the manner of slaughtered sheep . . .[35]

Diodorus Siculus records how Agathocles, King of Syracuse, turned on the city of Egesta nearly two and a half thousand years ago – and, I must warn you, it is gruesome:

> He constructed a bed of bronze in the shape of a human body, with bars regularly spaced all around it, slotted his victims into it, and lit a fire under it while they were still alive . . . He maimed the wives of the rich either by crushing their ankles with iron pincers or by cutting off their breasts, and if any of them were pregnant he piled bricks on the small of her back until the weight squeezed out the foetus.[36]

Little wonder Erasmus stated, 'the most disadvantageous peace is better than the most just war.' Our history is a bloodbath. But all conquerors are conquered in the end, as Plutarch tells us:

> Alexander wept when he heard from Anaxarchus that there was an infinite number of worlds; and his friends asked him if any accident had befallen him, and he returned this answer: 'Do you not think it a matter worthy of lamentation that when there is such a vast multitude of them, we have not yet conquered one?'[37]

Alexander knew his empire would not last. And what about his successors? Perdiccas, Ptolemy, Seleucus, Cassander, Antigonus:

history has hardly remembered you! All kingdoms collapse. Albert Einstein was born in the kingdom of Württemberg, a federal state of the German Empire. In Einstein's lifetime this kingdom became the Free People's State of Württemberg, first in the Weimar Republic and then the Third Reich. Later it was divided between the French and Americans until it finally became Baden-Württemberg in the Bundesrepublik Deutschland. Nations come and go. There is no Duke of Normandy now; Carthage once sent her armies to Rome; this 'United States of America' will disappear. More wars shall come, more Bulls of Phalaris, another Dresden or Tokyo laid low.

But the strange thing is that, amid such ceaseless chaos and churn, life always manages to get on. Imagine yourself in the year 1348. The Black Death has just arrived. Would you not think the world was ending?

> Everyone felt he was doomed to die and, as a result, abandoned his property, so that most of the houses had become common property, and any stranger who came upon them used them as if he were their rightful owner. Brother abandoned brother, uncle abandoned nephew, sister left brother, and very often wife abandoned husband, and – even worse, almost unbelievable – fathers and mothers neglected to tend and care for their children as if they were not their own. Many ended their lives in the public streets, during the day or at night, while many others who died in their homes were discovered dead by their neighbours only by the smell of their decomposing bodies. The city was full of corpses.[38]

This eyewitness account was written by Giovanni Boccaccio as the preface to his *Decameron* – a book of one hundred comical tales. We have a remarkable tendency to make light of

disaster, then endure and recover. Humans are a civilising force and wherever we find chaos we sow order: the field eaten by brambles we nurse, somebody among a disparate band of survivors takes the lead, roots out ill-discipline, and sets down laws. Society as *we* know it may collapse, but survivors will linger, procreate, and give rise to future generations. And perhaps they will live among the ruins of a lost civilisation, among crumbling highways and shattered towers of glass. And they will learn who we were – they may curse us, or even say, 'How great they were!' Yes, nuclear war is a threat to the world as we know it, but we shouldn't be too attached to our version of the world. Half the countries that existed in 1923 have gone; new ones have risen. A Bible has been written before and a Bible may be written again. And if my words have survived this hypothetical war, and you, some future human 100,000 years from now are reading them, to you I say, 'The world is yours, so make of it what you will – while you have it!' Who knows? Extinction is not impossible, and I am not confident the bees (if they survive) will learn to miss us.

Well, we do not know what the future holds – and will never be able to judge, truly, if we are living in the best or the worst of times. But we *can* have perspective. Using imagination, hand in hand with empathy, we can glimpse the lives of others. Look at the photo taken by Danish missionary Karen Jeppe just over a hundred years ago. We see an old woman bearing a bundle of thistles on her back.*

* It drew me to think of an old Lincolnshire folk poem:
 Ohd woman, ohd woman,
 Thoo mun go-a shearin';
 No-a, maister, no-a,
 For I'm dull o' hearin'.

THE SIXTH PILLAR OF THE CULTURAL TUTOR

Is it possible to make a judgement on how happy this woman was? Was she happier than you or I? We might assume that her life was one of unrelenting hardship and misery, but what would she make of our lives?* Truly: 'Better is a dinner of herbs where love is, than a stalled ox and hatred therewith.'⁴⁰

Still, we look at this woman and think ourselves lucky not to be in her situation. And so to know other people endure terrible burdens is not about pity or guilt; it is about *gratitude*. Have you had a glass of water today? You probably didn't think much of it. Well, when Dr Price and George Godwin investigated the cellars of Nichol Street, London, in 1864, they found a subterranean room with a single window, broken and boarded up. It was one o'clock in the afternoon and the room was in darkness. There were pools of sewage on the floor and refuse that had not been removed, one

* Remember Montaigne: 'Let us look down and see the poor people scattered about the fields, their heads bowed over their labour; they know nothing of Aristotle or Cato ... From them nature every day draws purer and stronger demonstrations of fortitude and patience than those we study attentively at school ... "This simple virtue, which is within the reach of all, has been turned into an obscure and subtle science."'³⁹

tenant said, for fourteen years. Price and Godwin found two teenagers dressed in oily rags leaning against the walls, walls of green and peeling plaster. Another tenant had, we are told, 'expired'. No running water; the only water they had came from begging. Every glass of clean and cool water you drink is a blessing!

'There but for the grace of God go I.' So said John Bradford on seeing a criminal led to the gallows. That is the message of these stories, whether you believe our fortunes are the result of God's grace or cosmic luck. So we must remember to have gratitude for what we do have, however calamitous our times seem to be. Perspective is a beacon of tranquillity. What point is there in hatred when 'politics' doesn't amount to a hill of beans in this galaxy? When we fall prey to self-pity, to anger with our fellow creatures, when we argue, criticise, despise, curse, or wallow – recall the Armenian woman with her bundle of thistles, the victims of Agathocles, or Boccaccio amid the Black Death. And, crucially, keep in mind that even those who lived through those times . . . lived nonetheless! They still found heart for laughter, and even romance in the rubble.

What to conclude from all this? Nobody was ever happy because of their times; they were happy regardless of them.

CHAPTER VI

Melencolia

†

Bound to the earth, he lifts his eyes to heaven—
Is't not enough, unhappy thing, to know
Thou art?

– Lord Byron, *Childe Harold's Pilgrimage*

There is an old story about the King of Persia. He wanted to know if there was anything he could say that would always be true, whenever and wherever it was spoken. So he gathered the wisest men in the land, who agreed upon a solution to the king's problem: 'This too shall pass.'

Ask yourself: is there *anything* that has not ever changed? We leave childhood behind, then youth. We finish school and find work. Our parents age, our dogs die, our grandparents die. Siblings and friends have children. We make friends and lose them. We have good days and bad. Moments when everything seems just right, others when every hour seems like torture. Summer gives way to autumn, to winter, to spring. The Sun rises, evening falls, and in the long dark we wonder if we will see the light again – and the Sun rises once more. In whatever situation we find ourselves, whatever circumstances confront us, however we are feeling, and whether any of these are good or bad – all will inevitably pass. Commenting on the

old adage – 'this too shall pass' – Abraham Lincoln said in 1859: 'How chastening in the hour of pride!'[41]

This was what Percy Shelley had in mind when he wrote *Ozymandias* in 1818. A statue had been uncovered in Egypt: the shattered face of Pharaoh Ramesses II. Shelley imagined this statue,* once sixty feet tall, submerged beneath the sands:

> I met a traveller from an antique land,
> Who said—'Two vast and trunkless legs of stone
> Stand in the desert . . . Near them, on the sand,
> Half sunk a shattered visage lies, whose frown,
> And wrinkled lip, and sneer of cold command,
> Tell that its sculptor well those passions read
> Which yet survive, stamped on these lifeless things,
> The hand that mocked them, and the heart that fed;
> And on the pedestal, these words appear:
> My name is Ozymandias, King of Kings;
> Look on my Works, ye Mighty, and despair!
> Nothing beside remains. Round the decay
> Of that colossal Wreck, boundless and bare
> The lone and level sands stretch far away.'

Like Ramesses, who when his statue was erected must have seemed like a god, but whose broken likeness glared over an emptiness that had forgotten him, all who hold power *will* lose it. Remember that as we admire or detest the prime ministers, presidents, gurus, and oligarchs of the present day. Thomas Gray said it best, giving us eternal words with which to rebuke the mighty:

* He never saw it. By the time it arrived in the British Museum, Shelley was already in Italy, never to return.

> The boast of heraldry, the pomp of pow'r,
> And all that beauty, all that wealth e'er gave,
> Awaits alike th' inevitable hour.
> The paths of glory lead but to the grave.⁴²

But Gray's words are true for you and me no less than for world leaders and billionaires. 'This too shall pass' is a universal invocation to humility.

Any such reminder of mortality is known as a memento mori. In art it often took the form of a skull or an hourglass hidden away somewhere in the painting. There was even, once, a trend of 'cadaver tombs'. These were memorial monuments with a gruesome twist. The deceased were portrayed not as they had been in life but as they would look in death: rotting flesh, skin falling away, a skeleton beneath. The

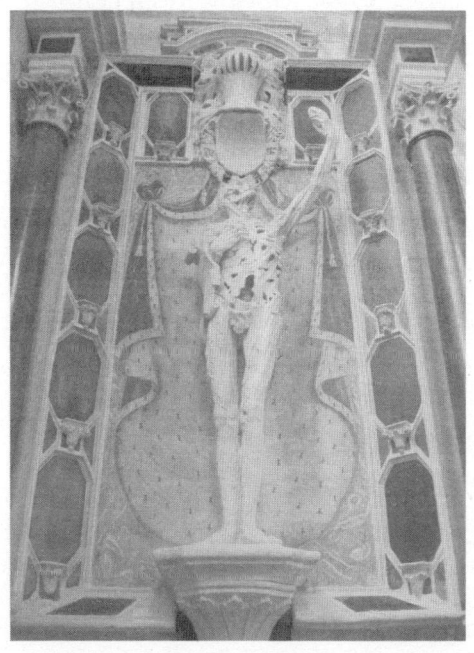

message: all that is material fades and so we must focus on what is eternal. The cadaver tomb of René de Chalon, sculpted by Ligier Richier, is among the most striking of these macabre monuments.

The laws of entropy state that all energy spreads out over time, and that all matter tends inevitably toward decay – therefore meaning that all things in the universe must be, and always are, changing. Rudolf Clausius, who first conceptualised entropy, adapted its name from the ancient Greek for 'transformation'. What he theorised, and what a century of scientists proved true, was not so different from the old Persian adage with which we began this chapter.

But if it is true that all things shall pass, why bother doing anything? We pursue happiness – it cannot last. We admire beauty – it must fade. This feeling has a name: *Weltschmerz*. It translates from the German as 'world pain', and refers to the melancholy idea that this life of ours – where nothing good can last – must always be a disappointment and will never satisfy us. Nobody expressed it better than Byron. In *Childe Harold's Pilgrimage*, which tells the story of a world-weary youth, we find this feeling entire:

> Ancient of days! august Athena! where,
> Where are thy men of might, thy grand in soul?
> Gone—glimmering through the dream of things
> that were:
> First in the race that led to Glory's goal,
> They won, and passed away—is this the whole?
> A schoolboy's tale, the wonder of an hour!
> The warrior's weapon and the sophist's stole
> Are sought in vain, and o'er each mouldering tower,
> Dim with the mist of years, grey flits the shade of
> power.

The realisation that all things must pass can be discouraging and lead us to brooding inaction. We might call that depression, but to medieval people it was a form of spiritual failure. They called it *accidie*, from the Greek *akidía*. Perhaps this apathetic darkness was what Albert Dürer felt when he engraved *Melencolia I* in 1514.* We see an angel – usually so bright – consumed by pensive gloom, verging on anguish.

But sadness is not the inevitable result of realising that this too shall pass. Another version of the story I began with has the Persian king seeking out a statement of eternal truth *because* he was melancholic. Abraham Lincoln also said, in that same speech of 1859, that

* Dürer is sometimes described as a Renaissance artist; that is partly true in a technical sense, but like the other great artists of his generation – from Raphael to Leonardo – he represented something like a synthesis of the Middle Ages and Renaissance.

the old Persian tale was 'consoling in the depths of affliction'. For it is precisely when we are consumed by anguish – or boredom, frustration, anger, or any of the dark feelings which plague us – that this adage is most important. If it really is true that nothing is permanent, this must also be true of suffering.

We could even say that transience enhances life. Yoshida Kenko, a fourteenth-century Japanese monk, thought so: 'If man were never to fade away . . . but lingered on forever in the world, how things would lose their power to move us! The most precious thing in life is its uncertainty.'[43]

Perhaps nowhere has transience been better understood than in Japan, home to a concept called *mono no aware*. It confounds translation but its kernel is this: a deep sensitivity to impermanence gives us a greater appreciation of the world's beauty. *Hanami* – the season from March to May when the *sakura*, or cherry tree, blossoms, and people gather to watch the blossom fall – is the embodiment of this spirit.

Suddenly, rather than an invitation to despondence, realising that nothing can last becomes a call to arms. The seventeenth-century poet Robert Herrick once wrote, 'gather ye rosebuds while ye may' – this is the essence of *carpe diem*, or 'seize the day', popularised by the 1989 film *Dead Poets Society*. Does it encourage heedless indulgence? Not necessarily. The ancient poet Pindar wrote of victorious athletes:

> There a man's strong prime endures its toils,
> And the victor all his remaining days
> Breathes a delicious and serene air
> When he remembers the Games.[44]

If we make the most of what we are given we can enjoy the fruits of doing so even after they have passed. *A good thing done is good for*

ever. There is fundamental worth in making the most of our brief and changeful life. Recognising that this too shall pass not only enhances our appreciation of beauty, nor is it simply an anchor to ground us when we are prideful, nor solely a buttress against suffering – it also exhorts worthy action.

In Virgil's *Aeneid* we find these lines:

> He stopped and cried weeping, 'What land is left, Achates, what tract on earth that is not full of our agony? Behold Priam! Here too is the meed of honour, here mortal estate touches the soul to tears. Dismiss thy fears; the fame of this will somehow bring thee salvation.'[45]

Aeneas and his refugees, having fled Troy, have landed near Carthage in North Africa. There Aeneas finds murals depicting the Trojan War: his countrymen defeated, his great city fallen, vicious Achilles. Aeneas is brought to tears looking upon the men who came before him, who seemed so glorious once, and his former homeland condemned to oblivion . . . and *yet*. Aeneas does not despair. This sight rouses him to continue the perilous quest of leading his lost people to safety. 'The fame of this will somehow bring thee salvation.' Somehow. A melancholy legacy of what has been becomes an invocation to strike forth and continue.

And there we have it – reconcile yourself to the impermanence of all things, to the fickleness of fortune, to the strange workings of your heart and mind that make you sad now and happy tomorrow, and rise above it all to see clearly, as though from a mountaintop, what it is you seek, what it is you must do, even falteringly. Like Aeneas, perceive truth in the distance, be at peace with the changefulness of the universe, not despondent but uplifted, strive, never too prideful nor losing faith, always remembering: this too shall pass.

CHAPTER VII

Death, Thou Shalt Die

†

Empty-handed I entered the world
Barefoot I leave it.
My coming, my going—
Two simple happenings
That got entangled.

— *Jisei* of Kozan Ichikyo

You are going to die. So am I. Of all the hundreds of millions of breaths you take, one of them, at some point, will be the last. Does that frighten you? Dwelling on death pervades our culture and always has. In *Gladiator*, Maximus, played by Russell Crowe, says, 'What we do in life echoes in eternity.' Then there are Dumbledore's curious words, 'Don't pity the dead, Harry, pity the living.' Or Gandalf, comforting Pippin, 'Death is just another path, one that we all must take.'

But we begin with the beginning, with humanity's oldest story – the *Epic of Gilgamesh*, told by the Sumerians 5,000 years ago. Our hero, Gilgamesh, has a beloved friend and fellow quester called Enkidu. After they have slain the Bull of Heaven, sent to destroy them by the jealous goddess Ishtar, Enkidu falls sick. He asks Gilgamesh not to forget him – and dies. Gilgamesh gives a moving lament for his friend and suddenly realises that he, like Enkidu, shall perish:

> Six days and seven nights I mourned over him
> And would not allow him to be buried
> Until a maggot fell out of his nose.
> I was terrified by his appearance!
> I began to fear death, and so roam the wilderness.
> The issue of my friend oppresses me,
> So I have been roaming long trails through the wilderness.
> The issue of Enkidu, my friend, oppresses me,
> So I have been roaming long roads through the wilderness.
> How can I stay silent, how can I be still?
> My friend whom I love has turned to clay.
> Am I not like him? Will I lie down, never to get up again?[46]

Gilgamesh seeks out Utnapishtim, the only man to achieve immortality, and begs him for the secret to eternal life. Utnapishtim says if Gilgamesh can stay awake for a week he will reveal it . . . but Gilgamesh falls asleep. He returns to Uruk knowing he must die.

Being frightened is surely the most natural reaction when any of us, like Gilgamesh, are first confronted by mortality. But what is instinctive is not necessarily truthful – Cicero believed instead that it was wrong to fear death, and so set himself the goal: 'To teach you, if I can, that death is not only no evil, but a good.'[47]

The Norsemen, for example, welcomed death. They believed that, were you to die in battle, you would be taken up by Valkyries and flown to Valhalla, a hall in Asgard decorated with golden shields and stocked with an endless supply of boar-meat and mead. They are with Odin, these sacred warriors, the *einherjar*, preparing for Ragnarök by

battling all day and feasting all night. Does this seems like nonsense? Alas, science has done nothing to explain the nature of death – but nor could it. The secret to life's meaning will not be found in a Petri dish. Is it then a mysterious book, forever to be sealed?

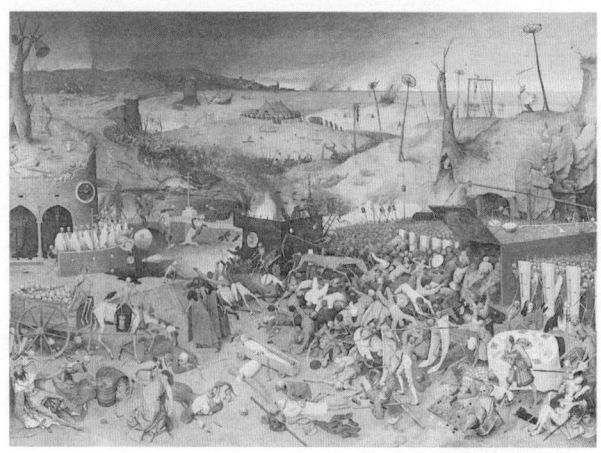

The Triumph of Death by Pieter Brueghel the Elder (1562).

A group of ancient philosophers known as the Epicureans believed that death was a physical phenomenon. Mind, body, and soul are one. Thus, when the biological machine breaks and its atoms disperse, the mind disintegrates also. Lucretius, a mysterious Roman poet who lived in the first century BCE, makes this argument in *On the Nature of Things*, an epic poem about Epicureanism.[48] Here, for example, he skewers any notions of an afterlife:

> And Cerberus, and the Furies, and the dearth of
> light as well,
> And noxious vapours belching forth out of the maws
> of Hell –
> These do not anywhere exist, nor can they, it is clear.

Why? Because:

> The spirit has a day when it is born
> And an hour when it must pass away.

And thus, Lucretius says, we needn't fear death:

> It's clear,
> Therefore, that Death is absolutely nothing we
> need fear,
> And that he who is *not* cannot be wretched or forlorn.

Then, as was the Epicurean way, he compares death with sleep – an idea taken up centuries later by the seventeenth-century poet and Epicurean John Hall:

> So perfect nothings, such light blasts are we,
> That ere we're aught at all, we cease to be.
> Do what we will, our hasty minutes fly,
> And while we sleep, what do we else but die?[49]

We die every night – and are resurrected each morning. A striking thought, no? And one that makes death seem less frightening. Who does not find in that unknowable thing called sleep a perfect rest from life's weariness? But this Epicurean view was heresy! For pagans and Abrahamics alike it has always been unthinkable to say that humans are coincidences of matter rather than divinely crafted creatures with immortal souls. Hence many societies have been concerned with how we are buried. Think of the Pyramids, tombs of the Pharaohs, or of Emperor Qin Shi Huang and his terracotta army of 10,000 warriors to serve him in the afterlife, or of Sumerian kings whose servants were slaughtered and buried with them. The Greeks could imagine no worse fate

than their body being left untended; in the Bible it is damnation to be 'left out for the dogs'.

Among our strictest modern taboos is suicide, but suicide was not always regarded as a bad thing. Cato the Younger, a passionate republican, was praised for having taken his own life rather than live under the rule of Caesar. And for the Samurai there was no more perfect way to die than to kill oneself at the right time and in the right way.* But we should not be surprised that there are alternative views about death, even of suicide. Because alongside Hebrew, Christian, Islamic, and Greek philosophies there are also Buddhism, Hinduism, Sikhism, Jainism, Confucianism, and Shinto – among so many others – all born of different seeds than Socrates or Abraham. Some are almost so different the English language does not have the words to explain them. At the risk of oversimplifying a vastness of philosophies, I quote for you one small part of the *Upanishads*, a set of ancient Hindu texts:

> The Ātman is not born, nor does he die,
> He does not originate from anybody, nor does he
> become anybody,
> Eternal, ancient one, he remains eternal,
> He is not killed, even though the body is killed.[51]

Each person has an *atman* – perhaps best described, simply, as a soul – and is destined to a cycle of endless reincarnation called

* The Japanese could also be witty about death. A *jisei* by Moriya Sen'an:
> Bury me when I die
> beneath a wine barrel
> in a tavern.
> With luck
> the cask will leak.[50]

samsara. To escape this cycle is *moksha*, at which point the *atman* enters oneness with Brahman, the Ultimate Oneness, the Supreme Reality. That is a simplified retelling which flattens the many and varying interpretations of Hindu theology, but it is sufficient, I think, to make for a stark contrast with, say, the Christian beliefs of somebody like Dante, whose highly personal vision of the afterlife has essentially shaped the popular understanding of Hell. For Dante there was no reincarnation, as in Buddhism or Hinduism. A human lives but once, and judged by that life arrives after death in Hell, Purgatory, or Paradise. For him death was only the curtain-raiser to an eternal life hereafter – as it was for the seventeenth-century poet and priest John Donne. Here Donne writes about death with startling conviction during a bout of illness that threatened to end his life:

> Death, be not proud, though some have called thee
> Mighty and dreadful, for thou art not so;
> For those whom thou think'st thou dost overthrow
> Die not, poor Death, nor yet canst thou kill me.
> From rest and sleep, which but thy pictures be,
> Much pleasure; then from thee much more
> must flow,
> And soonest our best men with thee do go,
> Rest of their bones, and soul's delivery.
> Thou art slave to fate, chance, kings, and
> desperate men,
> And dost with poison, war, and sickness dwell,
> And poppy or charms can make us sleep as well
> And better than thy stroke; why swell'st thou then?
> One short sleep past, we wake eternally
> And death shall be no more; Death, thou shalt die.[52]

So, you see, there are a thousand reasons not to fear death! But, if you believe only in a material world and do not find the Epicurean view convincing, death must be terrifying. Camus is reported to have said that the meaning of life is 'whatever is preventing you from killing yourself'. One might amend that statement and say the meaning of life is whatever you are willing to die for. It is only those of us too attached to our material world, to physical pleasures and illusory joys, ill at peace with ourselves, who would say, like Richard II:

> Woe, destruction, ruin, and decay;
> The worst is death, and death will have his day.[53]

Nobler minds would say, like Henry Hotspur:

> Come, let us take a muster speedily:
> Doomsday is near; die all, die merrily.[54]

There are few greater signs of egomania or small-mindedness than the desire for immortality; it can only result from a gross misunderstanding of oneself and this universe.* Lucretius, as so often he did, sang clearly:

> No measure
> Of added life will ever coin for us a novel pleasure.
> True, while we lack that which we long for, it is an obsession,
> But we will just crave something else once it's in our possession.[56]

* As Seneca says: 'A man would die, though he were neither valiant, nor miserable, only upon a weariness to do the same thing so oft, over and over.'[55]

But you know me by now – I am like Sappho when she said, 'I don't know what to do: I am of two minds' – and so here is another perspective. In computing there is something known as 'the halting problem'. Put rudimentally, it means that no computer can figure out whether a particular program will cause a crash without the program being run. Maybe we operate under the same limitation, and as living beings are simply unable to compute death. It may be, as a matter of hard fact, beyond our comprehension. As it was written in the *Epic of Gilgamesh*, 'The image of Death cannot be depicted.'[57]

Why all this talk of death? Serious philosophers have proudly told us that 'the point of life is to prepare for its end,' but even Francis Bacon wrote, 'the Stoics bestowed too much cost upon death, and by their great preparations, made it appear more fearful.' Forget all these macabre thought experiments – let us live while we are living and worry about death when we are dead! Might that not be the real solution, instead of all this quarrelsome inquiry into the unquantifiable? Montaigne himself wondered about this – and said so wonderfully:

> We trouble our life by thoughts about death, and our death by thoughts about life . . . it is only the learned who let these thoughts spoil their dinners while they are in good health, and who scowl at the image of the death. The unlearned man has no need of remedy or consolation till the blow strikes; and he dwells on it only at the moment when he feels it.[58]

The Seventh Pillar of
The Cultural Tutor

The Way Things Are

CHAPTER I

'Ché da le reni era tornato 'l volto...'

†

There lived many brave men before Agamemnon,
but they are all buried unwept and unknown in
long night.

– Horace, *The Odes IV: IX*

What is the use of history, politics, religion, thinking, speaking, writing, philosophising, and art? A thorny question that lies at the heart of this book – and one that I hope, in the pillars about those things, I have answered. But, in this final pillar, we will be more direct: how can they help us with some of the problems we face today?

We begin with a potentially troubling question: does education help us to predict the future? It was once said that 'he who fails to learn from history is doomed to repeat it.' But is this true? To answer that question I give you Albert Einstein, who stated in 1932: 'There is not the slightest indication that nuclear energy will ever be obtainable.'[1] Nobody could have been blamed for accepting Einstein's authority and confidently asserting, on radio or around the dinner table, that nuclear power was unobtainable. But technology and predictions go together like water and oil.

On one side are those who *underestimate* technology, like Lee

de Forest, who in 1957 said that the notion of putting a man on the Moon 'constitutes a wild dream worthy of Jules Verne.'[2] Or, as Arthur C. Clarke once commented: 'The classic example is the statement, made in the late 1940s, by the then-chairman of IBM that the world market for computers was five.'[3]

On the other side are those who *overestimate* new technology. Read this jolly forecast from a 1966 article in *Time* magazine:

> The new thing will be transport by ballistic rocket, capable of reaching any place on earth in 40 minutes. In Rand's Delphi study, 82 scientists agreed that a permanent lunar base will have been established long before A.D. 2000 and that men will have flown past Venus and landed on Mars . . . Nearly all experts agree that bacterial and viral diseases will have been virtually wiped out. Probably arteriosclerotic heart disease will also have been eliminated.[4]

Not quite! And yet, once in a blue moon, predictions do seem to come true. From that same article: 'Futurist Marshall McLuhan even foresees the possibility that many people will stay at home, doing their work via countrywide telecommunication.'

How did McLuhan foresee Zoom? If you get enough experts to make enough predictions, one or two will turn out to be more or less correct. This is monkeys and typewriters. Or you make a prediction so vague it can always be construed as prophetic. Let us be clear: there is no reason to believe we will have any more success foreseeing what AI will do (for example) than those 1960s futurists had with moonbases or medicine.

Theirs was a kind of optimism which now looks like naivety. But, you might say, certain claims about AI seem reasonable. Well, this might also have been said of claims in the 1960s; we once imagined

flying cars, but there is still no essential difference, driverless or not, between automobile travel in 2025 and in 1963. It seems that every new technology inevitably reaches a limit and then ceases to develop in any fundamental way, and the trouble is that we can never know what that limit is or when it will arise. So perhaps AI will also plateau – and sooner than we think.

Or not. Consider what was once written in the *Scientific American* in 1909: 'That the automobile has practically reached the limit of its development is suggested by the fact that during the past year no improvements of a radical nature have been introduced.'[5] There seemed to be a limit in 1909 – but automobiles pushed past it and developed majorly in the decades that followed. So sometimes technology *does* deliver and surpasses a seeming developmental limit. Maybe, then, even the wildest predictions about AI are woeful underestimations.

My point is that we are inescapably incapable of predicting the future. This is worth remembering as we get hot under the collar about AI. Some think it will liberate humanity; others believe it will enslave us. Some think it will shake things up before settling into its place and that things will carry on as they always have; others call it a fad. Might there be an analogue revolution? Nobody knows – but nobody has ever known anything about the future. The Roman historian Tacitus once declared, 'posterity makes a mockery of all our plans,'[6] and posterity has proven him right.

This is also true of politics. Marx predicted that communist revolution would occur first in the most industrialised economies, so it must have been surprising enough when it happened in Russia; that it later happened in China was a total reversal of Marx's prediction. And yet, even if the predicted communist uprising never took place in Britain, a welfare state *has* been established, partly thanks to

Marx's own theories. But this welfare state, Marxists argue, is a false prop for capitalism. And so Marx's most enduring legacy in Britain is... the prolongation of capitalism? Diodorus of Sicily put it best: 'What is strange is not that unexpected things happen, but that not everything which happens is unexpected.'[7]

The world is simply too complicated to model – even if we narrow our parameters. Look at any 'Sports Team of the Future' a few years on and most of the predicted superstars will have turned out to be flops – but nobody imagining in 2012 England's squad for the 2018 World Cup could have foreseen the rise of Jamie Vardy. What about those investors who are held up as paragons of predictive perfection? Within certain limits, prediction is broadly possible (that's why bookies win more than punters), but studies have shown that even the world of investing is little more than monkeys and spreadsheets.

Unpredictable events provoke great changes, and you cannot predict the unpredictable. Think of Thomas Malthus: he could not have foreseen the full impact of the Industrial Revolution when he predicted population collapse in 1798. The key to dark matter might be uncovered tomorrow – and then anybody who has recently tried to discern the future will find their predictions nullified. AI is leading somewhere... whether to dead-end or revelation we cannot know. Marconi thought that radio would end war; it has been one of war's most fecund tools. Machines were intended to free us from labour; we are still working. The Wright brothers' first flight was in 1903, by 1969 we were on the Moon... but little progress since then. All we can truly say about predictions is what the clairvoyant Tiresias says to Odysseus in one of Horace's odes:

> O son of Laertes, everything I say shall come to pass – or not![8]

And whoever made an unprejudiced prediction? Every prediction comes from a person, and a person has biases, fears, hopes, and vested interests. Thus predictions reveal more about the person who made them than about the future. Think of the 'Mirror of Erised' in the Harry Potter series. Those who look into it do not see a true reflection; they see their innermost desire. Predictions are similar. In the early days of the car there were people who confidently predicted its failure. Many of them made a living in some way related to horses; they wanted the automobile to fail and feared it would succeed. This was not a neutral prediction, then. So when we read 'I believe X is going to happen,' we should read 'I want X to happen' or 'I am worried X will happen.' I'm not saying that behind every prediction lies a calculated agenda. More often predictions simply reveal the general character of a society, as Carlyle so rightly wrote: 'For in truth, the eye sees in all things "what it brought with it the means of seeing".'[9]

This should lead us to consider two things when we come across a prediction. The first is *cui bono?* – who benefits? No wonder that people who stand to gain from the success of AI forecast a revolution and those who may lose call it preposterous. The second is what these predictions say about us. Do we believe the future can be a better place? Or do we see it as an ever-darkening realm?

But there is a bright line between backseat drivers and those in the driving seat. This is one reason most predictions are wrong; because the people making them have no idea what they are talking about. So there is another sort of prediction we need to consider: when somebody talks about *what they intend to do*. Muhammad Ali proclaimed, 'Archie Moore must fall in four' – and, what do you know? Petrarch predicted the end of the Dark Ages, and it was thanks to his work the Renaissance came into being. The same could

be said of Filippo Brunelleschi. He predicted a revival of Classical architecture and by constructing his dome at Florence Cathedral set this process in motion. These were not experts who prognosticated – they *built* the future. Or consider this, a colossal installation called *Futurama*, exhibited at the 1939 New York World's Fair.

This installation, designed by Norman Bel Geddes, imagines a 'city of the future'. We see a city with soaring skyscrapers and eight-lane highways snaking between them, spreading out from the city and over the countryside. Nothing like that existed in 1939, but it is how most of the developed world now looks. An inspired prediction? *Futurama* was sponsored by General Motors, who hired Bel Geddes. Millions of people saw *Futurama* and GM dutifully played its role in lobbying for the Federal-Aid Highway Act

of 1956. *Futurama* was not so much a prediction as a statement of intent. These are worth closer attention than backseat predictions. Anybody can say that there will be flying cars; much harder to invent them. Anybody can hold forth about artificial intelligence; it is more worthwhile to listen to those with the will to bring their visions to life – or obviate them. These people we can compare to Prometheus, who says in Aeschylus' play: 'What I foresee will come to pass – and it is also my desire.'[10]

Returning to our original question – can education help us predict the future? – it seems we have an answer: it can't . . . because nothing can. So what is the point of education? It helps us to prepare for that inevitably unpredictable future. All manner of ancient philosophies emerged to deal with the unforeseeable vagaries of fortune. Today, with science and data rather than philosophy, we endeavour to understand the world around us in the hope of mitigating threat and uncertainty. Has it worked? That depends on your point of view. But the point is *this*, from Diodorus Siculus:

> The truest education in life is the knowledge that comes from history, and the most vivid and indeed only teacher of the ability to bear the changes of fortune nobly is the recollection of the reversals of others.[11]

A study of failed historical predictions prepares us to be disappointed, surprised, and shocked. Knowing we are bad at predicting the future ensures that we do not become complacent or downcast – and insulates us against being manipulated. Because the trouble is that predictions, despite their general inaccuracy, *are* important. Why? We use them to guide our behaviour. What else is the weather forecast? Few predictions are whims or thought experiments; their purpose is almost always to influence our decisions. Economists say

that a recession is coming – time to save. They predict a boom – time to spend. We are told climate catastrophe is imminent – we must change our ways. We are told this is piffle – carry on as we were. Predictions, especially when they come from people we are supposed to trust, have consequences, regardless of how accurate or informed they are. And, as we have seen, rarely are they the former, even if supposedly the latter.

Call them clairvoyants, futurists, or experts – predictors have the power to terrify, excite, manipulate, and influence us. This is much why Emperor Tiberius banished soothsayers from Rome and why Dante placed them in the eighth circle of Hell with their heads monstrously twisted backwards – *Ché da le reni tornato 'l volto* – as punishment for having tried to see ahead.

We are anxious creatures and we have always been desperate to know what the future holds, for ours is a world of uncertainty and all things are in flux. There are a thousand variants of that old question, 'Will everything be all right?' and we have been asking it since the dawn of time. The Greeks would not go into battle if their augurs did not predict good fortune; the Bible says the test for any prophet is whether he can prophesy accurately. The bittersweet truth is that we would not be so anxious if we *could* see that dim future – but we cannot and never will. This is fact, a hard fact if ever we found one, and we must simply deal with it. And education, I believe, is what helps us to do so.

CHAPTER II

Coals of Juniper

†

> Another Athens shall arise,
> And to remoter time
> Bequeath, like sunset to the skies,
> The splendour of its prime;
> And leave, if nought so bright may live,
> All earth can take or Heaven can give.
>
> – Percy Bysshe Shelley, *Hellas*

There are people who believe the past was better than the present. They say architecture and art were once beautiful and are now ugly, that people were once decent and now are wicked, that any sense of right or wrong has melted away. They ask, 'Why don't men wear suits any more?'* and proclaim that 'The West has lost its way.' They say we must preserve our inherited culture and strive to be like those who came before us.

Well, the first thing you learn when you read anything written in the past is that people have *always* condemned 'the present'. Yoshida Kenko, a fourteenth-century Japanese travelling-monk, once wrote:

* Adolf Loos on this: 'Even I myself must admit that I am very fond of the old costumes. But that doesn't give me the right to demand of my neighbour that he wear them for my sake.'[12]

In all things I yearn for the past. Modern fashions keep on growing more and more debased. Even among the splendid pieces of furniture built by our master cabinetmakers, those in the old forms are most pleasing.[13]

Those cabinets called debased by Kenko are today regarded as priceless. We marvel at Gothic architecture and wonder, 'Why have we forgotten beauty?' Bernard of Clairvaux, writing in the twelfth century, called it decadent and even dangerous. We find the author of *On the Sublime* complaining about the state of 'modern literature' 2,000 years ago: 'Such a great and world-wide dearth of literature attends our age.'[14]

And then we have our old friend William Harrison calling out the frivolity of fashion in the 1570s:

> . . . nothing is more constant in England than inconstancy of attire. Oh, how much cost is bestowed nowadays upon our bodies, and how little upon our souls![15]

Tacitus hardly stopped comparing the degeneracy of the empire with the honest days of the Republic:

> Thus the State had been revolutionised, and there was not a vestige left of the old sound morality.[16]

And here's Thucydides writing about the revolt on the island of Corcyra in 427 BCE. It is chillingly familiar in its description of what political divisions do to a society:

> The simple way of looking at things, which is so much the mark of a noble nature, was regarded as a ridiculous quality and soon ceased to exist. Society had become divided into two ideologically hostile camps, and each side viewed the other with suspicion.

> To fit in with the change of events, words, too, had to change their usual meanings . . . to think of the future and wait was merely another way of saying one was a coward; any idea of moderation was just an attempt to disguise one's unmanly character; ability to understand a question from all sides meant that one was totally unfitted for action.
>
> Fanatical enthusiasm was the mark of a real man. Anyone who held violent opinions could always be trusted, and anyone who objected to them became suspect. Family relations were a weaker tie than party membership.[17]

There has never been a generation in human history that did not believe things were worse than they ever had been; claims of the superiority of past ages do not hold up well against what those ages had to say about themselves. What people say about modernity is exactly what people have always said about their present day. You may admire the architecture of the nineteenth century, but people then were just as dissatisfied with their architecture as you may be with yours. William Morris, giving a lecture in 1887, spoke of the Victorian era as an 'antiarchitectural age' and of Britain's 'ever increasing ugliness'.

And this goes beyond architecture. You would be hard pressed to find a sterner condemnation of the nineteenth century than this, by John Ruskin in 1872:

> We shall be remembered in history as the most cruel, and therefore the most unwise, generation of men that ever yet troubled the earth:—the most cruel in proportion to their sensibility,— the most unwise in proportion to their science. No people, understanding pain, ever inflicted so much: no people, understanding facts, ever acted on them so little.[18]

Would you say the same thing about your society? If so, we have a serious problem to contend with. We say they were better than us; they said they were not really so good, that another time was better. We look back on previous centuries with envious eyes; the Victorians looked to the Middle Ages in the same way; eighteenth-century buffoons to the Renaissance; Renaissance scholars to the Roman Empire; imperial Romans to Republicans. If you were to ask at which point, precisely, things were better in the past, it would be impossible to answer. Too often we are guilty of the peculiar hypocrisy noted by Thomas Browne four hundred years ago in his *Pseudodoxia Epidemica*: 'Condemning the vices of their own times, by the expressions of vices in times which they commend.'[19]

Our ancestors were, at least, more religious and more pious than us – so the argument goes. No doubt, in some cases, they were, but what of Durham Cathedral in northern England? Go there now and you find a castle-church soaring over the forested banks of the River Wear. Inside: barrels of stone holding up a heavenly vault lined with the scarlet glass of painted windows, all around altarpieces, marble tombs, tapestries, candlelit corners, the sarcophagus of Bede, the glittering shrine of St Cuthbert. But if you have a perceptive eye you will notice there is no medieval woodwork in the cathedral . . . with one exception: a clock-case, decorated with thistles, in the north transept. Why? A little less than four hundred years ago, Oliver Cromwell eviscerated the Scots at the Battle of Dunbar, frogmarched 3,000 captives to Durham and locked them in the cathedral. These 3,000 Scots were so cold in the winter of 1650 that they chopped up the benches, chairs, chests, and choir stalls and used them as firewood. The clock they left – because the thistle is a symbol of Scotland. Nearly 2,000 Scots died in Durham Cathedral and were buried in a mass grave beside it; the rest were

sent as slave labour to America. Were those times really more religious, then? Where was that 'fear of God' or 'love of beauty' that we feel is so lacking in us? If you believe the past was more pious than the present, then it is to those thousands of Scotsmen locked up to die in a cathedral (and millions more like them) that you must address your argument.

But this goes beyond religion. All those who proclaim the former (and *perhaps* enduring) greatness of the West must explain the First World War. When Wilfred Owen called *dulce et decorum est pro patria mori** 'the old Lie', he spoke for a whole, damned generation. Where were Judeo-Christian values in the trenches? Where was 'Western culture' in the mustard gas? 'Tradition is not the preservation of ashes, but the worship of fire.' So said Gustav Mahler; if that is the culmination of your fire, then let us hope it *does* burn to ashes.

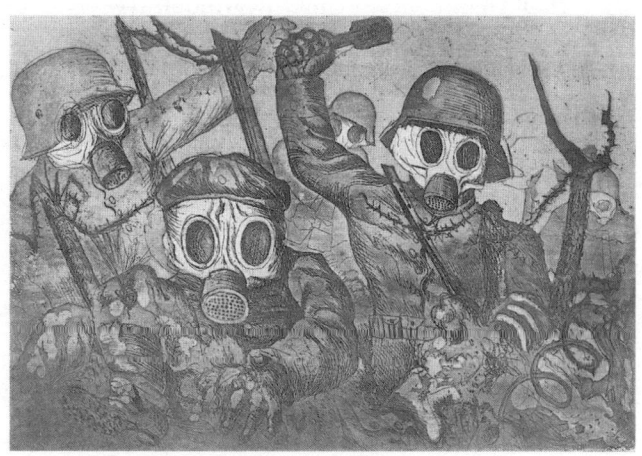

Stormtroopers Advancing under Gas by Otto Dix (1924).

* 'It is sweet and fitting to die for one's country.' A line from the Roman poet Horace that was written on the walls of the chapel at Sandhurst, Britain's military academy, in 1913.

And yet, despite all that I have said, believing that the past was better than the present can be a useful, even progressive belief. The foundational idea of the Renaissance, first given voice by Petrarch, was that Europe had declined from its zenith during the age of Greece and Rome. Petrarch's belief in the superiority of the past was a catalyst for change in his present – change which, on the whole, is regarded as good. Suffice to say there would have been no Reformation, no Scientific Revolution, no Industrial Revolution without the Renaissance.

Demosthenes, in 330 BCE, compared his 'repugnant' times with the Golden Age of Athens a century before: 'Reflect, then, that your ancestors set up those trophies, not that you may gaze at them in wonder, but that you may also imitate the virtues of the men who set them up.'[20] In some sense it did not matter if, 'upon close historical analysis', those ancestors were really as great as supposed. What mattered is that Demosthenes saw the Golden Age as an exhortation, not to re-create the city exactly as it had been in the days of Pericles, but to live by Pericles' example. Believing that the past has something to teach us implies that the present could be better, that by looking to the past we might find models for improving it. And, no doubt, when we search through history we do find things that were – setting aside 'better' – clearly very good. Uninformed nostalgia leads to regression: the past was filled with beauty, but also with misery. So we must be careful to discern how the one was created, and whether the other can be avoided if we want to create it again. How many 'great thinkers' have casually condoned slavery, pillage, and oppression? Some say: 'They were men of their times.' Fine! But let us not then admire those times too blindly – or else we, too, may carelessly approve of patent evils. We must look upon the past with unprejudiced eyes, an honest heart, and a clear mind,

always remembering: *a thing is not good because it is old; a thing is good because it is good.* As Pope Gregory VII wrote to Bishop Wimund a thousand years ago: 'Any custom, however long established and widespread, must stand second to truth, and practice which is contrary to truth must be abolished.'[21]

And, strange as it sounds, one hundred years from now there will be people saying, 'How good things were in 2025!' They will look back and admire our architecture and art, our moral decency and political integrity, our simpler and happier way of life. You may not believe me – but history tells us it is inevitable.

This leads us to a simple conclusion: that the question we should ask is not 'Was the past better than the present?' but 'How can the past help us improve the present?' We must not be like that old farmer in Lucretius' *On the Nature of Things*, who

> Shakes his head and groans again and again
> That the hard labours of his hands have turned out
> all in vain.
> He rails against the present, while he has nothing
> but praise
> For the fortunes of his father – yes, those were the
> good old days![22]

We should, instead, be like our old friend Pliny the Younger, who wrote to Caninius Rufus in 97 CE:

> I am an admirer of the ancients, but, not like some people, so as to despise the talent of our own times. It is not true that the world is too tired and exhausted to be able to produce anything worth praising.[23]

CHAPTER III

The Howling of Garmr

†

> For out of olde fields, as men saith,
> Cometh all this new corn from year to year;
> And out of olde books, in good faith,
> Cometh all this newe science that men learn.
> – Geoffrey Chaucer, *The Parlement of Foules*

Some people take the opposite view to those discussed in the previous chapter – rather than thinking too highly of the past, they either disregard or despise it. To these I say: more than 100 billion human beings have lived and died, and it is surely not unreasonable to think we might learn something from them.

We can think of it in purely scientific terms. No experiment has been run so many times (as stated, 100 billion) as that of human existence. Data – the fruits of culture and history – from these experiments has survived in great quantities. It is there to be studied, theses drawn up, and conclusions applied. There is more than a small chance that solutions to the problems we face may be discovered in this data.

But, you might say, the world has changed immeasurably – and therefore question whether the lives of people long gone have any relevance to us. Well, the world has changed – but people have not.

THE SEVENTH PILLAR OF THE CULTURAL TUTOR

We are separated from our ancestors by a gulf of time, not nature. And, upon inspection, although modern technology seems to have created 'new problems', they almost always turn out to be the same old problems. Look to our ancestors for wisdom and they will give it willingly, for all the things that trouble you once troubled them also. Thomas Browne knew it four centuries ago:

> There is a certain list of vices committed in all Ages, and declaimed against by all Authors, which will last as long as human nature; which digested into common places, may serve for any Theme, and never be out of date until Dooms-day.[24]

We must know where we have come from if we hope to understand who we are. By closing our eyes to the past we overcomplicate, overestimate, and misunderstand the present. Without a comparison for modern-day problems, how can we really take their measure? As Lucretius said:

> Any stream will seem huge to somebody who has
> never seen a river . . .
> Anything we see we shall imagine is the largest of
> its kind,
> If it is the largest we have yet laid eyes on.[25]

There are also serious risks to disregarding and blindly condemning the past. Edmund Burke, a statesman and quasi-philosopher, wrote about them in the 1790s.* Here he is, in the immediate wake of the French Revolution (*not* in comfortable hindsight) describing the dangerous hubris that so often accompanies revolutionary spirit:

* You may find Burke described as the 'Father of Conservatism' and suchlike. I'm not sure this is true – and, at least in its modern sense, the word belies the broad beliefs of the man.

With them it is a sufficient motive to destroy an old scheme of things, because it is an old one. As to the new . . . duration is no object to those who think little or nothing has been done before their time.

They think that government may vary like modes of dress, and with as little ill effect . . . [they] think it amongst their rights to cut off the entail or commit waste on the inheritance, by destroying at their pleasure the whole original fabric of their society: hazarding to leave to those who come after them a ruin instead of an habitation.[26]

The French revolutionaries attempted to destroy the very fabric of their society. It is beyond question that the system inherited by Louis XVI was monstrously oppressive – but was its sudden downfall worth the collapse of social order and the cataclysmic wars that plagued Europe for decades afterwards? Could there have been a more peaceful – albeit slower – way? But I am not speculating about alternative histories and whatmighthavehappeneds here. My point is simply that the revolutionary hatred of all that was old *did* unleash a cyclone of suffering on France – and far beyond.

Still, those who would condemn the past and tear up what it has bequeathed us are in plentiful company. History has never been short of people who believed a better world was possible and often with the best of intentions set about dismantling the real world, only to discover how easily things fall apart.*

* There is a more dangerous type – not the one who tries to make the world better but, filled with hatred, is of the sort described by Burke: 'Something they must destroy, or they seem to themselves to exist for no purpose.'

> There was once a dream that was Rome. You could only whisper
> it. Anything more than a whisper and it would vanish.

So said Marcus Aurelius, played by Richard Harris, in *Gladiator*. Delicate as a whisper have been our dreams, and many times have they vanished. This is true even of something as apparently inconsequential as the film industry. Critics and moviegoers alike (rightly or wrongly) constantly deride the failures of modern cinema. They wonder why we cannot simply look back and learn from the beloved films of old. Well, all it takes to uproot a working system – whether of national government or film-making – is one brief period of reckless reform. Because, once gone, a system cannot easily be recreated. As Ruskin said of art:

> The whole system and discipline of art, the collected results of the experience of ages, might, but for the fixed authority of antiquity, be swept away by the rage of fashion, or lost in the glare of novelty; and the knowledge which it had taken centuries to accumulate, the principles which mighty minds had arrived at only in dying, might be overthrown by the frenzy of a faction, and abandoned in the insolence of an hour.[27]

It is pathetically easy to criticise the past, but that same highminded judgement with which we condemn our ancestors will be the rod for our own backs when future generations condemn us. It is not easy to change the world. We are now using phones soldered by children with metals mined by slaves. At least the Victorians made their own children labour; we force children on the far side of the world to labour for us. Who are we, truly, to judge the sins of the past? Tell me, what would *you* have done? Our ancestors were no less cowardly or clueless than we, desperately trying to make the most

of what they had and protect their loved ones in a world too big to battle and too complicated to comprehend.*

Our shared human history is a chronicle of trial by bloodshed and error by catastrophe. And what is the lesson of these centuries of failed political, religious, social, economic, and cultural experiments? That to build even a half-functioning society is inconceivably difficult. Things can quickly go wrong. If we tamper carelessly with our constitutions, fired only by idealism or ideology, they will soon fracture, and bloodshed and misery are the likely result.

Think how many peasants had to starve for the Soviet Union to rise. Civilisation can collapse, and it has done in the past. During the Pax Romana there were bookshops in every city – how many centuries passed before another was opened in Europe? There are wolves at the door, ravenous and alert – like the mythical hound of Norse mythology, Garmr, whose baying signifies *Götterdämmerung*, the coming destruction of the gods – should the foundations of our civilisation start to creak. As soon as we despise those who built our world, think ourselves worthy to discard their time-battered yet surviving systems, and fail to learn from our shared past, it's *Götterdämmerung* all over again: reigns of terror, mobs in the street, laws trampled, and human progress set back a generation or more.

My purpose in dwelling over the horrors of past revolutionaries and civilisational failures is to impress upon you the truth of what Burke concluded from the disasters of revolutionary France:

> It is with infinite caution that any man ought to venture upon pulling down an edifice which has answered in any tolerable degree for ages the common purposes of society, or on building it

* All the more then must we praise the Wilberforces and Erasmuses of history, who *did* have the strength to drag the world a little further towards the light.

up again without having models and patterns of approved utility before his eyes.[28]

Any tolerable degree. They are the operative words. For it is difficult to build anything, and it is a grand achievement to forge a society that is even vaguely stable and prosperous. 'A thing is not good because it is old; a thing is good because it is good.' This is true. But what is 'good' is not always obvious. Where to find it? What is old, precisely because it is old, because it has survived, is more likely to be good.* And so, where stability *has* been achieved, we must be careful not to endanger it by audaciously reforming systems we do not fully understand, nor wholly know why they were first created. That is at least one reason to respect – not blindly, but prudently – the past.

We live in a colossal and interconnected system built on ceaseless cooperation and a complexity of organisation beyond the comprehension of any individual. We flick a switch and – FIAT LUX! – there is light. Not a small thing, when you consider where humankind started out, to create light at will. Trains running, parcels delivered, shelves stocked with food, running water, the lights coming on – these things do not merely happen. Somebody makes them happen, and not one person alone. It takes time to build a society, a great deal of time. And not only time, but thought and effort – and a hundred thousand failures – too.

* I could have talked also about traditions in this discussion, but here it is enough to note that what has been said of constitutions and governmental systems is often true of seemingly minor and unimportant relics of the past. Traditions emerge for a reason and within them is often concealed something of greater importance than we can easily conceive – which is frequently their purpose. We can also hang the coat of our uncertainties and yearnings upon their hook. What else are funerals and weddings for? The traditions of all cultures and all nations bring colour and texture and meaning into the world.

Yet, somehow, a society *has* been built. Flick your light switch and there is proof we have achieved something worthwhile, something surely better than the barbarous darkness in which humankind once wept.

But theoretical worlds are always more appealing than this real world; problems are easy to identify and gratitude comes less naturally to us. Montaigne wrote of this five hundred years ago, as religious civil war descended on his homeland:

> It is very easy to accuse a government of imperfection, for all mortal things are full of it. It is very easy to arouse people to a contempt for their ancient observances: no man has ever attempted this without succeeding. But to establish a better state of things in place of what he has destroyed – many a man has failed in his endeavours to do that.[29]

To burn is easier than to build. This is as true of planets as it is of pottery: a cathedral is five centuries in the making and five hours in the conflagration; the most beautiful vase can be shattered by the slip of a finger; a sparrow spends weeks weaving its nest, only for a thoughtless gardener to destroy it in a moment.

Where do you suppose this civilisation came from? These laws, these roads? They did not just appear. Every single thing which works, however imperfectly, stands for a hundred thousand things which did not work, which we tried and failed, usually for a steep rate of suffering. Our world, our civilisation, is, as it was written in Deuteronomy:

> Houses full of all good things, which thou filledst not, and wells digged, which thou diggedst not, vineyards and olive trees, which thou plantedst not.[30]

THE SEVENTH PILLAR OF THE CULTURAL TUTOR

It is tempting to think we can tear it all down and start again, and it is easy to believe the past was tainted by evils that only we, and not our ancestors, have the moral clear-sightedness to notice. But the message of history is unavoidable: we must beware biting the hand that feeds us, of cutting down the olive tree we did not plant, only to discover it was planted well, and with difficulty, and that its fruit is not easily brought forth.

CHAPTER IV

O Bezaleel, where hast thou gone?

†

> Expect another job this time next year,
> For pity and religion grow i' the crowd—
> 'Your painting serves its purpose!'
> – Robert Browning, *Fra Filippo Lippi*[31]

Modern art. Where to begin? The words 'modern art' are themselves somewhat strange. For the general public, they refer to any and all kinds of art made in the present day, especially things that are strange. To critics the term 'modern art' is much more specific; it refers to art produced from the outset of Impressionism through to the 1960s.* Those strange things the public put under the umbrella term 'modern art', meanwhile, are broadly known as contemporary art, which itself has dozens of subgenres, from installation art to conceptual art.

But this very divergence of terminology represents a broader division between the public and the art world. One certainly wonders why a few seemingly random splashes of paint can sell for hundreds of millions these days. Take *Interchange*, painted by Willem de Kooning in 1955 and sold in 2015 for $300 million. Would you pay that much? It hardly matters, because any 'thing' is only

* Vincent van Gogh and Claude Monet, perhaps to our surprise, are modern artists.

worth as much as someone is willing to pay. Besides, financial value has never been a reliable indicator of quality in art. Recall that Vincent Van Gogh sold but one painting in his lifetime.

It is uncontroversial to say that most people believe art has lost its way, regardless of whether they are right or wrong. See the poll overleaf, conducted by YouGov in 2016. I'm not endorsing its results. My point, as stated, is simply to observe that the general view of twenty-first-century art is one of bafflement. I believe many of our modern installations are wonderful – but the public looks longingly on the days of Monet, Vermeer, and Michelangelo. 'Where has real art gone?' they ask. 'Art has changed,' critics retort. Blah, blah, and blah again. This peculiar dichotomy – the divergence between public and professional taste – is the quandary at the heart of this chapter, along with the correspondent question of what to do about it.

Well, perhaps we are just looking in the wrong place. Because in the twentieth century something new was invented – cinema – and it has become *the* modern art form. For it is art in every sense of the word, and it draws directly on other forms of art: opera, theatre,

But is it art?
% who consider each of the below pieces to be art

97	94	91	78		67
Mona Lisa / Leonardo da Vinci / 1503-4	The Singing Butler / Jack Vettriano / 1992	Mystic Mountain / Bob Ross / 1990	Guernica / Pablo Picasso / 1937		Whaam! / Roy Lichtenstein / 1963
42	41	38	35		31
Campbells soup can / Andy Warhol / 1962	Number 5 / Jackson Pollock / 1948	'Installation' / Helen Marten / 2016	'Poverty line in pennies' / Michael Dean / 2016		'Project for a door' / Anthea Hamilton / 2016
30	28	27	12		12
Untitled (Yellow, Orange, Yellow, Light Orange) / Mark Rothko / 1955	'A fun ride to nowhere' / Josephine Pryde / 2016	Abalone Acione Powder / Damien Hirst / 1991	Fountain / Marcel Duchamp / 1917		My bed / Tracey Emin / 1998

YouGov | yougov.com 'Turner Prize 2016 finalist October 5-7, 2016

poetry, prose, painting, sculpture, the decorative arts, and photography. Film-makers are, in a very technical sense, direct heirs to the artists of yesteryear. They rely on the same skills that were required of Aeschylus (dramatic narrative), Shakespeare (dialogue), Michelangelo (composition), Vermeer (colour), Kawase (light), Wagner (musical accompaniment to action) . . . I could go on. Let me give one specific example. In Leonardo's treatise *On Painting* he advises all artists to learn about human anatomy. He believed you must paint first the skeleton, then muscles, then skin, and finally the clothes to paint a truly believable human figure.* That is exactly what VFX

* I happen to think he was wrong – but my point here is simply about the astonishing similarity between modern film-makers and Renaissance painters, *not* about what makes art of any kind good or bad.

artists do. In order to create those CGI characters on our screens they construct skeletons, muscles, skin, and clothes. Leonardo also writes about smoke, liquid, rain, the movement of cloth, and other challenges faced by any painter who wishes to create the illusion of reality. What else are VFX artists doing? Renaissance painters slaved over their panels to create the impression of realistic lighting; we have just about mastered the art of digital lighting in no fewer decades than was needed by the Italians and Flems. Those rules, almost invisible, that make certain paintings 'look right' because all figures and colours are in perfect balance, are the very same rules that render certain shots in cinema so appealing and so memorable.

Had VFX artists, production designers, screenwriters, and directors been born four hundred years ago, they would have been sculptors, muralists, playwrights, and poets. The reverse is also true: Dante, Titian, or Bernini, had they been born in the twentieth or twenty-first century, would surely have dreamed of becoming film-makers. Aristotle's *Poetics* applies no less to the Greek stage than to Hollywood. We, crowding into the motion-picture houses on the release of a new film, are just like Piotr Ilyich Tchaikovsky taking his seat at the Bayreuth Festspielhaus in 1876 to watch the debut of Richard Wagner's long-anticipated *Ring Cycle*. And so I say with conviction that film-makers are *the* artists of modern times.* These artists have made us weep and dream, given us nightmares and raised up our souls, and done all that art ever could.

And what about video games? They, too, are art. Those who make them and those who play them know this. Not *all* video games, of course. But are all books literature? Are all paintings art? A lot of what I said about cinema also applies to video games. But there

* Are not Morricone, Williams, and Zimmer the Bachs and Liszts of modernity?

is one difference – we play them. There is something unfortunate about the word 'play'. It sounds trivial. But there is nothing trivial about, say, *Shadow of the Colossus* or *Dear Esther*. You no more 'play' these games than 'flick through' John Milton. The technical skill of game designers, the vigour of the ethical and intellectual challenges they present, the dramatic depth of their narratives – this is a thoroughly new form of art and we should be grateful to have it.

But, despite these new forms of art, is there still a place for paintings and sculptures? Let us turn to Bezaleel, the biblical craftsman who made the Ark of the Covenant in the Book of Exodus, described as a man of 'wisdom, understanding, and knowledge of all manner of workmanship'. So this Bezaleel was, we are told, a talented artist. But that is not all. He was *asked* to make the Ark – and given specific instructions for what it should look like:

> And Bezaleel made the ark of shittim wood: two cubits and a half was the length of it, and a cubit and a half the breadth of it, and a cubit and a half the height of it: And he overlaid it with pure gold within and without, and made a crown of gold to it round about.[32]

The point of this story is simple: *pay artists to make the art you desire.* Without Pope Julius II there would have been no Sistine Chapel, without a Cangrande no *Divine Comedy*, nor the Duc de Berry a *Très Riches Heures*, nor Cardinal Scipione Borghese any Bernini, nor Pericles the Parthenon.* We must ask artists for the art we want and pay them their 'bread and salt' to make it.

* To my former patron, David Perell, I offer, gratefully, the words of Thomas Dekker: 'WHOM can I choose (my most worthy Maecænasses) to be Patrons to this labour of mine fitter then yourselves? Your hands are ever open, your purses never shut . . . Who is more liberal! than you ? who (but only Citizens) are more free ? Blame me not

Where will we find these artists? It is complacent to adopt a romantic view and assume these mythical 'artists' will make their art come what may. This is untrue. A child born who could become a wonderful sculptor, were they never given the chance – at school, say – might never discover their talent. Think of Giotto, first painter of the Italian Renaissance in the early fourteenth century. He was a shepherd boy who, unless he had been discovered by Cimabue, a master painter, would have remained a shepherd all his life. From the sixteenth-century biographer Giorgio Vasari:

> One day Cimabue, going on business from Florence to Vespignano, found Giotto, while his sheep were feeding, drawing a sheep from nature upon a smooth and solid rock with a pointed stone, having never learnt from any one but nature.[34]

And so what Ruskin said two centuries ago is also true today:

> For aught I know, there may be two or three Leonardo da Vincis employed at this moment in your harbours and railroads: but you are not employing their Leonardesque or golden faculty there,—you are only oppressing and destroying it.[35]

If it is the case – as the polls suggest – that we are longing for artists of a different kind to the ones promoted by the art world, then the simple but unavoidable truth is that they are already here. There are millions of Giottos all around the world waiting to be discovered, nurtured, and given work. And, besides, there are millions more who have *already* discovered their talents and mastered them. The internet (for example) is an abundance of artists plying their

therefore, if I pick you out from the bunch of Booke-takers, to consecrate these fruits of my braine (which shall never die) onely to you. I know that most of you (O admirable Guls!) can neither write nor reade.'[33]

trade – and all we need do, if we really want a different kind of art, is pay them to make it. You want sculptures, paintings, mosaics, or anything else? There can be no return to days of old; there is only the future. And, if you want this rapidly onsetting futurity to be filled with a particular kind of art then you will have to ask for it and pay for it. This may sound too simple, but the simplest truths are always the hardest to reconcile. Every age of 'beautiful art' was only beautiful because its artists were given work; the commissioning of art is all art ever was.

CHAPTER V

Peasant's Quantum

†

I found Rome a city of bricks; I leave it a city of marble.

— Augustus[36]

Look at the buildings around you. Are they ugly or beautiful, interesting or boring? Do they mean anything to you? What sort of architecture would you like to see in the places you live and work? You must ask yourself these questions. Because, although we each have instinctive feelings about the world, they are only a thin film of ice, easily broken, beneath which lies the deep well of our true taste. We must delve there. If not, other people will craft our opinions for us and we will call beautiful whatever somebody else has called beautiful, deem ugly what others have deemed ugly. And this matters because what we generally consider good creates a consensus that guides the creation of the things in our society, be it films, forks, sandwiches, coffee, or architecture.

You may have noticed that, while we find so much old architecture beautiful, despite our modern wealth and technology we do not seem to build such things for ourselves. This is not about whether architecture 'used to be better'. The question is simply why we choose not to build any buildings in the styles of old, despite the fact that most people would like that to happen. Well, this is

something you might accept as a fact of life. William Morris noted this sort of thinking a long time ago:

> ... they have no doubt that it is natural and not wrong that while all ancient towns, I mean towns whose houses are largely ancient, should be beautiful and romantic, all modern ones should be ugly and commonplace: it does not seem to them that this contrast is of any import to civilisation, or that it expresses anything save that one town IS ancient as to its buildings and the other modern.[37]

I have already defended in this book the tedium of (some) modern architecture on the grounds of socioeconomic necessity. But we must be careful, as Morris warns us, not to become conditioned to accept as necessary what is at least partly optional – and so condemn the world to an avoidable ugliness.

How did we get here? It is tempting to believe that a caste of architects has positioned themselves as high priests and priestesses privy to sacred truths about the nature of architecture too holy for the common people to understand. We may find modern architecture boring, but that is our problem, they say. That may be true up to a point, but I hardly think nineteenth-century architects were 'men of the people', nor did any Kyoto temple-builder or Samarqand mosque-maker have 'popular taste' in mind. Rather, they were working in an ancient and unbroken tradition that had created a time-honoured manner of building to which builders paid due reverence, from which they learned and in which they were reared. Even when Renaissance architects cast off the Gothic they turned to another manner of building – the Classical – that had also been distilled by centuries of growth.

Our modern global architecture, meanwhile, is a thing cut loose.

Perhaps because of the First and Second World Wars, the industrial and digital revolutions, globalisation, concrete and steel and plastic, a line has been drawn between the architecture of now and the architecture of then. Le Corbusier said so in 1923:

> If we set ourselves against the past, we are forced to the conclusion that the old architectural code, with its mass of rules and regulations evolved during four thousand years, is no longer of any interest; it no longer concerns us: all the values have been revised; there has been revolution in the conception of what Architecture is.[38]

Maybe we didn't change, and neither did our sense of beauty. Maybe the world changed and our buildings have simply changed with it – in which case the vilified architectural elite may not be to blame, and the truth could well be that they are only making the best of what they have been given.

Le Corbusier's ideal city and a panorama of Rome, which he called ugly.

And yet there was also a clear and highly conscious decision to break away from the traditions of old. The early Modernists did not present themselves as innocent bystanders in an inevitable process of modernisation; they made their revolutionary intentions plain. Consider, for example, their dislike of 'decoration'; they mocked

Gothic variety and Classical rules as relics of an uncivilised past, as idols of impure minds. Perhaps, in the 1920s, this sort of thinking was necessary in order to save the world from destitution; that does not mean it holds true now. And yet this mindset – that taking inspiration from the past is an aesthetic sin – has long dominated architecture:

> Decoration is of a sensorial and elementary order, as is colour, and is suited to simple races, peasants, and savages. Harmony and proportion incite the intellectual faculties and arrest the man of culture. The peasant loves ornament and decorates his walls . . . Decoration is the essential overplus, the quantum of the peasant; and proportion is the essential overplus, the quantum of the cultivated man.[39]

Read those words slowly: they are written in Le Corbusier's *Vers une Architecture*, the bible of Modernist architecture, and they represent the unspoken mantra of modern design.* Architecture is the only form of art in which 'popular opinion' should guide what artists do, for it is the public – peasants or otherwise – who must live and work in what has been created. But these 'learned architects' think you are a savage for loving colour, pattern, and decoration, even though these are the currency of all natural beauty.

Nature – an important word. Le Corbusier was correct in his analysis here:

* Eighty years ago, Ruskin had already stated: 'No architecture is so haughty as that which is simple; which refuses to address the eye, except in a few clear and forceful lines; which implies, in offering so little to our regards, that all it has offered is perfect; and disdains, either by the complexity or the attractiveness of its features, to embarrass our investigation, or betray us into delight.'[40]

THE SEVENTH PILLAR OF THE CULTURAL TUTOR

The prime consequences of the industrial revolution in 'building' show themselves in this first stage; the replacing of natural materials by artificial ones, of heterogenous and doubtful materials by homogenous and artificial ones (tried and proved in the laboratory) and by products of fixed composition. Natural materials, which are infinitely variable in composition, must be replaced by fixed ones ... steel girders and, more recently, reinforced concrete, are pure manifestations of calculation.[41]

This world of plastic and chrome has proven to be a boring one. The 'infinite variability' of natural materials is precisely what makes them beautiful, and I think most of us would now trade a few 'pure manifestations of calculation' for a little charm; we yearn for *less* standardisation. But engineering now dominates architecture,* and though engineers are inspired problem-solvers their chief concern is not the creation of beautiful buildings. Standardisation is an engineer's dream; it is not the dream of an architect, of a Peter Parler, Erwin von Steinbach, or Mimar Sinan.

Even though modern architecture liberated millions from misery it has not been the aesthetic triumph once hoped for. Pure geometry does not accord with what most people consider beautiful.† Convention has got its claws into our exhausted Modernism. What once stood out has faded into the background. All is grey and square, steel and glass. Some have tried to find another way. Gone is the International Style and gone is Brutalism; contemporary architecture has become frivolous. This was a trend set by the Sydney

* Le Corbusier himself said: 'The architect is above all an engineer.'
† A YouGov survey found that 77 per cent of British people prefer 'traditional' architecture. And this is a view shared around the world. Just look at where tourists take photos and you will see what kinds of architecture people like most.

Opera House. After that every city wanted their own 'icon'. Paris got the Pompidou Centre, Bilbao the Guggenheim, and London the Gherkin. These have made the world a more interesting place, but most ordinary buildings – schools, houses, offices – remain unornamented and fundamentally boring boxes.

There are uncomplicated things we could easily do better. What would be wrong with a few finials on our rooftops or capitals astride our doorways? Pleasing proportion is exceedingly simple and it is the joy of Georgian architecture; why have we stopped designing buildings with proportion in mind? It certainly wouldn't cost any more money – only care. Some cornices and non-grey carpets or walls might do much for our interiors. And what if we still allowed, or even encouraged, bricklayers to make patterns with their bricks? This is just about the cheapest possible form of decoration and yet it is utterly delightful, as the Aliabad Tower or Gonbad-e Sorkh prove. Why not use either colourful or patterned tiles like those found in Victorian pubs or Ottoman mosques? The older stations on the London Underground have a great deal of decorative tilework; newer stations also have tiling, but it is plain white or grey. Decorative ceramics would be a simple but effective way to make our world prettier. Why not make lamp posts a little more interesting, and air conditioning units also? Why not spend a few pennies commissioning artists to decorate our new buildings – whatever their architectural style – with murals or friezes? But there seems to be no impulse to do these simple things – a sign of architectural rigor mortis. Perhaps we suffer, above all, from a worrying drought of imagination.

There is also no reason modern materials and methods cannot be used to build in the styles of old. It has been done before, and many times! The Dresden Frauenkirche, Kinkaku-ji, the old towns

of Frankfurt and Warsaw, Belgrade's Cathedral of Saint Sava, the Cathedral of Christ the Saviour in Moscow, the Swaminarayan Akshardham in Delhi, or the Ox Horn Campus in Dongguan. In all these cases the right balance has been struck between tradition and regulation, between modern methods and old ways. There is even reinforced concrete in the Sagrada Família! These buildings stand as proof that all it takes to employ a certain kind of architecture, however historical, is the desire and imagination to build it.

Still, we cannot forget the labyrinth of regulation all designers must navigate, whereby individuality and imagination have been systematically quashed. Increasingly, architects themselves are sidelined. Property developers save money by using cheap houseblueprints. Overbearing regulation and rabid commercialism have stripped the world of character. And, after all, architects will only do what is asked of them. If politicians, ministers, councillors, and bureaucrats lack the imagination or desire to ask for certain kinds of buildings we can hardly blame architects for not designing them.*

Some people think problems of architecture are political – in the sense that ugly architecture is, to quote some popular claptrap, socialist. If only it were so simple! The truth is that there was overt fascism in the origins of Modernist architecture; Adolf Loos said ornamentation was 'African', and in the work of Le Corbusier we find a peculiar union of seething totalitarianism and zealous capitalism. Those who condemn ugly buildings as socialist ought better to rail at consumerism. And as for what we might loosely call 'traditional architecture', increasingly regarded as the exclusive domain of conservatives, we find much that is liberal, progressive,

* And, I must add, we only criticise architects so heartily because theirs is a great responsibility; if we ask much of them it is a mark of respect for their station and a statement of faith in what they can do for humankind.

and socialist. Ruskin and Morris loved medieval architecture *precisely because* it empowered working people, provided a bulwark against exploitation, put human wellbeing above corporate gain, and because it was less environmentally destructive. The Soviet Union built a Baroque metro; capitalist America filled its cities with glass skyscrapers.

My point is that we must dispense with the notion that any ideology can lay claim to 'good architecture'. This is useless, harmful, and untrue – beauty is the inheritance of all humankind. For our collective history is a treasury of delight that has bequeathed us models for architecture and urban design waiting (crying out!) to be emulated, from Safavid Isfahan to Art Deco New York, models beloved around the world but bizarrely regarded as irrelevant to the present. To learn from our ancestors is common sense – there is no reason we should not attempt to, nor anything to suggest we cannot, 'become as Venice without her despotism, and as Florence without her dispeace.'[42] To ignore our global architectural heritage – on the grounds of perceived political loyalties – is idealistic foolhardiness at best and dangerous hubris at worst.

We must never forget that we always have a choice. The revivalism of the nineteenth century was a conscious decision to build in the manner of past ages. In Bulgaria (for example) it was not some unconscious 'product of the times' that led to the construction of the Alexander Nevsky Cathedral in the style of the Byzantines – it was something the Bulgarians wanted to do. In Britain, meanwhile, the likes of Pugin, Ruskin, and Morris argued that society *should* return to the Gothic. There was nothing indirect, no sly socioeconomic 'context' about their critiques of Classical architecture and correspondent demands for medievalism. And Britain listened – from the pediments of a Neoclassical land rose a new age of neo-Gothic spires.

So... what is the future of architecture? As I have said, the chief problem today – the one that bothers most people – is that we do not build whatsoever like we used to. Not that we don't *only* build in those ways – much modern architecture is beloved! – but that we cannot seem to put up a single building like those historical ones most photographed and admired along our older streets. Well, we will not get the architecture we want if we do not ask for it. And though it may be more costly to build such historically inspired buildings, anything is too expensive if you do not want it – thing are usually 'too expensive' only because we think they are unimportant. So we must *prioritise* architecture, though it will likely be cheaper than we believe, and the money will in any case be well spent on artisans and labourers, much to the joy of *all* political parties and of *all* people. Good architecture is a long-term investment and its profits are human joy. In the end, conjecture about regulations and economics might be a smokescreen for the truth: that the first necessary step toward anything is demanding it and prioritising it, regardless of how our society is organised. No 'ism' or 'economic consideration' ever laid a brick – only a human being can do that.

CHAPTER VI

The Last Library on Earth

†

> Now, I shall sing these songs
> Beautifully
> for my companions.
>
> – from the *Fragments of Sappho*[43]

This book is nearly done. What next? Choosing what to read is fantastically significant, and now more than ever before. Why? Because there are too many books.

You can read anything but not everything. If you read ten books every year then, by the end of a normal life, you will have read about seven hundred books. But there are more than 100 million books in the world. Thus you will have read 0.0007 per cent of all the books you *could* have. Even if you read one hundred books every year you would not exceed 0.007 per cent. Troubling. But there is hope – because to know there are books we will never read reminds us that what we choose to read matters.

So . . . where to look for recommendations? Can you trust bestseller lists or 'Book of the Year' awards? Can you trust what YouTubers say was instrumental in their success? There is a desert of books out there, every book a grain of sand, and among them a few rubies in the rough. Finding these rubies is not easy and we have no

reason to believe the capricious winds of taste or the preferences of podcasters will sieve them for us. To read only those books recommended by algorithms and influencers is to 'worship Glow-wormes (instead of the Sun) because of a litle false glistering', as Thomas Dekker put it.* I almost believe we should impose a moratorium on publishing; there is already more than enough to read. Dekker, again, was right: 'Wee should come to the Presse as we come to the Field (seldome).'⁴⁴

But our rule is to publish willy-nilly: wherever a buck is to be made, wherever the reputation of a 'public intellectual' is to be forged, wherever experts have an axe to grind or a course to flog.† That is somewhat hyperbolic; much of what we publish is undoubtedly brilliant. Still, I think it is only reasonable to suggest we should pay more of our precious attention to what a hundred generations have deemed worthy of our time than what a small percentage of the current generation have, at first glance, found interesting.

Suppose you could enter a room filled with the greatest minds in human history, all miraculously alive again, and talk with them. That would be something! But this is no dream – it is reality. These minds are preserved in the books they have written, and by reading

* How did you stumble across this very book? It may itself be such a worm!
† In which case you may rightly call me a hypocrite, though an honest hypocrite I protest! And, if guilty, I offer Stephen Gosson's words as apology – and not ironically: 'Gentlemen, and others, you may wel thinke that I sell my corne, and eate Chaffe; barter my wine, and drinke Water; sith I take upon mee to drive you from Playes, when mine owne woorkes are dayly to be seene upon stages . . . But if you sawe how many teares of sorrowe mine eyes shed, when I beholde them; or how many drops of blood my heart sweates, when I remember them; you would not so much blame me for missespending my time, when I knew not what I did; as commend mee at the laste, for recovering my steppes, with graver counsel.'⁴⁵

their books we can talk to them, ask questions, get to know them, challenge them, even have a laugh.* Niccolò Machiavelli, author of *The Prince*, said this in a rather lovely way:

> When evening comes, I return home and go into my study. On the threshold I strip off my muddy, sweaty, workday clothes, and put on the robes of court and palace, and in this graver dress I enter the antique courts of the ancients and am welcomed by them . . . And for the space of four hours I forget the world . . . I pass indeed into their world.[47]

We too can pass into their world, the world of these writers who have topped the bestseller lists of all time, not just of 2025, the writers who have 'made immortal all that is best and most beautiful in the world', as Shelley had it. These books, by virtue of their long-standing success, demand our preference. Hence my tendency to quote them so often. As Seneca wrote:

> I shall continue to heap quotations from Epicurus upon you, so that all persons who swear by the words of another, and put a value upon the speaker and not upon the thing spoken, may understand that the best ideas are common property.[48]

But the vast majority of things we read have been written in the last decade, if not the last month. Meanwhile the online content cycle gives us what the last twenty-four hours alone have judged clickworthy. There is nothing necessarily wrong with reading works written in the recent past, but anything popular right now, any bestseller list, is inevitably and definitionally untested but for the

* It is not all philosophising! Even Montaigne was wont to say, 'both kings and philosophers defecate, and so do the ladies.'[46]

fashions of the present.* Most bittersweet by far is that this very internet which has given rise to the Twenty-Four-Hour Content Cycle has also given us greater access to what is good – by which I mean what has survived the litmus test of millennia – than any human in history could have dreamed.

What should you read, then? If you are interested in history and usually read books that have recently been written, why not try out a primary source alongside them? They sparkle, these 'primary sources' – they are real things, not abstractions or concepts. Diaries, letters, poems, court cases, graffiti, surveys, maps, paintings, statues, architecture, captains' logs, travelogues, dinner menus, coins, epitaphs ... primary sources are everything created at any point in the past, and (as stated) the internet means that access to them is now greater than it has ever been.

If you want to learn about the Romans, then Livy, Tacitus, Sallust, Plutarch, Cassius Dio, the Plinies, and so many others are crying out for your attention. Though many of them are wonderful and the authors behind them supremely scrupulous and perceptive historians, I do wonder why we need a hundred new books about Rome every year when the Romans themselves have already written so much. Montaigne said it best:

> There is more trouble in interpreting interpretations than in interpreting the things themselves, and there are more books on books than on any other subjects. We do nothing but write comments on one another. The whole world is swarming with commentaries; of authors there is a great dearth.[49]

* This is why, for example, the 'Golden Age' of Hollywood was (despite what nostalgia leads us to believe) really no less permeated by flops and cash-grabs than modern Hollywood. Most films produced in the 1940s were not *Casablanca* – time is a filter and the chaff has been strained.

Remember that whenever you read something *about* something else, you are reading somebody else's interpretation rather than *the thing itself*. And this is no criticism of historians – they would agree, and readily accept that any given writer can only strive, ever failingly, to cast off the baked-in biases of their own age.

Besides, there is something uniquely valuable about reading history written by the people who lived through that history. Livy knew and spent time with Emperor Augustus. Clearly we can learn a lot from him – and his grand history, *Ab Urbe Condita*, is melodiously readable. Or perhaps you want to know about the vicious Vikings and their sudden intrusion into the geopolitics of ninth-century Europe? Read some lines from the *Anglo-Saxon Chronicle*, penned hurriedly in a fen-monastery by tallow light precisely when those northerners first arrived:

> 787: In this year Beorhtric took to wife Eadburh, daughter of king Offa. And his days came first three ships of Norwegians from Hörthaland: and then the reeve rode thither and tried to compel them to go to the royal manor, for he did not know what they were: and then they slew him. These were the first ships of the Danes to come to England.[50]

Ahmad Ibn Fadlān, emissary of the Caliph of Baghdad, was sent to parley with the Vikings of the Volga and wrote about his travels – you can learn about the Vikings from a man who knew them (or, alternatively, read their very own *Eddas* and *Sagas*):

> They are the filthiest of all Allah's creatures: they do not clean themselves after excreting or urinating or wash themselves when in a state of ritual impurity and do not wash their hands after food. Indeed they are like asses that roam.[51]

When Joan of Arc was put on trial in 1431 a record was made – and you can read it. In it we can hear – apparently – the words of Joan of Arc herself:

> On the Wednesday, IXth of May, in the great dungeon of the castle of Rouen, Joan was led into the presence of her judges . . . Joan replied to the judges and assessor: Truly if you were to tear me limb from limb and make my soul leave my body, I would not say to you anything else.[52]

If we desire to understand the past we *must* read what people from that past wrote themselves. Always judiciously and incredulously; but that is true of modern books also. It's fabulously good fun, frequently surprising, and every single line is of value – if not because it is 'factually' correct then, more often, because it reveals something about what they thought and how they felt.

Still, I wonder if we should eschew 'recommendations' entirely. Ignore what people say. Ignore me. Ignore the so-called greats. Go into a second-hand bookshop and find something that calls out to you.* *Read it*. Forget what you 'should' read. Construct a personal canon and become a fortress unto yourself, unburdened by received opinions. Plunge into that vast ocean of books, so broad and deep no living person has ever read even a trifling fraction, and discover those pearls on your own terms. Read books at random, picked from dusty shelves. Do not be a puppet for the preferences of others. Do not be a cog in the bookselling machine. Forge your own path.

Imagine the last library on Earth, containing every book ever written. And, at this far-flung moment, the Sun is expanding and Earth must be evacuated. All digital information has been fried by

* Truly, reading old and second-hand books is both better *and* cheaper.

cosmic rays and there is only room aboard the spaceship for, say, ten books. What books would you choose? My choice, perhaps surprisingly, would be none. Because the world itself is a book, and is the wisest, funniest, and greatest book of all. It is the one we must read most reverently; it is the one that can teach us most. Other books too often muddy the mirror of our mind's eye. Train that eye upon the world – and also upon *yourself* – and therein you shall find all the pages you ever needed. Again I turn to the wisdom of Montaigne:

> I would rather understand myself well by self-study than by reading Cicero.[53]

Yes, there comes a moment when we must put down our books and brave the world. In the lines of Walt Whitman:

> This is thy hour O Soul, thy free flight into the
> wordless,
> Away from books, away from art, the day erased, the
> lesson done.
> Thee fully forth emerging, silent, gazing, pondering
> the themes thou lovest best,
> Night, sleep, death and the stars.[54]

Should my book be published? Probably not.* But all I can do is echo Livy, who said that even if he were consigned to obscurity he would be at peace in the knowledge that nobler minds accomplished what he only hoped to achieve. I feel the same way.

* Though I do offer you that lovely preface by Thomas Dekker, hoping that you too will not say your bargain has been hard: 'Bookes are but poore gifts, yet Kings receive them: upon which I presume, you will not turne this out of doores. Yet cannot for shame but bid it welcome, because it bringes to you a great quantitie of my love: which, if it be worth litle, yet I hope you will not say you have a hard bargaine, Sithe you may take as much of it as you please for nothing.'[55]

CHAPTER VII

Postlude

†

The things that actually happened were of small consequence—
the thoughts that were developed are of infinite consequence.

— John Ruskin, *The Eagle's Nest*[56]

What did you expect when you first picked up this book? In the prelude I said that I would attempt to teach you something about the language of culture, about all those things that we hear of but never quite learn at school. This book was intended as a starting point, an introduction to the worlds of art, architecture, history, literature, and philosophy. These form a singular and united world – our world – touching each and every part of it.

If this book has achieved only one thing, I hope it is that you find yourself paying a little more attention to what surrounds you. Perhaps you'll notice something you hadn't noticed before in the architecture where you live, or look at traffic lights and wonder why green means *go* and red means *stop*. Every detail, of every single thing, has a story to tell. Culture, ultimately, is about engaging with and seeing the world more fully. Once we notice things we cannot unnotice them, but in an age where so many demands are placed on our attention

the hardest and most important part is allowing ourselves the time to look around, breathe for a moment, and ask, 'Why?'

There is something intrinsically exciting when things start to make sense, a sort of thrill as the scattered pieces you have gathered throughout your life begin to assemble into something more. 'So *that* is why . . .' you realise. The connection could be simple, like figuring out where the colours of your country's flag come from, or it could be much grander, like weaving together the long threads of history and stumbling upon some assumption-shattering conclusion about the present day. Both are legitimate, both equally vital, and both are the fruits of learning more about culture. This sort of learning is a joy in and of itself, regardless of where it leads us. And it is a more deeply fulfilling satisfaction than the fleeting pleasures we are often and most easily drawn to.

The story of our civilisation is epic and ancient, often wondrous though oftener sorrowful, and it is a story in which you are involved. I hope you have grasped this and seen that there is more in life than streamlining schedules or thinking about day-to-day politics. These are not intrinsically bad, but we cannot live – or at least live well – through them alone. In what I have written about art and architecture, history and literature, etymology and love poetry, I hope you have had a few glimpses of what it means to speak the language of culture, of that 'something more' we are always searching out, a brighter and broader way of being.

As I said in the prelude, the purpose of learning this language is not just in collecting its vocabulary, in merely 'knowing' things – it is in speaking and reading that language, using it and living with it. Understanding culture breeds in us a general sense of inquisitiveness that we can bring to all moments and all things, however mighty or humble; it gives us an appreciation for what is most beautiful and

helps us appreciate it more; it equips us with greater fortitude in the face of hardships, with the perspective necessary to understand when we must be gentle and when stern. Having some awareness of why things look the way they do, of where our political systems and ideas – the thoughts in our heads – came from, of the deeper nature of our fellow creatures, can only be a good thing.

This is the real purpose of education, the real meaning of 'being educated'. Not in impressing people, getting a particular job, or anything of that sort. Being educated makes us happier, stronger, and wiser; it helps us think more clearly, love more deeply, and live more vigorously, both personally and collectively. Education is the place from which the winds of peace blow, the skill through which we learn to overcome our most barbarous instincts and together inch, however slowly, towards our better and nobler nature.

Where you take it is up to you – let nobody tell you which path *must* be taken! I simply hope to have pointed out a few places of possible departure for the journey that lies ahead.

We only have so many hours on this Earth and can only give our attention to so many things in a lifetime. What we choose to spend our time looking at and thinking about is what defines that lifetime. So, what will it be? This is a question we must answer ourselves. If we let others answer it for us we will spend our time thinking about and doing whatever is suggested by the most immediate, most convenient source. Try a little harder, look a little more judiciously, and what you discover will be far more rewarding.

And, moreover, culture is bloody good fun. What is the oldest joke in human history?

> Something which has never occurred since time immemorial; a young woman did not fart in her husband's lap.[57]

That's Sumerian scatology for you – still funny (sort of?) 4,000 years later. Yes, much has been said and done before that we say and do also. Clickbait? Lucian called it out in the second century:

> There is nothing agreeable in these things, except to anyone who is fool enough to enjoy commendations which the slightest inquiry will prove to be unfounded.[58]

Read Jean Froissart's report of the Peasant Revolt in 1381:

> There fell in England great mischief and rebellion of moving of the common people, by which deed England was at a point to have been lost without recovery. There was never realm nor country in so great adventure as it was at that time.[59]

These words ring familiar bells. 'Our country is on the verge of being lost without recovery' – have not we heard that in the news today, and from all sides of the political spectrum?

Even FOMO is ancient; Pindar felt this fear of missing out two millennia or more past:

> They say there is nothing more sorrowful
> Than to see joy and stand perforce outside.[60]

Listen to *Si dolce è'l tormento*, a short piece of music written by Claudio Monteverdi four hundred years ago. In those plaintive notes you will learn, in an instant, that machines come and go but heartbreak remains. Or listen to 'Past-time with Good Companye', said to have been written by Henry VIII; our ancestors did also like to enjoy themselves, it seems. And I let that ranging thought of Sappho's, quoted elsewhere in these pages, speak once again for all who have wondered whether we will be remembered after we die:

THE SEVENTH PILLAR OF THE CULTURAL TUTOR

> I tell you/someone will remember us/in the future[61]

What am I driving at? That we have not changed very much these last several millennia. And if human nature is forever unchanging, the things we have said and done in the past, however distant in time, are eternally relevant.

But there is a broader truth here: that on the face of this Earth, the third planet of the Solar System, with a little Moon revolving around it, there does seem to be a thing called humanity, a great many human beings scuttling about on its face. And *you* are one of them. How? From where did we emerge? What are we? No creed, religious or atheist, of spirit or science, has ever got around this one fact, this one truth: that existence, whatever its nature, is inexplicable. This is one point where microscopes and haruspices agree; every '-ism' and '-ology' agrees also. Whether we are driftwood of an ash tree on the shore, breathed into life by Odin and his divine companions, or whether we are freak coincidence of a material universe whereby atoms under sway of entropy somehow produced life, somehow produced consciousness, either way it is a remarkable thing to exist. This we cannot find a way of denying however hard we try. Strange to think, strange but unavoidably true, and worth remembering more often, is that *you* reading these words are connected by a literally unbroken chain to the origin of life hundreds of millions or billions of years ago, and in the atoms of your body to the very beginning of the universe itself.

What to conclude? In a word? In a single word, only one, how will we summarise all this? MIRACULOUS! There is no other.

There are many things I haven't covered in this book. Fields like oceanology, meteorology, minerology, or botany are just a few of them – these are part of culture too. Though the stars twinkle

separately, together they form the vaults of the heavens. We gain much by broadening our minds, little by narrowing them. It could not be any other way. Our imagination is a kind of soul; you *can* see the universe – the culture that draws all life together across the ages – in a puddle, in a star, in a shard of broken pottery, in all things around you, if you choose to look.

This book draws to a close. I have tried to imagine you, my Reader, as I have written it, tried to imagine what you will find most interesting, useful, and beautiful. So you have been my companion in this journey. And we have travelled far. Yes, you have kept me company, and good company you have been; I thank you for it. Are you glad to have read this book? All I can say is that I have written these words with love in my heart and endeavoured to make them worth your time. If they were not useful I hope at least they have been entertaining. Otherwise, as they say, too bad! Farewell.

Acknowledgements

If you are a 'general reader', as they say, these pages will be without much meaning. They are a chance, for me, to thank those who already know they have my gratitude, committing that gratitude to the strange, eventually unfamiliar eternity of the printed page, and also to thank those who do not already know they have my thanks.

Where to begin? In the past I never understood why authors always thank their agents and editors. Now I do. For their unflagging patience, probity, and imagination I thank my agent, Tom Killingbeck, and my editor, Shyam Kumar. Thanks of a similar nature are due to Sarah Day and Peter Furtado. Nor did I have any idea just how many people are involved in the creation, publication, and distribution of a book. Let me tell you – it's an awful lot of people! I have not met most of them. What a shame. Nonetheless, even at a distance, you have my gratitude.

Who else? Mrs McNeilly, Dr Wilton, Dr Carr, Mr Holland, and Mr Hale. Good teachers are a blessing every youth deserves; I had that blessing. Another I must thank is Alexis Katakalidis. If only I had space to mention all the rest. Suffice to say that CGS is forever in my heart – and also, therefore, somehow, in this book. To all at Mildert – *sic vos non vobis* and suchlike – and to a handful in particular, my love is endless. You know who you are! To Elaine Day, no longer with us, for a brief but life-changing conversation. To the boys of the Avenue (plus Dan) – need I say more? To the Sabbs – companions of an indescribable sort! To Tirian – I'm sorry about the biscuits. To Asa – a champion of a man. For their exceptional

ACKNOWLEDGEMENTS

company, David and Mark at Sullivan's. To Micheal Cooke, who may or may not remember me from those bookshop days. To my adoptive family in Poblenou, and to all the others who have taken the care to show me the wonders and secrets of their cities and nations – you, too, know who you are. To the Summersgills – for, among so much else, showing me a new home.

Who else? Without Harry Dry there's no Sheehan Quirke, for good or for bad, and without David Perell or Chris Monk there's no Cultural Tutor. Rhys, Ben, Alex, James – and John. To old Chalmers, to the Snoxalls, to O'Connor and Dr Nelson. To Mubasil, wholly unlike any other. To the Samotoys and the Chebotkos – a new family. And, lastly, to my family. I'd list your names but there's a lot of you. To all at Tara, and also at No. 6; to those in the North, in the South, and in Ireland; to Jenny, dearest cousin and mentor; to Mum and Dad.

There's also Polina – I'm glad you found me.

It had always been my dream to 'write a book', whatever precisely that meant. The dream is achieved. What next? Well, if I never write another word – so be it! We mustn't count too many of our unhatched chickens. I do believe somewhat in the transcendental power of love. Such is my final word. Otherwise: I have definitely forgotten somebody. Well, if that's you . . . thanks!

Notes

PILLAR I, CHAPTER I

1. Thomas Carlyle, *Signs of the Times* (1829).
2. An email sent by Steve Jobs to himself in 2010 (Put Something Back, Steve Jobs Archive).
3. Cicero, *Brutus & Orator*, trans. G. L. Hendrickson and H. M. Hubbell (Loeb Classical Library, Harvard University Press: 1939).

PILLAR I, CHAPTER II

4. Tacitus, *Annals*, trans. A. J. Church and W. J. Brodribb (New English Library: 1964).
5. All quotations from *The Letters of the Younger Pliny*, trans. Betty Radice (Penguin: 1983).
6. The Roman Twelve Tables, translated in *Ancient Roman Statutes: Translation, with Introduction, Commentary, Glossary, and Index* by Allan Chester Johnson, Paul Robinson Coleman-Norton, and Frank Card Bourne (University of Texas Press: 1961).

PILLAR I, CHAPTER III

7. Letter from Cuthbert to the Archbishop of Mainz, in J. P. Migne (ed.), *Patrologiae Cursus Completus* (Paris, 1862), Vol. XCVI; reprinted in Roy C. Cave and Herbert H. Coulson (eds.), *A Source Book for Medieval Economic History* (The Bruce Publishing Co.: 1936; reprint edn, Biblo & Tannen: 1965).
8. Bartholomew Anglicus, *The Properties of Things*, in *Mediaeval Lore from Bartholomew Anglicus*, Robert Steele (ed.) (Alexander Moring Ltd: 1905).

9. Joinville and Villehardouin, *Chronicles of the Fourth Crusade*, trans. M. R. B. Shaw (Penguin Books: 1963).
10. Thomas à Kempis, *The Imitation of Christ*, trans. Revd William Benham (Routledge: 1905).
11. Dante, *The Divine Comedy*, trans. Henry Cary (George Bell & Sons: 1910).
12. *The Letters of Abelard and Heloise*, trans. Betty Radice (Penguin Books: 1978).

PILLAR I, CHAPTER IV

13. Virgil, *Bucolics, Aeneid, and Georgics*, trans. J. B. Greenough (Ginn & Co.: 1900).
14. *The International System of Units*, Bureau International des Poids et Mesures, 9th edn (2019).
15. Ibid.
16. John Donne, *An Anatomy of the World* (1611).

PILLAR I, CHAPTER V

17. Homer's *Iliad*, trans. Samuel Butler (Longmans, Green and Co.: 1898).
18. John Milton, *Sonnet XIII* (1673).
19. Erasmus, *Spongia adversus aspergines Hutteni* (1523), as quoted in *Desiderius Erasmus of Rotterdam*, Ephraim Emerton (G. P. Putnam's Sons: 1899).
20. Giorgio Vasari, *Lives of the Most Eminent Painters, Sculptors, and Architects*, trans. Gaston du C. de Vere (Macmillan and Co. and the Medici Society: 1912–14).

NOTES

PILLAR I, CHAPTER VII

21. *The Poems of Sappho*, trans. Julia Dubnoff (https://www.uh.edu~cldue/texts/sappho.html).
22. John Milton, *Paradise Lost, Book XII* (1674).
23. Pompeiian Graffiti: CIL 3457, 2048, and 6702, from https://ancientgraffiti.org/Graffiti/results.
24. *The Upanishads*, trans. Eknath Easwaran (Penguin: 1989).
25. *The Fragments of Heraclitus*, trans. John Burnet, in *Early Greek Philosophy* (Adam and Charles Black: 1920).
26. Translation of letter RS 20.18 from *1177 B.C.: The Year Civilisation Collapsed*, Eric H. Cline (Princeton University Press: 2014).

PILLAR II, CHAPTER I

1. Lao-Tzu, *Tao Te Ching*, trans. Wing-Tsit Chan (Bobbs-Merrill: 1963).
2. *Hesiod: The Homeric Hymns and Homerica*, trans. Hugh Gerard Evelyn-White (Heinemann: 1920).
3. John Burnet, *Early Greek Philosophy* (Adam and Charles Black: 1920).
4. Lucretius, *On the Nature of Things*, trans. A. E. Stallings (Penguin: 2007).
5. Thomas Carlyle, *On Heroes, Hero-worship, and the Heroic in History* (Oxford University Press: 1924).
6. John Ruskin, *The Queen of the Air* (George Allen and Sons: 1911).
7. *Hymns of the Rigveda*, trans. Ralph T. H. Griffith (E. J. Lazarus & Co.: 1896).

PILLAR II, CHAPTER II

8. *Bhagavad Gita*, trans. Juan Mascaró (Penguin: 1970).
9. Edmund Spenser, *The Shepheardes Calender* (1579).

10. Diogenes Laertius, *The Lives of the Eminent Philosophers*, trans. R. D. Hicks (William Heinemann: 1925).
11. Plutarch, *Parallel Lives*, trans. Bernadotte Perrin (William Heinemann: 1919).
12. Ibid.

PILLAR II, CHAPTER III

13. Edward Coke, *Case of Prohibitions* (1607) EWHC KB J23.
14. Propertius, *Elegies*, ed. and trans. G. P. Goold (Loeb Classical Library 18, Harvard University Press: 1990).
15. Robert Burton, *The Anatomy of Melancholy* (1621).
16. L. J. Camden, *Entick v Carrington* [1765] EWHC KB J98.
17. 'The Code of Ur-Nammu', in *Babylon: Mesopotamia and the Birth of Civilization*, Paul Kriwaczek (St Martin's Griffin: 2012).
18. *The Code of Hammurabi*, trans. Robert Francis Harper (University of Chicago Press: 1904).
19. Scripture quotations from the Authorized (King James) Version. Rights in the Authorized Version in the United Kingdom are vested in the Crown. Reproduced by permission of the Crown's patentee, Cambridge University Press. (Hereafter referred to as KJV.)
20. Plutarch, *Parallel Lives*, trans. Bernadotte Perrin (William Heinemann: 1919).
21. Ibid.
22. *The Institutes of Justinian*, trans. J. B. Moyle (Clarendon: 1913).
23. Aeschylus, *Prometheus Bound*, trans. Philip Vellacott (Penguin: 1964).
24. John Locke, *Second Treatise of Civil Government* (1689).
25. Edward Coke, *Case of Proclamations* (1610) EWHC KB J22.

NOTES

26. Tacitus, *Annals*, trans. A. J. Church and W. J. Brodribb (New English Library: 1964).
27. Erasmus, *The Education of a Christian Prince*, trans. Lester K. Born (Octagon Books: 1963).
28. From an Address by the Revd Dr Martin Luther King, Jr at Cornell College, Mount Vernon, Iowa (15 October 1962).

PILLAR II, CHAPTER IV

29. Plutarch, *The Rise and Fall of Athens: Nine Greek Lives*, trans. Ian-Scott Kilvert (Penguin: 1973).
30. Polybius, *The Histories*, trans. W. R. Paton (Loeb Classical Library, Harvard University Press: 1922).
31. Tacitus, *The Agricola and The Germania*, trans. Harold Mattingly and Sallie Marston (Penguin: 1970).
32. Demosthenes, *The Crown, the Philippics, and Ten Other Orations*, trans. Charles Rann Kennedy (Everyman: 1938).
33. Thomas Dekker, *The Guls Horn-Booke* (1609).
34. Plutarch, *Parallel Lives*, trans. Bernadotte Perrin (William Heinemann: 1919).
35. Tacitus, *The Agricola and The Germania*.
36. Caesarius of Heisterbach, *Dialogue on Miracles*, trans. H. von E. Scott and C. C. Swinton Bland (Harcourt, Brace and Company: 1929).
37. *A Narrative of a Voyage to Senegal in 1816*, J. B. Henry Savigny and Alexander Corréard (Henry Colburn: 1818).
38. William Harrison, *A Description of England*, in *Elizabethan England*, Walter Scott (1889).

PILLAR II, CHAPTER V

39. Letter of Galileo Galilei to Benedetto Castelli, in *Opere di Galileo Galilei*, Vol. V, Antonio Favaro (ed.) (Giunti Barbera: 1968).
40. Galileo, *Dialogue Concerning the Two Great World Systems*, trans. Thomas Salusbury and Giorgio de Santillana (University of Chicago Press: 1956).
41. Ibid.
42. Quoted in *The Crime of Galileo*, Giorgio de Santillana (Heinemann: 1955).
43. From 'Galileo's Sentence', in *Galileo Galilei and The Roman Curia*, Karl von Gebler, trans. Mrs. George Sturge (C. Keegan Paul & Co.: 1879).
44. Arthur R. Clute, 'The Trials of Galileo', *Journal of the Royal Astronomical Society of Canada*, Vol. 45, February 1951.
45. John Milton, *Areopagitica* (1644).

PILLAR II, CHAPTER VII

46. Adolf Loos, *Ornament and Crime*, trans. Shaun Whiteside (Penguin: 2019).
47. Ibid.
48. William Morris, *Hopes and Fears for Art* (Ellis and White: 1882).
49. Loos, *Ornament and Crime*.
50. Morris, *Hopes and Fears for Art*.
51. Theocritus, Idyll XIII, in *The Idylls of Theocritus and The Eclogues of Virgil*, trans. C. S. Calverley (George Bell and Sons: 1913).
52. Lucretius, *On the Nature of Things*, trans. A. E. Stallings (Penguin: 2007).

NOTES

PILLAR III, CHAPTER I

1. From Aristotle's *Poetics*, in *Aristotle, Horace, Longinus: Classical Literary Criticism*, trans. T. S. Dorch (Penguin: 1965).
2. Le Corbusier, *Toward a New Architecture*, trans. Frederick Etchells (Dover: 1986).
3. John Ruskin, *A Joy Forever and The Two Paths* (George Allen and Sons: 1911).
4. Andrea Palladio, *The Four Books on Architecture*, trans. Robert Taverner and Richard Schofield (MIT Press: 2002).
5. Louis Sullivan, 'The Tall Office Building Artistically Considered', *Lippincott's Monthly Magazine*, No. 57 (March 1896).
6. Leon Battista Alberti, *The Ten Books on Architecture: The 1755 Leoni Edition* (Dover: 1986).
7. Hugh Ferriss, *The Metropolis of Tomorrow* (Ives Washburn: 1929).
8. William Morris, *Hopes and Fears for Art* (Ellis and White: 1882).

PILLAR III, CHAPTER II

9. *The Epic of Gilgamesh*, trans. Maureen Gallery Kovacs (Stanford University Press: 1989).
10. William Harrison, *A Description of England*, in *Elizabethan England*, Walter Scott (1889).

PILLAR III, CHAPTER III

11. Vitruvius, *The Ten Books on Architecture*, trans. Morris Hicky Morgan (Oxford University Press: 1914).
12. Ibid.
13. Ibid.
14. Leon Battista Alberti, *The Ten Books on Architecture: The 1755 Leoni Edition* (Dover: 1986).

NOTES

15. Andrea Palladio, *The Four Books on Architecture*, trans. Robert Taverner and Richard Schofield (MIT Press: 2002).
16. John Ruskin, *The Stones of Venice Volume III: The Fall* (J. M. Dent & Sons: 1927).
17. William Morris, *Gothic Architecture: A Lecture for the Arts and Crafts Exhibition Society* (Kelmscott Press: 1893).

PILLAR III, CHAPTER IV

18. Le Corbusier, *Toward a New Architecture*, trans. Frederick Etchells (Dover: 1986).
19. Adolf Loos, *Ornament and Crime*, trans. Shaun Whiteside (Penguin: 2019).
20. Ibid.
21. Le Corbusier, *Toward a New Architecture*.
22. Ibid.
23. Ibid.

PILLAR III, CHAPTER V

24. *Le Paris d'Haussmann*, Patrice de Moncan (Du Mecene: 2002).
25. Ibid.
26. Victor Hugo, *Les Misérables*, trans. Isabel F. Hapgood (Thomas Y. Cromwell & Co.: 1887).
27. Ildefons Cerdà, *General Theory of Urbanisation 1867* (Actar: 2018).
28. William Morris, *Town and Country*, speech delivered 29 May 1892 at a meeting sponsored by the Hammersmith Socialist Society at Kelmscott House, Hammersmith, published in *Journal of Decorative Art* (13 April 1893).
29. George Godwin, *Another Blow for Life* (William H. Allen & Co.: 1864).

NOTES

PILLAR III, CHAPTER VI

30. KJV.

PILLAR III, CHAPTER VII

31. Douglas Adams and Mark Cawardine, *Last Chance to See* (Pan Books: 1990).
32. John Ruskin, *The Seven Lamps of Architecture* (J. M. Dent & Sons: 1910).

PILLAR IV, CHAPTER II

1. Walter Pater, *The Renaissance* (Oxford University Press: 1986).
2. Walter Thornbury, *The Life of J. M. W. Turner*, Vol. II (Hurst and Blackett: 1862).
3. *The Works of Plato: The Jowett Translation, with the Introduction and Analysis* (Tudor Publishing: 1945).
4. John Ruskin, *Modern Painters*, Vol. I (George Allen: 1900).
5. John Donne, 'The Relic' (1633).

PILLAR IV, CHAPTER III

6. Stéphane Mallarmé, in *Un Coup de Dés & Other Poems*, trans. A. S. Kline (2018).
7. Paul Valéry, 'The Conquest of Ubiquity', in *Aesthetics*, trans. Ralph Mannheim (Pantheon Books: 1964).
8. Ibid.
9. Charles Baudelaire, *The Mirror of Art*, trans. Jonathan Mayne (Phaidon Press: 1955).
10. George Orwell, 'Benefit of Clergy: Some Notes on Salvador Dalí', in *The Saturday Book*, No. 4, Leonard Russell (ed.) (Hutchinson: 1944).

11. Ibid.
12. Walter Pater, *The Renaissance* (Oxford University Press: 1986).

PILLAR IV, CHAPTER IV

13. Lucretius, *On the Nature of Things*, trans. A. E. Stallings (Penguin: 2007).
14. William Morris, *Hopes and Fears for Art* (Ellis and White: 1882).
15. Thomas à Kempis, *The Imitation of Christ*, trans. Revd William Benham (Routledge: 1905).
16. Percy Shelley, *Hellas* (1821).

PILLAR IV, CHAPTER V

17. William Morris, *Hopes and Fears for Art* (Ellis and White: 1882).
18. Ibid.
19. Ibid.

PILLAR IV, CHAPTER VI

20. Dante Alighieri, *La Vita Nuova*, trans. Mark Musa (Oxford University Press: 1992).
21. Enheduanna, *Hymn to Inanna*, trans. Jane Hirshfield in *Women in Praise of the Sacred: 43 Centuries of Spiritual Poetry by Women*, Jane Hirshfield (trans. and ed.) (HarperCollins: 1994).
22. W. H. Davies, 'Leisure', in *Collected Poems of W. H. Davies* (Jonathan Cape: 1942).
23. Elizabeth Siddal, 'Worn Out' (1899).
24. W. N. Hodgson, 'Before Action', *The New Witness* (29 June 1916).
25. Arthur Rimbaud, 'Le Dormeur du Val', in *Rimbaud: Complete Works and Collected Letters* (trans. Wallace Fowlie) (University of Chicago Press: 1966).
26. Victor Hugo, 'Demain, dès l'aube' (1856).

27. William Wordsworth, 'Lines Written a Few Miles above Tintern Abbey' (1798).
28. *The Essential Haiku: Versions of Basho Buson and Issa*, trans. Robert Hass (The Ecco Press: 1994).
29. *The Poems of Sappho*, trans. Julia Dubnoff (https://www.uh.edu/~cldue/texts/sappho.html).
30. Thomas Gray, 'Elegy Written in a Country Churchyard' (1751).
31. Michel de Montaigne, *The Essays*, trans. J. M. Cohen (Penguin: 1958).
32. Elizabeth Barrett Browning, 'Love' (1850).
33. Sir Philip Sidney, *The Defence of Poesy* (1595).

PILLAR IV, CHAPTER VII

34. Pindar, *The Odes*, trans. C. M. Bowra (Penguin: 1988).
35. *The Essential Haiku: Versions of Basho Buson and Issa*, trans. Robert Hass (The Ecco Press: 1994).
36. Enheduanna, *The Temple Hymns*, Ake W. Sjöberg and E. Bergmann, 'The Collection of the Sumerian Temple Hymns', in Ake W. Sjöberg (ed.), E. Bergmann, Gene B. Gragg, *The Collection of the Sumerian Temple Hymns* (J. J. Augustin: 1969).
37. Virginia Woolf, in *The Diary of Virginia Woolf*, 5 vols., Anne Olivier Bell and Andrew McNeillie (eds.) (Hogarth Press: 1977–84).
38. Gertrude Stein, *The Autobiography of Alice B. Toklas* (Harcourt, Brace, and Co.: 1933).
39. Lord Byron to John Murray, from Ravenna, 12 August 1820.
40. Robert Louis Stevenson, *The Essay on Walt Whitman* (The Roycroft Shop: 1900).
41. D. H. Lawrence, *Studies in Classic American Literature* (Penguin: 1990).

42. Samuel Johnson, *Preface to Shakespeare* (1765).
43. Percy Shelley, *The Defence of Poetry* (1840).
44. Virgina Woolf, *The Second Common Reader* (Penguin: 1944).
45. From Horace's *Ars Poetica* in *Aristotle, Horace, Longinus: Classical Literary Criticism*, trans. T. S. Dorch (Penguin: 1965).

PILLAR V, CHAPTER I

1. *The Elder or Poetic Edda, commonly known as Sæmund's Edda, Part I: The Mythological Poems*, ed. and trans. Olive Bray (printed for the Viking Club: 1908).
2. Sallust, *The Jugurthine War*, trans. Revd John Selby Watson (Harper & Brothers: 1899).
3. Michel de Montaigne, *The Essays*, trans. J. M. Cohen (Penguin: 1958).
4. Erasmus, *Education of a Christian Prince*, trans. L. K. Born, in 'Erasmus on Political Ethics: The Institutio Principis Christiani', *Political Science Quarterly*, Vol. 43, No. 4 (December 1928).
5. Thomas Carlyle, *Past and Present* (Henry Frowde: 1909).

PILLAR V, CHAPTER II

6. Thomas à Kempis, *The Imitation of Christ*, trans. Revd William Benham (Routledge: 1905).
7. Thomas More, *Utopia* (1516).
8. Arthur Schopenhauer, *On the Suffering of the World* (Penguin: 2004).
9. Ibid.
10. John Milton, *Areopagitica* (1644).
11. Michel de Montaigne, *The Essays*, trans. J. M. Cohen (Penguin: 1958).
12. Ibid.
13. Kempis, *The Imitation of Christ*.

NOTES

PILLAR V, CHAPTER III

14. Cicero, *Selected Works*, trans. Michael Grant (Penguin: 1972).
15. Pacuvius, quoted in Michel de Montaigne, *The Essays*, trans. J. M. Cohen (Penguin: 1958).
16. Thomas à Kempis, *The Imitation of Christ*, trans. Revd William Benham (Routledge: 1905).
17. KJV.
18. Polybius, *The Histories*, trans. W. R. Paton (Loeb Classical Library, Harvard University Press: 1922).
19. Michel de Montaigne, *The Essays*, trans. J. M. Cohen (Penguin: 1958).
20. Kempis, *The Imitation of Christ*.
21. Pindar, *The Odes*, trans. C. M. Bowra (Penguin: 1988).
22. Kempis, *The Imitation of Christ*.
23. Ibid.
24. Erasmus, *On the Education of Children*, trans. Richard Sherry (1469–1536).

PILLAR V, CHAPTER IV

25. Plutarch, *Parallel Lives*, trans. John Dryden, in *Plutarch's Lives: The Translation called Dryden's, corrected from the Greek and revised by A. H. Clough, in 5 volumes* (Little Brown and Co.: 1906).
26. Demosthenes, 'On the Chersonese', in *Demosthenes*, trans. J. H. Vince (William Heinemann Ltd: 1930).
27. Oliver Cromwell MP's speech on the dissolution of the Rump of the Long Parliament, given to the House of Commons on 20 April 1653.
28. Philip Melanchthon, *Orations on Philosophy and Education*, trans. Christine Salazar (Cambridge University Press: 1999).

29. Erasmus, quoted in *Erasmus of Christendom*, Roland Bainton (HarperCollins: 1972).
30. Plato, *Gorgias*, from *Plato in Twelve Volumes*, Vol. 3, trans. W. R. M. Lamb (William Heinemann Ltd: 1967).
31. Quintilian, *The Institutes of Oratory*, trans. Harold Edgeworth Butler (William Heinemann Ltd: 1922).
32. Demosthenes, *The Second Philippic*, in *The Public Orations of Demosthenes*, trans. Arthur Wallace Pickard-Cambridge (Clarendon: 1912).
33. Aristotle's *Poetics*, in *Aristotle, Horace, Longinus: Classical Literary Criticism*, trans. T. S. Dorch (Penguin: 1965).

PILLAR V, CHAPTER V

34. William Wordsworth, 'The Tables Turned' (1798).
35. Cicero, *Against Catiline*, in *The Orations of Marcus Tullius Cicero*, trans. C. D. Yonge (Henry G. Bohn: 1856).
36. Plutarch, *Parallel Lives*, trans. John Dryden, in *Plutarch's Lives: The Translation called Dryden's, corrected from the Greek and revised by A. H. Clough, in 5 volumes* (Little Brown and Co.: 1906).
37. Ibid.
38. Plato, *Phaedrus*, trans. Benjamin Jowett, in *The Works of Plato: The Jowett Translation with the Introduction and Analysis* (Tudor Publishing: 1945).

PILLAR V, CHAPTER VI

39. Quintilian, *Institutes of Oratory*, trans. Revd John Selby Watson (Bohn's Classical Library: 1856).
40. Arthur Quiller-Couch, *On the Art of Writing* (Cambridge University Press: 1923).

NOTES

41. Sir Philip Sidney, *Astrophil and Stella* (1591).
42. *On the Sublime* in *Aristotle, Horace, Longinus: Classical Literary Criticism*, trans. T. S. Dorch (Penguin: 1965).
43. John Ruskin, *Inaugural address delivered at the Cambridge School of Art* (George Allen: 1879).
44. Quiller-Couch, *On the Art of Writing*.
45. KJV.
46. George Orwell, 'Politics and the English Language', *Horizon* (April 1946).
47. Paul Graham, 'Write Simply', March 2021.
48. Dr Johnson, *The Idler*, No. 70 (18 August 1759).
49. Quintilian, *Institutes of Oratory*.
50. *On the Sublime* in *Aristotle, Horace, Longinus*.
51. Ibid.
52. Lucian, 'The Way to Write History', in *The Works of Lucian of Samosata*, trans. H. W. Fowler and F. G. Oxford (The Clarendon Press: 1905).
53. Lord Byron, *Don Juan* (1819).

PILLAR V, CHAPTER VII

54. KJV.
55. Noah Webster, *An American Dictionary of the English Language* (1828).
56. Ibid.
57. Thomas Dekker, *The Wonderfull Yeare* (1603).
58. Arthur Quiller-Couch, *On the Art of Writing* (Cambridge University Press: 1923).
59. *The Translators to the Reader* from the KJV.

NOTES

PILLAR VI, CHAPTER I

1. From the *Kasha Upanishad*, in *The Upanishads*, trans. Juan Mascaró (Penguin: 1973).
2. Plato, *Apology*, trans. Benjamin Jowett, in *The Works of Plato: The Jowett Translation with the Introduction and Analysis* (Tudor Publishing: 1945).
3. Ibid.
4. Michel de Montaigne, *The Essays*, trans. J. M. Cohen (Penguin: 1958).
5. All quotes from Boethius, *The Consolation of Philosophy*, trans. Peter Walsh (Oxford University Press: 2008).
6. Montaigne, *The Essays*.
7. Sophie Scholl, as reported in a letter from Else Gebel, 1945 (*So ein herrlicher sonniger Tag, und ich muss gehen*).
8. His last words, according to Bl. Franz Jägerstätter (1907–43), Biography.
9. Xenophon, *Apology*, in *The Works of Xenophon*, trans. H. G. Dakyns (MacMillan: 1890).
10. Montaigne, *The Essays*.

PILLAR VI, CHAPTER II

11. Xenophon, *Anabasis*, in *The Works of Xenophon*, trans. H. G. Dakyns (MacMillan: 1890).
12. Michel de Montaigne, *The Essays*, trans. J. M. Cohen (Penguin: 1958).
13. Herodotus, *The Histories*, trans. Aubrey de Sélincourt (Penguin: 1964).
14. Marcel Proust, *Within a Budding Grove*, from *Remembrance of Things Past*, trans. C. K. Scott Moncrieff (Chatto & Windus: 1924).

15. Montaigne, *The Essays*.
16. William Wordsworth, *The Prelude* (1850).

PILLAR VI, CHAPTER III

17. KJV.
18. Baldassare Castiglione, *The Book of the Courtier*, trans. Leonard Eckstein Opdycke (Courier Dover: 2003).
19. From *The Cynic Epistles: A Study Edition*, ed. Abraham J. Malherbe (Society for Biblical Literature: 1977).
20. Marcus Aurelius, *Meditations*, trans. George Long (George Bell & Sons: 1890).
21. Seneca, *Epistles Volume II*, trans. Richard M. Gummere (Loeb Classical Library, Harvard University Press: 1920).
22. Epictetus, from *Epictetus, the Discourses as reported by Arrian, the Manual, and Fragments*, trans. William Abbot Oldfather (Loeb Classical Library, Harvard University Press: 1925).
23. William Blake, *Jerusalem* (1802–20).
24. Albert Camus, *The Myth of Sisyphus*, trans. Justin O'Brien (Alfred A. Knopf: 1955).
25. Walter Pater, *The Renaissance* (Oxford University Press: 1986).
26. Rumi, in *I Am Wind, You are Fire*, trans. Annemarie Schimmel (Shambhala Publications: 1996).

PILLAR VI, CHAPTER IV

27. KJV.
28. From Atrahasis, in *Before the Muses: An Anthology of Akkadian Literature*, trans. Benjamin R. Foster (CDL Press: 1996).
29. Hesiod, *Works and Days*, in *Hesiod: The Homeric Hymns and Homerica*, trans. Hugh Gerard Evelyn-White (Heinemann: 1920).

NOTES

30. 'The Futurists: Looking Toward A.D. 2000', *Time*, 25 February 1966.
31. Sir Philip Sidney, *Astrophil and Stella XXXIX* (1591).
32. Rupert Brooke, 'Pine-Trees and the Sky: Evening' (1907).
33. William Blake, *Auguries of Innocence* (1863).
34. John Constable, in *Memoirs of the Life of John Constable*, C. R. Leslie (J. M. Dent & Sons: 1912).

PILLAR VI, CHAPTER V

35. Solomon bar Simson, in *Chronicles of the First Crusade*, Christopher Tyerman (ed.) (Penguin: 2011).
36. Diodorus Siculus, in *The Library, Books 16–20: Philip II, Alexander the Great, and the Successors*, trans. Robin Waterfield (Oxford University Press: 2019).
37. Plutarch, in *Plutarch's Morals, translated from the Greek by several hands*, corrected and revised by William W. Goodwin (Little, Brown and Company: 1874).
38. Giovanni Boccaccio, *The Decameron*, trans. M. Rigg (David Campbell: 1921).
39. Michel de Montaigne, *The Essays*, trans. J. M. Cohen (Penguin: 1958).
40. KJV.

PILLAR VI, CHAPTER VI

41. Abraham Lincoln, from a speech given on 30 September 1859 in Milwaukee, Wisconsin.
42. Thomas Gray, 'Elegy Written in a Country Churchyard' (1751).
43. Yoshida Kenko, in *Three Japanese Buddhist Monks* (Penguin: 2020).
44. Pindar, *The Odes*, trans. C. M. Bowra (Penguin: 1988).
45. Virgil, *The Aeneid*, trans. J. W. Mackail (MacMillan and Co.: 1885).

NOTES

PILLAR VI, CHAPTER VII

46. *The Epic of Gilgamesh*, trans. Maureen Gallery Kovacs (Stanford University Press: 1989).
47. Cicero, in *Cicero's Tusculan Disputations: Also Treatises On the Nature of the Gods, and On the Commonwealth*, trans. C. D. Yonge (Harper & Brothers: 1888).
48. All quotes from Lucretius, *On the Nature of Things*, trans. A. E. Stallings (Penguin: 2007).
49. John Hall, *On an Hour-Glass* (1646).
50. Moriya Sen'an, in *Japanese Death Poems*, trans. Yoel Hoffmann (Tuttle: 1998).
51. From *The Upanishads*, trans. Juan Mascaró (Penguin: 1973).
52. John Donne, 'Sonnet' X from the *Holy Sonnets* (1633).
53. William Shakespeare, *Richard II* (1597).
54. William Shakespeare, *Henry IV Part I* (1597).
55. Seneca, quoted in the *Essays* of Francis Bacon (1597).
56. Lucretius, *On the Nature of Things*, trans. A. E. Stallings (Penguin: 2007).
57. *The Epic of Gilgamesh*.
58. Michel de Montaigne, *The Essays*, trans. J. M. Cohen (Penguin: 1958).

PILLAR VII, CHAPTER I

1. Albert Einstein, quoted in 'Atom Energy Hope is Spiked By Einstein / Efforts at Loosing Vast Force is Called Fruitless', *Pittsburgh Post-Gazette*, 29 December 1934.
2. Quoted in *Lewiston (Idaho) Morning Tribune*, 25 February 1957.
3. Arthur C. Clarke, 'Beyond 2001', *Reader's Digest*, February 2001.
4. 'The Futurists: Looking Toward A.D. 2000', *Time*, 25 February 1966.

5. *Scientific American*, 2 January 1909.
6. Tacitus, *Annals,* trans. A. J. Church and W. J. Brodribb (New English Library: 1964).
7. Diodorus Siculus, in *The Library, Books 16-20: Philip II, Alexander the Great, and the Successors*, trans. Robin Waterfield (Oxford University Press: 2019).
8. *The Works of Horace*, trans. C. Smart and revised by Theodore Alois Buckley (Harper & Brothers: 1863).
9. Thomas Carlyle, *Past and Present* (Henry Frowde: 1909).
10. Aeschylus, *Prometheus Bound*, trans. Philip Vellacott (Penguin: 1964).
11. Diodorus Siculus, in *The Library*.

PILLAR VII, CHAPTER II

12. Adolf Loos, *Ornament and Crime*, trans. Shaun Whiteside (Penguin: 2019).
13. Yoshida Kenko, in *Three Japanese Buddhist Monks* (Penguin: 2020).
14. Anonymous, *On the Sublime*, from *Aristotle, Horace, Longinus: Classical Literary Criticism*, trans. T. S. Dorch (Penguin: 1965).
15. William Harrison, *A Description of England*, in *Elizabethan England*, Walter Scott (1889).
16. Tacitus, *Annals*, trans. A. J. Church and W. J. Brodribb (New English Library: 1964).
17. Thucydides, *The Peloponnesian War*, trans. Rex Warner (Penguin: 1959).
18. John Ruskin, *The Eagle's Nest* (George Allen: 1899).
19. Thomas Browne, *Pseudodoxia Epidemica*, in *The Prose of Thomas Browne*, Norman J. Endicott (ed.) (Anchor: 1967).
20. Demosthenes, *On the Liberty of the Rhodians*, in *Demosthenes*, trans. J. H. Vince (William Heinemann Ltd: 1930).

NOTES

21. From *The Letters of Abelard and Heloise,* trans. Betty Radice (Penguin Books: 1978).
22. Lucretius, *On the Nature of Things*, trans. A. E. Stallings (Penguin: 2007).
23. From *The Letters of the Younger Pliny*, trans. Betty Radice (Penguin: 1983).

PILLAR VII, CHAPTER III

24. Thomas Browne, *Pseudodoxia Epidemica*, in *The Prose of Thomas Browne*, Norman J. Endicott (ed.) (Anchor: 1967).
25. Lucretius, *On the Nature of Things*, trans. A. E. Stallings (Penguin: 2007).
26. Edmund Burke, *Reflections on the Revolutions in France* (1790).
27. John Ruskin, *Modern Painters Volume I* (George Allen: 1900).
28. Burke, *Reflections on the Revolutions in France.*
29. Michel de Montaigne, *The Essays*, trans. J. M. Cohen (Penguin: 1958).
30. KJV.

PILLAR VII, CHAPTER IV

31. Robert Browning, in *Men and Women* (1855).
32. KJV.
33. Thomas Dekker, *The Guls Horn-Booke* (1609).
34. Giorgio Vasari, *Lives of the Most Eminent Painters, Sculptors, & Architects*, trans. Gaston du C. de Vere (MacMillan and Co. & the Medici Society: 1912–14).
35. John Ruskin, *A Joy Forever* and *The Two Paths* (George Allen and Sons: 1911).

NOTES

PILLAR VII, CHAPTER V

36. Augustus, in Suetonius, *Lives of the Caesars, Volume I*, trans. J. C. Rolfe (Loeb Classical Library, Harvard University Press: 1914).
37. William Morris, *Hopes and Fears for Art* (Ellis and White: 1882).
38. Le Corbusier, *Toward a New Architecture*, trans. Frederick Etchells (Dover: 1986).
39. Ibid.
40. Ibid.
41. Ibid.
42. John Ruskin, *The Stones of Venice Volume III: The Fall* (J. M. Dent & Sons: 1927).

PILLAR VII, CHAPTER VI

43. *The Poems of Sappho*, trans. Julia Dubnoff (https://www.uh.edu/~cldue/texts/sappho.html).
44. Thomas Dekker, *The Guls Horn-Booke* (1609).
45. Stephen Gosson, *The Schoole of Abuse* (1597).
46. Michel de Montaigne, *The Essays*, trans. J. M. Cohen (Penguin: 1958).
47. Niccolò Machiavelli, in *The Literary Works of Machiavelli with Selections from the Private Correspondence* (ed. and trans. John R. Hale) (Oxford University Press: 1961).
48. Seneca, *Epistles, Volume I*, trans. Richard M. Gummere (Loeb Classical Library, Harvard University Press: 1917).
49. Montaigne, *The Essays*.
50. *The Anglo-Saxon Chronicle*, trans. G. M. Garmonsway (Everyman: 1967).

NOTES

51. Ibn-Fadlan, in 'Ibn-Fadlan and the Russiyah', James E. Montgomery, *Journal of Arabic and Islamic Studies*, Vol. 3 (2000).
52. From *The Trial of Jeanne d'Arc*, trans. W. P. Barrett (Gotham House: 1932).
53. Montaigne, *The Essays*.
54. Walt Whitman, 'A Clear Midnight' (1881).
55. Thomas Dekker, *The Wonderfull Yeare* (1603).

PILLAR VII, CHAPTER VII

56. John Ruskin, *The Eagle's Nest* (George Allen: 1899).
57. August 2008: The world's ten oldest jokes revealed, University of Wolverhampton.
58. Lucian, 'The Way to Write History', in *The Works of Lucian of Samosata* (trans. H. W. Fowler and F. G. Oxford) (Clarendon Press: 1905).
59. Jean Froissart, *Froissart's Chronicles*, translated, selected, and edited by Geoffrey Brereton (Penguin Books: 1968).
60. Pindar, *The Odes*, trans. C. M. Bowra (Penguin: 1988).
61. *The Poems of Sappho*, trans. Julia Dubnoff (https://www.uh.edu/~cldue/texts/sappho.html).

List of Illustrations

1. North front of the White House (The White House / Public Domain / https://commons.wikimedia.org/wiki/File:028-P20210222CW-0151_(51146040430).jpg)
2. Map of Greece (Bernard Suzanne: https://plato-dialogues.org/tools/gk_wrld.htm)
3. Maison Carrée in Nîmes, France (Krzysztof Golik / CC BY SA-4.0 / image altered; superimposed text / https://en.wikipedia.org/wiki/File:Maison_Carree_in_Nimes_(16).jpg)
4. Temple of Bel, Palmyra, Syria (James Gordon / CC BY SA-2.0 / image altered; superimposed text / https://commons.wikimedia.org/wiki/File:Temple_of_Bel,_Palmyra,_Syria_-_1.jpg)
5. Roman Temple of Artemis in Jerash, Jordan (Askii / CC BY SA-3.0 / image altered; superimposed text / https://commons.wikimedia.org/wiki/File:Artemis_Temple_Pan_2_touched.jpg)
6. Front of the Capital, Dougga, Tunisia, 2006 (Eric T Gunther / CC BY SA-3.0 / image altered; superimposed text / https://commons.wikimedia.org/wiki/File:The_Capital_Dougga_Tunisia_2006.jpg)
7. Ancient Graeco-Roman city of Aphrodisias (Rabe! / CC BY SA-4.0 / image altered; superimposed text / https://commons.wikimedia.org/wiki/File:Aphrodisias_2013-03-27zzl.jpg)
8. Roman Temple of Evora (Digitalsignal / CC BY SA-4.0 / image altered; superimposed text / https://commons.wikimedia.org/wiki/File:Evora_roman-temple_panoramic-view_cropped.jpg)

LIST OF ILLUSTRATIONS

9. The Temple of Bacchus, Heliopolis, Baalbek, Lebanon (Vyacheslav Argenberg / CC BY SA-4.0 / image altered; superimposed text / https://commons.wikimedia.org/wiki/File:Lebanon,_Baalbek,_Temple_of_Bacchus_2.jpg)
10. Roman temple in Vic, Catalonia, Spain (Krzysztof Golik / CC BY SA-4.0 / image altered; superimposed text / https://commons.wikimedia.org/wiki/File:Roman_temple_in_Vic_(3).jpg)
11. Temple of Portunus, Piazza Bocca della Verito, Roma, Italy (Son of Groucho / CC BY SA-2.0 / image altered; superimposed text / https://commons.wikimedia.org/wiki/File:Roma-tempio_di_portunus.jpg)
12. Mooning gargoyle, St. Benedict's Church, Glinton (Paul Bryan / CC BY-SA 2.0 / https://commons.wikimedia.org/wiki/File:Mooning_gargoyle,_St._Benedicts_Church,_Glinton_(geograph_5324503).jpg)
13. Discobolus in National Roman Museum Palazzo Massimo alle Terme (Livioacreandronico2013 / CC BY-SA 2.0 / https://commons.wikimedia.org/wiki/File:Discobolus_in_National_Roman_Museum_Palazzo_Massimo_alle_Terme.JPG)
14. *Leaf from Carrow Psalter* (The Walters Art Museum / CC BY-NC-SA 3.0 / https://commons.wikimedia.org/wiki/File:English_-_Leaf_from_Carrow_Psalter_-_Walters_W3413V_-_Full_Page.jpg)
15. The Lady and the Unicorn, Paris (Didier Descouens / CC BY-SA 4.0 / https://commons.wikimedia.org/wiki/File:(Toulouse)_Mon_seul_d%C3%A9sir_(La_Dame_%C3%A0_la_licorne)_-_Mus%C3%A9e_de_Cluny_Paris.jpg)
16. Misericord, St Mary's church, Fairford (Julian P Guffog / CC BY-SA 2.0 / https://www.geograph.org.uk/photo/4109989)

LIST OF ILLUSTRATIONS

17. Employment in Agriculture (Max Roser (2013) Published online at OurWorldInData.org. Retrieved from: 'https://ourworldindata.org/employment-in-agriculture)
18. *September, November,* and *June* from *Les Très Riches Heures du duc de Berry* by the Limbourg Brothers and Jean Colombe (1412-1416)
19. *Saint Lucy* by Francesco del Cossa (1472)
20. *Saint Sebastian* by Albrecht Dürer (1499)
21. *Portrait of Erasmus* by Hans Holbein the Younger (1523)
22. *Isambard Kingdom Brunel Standing Before the Launching Chains of the Great Eastern* by Robert Howlett (1857)
23. *Virgin and Child*, mosaic from the Hagia Sophia in Istanbul (12th century) (Acaro / CC BY 2.5 / https://commons.wikimedia.org/wiki/File:Hagia_Sofia_mosaic_Virgin_and_Child.JPG)
24. *Madonna of the Book* by Sandro Botticelli (1481)
25. *Charles IV* by Carlos Espinosa Moya (1818)
26. *The Immaculate Conception* by Tiepolo (1767)
27. Lionel Messi playing for Argentina at the 2022 FIFA World Cup (Hossein Zohrevand / CC BY 4.0 / https://commons.wikimedia.org/wiki/File:Lionel-Messi-Argentina-2022-FIFA-World-Cup.jpg)
28. Life expectancy at birth (part of: Saloni Dattani, Lucas Rodés-Guirao, Hannah Ritchie, Esteban Ortiz-Ospina and Max Roser (2023) "Life Expectancy". Data adapted from Human Mortality Database, United Nations, Zijdeman et al., James C. Riley. Retrieved from https://ourworldindata.org/grapher/life-expectancy)
29. Extreme Poverty in absolute numbers (Ravallion (2016) updated with World Bank (2019) – processed by Our World in Data. Retrieved from https://ourworldindata.org/grapher/world-population-in-extreme-poverty-absolute)

LIST OF ILLUSTRATIONS

30. How has world population growth changed over time? (Max Roser and Hannah Ritchie (2023) Published online at OurWorldinData.org. Retrieved from: https://ourworldindata.org/population-growth-over-time)
31. *The Origin of the Milky Way* by Tintoretto (1580)
32. *Diogenes* by Jean-Léon Gérôme (1860)
33. *Bury Them and Keep Quiet*, from *The Disasters of War* by Francisco Goya (1810–20)
34. *The Raft of the Medusa* by Théodore Géricault (1819)
35. Escritoire designed by William Seuffert, 1903 (Auckland Museum / CC BY-SA 4.0 / https://commons.wikimedia.org/wiki/File:Escritoire_desk_(AM_2013.34.1-6).jpg)
36. Lamp and Lampshade made with Tiffany Glass by The Duffner and Kimberly Company, 1890-1900 (Budapest Museum of Applied Arts)
37. Silver Cutlery designed by Tiffany & Co, 1878 (Metropolitan Museum of Art)
38. Desk (photographed at "American Form", an exhibition organised by the Foreningen Brukskunst in 1954)
39. Mars Table Lamp designed by Per Sundstedt (Atelje Lyktan)
40. Fork (Aw58 / CC BY-SA 4.0 / https://commons.wikimedia.org/wiki/File:Widelec_-_2024.07.07.jpg)
41. Brand logos before and after from velvetshark.com (https://velvetshark.com/why-do-brands-change-their-logos-and-look-like-everyone-else)
42. Telegraph Machine and iPhone colour analysis from the Science Museum Group Digital Lab (https://lab.sciencemuseum.org.uk/colour-shape-using-computer-vision-to-explore-the-science-museum-c4b4f1cbd72c)

LIST OF ILLUSTRATIONS

43. A meme
44. Southern portal of Verona Cathedral (Andrea Bertozzi / CC BY-SA 4.0 / https://commons.wikimedia.org/wiki/File:Duomo_di_Verona_(4).jpg)
45. Entablature Diagram from the archives of Scott Foresman
46. Pantheon panorama, Rome (Maros M r a z / CC BY 2.5 / image altered; arrow and text superimposed / https://commons.wikimedia.org/wiki/File:Pantheon_panorama,_Rome_-_4.jpg)
47. The five orders of architecture with their pedestals, engraved by G.L. Smith (1756) from The Miriam and Ira D. Wallach Division of Art, Prints and Photographs: Art & Architecture Collection, New York Public Library
48. Corinthian Order diagram from Andrea Palladio, *The Four Books on Architecture*, translated by Robert Taverner and Richard Schofield, MIT Press (2002)
49. Wells Cathedral Nave (Lamiai / CC BY SA-3.0 / https://commons.wikimedia.org/wiki/File:Wells_cathedral_nave_clerestory.JPG)
50. Neuschwanstein Castle, Bavaria (Thomas Wolf / CC BY SA-3.0 DE / https://en.wikipedia.org/wiki/File:Schloss_Neuschwanstein_2013.jpg#/media/File:Schloss_Neuschwanstein_2013.jpg)
51. Maison Saint Cyr, Brussels (Thierry Demey / CC BY SA-4.0 / https://commons.wikimedia.org/wiki/File:BRUXELLES,_square_Ambiorix,_11_-_Maison_Saint-Cyr_-_BADEAUX_(4).jpg#/media/File:BRUXELLES,_square_Ambiorix,_11_-_Maison_Saint-Cyr_-_BADEAUX_(4).jpg)
52. Steiner House, Vienna (Marcelahernandezmoreira / CC BY SA-3.0 / https://commons.wikimedia.org/wiki/File:Casa_Steiner_-_Foto_Fachada_Trasera.jpg?uselang=de)

LIST OF ILLUSTRATIONS

53. Vienna, 1930s
54. American Radiator Building, New York (Jean-Christophe Benoist / CC BY SA-3.0 / image altered; text superimposed / https://commons.wikimedia.org/wiki/File:NYC_-_American_Radiator_Building.jpg)
55. Tribune Tower, Chicago (Antoine Taveneaux / CC BY SA-3.0 / image altered; text superimposed / https://commons.wikimedia.org/wiki/File:Tribune_Tower3.jpg)
56. Chrysler Building, New York (Kidfly182 / CC BY SA-4.0 / image altered; text superimposed / https://commons.wikimedia.org/wiki/File:Chrysler_Building_July_2024_006.jpg#/media/File:Chrysler_Building_July_2024_006.jpg)
57. UN Building (Stefan Schulze / CC BY SA-3.0 / image altered; text superimposed / https://commons.wikimedia.org/wiki/File:UNO_New_York.JPG)
58. Seagram Building, New York (Ken OHYAMA / CC BY SA-2.0 / image altered; text superimposed / https://commons.wikimedia.org/wiki/File:Seagram_Building_(35098307116).jpg)
59. SAS Building, Copenhagen (seier+seier / CC BY SA-2.0 / image altered; text superimposed / https://commons.wikimedia.org/wiki/File:SAS_Royal_Hotel,_Copenhagen,_1955-1960.jpg)
60. Plan for the Expansion of Barcelona by Ildefons Cerda, 1859 (Museu d'Historia de la Ciutat, Barcelona)
61. *Lodgers in Bayard Street Tenement, Five Cents a Spot* by Jacob Riis, from *How the Other Half Lives* (1890)
62. Water reflection of canal houses at blue hour in Damrak, Amsterdam, the Netherlands (Basile Morin / CC BY-SA 4.0 / https://commons.wikimedia.org/wiki/File:Water_reflection_of_canal_houses_at_blue_hour_in_Damrak_Amsterdam_the_Netherlands.jpg)

LIST OF ILLUSTRATIONS

63. John Gordon Rideout (American, 1898–1951). *Radio*, 1930–1933. Plaskon (plastic), metal, glass, 11 3/4 x 8 7/8 x 7 1/2 in. (29.8 x 22.5 x 19.1 cm). Brooklyn Museum, Purchased with funds given by The Walter Foundation, 85.9. Creative Commons-BY (Photo: Brooklyn Museum, 85.9_threequarter_right_bw.jpg)
64. Empire State Building, New York, photographed in 1931 by an unknown photographer
65. Nasir ol-Molk, Shiraz, Iran (Ramin Rahmani Nejad Asil / CC BY-SA 4.0 / https://commons.wikimedia.org/wiki/File:The_ Moqarnas.jpg)
66. Kinkaku-ji in Winter (Pubic Domain / https://commons. wikimedia.org/wiki/File:Kinkaku-Snow-8-Cropped.jpg)
67. Temple of the Golden Pavilion, Kyto (Jaycangel / CC BY SA-3.0 / https://commons.wikimedia.org/wiki/File:Kinkaku-ji_the_ Golden_Temple_in_Kyoto_overlooking_the_lake_-_high_rez.JPG)
68. Ruins of the Dresden Frauenkirche, date unknown (Erich Braum / CC BY SA-4.0 / https://commons.wikimedia.org/wiki/ File:Ruine_der_Dresdner_Frauenkirche_%26_Rathausturm. jpg#/media/File:Ruine_der_Dresdner_Frauenkirche_&_ Rathausturm.jpg)
69. Dresden, Germany, rebuilt Frauenkirche in winter with blue sky (Netopyr / CC BY SA-3.0 / https://en.m.wikipedia.org/wiki/ File:100130_150006_Dresden_Frauenkirche_winter_blue_ sky-2.jpg)
70. Bourtange Fortress (Dack9 / CC BY-SA 4.0 / Крепость Bourtange (Буртанж, она же Баургтанге, она же «Звездная крепость») — форт в Нидерландах на границе с Германией - File:Крепость Bourtange (Буртанж, она же Баургтанге, она же «Звездная крепость») — форт в Нидерландах на границе с Германией.jpg - Wikimedia Commons)

LIST OF ILLUSTRATIONS

71. *The Old Shepherd's Chief Mourner* by Edwin Landseer (1837)
72. *Sunrise on the Matterhorn* by Albert Bierstadt (late 19th century)
73. View of the Matterhorn from Zermatt (CaramelizedOnions / CC BY-SA 4.0 / https://en.m.wikipedia.org/wiki/File:View_of_the_Matterhorn_from_Zermatt.jpg)
74. *The Church at Auvers* by Vincent van Gogh (1890)
75. Church of Auvers-sur-Oise (ignis / CC BY-SA 3.0 / https://commons.wikimedia.org/wiki/File:Eglise_Auvers-sur-Oise_FRA_001.jpg#/media/File:Eglise_Auvers-sur-Oise_FRA_001.jpg)
76. *The Last Supper* by Leonardo da Vinci (1490s) at the Santa Maria della Grazie, Milan (Mariordo / CC BY-SA 4.0 / https://commons.wikimedia.org/wiki/File:2024_04_Da_Vinci_Last_Supper_Milan_7031.jpg)
77. Via Pietrapiana 38, Florence (sailko / CC BY SA-3.0 / image altered; circle graphic superimposed / https://commons.wikimedia.org/wiki/File:Via_pietrapiana_38,_casa_con_tabernacolo_01.JPG)
78. *Snow at Kinkaku-ji* from *Selected Views of Japan* by Hasui Kawase (1922)
79. *The Two Fridas* by Frida Kahlo (1939)
80. *The Destruction of Tyre* by John Martin (1840)
81. *Clouds Rising from the Green Sea* from *Water Studies* by Ma Yuan (early 13th century)
82. *Improvisation; Deluge* by Wasily Kandinsky (1913)
83. *The Lawyer* by Giuseppe Arcimboldo (1566)
84. Glass, water, metal and printed text on paper. 15 x 46 x 14 cm. Artist's proof, shown with permission of the National Gallery of Australia. © Michael Craig-Martin. Image courtesy Gagosian.
85. Marcel Duchamp's *Fountain* by Alfred Stieglitz (1917)

LIST OF ILLUSTRATIONS

86. Tutankhamun's Mask (Tarekheikal / CC BY-SA 4.0 / https://commons.wikimedia.org/wiki/File:The_famous_Tutankhamun_Mask_front.jpg)
87. Queen's Lyre, from the Royal Cemetery of Ur (Osama Shukir Muhammed Amin FRCP(Glasg) / CC BY-SA 4.0 / https://commons.wikimedia.org/wiki/File:Queen%27s_Lyre_Ur_Royal_Cemetery.jpg#/media/File:Queen's_Lyre_Ur_Royal_Cemetery.jpg)
88. Bull's Head Rhyton from the Palace of Knossos (Olaf Tausch / CC BY SA-3.0 / https://commons.wikimedia.org/wiki/File:Stierkopf-Rhyton_02.jpg)
89. Bronze Standing Figure from the Sanxingdui Museum, Guanghan, China
90. *The Dancing Girl of Mohenjo-Daro*, photogravure by Alfred Nawrath (1938)
91. Warrior of Hirschlanden (José Luiz Bernardes Ribeiro / CC BY-SA 4.0 / https://commons.wikimedia.org/wiki/File:Warrior_of_Hirschlanden_-_Landesmuseum_W%C3%BCrttemberg_-_Stuttgart_-_Germany_2017.jpg)
92. Diadoumenos (Tilemahos Efthimiadis / CC BY SA-2.0 / https://commons.wikimedia.org/wiki/File:Youth_binding_his_hair._About_450-425_BC_(3209630605).jpg)
93. Bust from the Torlonia Collection (Sailko / CC BY SA-3.0 / https://commons.wikimedia.org/wiki/File:Ritratto_maschile_detto_il_vecchio_di_otricoli,_50_ac_ca._(busto_moderno),_da_otricoli_(visconti),_MT533,_04.jpg#)
94. Panel from the bronze doors of the Basilica of San Zeno, Verona (Mattana / CC BY SA-3.0 / https://commons.wikimedia.org/wiki/File:Verona,_Basilica_di_San_Zeno,_bronze_door_013.JPG)

LIST OF ILLUSTRATIONS

95. Panel from the bronze doors of the Florence Baptistery by Lorenzo Ghiberti (Sailko / CC BY SA-3.0 / https://www.google.com/search?q=gates+of+paradise+ghiberti&oq=gates+of+paradise+ghiberti&gs_lcrp=EgRlZGdlKgkIABBF GDkYgAQyCQgAEEUYORiABDIHCAEQABiABDIICA IQABgWGB4yCAgDEAAYFhgeMggIBBAAGBYYHjI ICAUQABgWGB4yCAgGEAAYFhgeMgoIBxAAGAoYF hgeogEIMzg2MGowajGoAgCwAgA&sourceid=chrome&ie=UTF-8)
96. Jamb sculptures from Chartres Cathedral, France (Cancre / CC BY 2.5 / https://commons.wikimedia.org/wiki/File:Cenral_tympanum_Chartres.jpg)
97. *David* by Michelangelo (Livioandronico2013 / CC BY-SA 4.0 / https://commons.wikimedia.org/wiki/File:Michelangelo%27s_David_2015.jpg)
98. Tomb of Marino Morosini, Exterior of Santi Giovanni e Paolo, Venice (Didier Descouens / CC BY-SA 4.0 / https://commons.wikimedia.org/wiki/File:Exterior_of_Santi_Giovanni_e_Paolo_(Venice)_-_Tomb_of_Marino_Morosini.jpg)
99. Monument of the Valier family: Bertuccio Valier, Silvestro Valier and his wife Elisabetta Querini, by Andrea Tirali, Santi Giovanni e Paolo, Venice (Didier Descouens / CC BY-SA 4.0 / https://commons.wikimedia.org/wiki/File:Interior_of_Santi_Giovanni_e_Paolo_(Venice)_-_Monument_of_the_Valier_family.jpg)
100. The Bronze Head of Ife, New York (PaulAdogaOgbolo / CC BY-SA 4.0 / https://commons.wikimedia.org/wiki/File:IMG-20180922-WA0007_cropped.jpg#/media/File:IMG-20180922-WA0007_cropped.jpg)

LIST OF ILLUSTRATIONS

101. Plaster replica of Statue of George Washington by Antonio Canova at the North Carolina Museum of History; the plaster replica was made in 1910, the original was completed 1821 and destroyed by fire in 1831 (Public Domain)
102. *Andrieu d'Andres* by Auguste Rodin, 1900 (Saint Louis Art Museum)
103. *Statue of Thierry Henry* by Margot Roulleau-Gallais, MDM (company) at Emirates Stadium, London (David Holt / CC BY SA-2.0 / https://commons.wikimedia.org/wiki/File:Thierry_Henry_statue.jpg)
104. *Melancholia* by Albert György (CC BY-SA 4.0 / https://www.kozterkep.hu/28255/Melankolia_Genf_2012.html/photos/243469#vetito=243469)
105. Martin Luther King Jr by Tim Crawley on the west front of Westminster Abbey (https://pixabay.com/photos/london-united-kingdom-england-700860/)
106. Mercury Streamliner photographed by J. Baylor Roberts for National Geographic (November, 1936)
107. *Demosthenes* on the Shore by Eugène Delacroix (1859)
108. Apple, *Think Different*
109. *The Death of Socrates* by Jacques-Louis David (1787)
110. *Reflections at Ville d'Avray* by Grant Wood (1920)
111. *The Midnight Ride of Paul Revere* by Grant Wood (1931)
112. *Farm with Peat Stacks* by Vincent van Gogh (1883)
113. *Wheatfield with Cypresses* by Vincent van Gogh (1889)
114. *The Kiss* by Auguste Rodin (1882)
115. *Melancholy* by Edvard Munch (1894)
116. *Siesta* by Vincent van Gogh, painted in 1890
117. Bomb damage to Tokyo following United States raids on the city during World War II, 1945 (Public Domain)

LIST OF ILLUSTRATIONS

118. View of Tokyo (Yodalica / CC BY-SA / https://commons.wikimedia.org/wiki/File:Tokyo_from_the_top_of_the_SkyTree.JPG)
119. An Armenian woman photographed by Karen Jeppe, c.1915 (Public Domain)
120. Cadaver tomb of René de Chalon (Public Domain)
121. *Melencolia I* by Albrecht Dürer (1514)
122. *The Triumph of Death* by Pieter Brueghel the Elder (1562)
123. *Futurama* from the 1939 New York World's Fair, photographed by Richard Garrison
124. *Stormtroopers Advancing under Gas* by Otto Dix (1924)
125. *Interchange* by Willem de Kooning (1955)
126. "But is it art?" Poll by YouGov (https://yougov.co.uk/society/articles/16721-it-art-according-general-public-probably-not)
127. Ville Radieuse by Le Corbusier
128. Panorama of Rome (IonutDragu / CC BY SA-3.0 / https://commons.wikimedia.org/wiki/File:Rome_overview_from_Vatican_-_panoramio_%281%29.jpg)

Suggested Reading

What to Read Next?

Of all things in *The Cultural Tutor*, this has been the hardest to write. How to recommend further reading when the book covers so much? Well: every single book, poem, or document quoted in *The Cultural Tutor* was intended as a reading recommendation. Though, that being the case, it seems worth offering a more specific selection of two or three further things you might want to read, divided by Pillar. Only, please note, this is purely personal; it could not be exhaustive.

Pillar I

There is a time-honoured list of books to read about the Classics. The likes of Herodotus and Thucydides for the Greeks; Livy and Tacitus for the Romans. They are, like all the greats, genuinely worth reading. But, personally, I think Plutarch's *Parallel Lives* is a wonderful place to start. The *Letters of Pliny the Younger* are also excellent, and so too is Xenophon's *Anabasis* – a motion picture waiting to be made! Ancient literature is also important, not for only for its literary but its historical value – it helps us see into the minds and hearts of the ancients. Homer is as good as they say. In particular I think the Athenian tragedians – Aeschylus and Sophocles especially – will help you understand the Ancient Greek worldview.

The Middle Ages are a little trickier – there is no established canon. That being said, any of the many medieval chronicles are

worth looking in to. Jocelin of Brakelond's *Chronicle of the Abbey of Bury St Edmunds* is a brief and delightful place to begin. Froissart's *Chronicles* are fabulous. The *Letters of Abelard and Heloise* bring the Middle Ages to life like nothing else can. William Harrison's *Description of England* is unusual, revelatory reading. And, again, literature is powerful: the *Song of Roland*, *Beowulf*, the *Eddas*, and the *Divine Comedy* are all useful as history no less than poetry.

Pillar II

If the first pillar's recommendations were about history told more squarely, these are books that let you *inhabit* that history or think about it more obliquely. George Godwin's *Another Blow for Life* reveals more about Victorian Britain than a whole library of books. Meanwhile Thomas Carlyle's *Past and Present* remains a marvellous example of how to think about history imaginatively. The letters of Erasmus (in a particular volume, now out of print, by J.A. Froude) are a perfect portrait of early sixteenth century Europe. Thomas Browne's *Pseudodoxia Epidemica*, though bizarre, is an insight into what ordinary people thought in the seventeenth-century. As I've said elsewhere, 'primary sources' are always worth looking at, even more than full books, and you can find them online easily – the Internet History Sourcebooks are a particularly good place to do so.

Pillar III

As an introduction to classical architecture Vitruvius' *De Architectura* is absolutely necessary – and astonishingly readable. John Summerson's *Classical Language of Architecture* is, rightly, a staple modern introduction. Nobody has described the Gothic better than John Ruskin in *The Stones of Venice Volume II*. And, moreover,

all three volumes of *The Stones of Venice* are an unparalleled introduction to the principles and practices of architecture in general, along with his *Lectures on Architecture and Painting*, given at Edinburgh in 1853. Augustus Pugin's *True Principles* is a much shorter, though fantastically robust, introduction to Gothic Architecture. Le Corbusier's *Vers une architecture* demands to be read. It is an extraordinary treatise and explains why the modern world looks the way it does. Into this category I also put the essays of Adolf Loos.

Pillar IV

There are countless wonderful books about art – but I still think John Ruskin is the best place to begin. Not because everything he says is correct, but because of just how powerfully he opens our eyes. *The Eagle's Nest*, *A Joy for Ever*, and *Modern Painters* (this last one is an intimidating five volume work) are three places to begin. Otherwise, Leonardo's *Treatise on Painting* is worth reading because it reveals to non-artists (like myself!) just how much effort and thought are required of even the minutest detail in a painting. As for other forms of design, William Morris's *Hopes and Fears for Art* is a timeless treatise; as is Ruskin's *The Two Paths*.

Regarding 'literature', I cannot possibly make even a personal selection. All I will say is that the canonical greats, from every corner of the Earth, are always worth your attention – they have achieved their status for a reason. If you're considering some sort of big famous book (like Hugo's *Les Misérables* or Milton's *Paradise Lost*) then do so – you won't regret it. That being said, I discovered most of my favourite writers by picking out things at random from second-hand book shops – that's how I discovered Alejo Carpentier and Marina Tsvetaeva.

SUGGESTED READING

Pillar V

All the books quoted in this pillar are worth looking at for guidance on the various subjects of thinking, speaking, and writing. I think *On the Sublime* is superb – and has not aged a day in two thousand years. Horace's *Ars Poetica* is also useful, and very good fun. Arthur Quiller-Couch's *On the Art of Writing* is a gem. As for rhetoric, Quintilian's *Institutio Oratoria* is unmatched. It is monumental and intimidating – but, if you look into it, eternally rewarding.

Pillar VI

How to live and how to die? No two questions have received more attempted answers; there is an abundance of 'wisdom literature' from around the world and across the ages. I think the *Essays* of Michel de Montaigne are the best place to start. They'd been recommended to me for years – when I finally read them I understood why. Otherwise I think *The Imitation of Christ* by Thomas à Kempis is just about the wisest book ever written. Boethius's *Consolation of Philosophy* is also one of those little volumes you kind of want to take with you everywhere. I feel the same way about the *Upanishads*. Lucian's *Dialogues* are also splendid for shifting and improving one's perspective.

Pillar VII

I make no recommendations regarding the final pillar of *The Cultural Tutor*. It is, after all, about the present day. And, as it was written in that chapter, the most important book of all is this universe of ours. The best thing we can do, better than books and better than anything we find online, is to pay genuine, careful attention to the real world we are all living in. Consider that my final and most important 'reading recommendation'.